Turner *in his time*

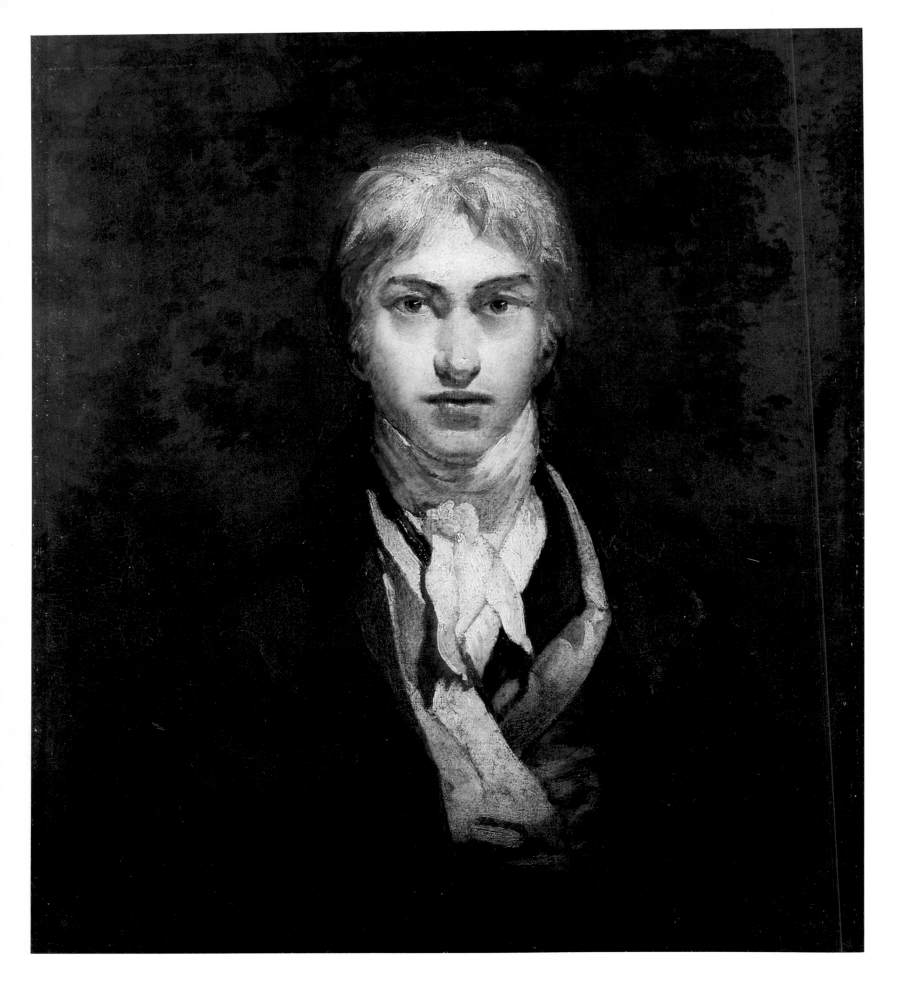

Turner *in his time*

ANDREW WILTON

HARRY N. ABRAMS, INC.,
PUBLISHERS, NEW YORK

For my parents

1 (*on the half-title page*) Turner's visiting card, covered with sketches (actual size).

2 (*frontispiece*) *Self-portrait, c.*1800. Usually dated to about 1798, this unexpectedly self-confident portrayal of himself was probably painted in the period following Turner's meeting with Sarah Danby and the birth of their first child. It also celebrates his election as Associate of the Royal Academy at the very end of 1799, and shows the artist at very much the same age as George Dance's profile portrait of him (ill. 15) which is dated March 1800.

Library of Congress
Cataloging-in-Publication Data

Wilton, Andrew.
 Turner in his time.

 Bibliography: p.
 Includes index.
 1. Turner, J. M. W. (Joseph Mallord William), 1775–1851.
—Criticism and interpretation. I. Title.
N6797.T88W56 1987 759.2 87–1790
ISBN 0–8109–1694–0

Published in 1987 by Harry N. Abrams, Incorporated, New York. All rights reserved. No part of the contents of this book may be reproduced without the written permission of the publishers

Times Mirror Books

Printed and bound in Great Britain

ACKNOWLEDGMENTS

To Ruskin, Thornbury and Finberg the modern biographer of Turner must acknowledge a vast debt of gratitude. To Falk too, to W. T. Whitley, to C. F. Bell, Hilda Finberg and numerous other researchers into the byways of Turner's life and career he owes much. There are the obituarists Peter Cunningham and Lovell Reeve, and the early memorialists who in the years immediately after Turner's death first began to gather anecdote and tradition together: Cunningham again and John Burnet (1852), Cyrus Redding (1852 etc.), Alaric Watts (1853), Thomas Miller (1854), and George Jones (composed *c.*1857–63).

A recent generation of scholars have done an enormous amount in a short time to change our understanding of innumerable aspects of the subject. They were led by Jack Lindsay who, in 1966, produced the most original account of the man to have appeared since Finberg's. Although they have been primarily concerned with Turner's art, Martin Butlin, Evelyn Joll and John Gage have unearthed rich mines of information; and the whole army of modern Turnerians – Fred Bachrach, Malcolm Cormack, Lindsay Errington, Gerald Finley, Hardy George, Lawrence Gowing, Robin Hamlyn, Craig Hartley, Luke Herrmann, David Hill, Adele Holcomb, Michael Kitson, Ann Livermore, Kathleen Nicholson, Mordechai Omer, Cecilia Powell, Lindsay Stainton, Eric Shanes, Barry Venning, Stanley Warburton, Selby Whittingham, Gerald Wilkinson, Bob Yardley, Ed Yardley, Patrick Youngblood, Jerrold Ziff and many more – have steadily brought the kaleidoscopic picture into gradually sharper focus. All have been of invaluable assistance, through their publications, in the compilation of this volume. Ann Forsdyke was responsible for the original draft of the Chronology; Julia Clarkson and Ian Warrell prepared the Index with diligence and enthusiasm; and Rosalind Turner was prodigal of encouragement and very practical help. To all the above I extend my grateful thanks.

A. W.

CONTENTS

INTRODUCTION

THERE IS A CENTRAL IRONY in any presentation of the life and personality of Turner, an irony which he himself put his finger on: 'No one', he said, 'would believe, upon seeing my likeness, that I painted these pictures' (Reeve*). That antithesis has been the motive of almost everything that has been written about him as a man. It has bred a kind of prurience, a sense of the uncovering of what is unmentionable, which Turner's own consciousness of the situation has only exacerbated. He was fully aware of the nature of creative genius as it manifested itself in him; and he was also aware of the ridiculous aspects of the human being in whom that genius resided. His art is essentially about that paradox: the pathetic inadequacy of human beings in an ineffably beautiful and terrible universe. The contrast of the ludicrous and the inspiring was exemplified in himself, and in his wisdom he recognized it. Knowing the greatness and littleness of himself he could understand and record the greatness and littleness of the world.

This insight has often been seen as the product of a tragic view of life. It is equally the concomitant of a lively sense of humour, and Turner's humour is well attested by all his friends. Nowhere did he apply it more consistently than in his comments on his own paintings, about which he loved to mystify earnest enquirers. In this respect there was, indeed, a clearly perceived correspondence between the man and his art: 'his life partook of the character of his works', a fellow-artist, David Roberts, remarked: 'it was mysterious, and nothing seemed so much to please him as to try and puzzle you, or to make you think so: for if he began to explain, or tell you anything, he was sure to break off in the middle, look very mysterious, nod, and wink his eye, saying to himself, "Make out that if you can"' (T., II, pp. 45–6).

The challenge to 'make out' the truth of Turner's life amid the web of misleading information that he spun around his affairs has led many biographers to emphasize the sordid and disreputable implications of his secrecy at the expense of what was in reality merely banal. This tradition culminated in Bernard Falk's *Turner the Painter: his hidden life*, of 1938. Falk availed himself of previously unexplored family documents to give a picture of the artist and his relations in more minute detail than had been attempted before. His motives in doing so were unfortunately those of the sensation-loving journalist rather than of the serious historian, and his reiterated appeals to the reader's moral sense, like those of any bad journalist, accord ill with the seamy or titillating details that he takes evident pleasure in extrapolating from the evidence. Yet such evidence, properly addressed and evaluated, is of importance in a full account of Turner, and his most significant biographer has been charged with a failure to address it with sufficient candour.

Almost immediately after the appearance of Falk's book, in 1939, A. J. Finberg published his exhaustive *Life of J. M. W. Turner, R.A.* which has been ever since the standard biography. Finberg's approach, dedicated, conscientious, thorough, highly appreciative of Turner's art while never sentimentally enthusiastic, is opposed to that of Falk in every way. If, through squeamishness or misunderstanding, he fails to give full weight to the facts on which Falk lays such stress, his view of Turner is nonetheless superior in all respects and remains, in its essentials, a just and accurate one. Yet it revolves round a perception which would seem the most unsatisfactory starting-point for an engaged biography. 'The real trouble', he wrote to his son while he was working on the book, '. . . is, I think, that Turner is a very uninteresting man to write about. There is nothing picturesque, romantic or exciting either in his

* Abbreviations used for sources of quotations are explained in the Bibliography, p. 249, which lists all works cited in the text. Reeve and other early writers are introduced on p. 4. Sketchbook titles are those adopted by A. J. Finberg in his *Inventory* of the Turner Bequest (1909), and all mentions of 'TB' refer to that work. Titles of pictures exhibited by Turner are generally given as they appeared in the catalogues of the time (where they usually followed his own wording, though often with vagaries of spelling which may be attributable to contemporary typesetters rather than to the artist).

character or in his life. His virtues and defects are all on the drab side. He was thoroughly plebeian in all things. A common workman and tradesman . . . the only interesting thing about him is that he was the man who painted Turner's pictures. He lived entirely for his work. Everything interesting about him appeared only in his work. The man is only the unimportant nexus that binds the works together. I have done my best to explore the inner sanctuary of a great artist's personality, and when I draw the veil, behold there is nothing there but a common man, an ingrained plebeian, so common, so undistinguished, so ordinary, that he seems to be merely the abstract idea of Everyman incarnate. He is nearly always described as eccentric. To me he seems exactly the bull's eye, the essence of centrality.'

And so Finberg, too, was concerned to contrast the man and his work, though not in the prurient manner of Falk, nor even with the lively ironic sense of Turner himself. He had recourse to two principal authorities for his account. One was that embodied in the copious references to Turner in the writings of John Ruskin, who at an early age recognized that behind the ordinariness of the man a very great mind was clearly apparent. 'Turner there is no mistaking for a moment,' he observed in 1841, '– his keen eye and dry sentences can be the signs only of high intellect.' For him, it was impossible that a 'common' man could have created the supremely distinguished works of art that were Turner's, and his friendship with the artist took the form of a perpetual search for signs of his greatness.

But Ruskin never wrote the life of Turner that he planned, and that he would have been particularly qualified to produce. Finberg's other source was the earliest full biography, written by a man who had never known Turner, the journalist Walter Thornbury, who tried to abide by the advice Ruskin gave him on commencing the work: 'Fix at the beginning the following main characteristics of Turner in your mind, as the keys to the secret of all he said and did: – Uprightness. Generosity. Tenderness of heart (extreme). Sensuality. Obstinacy (extreme). Irritability. Infidelity. And be sure that he knew his own power, and felt himself utterly alone in the world from its not being understood. Don't try to mask the dark side.'

Thornbury's book came out in 1861 (though, as Finberg points out, with the date 1862), and was demolished by contemporary reviewers for its slovenly construction and inaccurate detail. It nevertheless became, of necessity, the foundation for all subsequent accounts before Finberg's own, which also depends, willy-nilly, in important respects on the material that Thornbury assembled. It is still an unavoidable work of reference on the subject. Yet Finberg's estimate of Thornbury can hardly be refuted: the book is valuable almost solely in so far as it prints at length and, apparently, verbatim, the recollection of Turner's closest friends. In other respects it is a quite astonishingly badly organized farrago of sentimental invention.

All the same, at this distance of time we may attach some value to the immediacy of Thornbury's impressions. Even the fictitious nature of many of them may help us to recognize one important feature of his approach which bears on the problem of the modern biographer. Thornbury treats Turner neither as the subject of journalistic gossip nor as 'the essence of centrality', but (perhaps because of his anxiety to see him as Ruskin wished, in the round) as a character out of Dickens. Dickens, he makes us feel, could have written a superb life of Turner, engaging all his love of eccentric Londoners and dilapidated London scenery in doing so. That Turner the man could have been a character invented by Dickens is borne out repeatedly by contemporary descriptions of his various houses and his strange, secretive comings and goings. Even the long-drawn-out history of his will in the Court of Chancery is Dickensian.

If Thornbury enjoyed embroidering this idea he did not, at any rate, impose it arbitrarily on his material. Nothing could be more apt as a further parallel between art and artist. Ruskin observed that Turner was Shakespearean in his range and power; it is equally true that he is the most Dickensian of English artists – more so than the contemporary genre painters who consciously illustrated the novelist's works. For Turner does not 'illustrate' scenes from fiction. Like Dickens he describes life, the life of a vast and many-faceted world, stretching from the Himalayas to the Hebrides, from ancient Greece to the Great Western Railway. If so wide-ranging a mind, expressing itself on paper and canvas with such freedom and power, chose to house itself in obscure and unpretentious places full of the litter of a busy but not ultimately a materially-orientated existence, we cannot say that a novelist would find in that any very surprising discrepancy.

The purpose of this book is to provide the essential facts of Turner's life in an easily accessible form, couched as far as possible in the words of the artist himself or those of his contemporaries. Selecting such a nucleus of documents involves difficult choices. Innumerable records transmitted to us are so central to our perception of Turner that they select themselves; but others, perhaps equally well known, are probably the fictions of early gossip or later reconstruction. For example: '"The Sun is God," said Turner, a few weeks before he died, with the setting rays of it on his face'; so Ruskin, one of the most authoritative of all sources, reported (R., XXVIII, p. 147), and the remark has become the most famous of all Turner's *obiter dicta*. Yet Ruskin was not present, a fact which, together with his ambiguous phrasing – Turner died in the morning, not at sunset – casts doubt on the story as a whole. Many anecdotes about Turner are similarly interwoven fact and fiction.

The narrative text is intended to be read, chapter by chapter, in conjunction with the Chronology of each decade which gives details of Turner's exhibited works, his itineraries on tour, and the sketchbooks he used on his travels. The illustrations and captions amplify the information given in the text; Turner's own works have been used whenever possible to make biographical points, as well as to give a general survey of his prolific and endlessly innovatory career.

1775–1800

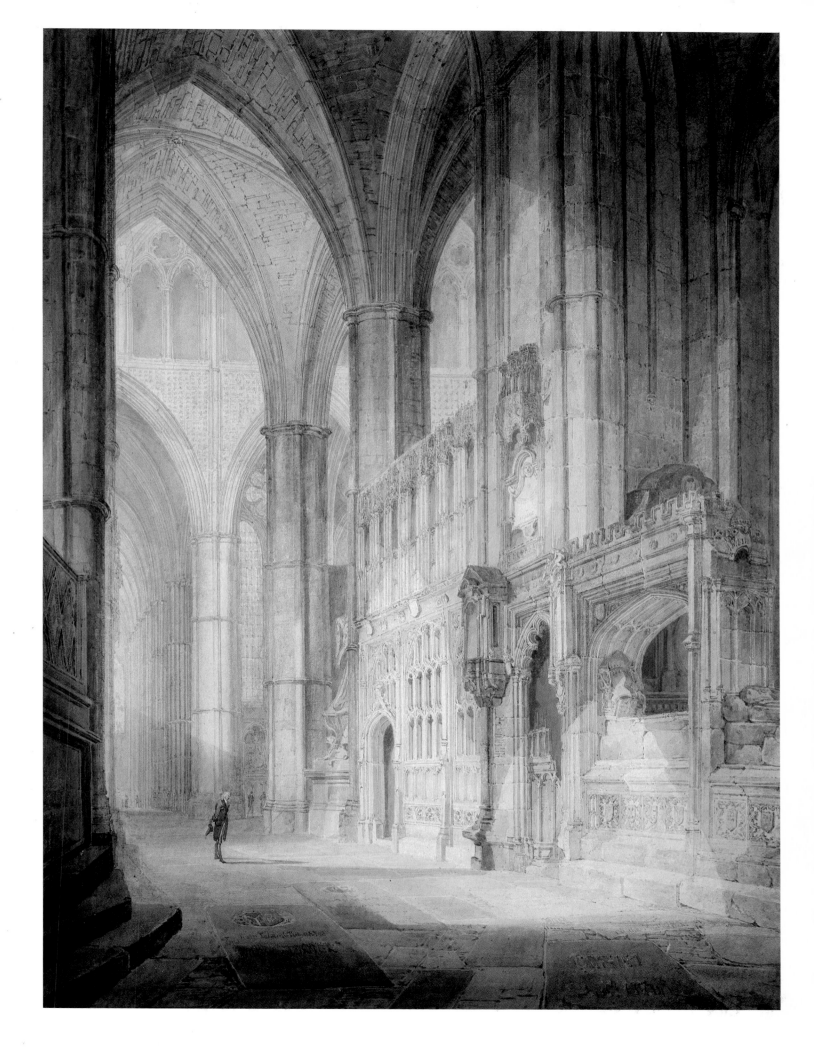

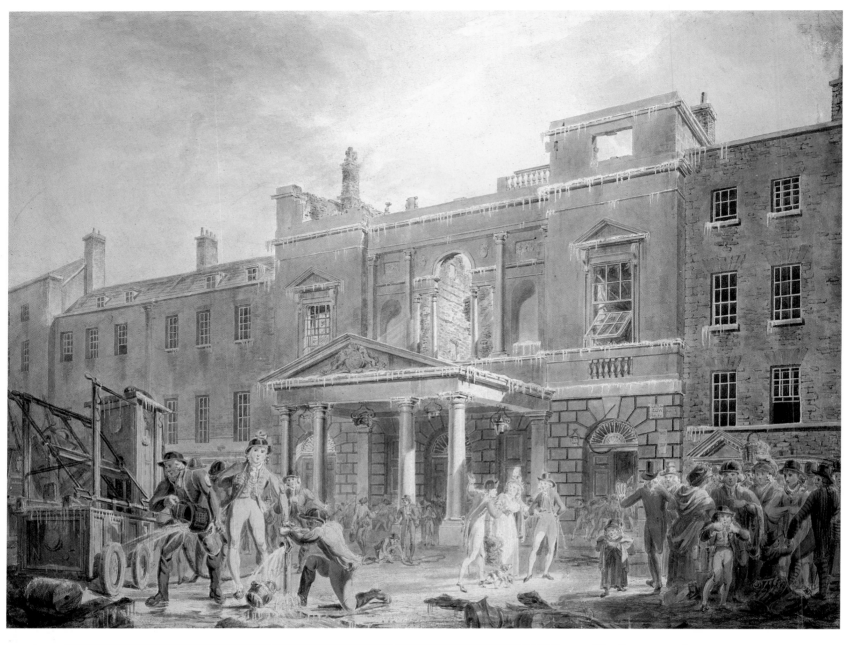

The first years of Turner's professional career saw rapid and radical advances in his use of watercolour. In *The Pantheon, the morning after the fire* (4), shown at the Academy in 1792, he combines architectural drawing in the style of his teacher, Thomas Malton (see ill. 16), with a sensitively observed effect of light and the vigorous depiction of a crowded street. A more explicit commitment to the presentation of light and atmosphere emerges in the landscapes of the following years. Of a watercolour shown at the Academy in 1793, *The rising squall – Hot Wells, from St Vincent's rock, Bristol*, now known only from the fully worked up study in the Turner Bequest (5), Peter Cunningham wrote in his obituary of Turner that it 'evinced for the first time that mastery of effect for which he is now so justly celebrated'.

Watercolours 1792–1797

Turner's study of the watercolours of
Rooker, Dayes and Hearne bore fruit in
a wealth of topographical views,
culminating in his work of 1795–6. At
this time he began an important series of
drawings for Richard Colt Hoare, of
Stourhead. They show Salisbury
Cathedral, which was in the process of
being restored by James Wyatt, and
other buildings in the town and
neighbourhood. This view of the *North
Porch of the Cathedral* (6) was executed in
about 1796, and imitates Rooker in its
treatment of the shadows of foliage on the
carefully textured masonry (see ill. 32).

In the collection at Stourhead were
examples of Piranesi's impressive
etchings and large watercolours by the
Swiss Louis Ducros. Both artists
evidently influenced Turner's
atmospheric view of the *Trancept of
Ewenny Priory, Glamorganshire* (7),
shown at the Academy in 1797.

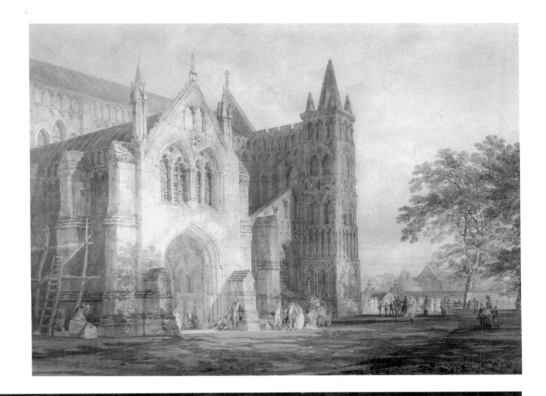

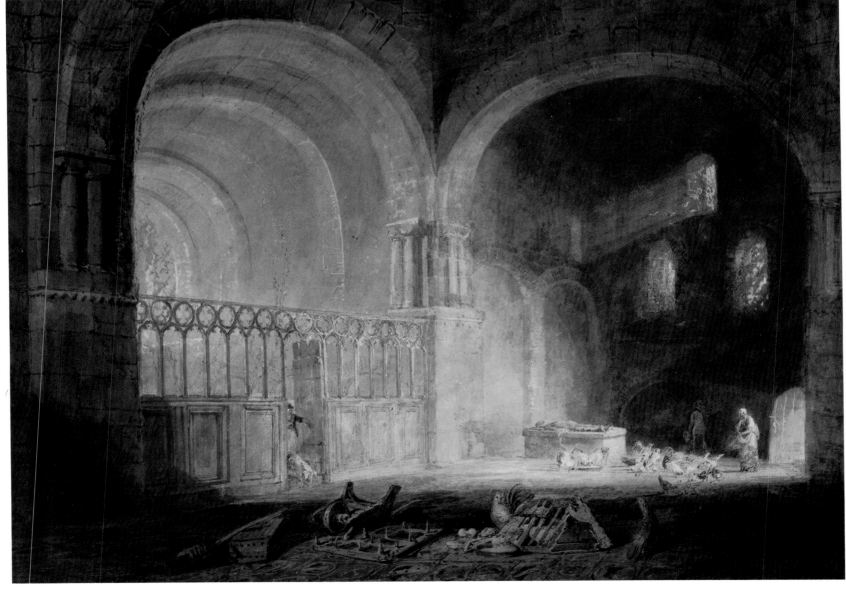

The Welsh watercolours, 1798–1800

Turner made his first visit to the mountains of North Wales in 1798. The scale and magnificence of the scenery profoundly modified his approach to watercolour. Having made numerous studies on tour, in both pencil and watercolour, he experimented in his studio with new procedures and new colour systems to create some of the most extraordinary of all landscapes. The large size of these drawings seems to have been necessary to the working out of a new range of ideas concerning the sublime in nature. The study of *Dolbadarn Castle* carried out in pale blue (8) shows Turner searching for coherence and pictorial unity, in the eighteenth-century tradition of serious and elevated art.

A long sequence of studies resulting from a second visit in 1799 is more concerned with details of geology and light effects. As in the view of *Snowdon from Llyn Nantlle* (9), Turner worked with large sheets of paper and in colour on the spot. He later developed his initial sketches into studies of immense power and complexity, such as this view looking down on *Llanberis* in a burst of sunlight (10). Only a few finished watercolours with Welsh subjects emerged from all this experiment, but it was to have an enduring effect on his later work.

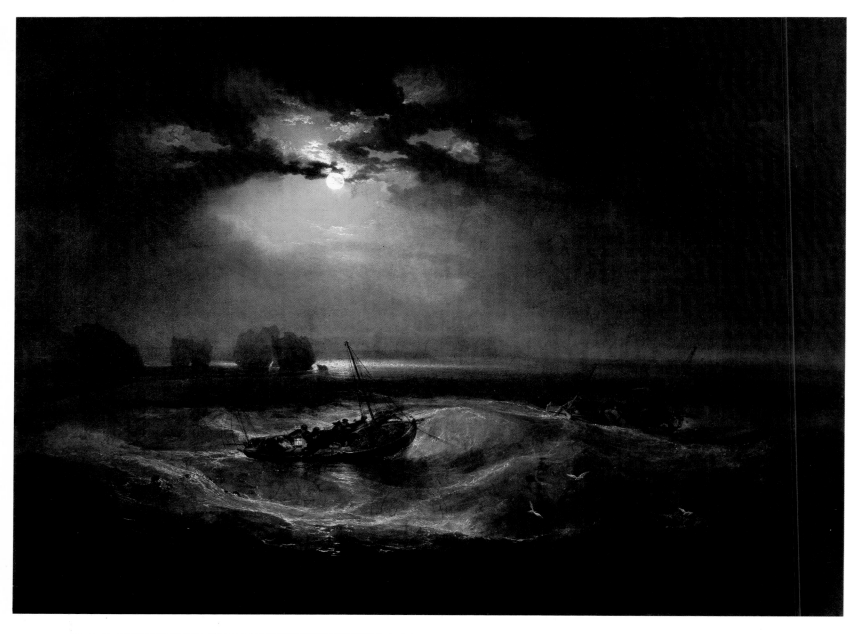

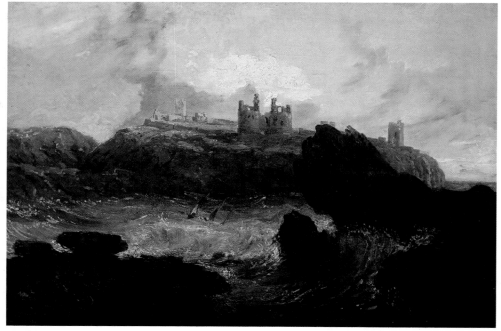

The early oil paintings

An important influence on the technical developments in watercolour of the later 1790s was Turner's introduction to the medium of oil. The elegance and smoothness of finish so conspicuous in his first exhibited work, *Fishermen at sea* (11) of 1796, betray the influence of Continental masters like De Loutherbourg and Vernet. This manner was quickly superseded by a more consciously 'British' style, modelled on the broad handling of Richard Wilson, and often involving the vigorous use of the palette knife, as in this view of *Dunstanburgh Castle* (12) of about 1798. By the turn of the century he had begun sketching in oils out of doors. This study of *Beech trees* (13) was probably made in the autumn of 1799 while Turner was staying with his friend W. F. Wells in Kent.

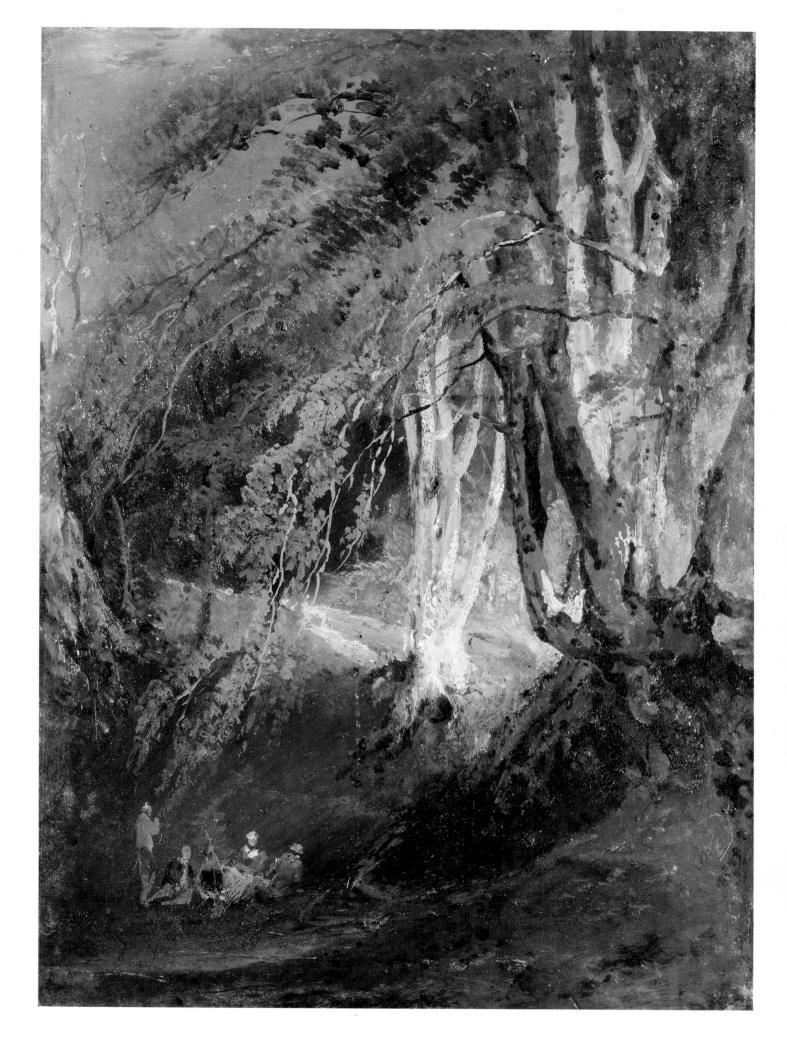

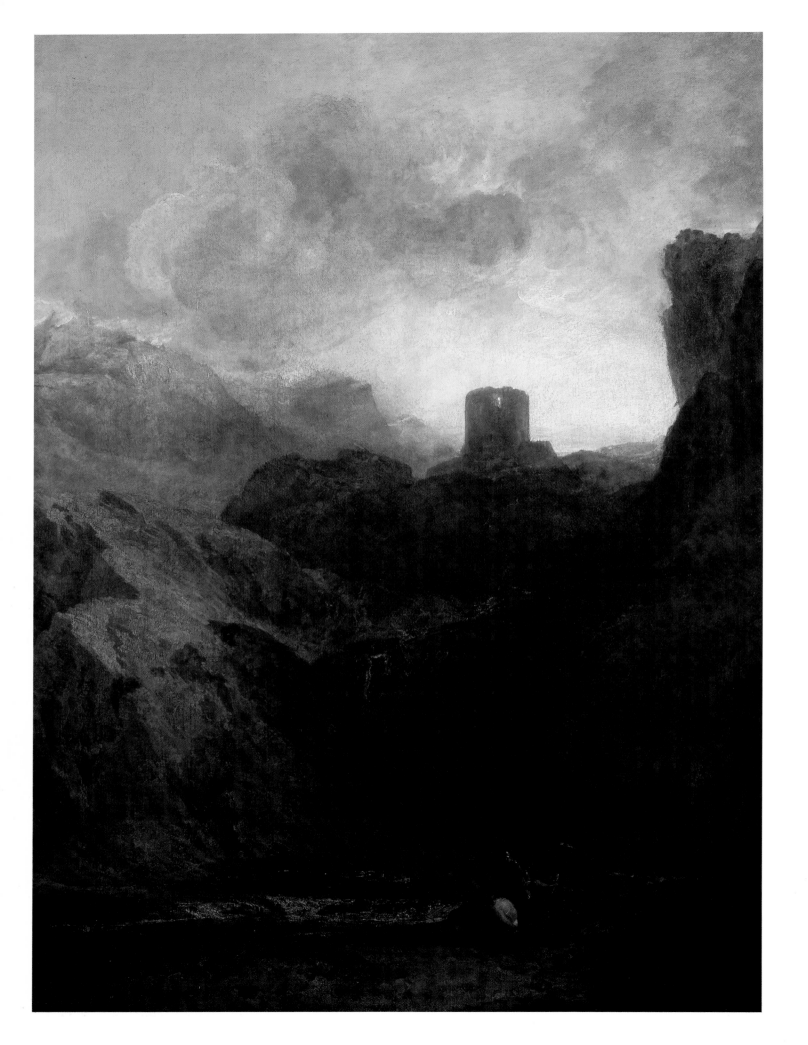

1775~1800

TURNER'S LOVE OF MYSTIFICATION made it difficult for his contemporaries to discover much about his private life; for his biographers it has meant that many of the statements that he made about himself, on which we need to rely for essential information, have to be treated very cautiously. We know from the evidence of the register of St Paul's Church, Covent Garden, that he was christened there as 'Joseph Mallord William Turner son of William Turner by Mary his Wife' on 14 May 1775; and this leads us to accept as accurate his own testimony that he was born in that year: a watercolour of the interior of Westminster Abbey shown at the Royal Academy in 1796 is signed by him in imitation of a carved inscription on a paving stone 'WILLIAM TURNER NATUS 1775'. Another statement, which occurs in his will, indicates that his birth date was 23 April, and this is now generally accepted as correct; but in the context – a direction to the Trustees of the Royal Academy to lay out £50 annually for a dinner to be held on that date – it is not impossible that he named the day more for its association with St George and perhaps Shakespeare than because it was really his birthday, the date of which he all his life kept secret from even his closest friends.

There is equal room for doubt as to the place in which he was born. His obituarists gave it as no. 26 Maiden Lane, Covent Garden, but his parents were living at no. 21 in the year of his birth; and Turner himself offered quite different information to a friend, Cyrus Redding, whose accounts of his conversations with the artist are for the most part highly circumstantial and, apparently, accurate. When Redding was with Turner in Devonshire in 1813, he elicited a rare snippet of autobiography:

> We were sailing together in a boat on the St. Germains river, near Ince Castle. I recollect it as well as if it had occurred yesterday. Turner, Collier [a friend], and myself were the only persons present except the boatmen. I was remarking what a number of artists the west of England had produced, particularly Devon and Cornwall. I enumerated all I could remember, from Reynolds to Prout. When I had done, Turner said, 'You may add me to the list; I am a Devonshire man.' I demanded from what part of the county, and he replied 'Barnstaple'. (Redding 1852, p. 151)

This observation could be interpreted as meaning merely that Turner's family originated there, but it is at least possible that his mother may have been sent to stay with her husband's relations in Devon when she was expecting her first child. William Turner senior was one of a large Devon family, scattered across the county; only his brother John actually lived in Barnstaple, where he was governor of the workhouse; by trade he was a saddler, based in South Molton. It was in South Molton that the artist's father was born on 29 June 1745, and if his son had been referring to his family origins in general it seems likely that he would have mentioned that town. However, the claims of Barnstaple have been dismissed by modern historians, and it is perhaps unlikely, though not impossible, that his mother would have made the long journey back to London soon enough for the christening in Covent Garden three weeks later.

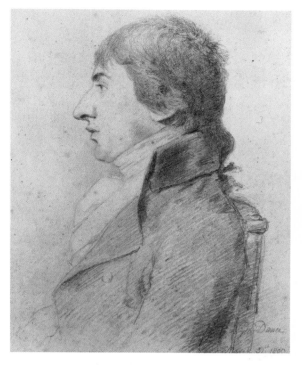

15 A portrait of Turner at the age of twenty-four, drawn by George Dance in March 1800 to mark the painter's election to Associateship of the Royal Academy the previous December.

OPPOSITE

14 *Dolbadern Castle, North Wales.* Turner presented this picture to the Academy as his Diploma Work on election as Academician in 1802. It had been exhibited in 1800 with five lines of poetry:

How awful is the silence of the waste
Where nature lifts her mountains to the sky.
Majestic solitude, behold the tower
Where hopeless OWEN, long imprison'd, pin'd,
And wrung his hands for liberty, in vain.

The picture sums up his aims at the time. A historical dimension is introduced into a sublime landscape without compromising its simple and generalized treatment; the figures in the foreground, including soldiers and what appears to be a half-naked and bound woman, strengthen the atmosphere of the work and echo the sentiments of the verse without illustrating them precisely.

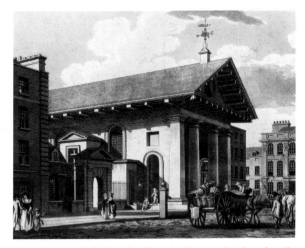

16 *St Paul's Church, Covent Garden*: detail of a view by Thomas Malton showing it as it was in Turner's childhood. In 1788 it was restored by Thomas Hardwick, whose office Turner shortly afterwards joined before going on to study with Malton himself.

17 *A street in Margate, looking down to the harbour*, watercolour, *c.*1786. This ambitious composition adumbrates many of Turner's lifelong interests. The cluster of masts beyond the buildings constitutes his first known depiction of sea-faring craft; he was reported to have had a youthful love affair in Margate, and in later life he was to stay regularly in a house close to the quay.

Indeed, we have evidence that Turner was fond of passing himself off as a 'native' of any part of the country that appealed to him. What he claimed for Devon when he was with Redding he also claimed for Kent in the company of others: 'Such a predilection had Turner for the Medway,' we are told, 'that he himself encouraged the notion of his being a Kentish man' (Miller, p. xxvi). His desire to associate himself thus intimately with many different places was perhaps an aspect of his vocation to create works of art out of a huge range of landscape settings; it seems also to be linked to his unwillingness, especially in later life, to be associated closely with any particular place of abode. He needed to create an image of himself almost as if disembodied, capable of surprising appearances and disappearances, of never being rooted in one dear perpetual place, and of being at no man's command. His private life was one of studied elusiveness, the manifestation of a certain shame, even disgust at himself which he felt to be at odds with his own genius and his stature as an artist. No doubt that shame sprang directly from the family background in which he found himself as an ambitious youth.

When Turner's parents married, on 29 August 1773, his father was a twenty-eight-year-old barber, his mother thirty-four, the granddaughter of an Islington butcher. The certificate of their marriage at St Paul's, Covent Garden, 16 identified them as 'William Turner of this Parish a Batchelor and Mary Marshall of this Parish a Spinster'; the ceremony was conducted by Ezekiel Ranse, Curate, and witnessed by Martha and Ellis Price. Mary Marshall was the daughter of William Marshall and his wife, Sarah Mallord, whose father was the butcher; another of their four children, Joseph Mallord William, was also a butcher, settled at Brentford, Middlesex. By Lady Day 1776 Mary and William Turner seem to have left 21 Maiden Lane, and there is no precise evidence as to where they settled, though they presumably remained in the district; and by the time William was fifteen they occupied no. 26 just opposite, where his father 18, 19 carried on the trade of barber and wig-maker, as described by all Turner's early

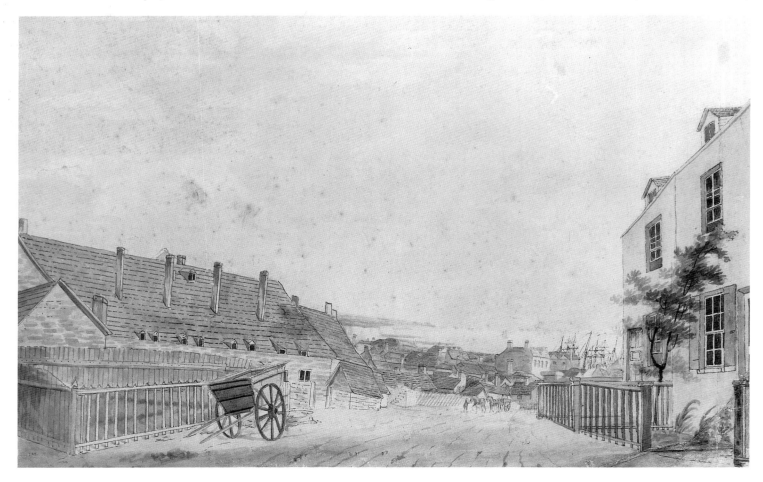

memorialists. On 6 September 1778 a second child, Mary Ann, was baptised at St Paul's, Covent Garden; when she died seven and a half years later her name was given in the register of burials there as 'Mary Ann Turner from St Martin in the Fields'.

In 1785, presumably to get him away from home during the illness of his sister, which the next year was to prove fatal, the young William was sent to his butcher uncle at Brentford. Here he went to the free school as a day boarder under its master, John White. Witnesses were not lacking, in later years, to testify to the manifestations of early genius that he displayed in the classroom and elsewhere; but among the welter of anecdote there is little that is evidently true of Turner in particular and not of any budding artist. However, there does survive (in Chiswick Public Library) a copy of one of the more unattractive late eighteenth-century topographical works, Henry Boswell's *Picturesque Views of the Antiquities of England and Wales*, in which around seventy of the small, ineptly engraved plates have been coloured with bright splashes of red, blue and green; and this illumination is said to have been undertaken by the young Turner for a friend of his uncle's, a distillery foreman who went by the appropriate name of Lees. Twopence a plate was the rate, and the boy may have regarded the unpromising task as justified by the money if not for any other reason. He would certainly have taken such work in his stride, as a necessary part of an artist's training; but he can hardly have derived much satisfaction or instruction from it.

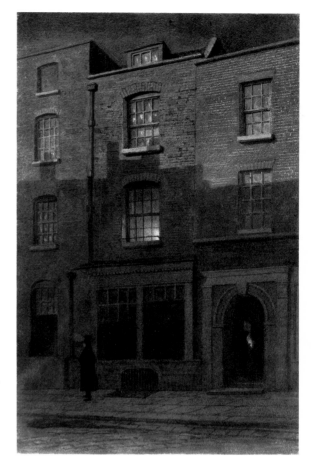

Within a year or two, at any rate, he had moved on to higher things. Sent to Margate to stay with a relative of his mother's in 1786 or thereabouts, he made a group of drawings which, simple and unsure though they are, announce a firm grasp of the principles of topographical view-making. One, which features an 17 elaborate perspective down a street towards the sea, is sophisticated in a surprising degree. William Turner senior was always ready to turn a venture into hard cash, so we must assume that drawings like these were quickly hung in his shop-window for sale. Alaric Watts, the writer of a memoir published shortly after Turner's death, has a story which characteristically, though not wholly convincingly, corroborates the legend:

> The late Mr Duroveray, whose embellished editions of popular British Classics exercised a beneficial influence on the public taste . . . showed the writer, more than twenty years ago, a very early drawing, either a copy or an imitation of Paul Sandby, signed W. Turner, which had been given him by a friend, who had purchased it from the hairdresser's window. He also stated, on the same authority, that the cellar under the shop was inhabited by the family, and that drawings of a similar character were hung round its entrance, ticketed at prices varying from one shilling to three! (Watts, p. ix)

18, 19 Two views of no. 26 Maiden Lane, the house to which Turner's family moved in the late 1780s, drawn by John Wykeham Archer in 1852. The entrance to Hand Court is the doorway to the right of the shop window. The upper room, where Turner was thought to have been born, is probably the room he used as a studio in the 1790s.

Although there is no proof of the family's being back at Maiden Lane before 18 1790, it is likely that the shop referred to was that in Hand Court, no. 26 Maiden Lane. Hand Court struck Thornbury as 'a sort of gloomy horizontal shaft, or paved tunnel, with a low archway and prison-like gate of its own'. Of no. 26 itself he says:

> I remember the house well – I have been up and down and all over it. The old barber's shop was on the ground floor, entered by a little dark door on the left side of Hand-court. The window was a long, low one; the stairs were narrow, steep, and winding; the rooms low, dark, and small, but square and 19 cosy, however dirty and confined they may have been. Turner's bedroom, where he generally painted, looked into the lane, and was commanded by the opposite windows. (T., 1, pp. 23–4)

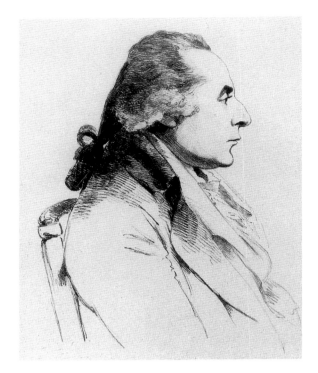

20 The architect Thomas Hardwick, drawn by George Dance in 1795. Hardwick employed Turner to make drawings of the buildings on which he was working, showing them in their landscape setting according to the standard practice of contemporary topographical watercolourists. A story told by the Redgraves credits Turner with an innovation: another architect employed him 'to colour the perspective front of a mansion', but 'in putting in the windows, Turner showed the effect of reflected light from the sky, contrasting with the inner dark of the room on the uneven surface of the panes. This was a new treatment, and his employer objected to it, declaring that the work must be coloured as was usual; that is, the panes an unvarying dark grey, the bars white. "It will spoil my drawing," said the artist. "Rather that than my work," answered the architect; "I must have it done as I wish." Turner doggedly obeyed, and when he had completed the work, left his employer altogether.' The architect later took up the practice himself, with great success. 'So much for genius in the mere colouring of a window' (R. and S. Redgrave, II, pp. 83–4).

The boy was certainly producing copies after Sandby and other topographers in the years after his stay at Brentford: one, in the Turner Bequest, is a plate from Sandby's *Virtuosi's Museum* showing Eton College from across the river; another, from Sandby's aquatint after Lallemand of St Vincent's Tower in the harbour at Naples, may date from a little later. A copy from Michael Angelo Rooker's *Oxford Almanack* design of *Folly Bridge and Bacon's Tower, Oxford* is signed 'W. Turner' and dated 1787. The same date appears on a view of Nuneham Courtenay, on the Thames near Abingdon, which may also be taken from a print, though Turner was shortly afterwards to visit the house and draw it on the spot.

This was in the summer of 1789, when he again stayed with his uncle, though not this time at Brentford, for the butcher had retired to Sunningwell near Oxford. He was particularly helpful to Turner at a crucial stage in his early development. In Oxfordshire a new landscape, and one that the artist was to appropriate as his own, was opened up to him. Turner's first views of the city of Oxford itself were made now; one, a carefully worked out watercolour, is dated to this year (TB III-A). There is a whole sketchbook (the first extant) that records the work he did; he seems to have sewn and bound it himself, perhaps with his father's help: it would be pleasant to think that their interdependent relationship, so important later in Turner's career, was already taking practical form. He labelled the book '76. Oxford'(TB II). The number was probably not allotted immediately; but in due course the importance of keeping his notes and records in some sort of order must have been borne in on him, for many of the sketchbooks are labelled and numbered like this one. It contains the sketch of Oxford that he used as a basis for his watercolour, embodying the relationship between pencil study on the spot and finished view that was to subsist essentially unchanged to the end of his career.

A further study in the book, which also foreshadows a particular love of his later life, is a view of Isleworth Church seen from the Thames. This was used as the basis of a finished watercolour acquired by the architect Thomas Hardwick, 20 and presumably done as part of Turner's training in Hardwick's office, which he joined the same year. Hardwick's father, a builder of Brentford, was no doubt instrumental in obtaining Turner the job. Hardwick was rebuilding Wanstead church in 1789, and Turner made watercolour views of the old and new buildings for him. These Hardwick retained all his life, and passed on to his son Philip, also an architect, who became a lifelong friend of Turner's.

All these signs of steady professional application were apparently encouraged by the boy's father, who was proud to tell his customers all about William's attainments: 'when asked, as he often was, "well, Turner, what is William to be?" he would reply, with a look of delight, adding a satisfactory curl to his customer's hair at the same time: "William is going to be a painter"' (Cunningham, p. 16). Lovell Reeve confirms this evidently embroidered account by quoting a son of the Royal Academician Thomas Stothard as saying that he 'perfectly remembers his father relating to him that in early life he went one day to Turner's shop in Maiden-lane, to get his hair cut, when the barber remarked in conversation, "My son is going to be a painter."'

The barber nevertheless had clear priorities: 'Dad never praised me for anything but saving a halfpenny', Turner used to say (T., I, p. 74). The association of creative effort with pecuniary reward was evidently inculcated from an early age, and must explain that sharp financial sense which people were later to interpret as miserliness. 'He was of an avaricious temperament, as was his father before him', Watts remarks (p. xxxi). The influence of paternal opinions would have been all the stronger since his mother could inspire little respect:

report proclaims her to have been a person of ungovernable temper, and to have led her husband a sad life. In stature, like her son, she was below the average height. In the latter part of her life she was insane and in confinement. Turner might have inherited from her his melancholy turn of mind. (T., 1, p. 5)

His father, on the other hand, had the character to endure the trials brought upon him by his unhappy wife, and to provide his gifted son with the support and encouragement he needed.

140,
193 He was about the height of his son, a head below the average standard, spare and muscular, with small blue eyes, parrot nose, projecting chin, fresh complexion, an index of health, which he apparently enjoyed to the full. He was a chatty old fellow, and talked fast; but from speaking through his nose, his words had a peculiar transatlantic twang. [This may have been the effect at least in part of a Devon accent.] He was more cheerful than his son, and had always a smile on his face. (Ibid., p. 6)

He was the one close relation to whom Turner was devoted; a man whose good humour could neutralize his son's habitual secretiveness and bouts of bad temper. His praise for 'saving halfpennies' was his way of relating the no doubt incomprehensible mystery of the boy's genius to a scale of values he understood – the best practical encouragement he could offer. The unswerving loyalty the father was to show all his life bound them together in a number of ways both practical and emotional. For old William, too, his son's career as an artist was of primary importance: their relationship thrived on shared priorities.

Before the end of 1789 Turner had advanced from Hardwick's office to the studio of a leading topographical draughtsman, Thomas Malton, whose
16 sophisticated views of London buildings he quickly learnt to imitate. He also entered the Royal Academy Schools: the Minutes of a meeting of the Academy Council held on 11 December record that 'The Keeper produc'd six Drawings done from Castes, which being all approv'd of; the followg. were Admitted students, – viz: Willm. Turner. – Edwd. Gyfford. – Fran. Jno. Wingrave Willm. Dixon. – Jno. Sheridan. Jno. Baptiste Rosetti'. The Keeper of the Academy at the time was Agostino Carlini; the President, Sir Joshua Reynolds, was present as Chairman. Stephen Rigaud, in a manuscript memoir of his father John Francis Rigaud, R.A., credited Turner's introduction to the Academy to the Rev. Robert Nixon, of Foots Cray, in Kent:

Mr Nixon had been one of the first to notice him when he was living with his father the hairdresser in Maiden Lane Covent Garden; he brought him to my father, who greatly encouraged him, introduced him to the Royal Academy as a Student, and was the first friend he had amongst the Royal Academicians. (Rigaud, p. 105)

As a probationer under Rigaud's aegis Turner produced the drawings from casts which were submitted to the Council. Once established in the Schools he
25 continued to work in the 'Plaister Academy', drawing from casts of antique sculpture, and his name appears fairly frequently in the registers between 21 July 1790 (the earliest record extant) and 8 October 1793. From June 1792 he
26 was also admitted to the 'Life Academy', to draw from the nude model. He became friendly with several of his fellow students, including Robert Ker Porter, one of the livelier sparks at the Plaister Academy. Porter introduced him
60 to the landscape watercolourist William Frederick Wells, a man of thirty in 1792, who was to become a close friend and whose cottage at Knockholt in Kent

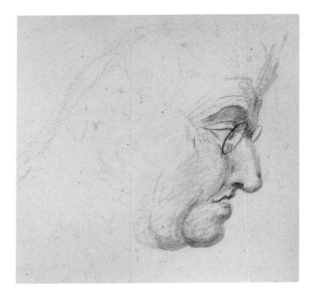

21 Study of a man, possibly John Narraway, *c.*1791. This characterful portrait has traditionally been identified as showing Turner's mother; but it evidently represents a man, and someone with whom Turner was intimate. Its style suggests a date around 1791, and it may well show his father's friend John Narraway the glue-maker of Bristol, of whose family we know he made portrait drawings at that time.

22 *The River Avon from Cook's Folly*, 1791. One of the watercolour studies in the *Bristol and Malmesbury* sketchbook which Turner intended for his set of 'Twelve Views on the River Avon'. The composition anticipates his lifelong predilection for vertiginous viewpoints.

was to provide him with a second home during the family crisis that overtook the Turners at the end of the decade.

His almost obsessive devotion to what from the beginning was for him a life's profession won him the admiration of fellow artists, with whom he was always to feel most at ease – perhaps because among them he had no difficulty in assuring himself of his own worth. From other people too, of all ranks and types, he was to command the greatest respect, loyalty and affection; but his was not a personality that either sought or naturally found the favour of all. There is a mildly satirical drawing of him, executed in the mid-1790s, which is ironically inscribed: 'A sweet temper'. He did not – could not – parade the social graces in 46 any obvious way: he was always himself.

When he went to stay with his father's friends the Narraway family at Bristol in 1791 and 1792 he spent so much of his time clambering about the Avon Gorge drawing the splendid scenery that they nicknamed him 'The Prince of 22 the Rocks', and looked on him as a decided oddity. At the Narraways' again in 1798 he struck a visiting niece, Ann Dart, as

not like young people in general, he was singular and very silent, seemed exclusively devoted to his drawing, and would not go into society, did not like 'plays', and though my uncle and cousins were very fond of music, he would take no part, and had for music no talent. (R., XIII, p. 473)

Initially, though, the Narraways seem to have taken to him, and were obviously impressed by his gifts. They asked him to paint them a miniature 23 portrait of himself, which he undertook reluctantly. Elsewhere in her letter to Ruskin of 30 May 1860 Ann Dart recalled the circumstances: 'it is no use taking such a little figure as mine,' he said, 'it will do my drawings an injury, people will say such a little fellow as this can never draw' (see Finberg, *Life*, p. 27). He invented difficulties: 'How am I to do it?' – but eventually used his bedroom mirror. It is far from being a tentative effort, however. The face is shown turned three-quarters to the spectator, and the folds of the large-buttoned coat are rendered with the same ebullient sense of life that permeates the foliage of the trees he drew along the Avon. The expression is one of concentration –

somewhat tight-lipped, but with eyes wide open and firmly fixed on their object. It is the face of someone drawing intently, a rare glimpse of the artist himself at work.

As he grew out of boyhood into an eccentric maturity, the Narraways became exasperated with his single-mindedness, which struck them simply as selfishness.

> When the portrait was given to us it was long hung in the stairs, my cousin saying he would not have the little rip in the drawing-room. He had no faculty for friendship and though so often entertained by my uncle he would never write him a letter, at which my uncle was very vexed. My uncle indeed thought Turner somewhat mean and ungrateful. (R., XIII, p. 473)

The same traits manifested themselves to everyone. But there are times when Turner's obstinate subordination of the polite conventions to the demands of art elicits a certain retrospective admiration. A good example is recounted by Stephen Rigaud. He and Turner were staying with the Rev. Mr Nixon at Foots Cray, in the spring of 1798. Turner had taken with him a stout leather-bound sketchbook that he had begun three years earlier in South Wales:

> It was then saturday evening, and it was soon arranged that on monday morning we should all three set off on a pic-nic sketching party for three days. The next day, being Sunday, I accompanied our mutual friend to the parish church, close by, which stood almost concealed by tall, majestic trees, a sweet secluded spot, whose solemn stillness seemed to invite the soul to meditation and to God! Alas! for Turner it had no such attraction. He worshipped nature with all her beauties; but forgot God his Creator, and disregarded all the gracious invitations of the Gospel. On our return from Church, we were grieved and hurt to find him, shut up in the little study, absorbed in his favourite pursuit, diligently painting in water-colours.
>
> The next morning, after an early breakfast, we started on our sketching party through a most beautiful part of the County of Kent. It was a lovely day, and the scenery most delightful. After having taken many a sketch, and walked many a mile, we were glad at length to seek for a little rest and refreshment at an inn. Some chops and steaks were soon set before us, which we ate with the keen relish of appetite, and our worthy friend the Clergyman, who presided at our table, proposed we should call for some wine, to which I made no objection, but Turner, though he could take his glass very cheerfully at his friend's house, now hung his head, saying – 'No, I can't stand *that*.' Mr Nixon was too polite to press the matter further, as it was a pic-nic concern; so, giving me a very significant look; we did without the wine. I mention this anecdote to show how early and to what an extent the love of money as a ruling passion, already displayed itself in him, and tarnished the character of this incipient genius; for I have no hesitation in saying that at that time he was the richest man of the three; Mr Nixon having then but a very small Curacy, and I having little more than the pocket money allowed me by my father, whilst Turner had already laid up money in the funds, for which his good friend Mr Nixon was one of the Trustees whilst he was still under age. This little incident, though calculated to throw a chilling influence over the cordiality of our sketching party, could not prevent our greatly enjoying the remaining part of our beautiful tour, particularly the river scenery on the banks of the Medway, as far as Aylesford; and at the end of the third day we returned to the quiet rural parsonage of Foots Cray, very much delighted with our excursion. (Rigaud, pp. 105–6)

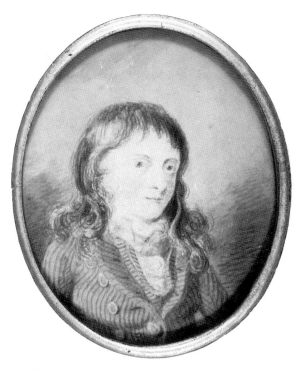

23 The self-portrait miniature which Turner made while staying with the Narraways at Bristol in 1791. It was later acquired by John Ruskin.

Ann Dart's recollections supply a more particular description of the twenty-three-year-old Turner. She remembered him

> as a plain uninteresting youth both in manners and appearance, he was very careless and slovenly in his dress, not particular what was the colour of his coat or clothes, and was anything but a nice looking man. . . . He would talk of nothing but his drawings, and of the places to which he should go for sketching. He seemed an uneducated youth, desirous of nothing but improvement in his art. He was very difficult to understand, he would talk so little . . . He was sedate and steady, he did not in the evenings go out except with our family, and mostly we staid at home, and Turner would sit quietly apparently thinking, not occupied in drawing or reading. He was not at table polite, he would be helped, sit and lounge about, caring little for anyone but himself. He was in my uncle's house as one of the family, did not make himself otherwise than pleasant, but cared little about any subject except his drawing, and did not concern himself with anything in the house or business. . . . Turner went from my uncle's house on a sketching tour in North Wales. My uncle gave him a pony, and lent him a saddle, bridle and cloak, but these he never returned. My uncle used to exclaim what an ungrateful little scoundrel . . . (see Finberg, *Life*, pp. 50–51)

These impressions accord with the rumour reported by the diarist-Academician [49] Joseph Farington on 12 May 1803: 'A Clergyman has complained of Turner neglecting an uncle, a Butcher, who once *supported him* for 3 years. He has become Academical He does not look towards him.' This lack of concern for his family was to extend even to his daughters, with whom he seems to have enjoyed a less close relationship than he did with his fellow artists. But, paradoxically, as he reached maturity he began to show a considerable pleasure in the company of his friends' children – a sympathy with childhood in general that is apparent in countless anecdotes, and evident throughout his work. Wells's daughter Clara, who knew him as a young man when she herself was a child, retained a lifelong affection for him, and remembered their early romps with delight:

> Of all the light-hearted, merry creatures I ever knew, Turner was the most so; and the laughter and fun that abounded when he was an inmate in our cottage was inconceivable, particularly with the juvenile members of the family. I remember one day coming in after a walk, and when the servant opened the door the uproar was so great that I asked the servant what was the matter. 'Oh, only the young ladies (my young sisters) playing with the young gentleman (Turner), Ma'am.' When I went into the sitting-room, he was seated on the ground, and the children were winding his ridiculously large cravat round his neck; he said, 'See here, Clara, what these children are about!' (T., II, pp. 56–7)

The too-large cravat is typical; all his life he was to look as if his clothes were not a proper fit. Another anecdote concerning Turner and the children at Knockholt was related to Samuel Palmer by a fellow watercolourist, Joshua Cristall:

> Turner had brought a drawing with him of which the distance was already carefully outlined, but there was no material for the nearer parts. 'One morning, when about to proceed with his drawing, he called the children as *collaborateurs* for the rest, in the following manner. He rubbed three cakes of watercolour – red, blue, and yellow – in three separate saucers, gave one to

each child, and told the children to dabble in the saucers and then play together with their coloured fingers on his paper. These directions were gleefully obeyed, as the reader may well imagine. Turner watched the work of the thirty little fingers with serious attention, after the dabbling had gone on for some time, he suddenly called out 'Stop!' He then took the drawing into his own hands, added imaginary landscape forms, suggested by the accidental colouring, and the work was finished.' (Webber, I, p. 81)

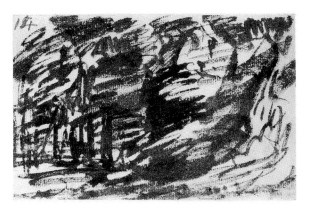

24 Alexander Cozens: *A Wooded Scene*, brush and black ink, ?*c*.1770. A typical example of the rough 'blots' or exploratory sketches by means of which Cozens evolved his idealized landscape subjects.

The process of building up an ideal or generalized landscape subject on a basis of random marks was one that Turner must have derived from Alexander 24 Cozens, a drawing master who had died in 1786. The year before that, Cozens had published his *New Method of Assisting the Invention in Drawing Original Compositions of Landscape*, which promulgated a system of inking and then crumpling paper which was quickly dubbed the 'Blottesque'. Turner was by no means the first English landscape painter to be accused of abstraction. At an early age he was aware of the value of such procedures in the evolution of pictorial ideas. He was, indeed, quite as much alive to the many theories of landscape painting current at the time as he was to the observable beauties of nature.

The influence of the Academy's ways of teaching and methods of thought can be seen gradually percolating through his work of the early 1790s, though it is difficult to be sure what his adaptable and experimental temperament would not in any case have sought out for itself. The little sketchbook now at Princeton, for instance, in use about 1791, contains *écorché* studies taken from woodcuts illustrating Vesalius, a volume of which he almost certainly procured at the Academy. There are also copies from prints after Ruysdael and 27 Gainsborough, and a sketch of the death of Ophelia looks like the copy from a print but may be his own design. Whether these were produced under the stimulus of Academy ideas is uncertain, but they represent the opposite impulse to that of the topographer: in them art is the prime inspiration, nature 28 secondary. Similarly, a small sheet of sketches illustrating characters from Robert Blair's famous meditational poem *The Grave*, betraying as it does a lively sense of the variety of human experience, is the kind of exercise that the highly literary academic milieu would naturally suggest.

29 A more evolved composition based on a scene from *Don Quixote* affords an even plainer clue to the workings of his mind in the winter of 1792–3: it is an evident pastiche of the drawing style of Philippe Jacques de Loutherbourg, who can be seen from a number of watercolours of this date to have exerted a very considerable influence on him, in style and subject-matter alike. De Loutherbourg, who had begun his career with great success at the Paris Salons of the 1770s, and could consequently demonstrate what the Continent understood by professional painting, was one of the established masters of the Academy, having been a member since 1780. But Turner was also alive to the example of younger men, especially those who had just achieved the status of Royal Academician. A cottage interior of about 1791 (TB XVII-L) echoes the picturesque rustic subjects of Francis Wheatley, elected R.A. in 1790; and it is executed in a rich, sonorous palette probably inspired by the watercolour experiments of Richard Westall, who was to become an Associate of the Academy in 1792. To the list of his concerns at this period must be added an 30 early essay in oil, a simple pastoral, painted on paper: it is a scene with a water-mill which, with its oval format, seems to be connected to the *Don Quixote* subject of the same time (they may well have both been instigated by Turner's admiration for De Loutherbourg); though, in its decorative rusticity, it probably owes much to the work of the topographer Thomas Hearne.

Early studies

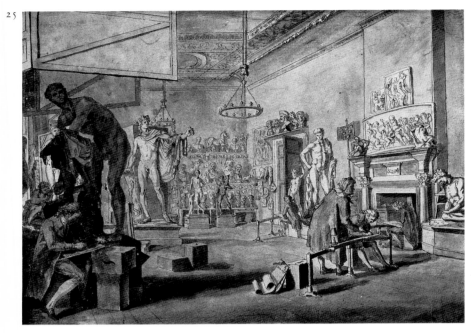

At the Royal Academy students drew from casts in the Antique School (25) and made studies from the nude (26, c.1793). The model's poses were often based on figures in paintings by the old masters. Turner was later, as Visitor, to set the poses himself, and 'introduced a valuable practice. . . he chose for study a model as nearly as possible corresponding in form and character with some fine antique figure, which he placed by the side of the model posed in the same action . . . it showed at once how much the antique sculptors had refined Nature. . .' (R. and S. Redgrave, II, pp. 93–4).

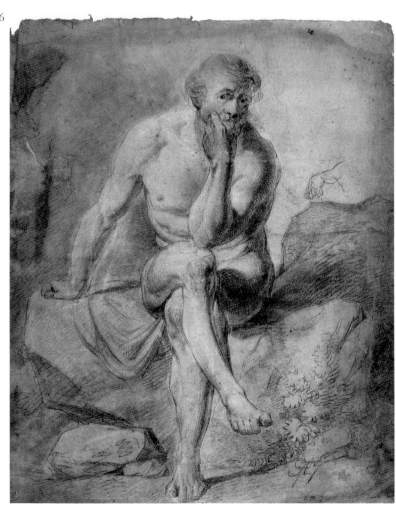

Elsewhere, Turner copied masters such as Gainsborough (27, *c*.1791) – through whose early work he encountered the influence of Dutch landscape – and experimented with literary illustration. About 1793 he drew the characters of the 'new-made widow' and the drunken gravedigger from Blair's *Grave* (28), and finished an elaborate composition of *Don Quixote and the enchanted Barque*, a comic subject for which a study (29) is handled with great gusto and lively characterization. Also about 1793 he produced his earliest known exercise in oil, *A Water-Mill* (30).

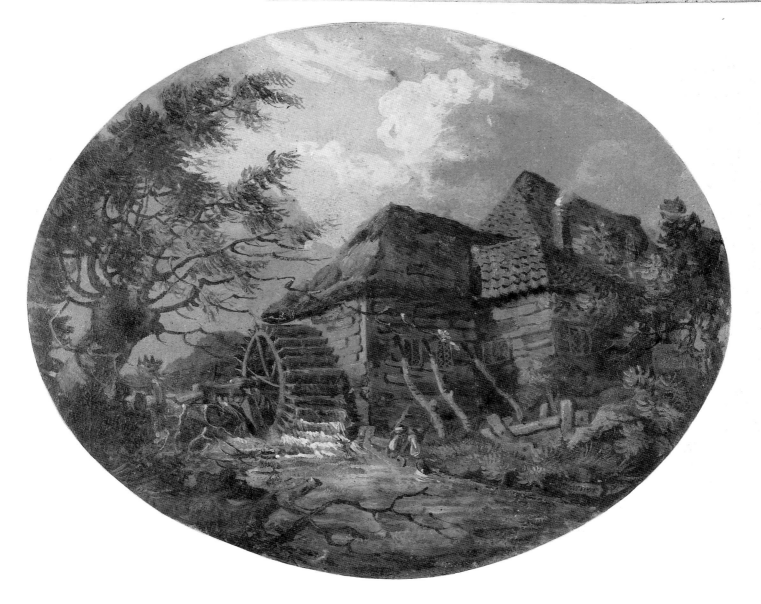

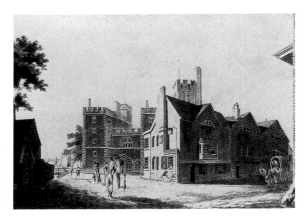

31 *The Archbishop's palace, Lambeth*, watercolour, 1790.

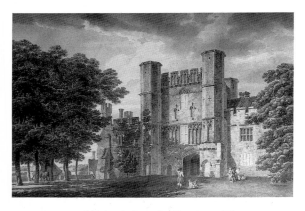

32 Michael Angelo Rooker: *The Gatehouse of Battle Abbey*, watercolour, 1792.

33 The pencil drawing that Turner made on the spot of the Oxford Street Pantheon after its destruction by fire on the morning of 14 January 1792. He has transcribed the names of shop-owners from neighbouring fascias to complete his careful reporting of the scene. The sketch is squared for transfer to the final sheet (4).

For his intelligent interest in the performance of the Academicians marched side by side with his particular concern for topography, in which he was already demonstrating some precocity. He sent his first watercolour to the Academy exhibition in 1790, a view of *The Archbishop's palace, Lambeth* which 31 demonstrates how thoroughly he had mastered Thomas Malton's style. There followed in 1791 *King John's Palace, Eltham* and *Sweakley* [Swakeleys], *near Uxbridge, the seat of the Rev. Mr. Clarke,* a red-brick fantasy of Dutch gables in those organic convolutions that he particularly enjoyed. In 1792 he showed a view of the London assembly rooms known as the Pantheon, just after they had 4 been destroyed by fire. It is pure, vivid journalism, presenting the frosty scene 33 in Oxford Street on the morning of 14 January 1792 as the fire-engines are finishing their task. A crowd of people has gathered outside the gutted building, which is lit by the early morning sun, its windows decked with icicles. The inquisitive townsfolk who occupy much of the foreground reveal an interest in the human figure which had only been hinted at in previous work. The effect of light on the neoclassical façade is a very different exercise from the more conventional weed-grown ruins of *Malmsbury Abbey* in the same exhibition; but if he sought the discipline of drawing James Wyatt's modern Pantheon he was equally concerned to broaden his vocabulary of the Picturesque. He made careful copies (TB XVII-Q, R) of parts of a watercolour sent in this year by one of Sandby's finest pupils, Michael Angelo Rooker. This was a 32 view of the gatehouse of Battle Abbey, from which Turner selected details of foliage and dappled shadows against masonry that sum up Rooker's special genius in the rendering of textures. It was a skill he perceived, admired, recognized as vital to his own craft, and determined to imitate.

And he had further ambitions. A trip to Bristol in 1791 had resulted in a series of studies in a sketchbook (TB VI) which he planned, it seems, to engrave 22 and publish as 'Twelve Views on the River Avon', with a wrapper vignette designed by himself. He was already in his own imagination a full-blown engraver-publisher, fifteen years before the inception of the *Liber Studiorum*. On the back of one of the studies from the nude model that he did at the Academy life class he wrote down a recipe for making an etching ground, which he may well have contemplated experimenting with. No etchings by him of this date are known, but there is little doubt that he had it in mind to imitate the topographical surveys that had achieved such success in recent years: the

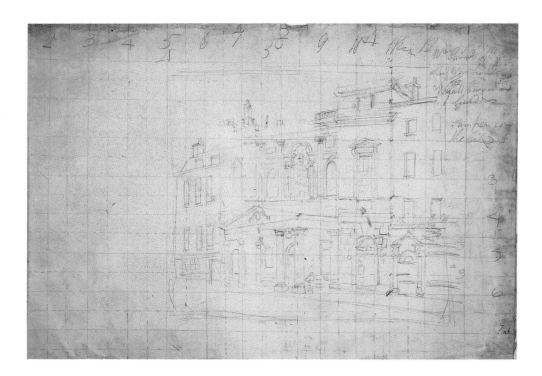

Antiquities of Great Britain by Hearne and Byrne, for instance, Sandby's *Virtuosi's Museum*, and numerous others.

5 Several of the 'Views on the River Avon' that he collected in 1791 were worked up as finished watercolours. One of them was a scene in the Avon Gorge at Hotwells which he showed at the Academy in 1793, with a longer title than usual: *The rising squall − Hot Wells, from St Vincent's rock, Bristol*. The explicit reference to climatic conditions ushers in a new phase of his development, a phase for which his careful preparations now made him quite ready. The watercolour was greeted even at the time as something novel, and

> recognized by the wiser few as a noble attempt at lifting landscape art out of the tame insipidities of Zuccarelli, and the Smiths of Chichester, bearing indications, as I am assured it did, that the school of landscape art in this country, which Wilson founded, and Gainsborough supported, was about to be maintained and perhaps strengthened. (Cunningham, pp. 17–18)

34 Probably in 1793 he was taken up by Dr Thomas Monro, a distinguished physician, specialist in mental disorders and consultant to the King during his attacks of madness. Turner was by then a far from inexperienced young artist. It is difficult to know in quite what spirit Dr Monro suggested that he and his
35 almost equally precocious contemporary Thomas Girtin (born not far away in Southwark) should come regularly on winter Friday evenings to copy landscape watercolours at his home in the Adelphi. Both young men, no doubt, expected to benefit from the exposure to a wide variety of works of art in Monro's extensive collection; but it is surprising to find them so submissively involved, year after year, in repetitive exercises of copying other artists' works. These were principally sketches by John Robert Cozens, Alexander's more inspired son, who by this date was suffering from melancholy madness and in Dr Monro's care; and topographical views by another rather disturbed draughtsman, Edward Dayes. Farington heard from a friend on 30 December 1794 that 'Dr. Munros house is like an Academy in an evening. He has young men employed in tracing outlines made by his friends, etc. − Henderson, Hearne, etc., lend him their outlines for this purpose.' Later (on 12 November 1798) he learned about it from the lips of the young men themselves:

> 37 they had been employed by Dr. Monro 3 years to draw at his house in the evenings. They went at 6 and staid til Ten. Girtin drew in outlines and Turner washed in the effects. They were chiefly employed in copying the outlines or unfinished drawings of Cozens &c &c of which Copies they made finished drawings. Dr. Monro allowed Turner 3s. 6d. each night. − Girtin did not say what He had.

If this menial activity hardly consorts with Turner's ambitious and wide-ranging plans, it is less surprising to find him, in 1793, undertaking with alacrity a commission for a project along the professional lines of his abandoned scheme for the series of views on the Avon:

> Mr Walker, an engraver, projected a work which, by employing the united talent of all the other works [Hearne and Byrne, etc.], should come in for a share of patronage; and, like a man of taste and judgment, cast his eyes upon [Turner and Girtin]. But Girtin, who was fast rising into fortune as well as fame, for a time refused his services; while Turner was at once engaged; and in the summer of 1793 he took his departure to Kent, to make the drawing of Rochester in this work. (Miller, p. xxvi)

'This work' was John Walker's *Copper-Plate Magazine*, which shortly gave way to a succession of periodicals with various titles, *The Itinerant, The Pocket*

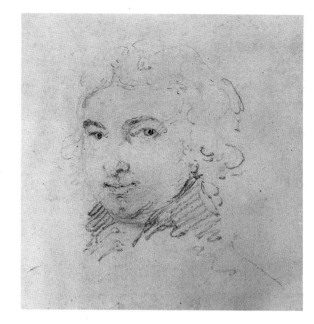

34 Dr Thomas Monro, *c*.1795. Turner probably made this lively and sympathetic pencil study while working for Monro at his 'Academy' in the Adelphi.

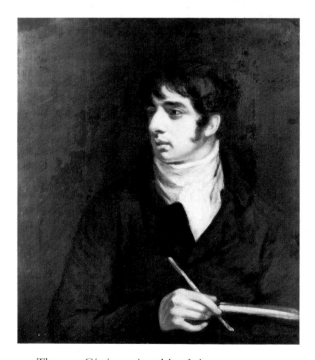

35 Thomas Girtin, painted by John Opie, *c*.1800. Girtin and Turner, born within two months of each other, were regarded in the 1790s as rivals in the field of watercolour, and Turner retained all his life the highest respect for the memory of 'Poor Tom'. Thornbury records him as saying 'in after life', 'If Tom Girtin had lived, I should have starved' (T., I, p. 117).

36 John Robert Cozens: *The Pays de Valais*, watercolour, *c*.1791. Cozens was a pioneer in the rendering of space, atmosphere and scale in landscape watercolour. He developed a range of techniques, from the massing of tight brushstrokes to the use of broad washes, on which Turner was to build his mature style.

37 *Tivoli*, *c*.1796, one of the more elaborate of the views which were copied in pencil by Girtin and washed with colour by Turner for Monro. This example does not seem to derive from J. R. Cozens, and is perhaps taken from a view by the German artist J. .P. Hackert, who was based in Rome.

Magazine and others; for these Turner made no less than thirty-two views of English and Welsh towns, published between 1794 and 1798. The 1793 journey to Kent produced one or two; and in 1794 he set out on an extended tour of the Midland counties, going as far north as Chester and Llangollen in the west, and Lincoln in the east. He returned by Peterborough and Cambridge. The little views that he made for Walker as a result of the trip are not very exciting, though they stand at the beginning of a long line of engraved landscape subjects by Turner, and incidentally adumbrate his later fondness for panoramic views of cities. He put the Midland tour to more impressive use in a number of finished watercolours that he sent to the Academy in the next year or two.

These subjects were amplified by others gathered during his journey through South Wales in 1795, the forerunners of an extraordinary outpouring of Welsh subjects in which his technical development in the medium of watercolour during these few crucial years can be minutely traced. Wales supplied him with one of his grandest and most Piranesian architectural

7 interiors, that of the *Trancept of Ewenny Priory, Glamorganshire*, exhibited in 1797; and when in 1798 he reached North Wales for the first time it gave him the clue

8 to a broader, freer, and altogether more expressive use of watercolour that was to reach a climax in the next two years with a long series of breathtaking colour

9, 10 studies, on a large scale, of the mountains of Snowdonia, and some splendid finished works in both watercolour and oil shown at the Academy. Despite the impressive watercolours that Girtin was producing at this time, and which many contemporaries felt to be superior, Turner's achievement in this sequence of Welsh subjects goes beyond anything that had ever been attempted in the analysis of the scale and atmosphere of sublime nature, leaving such important

36 precursors as John Robert Cozens far behind, and opening up a new potential for landscape which few artists besides Turner himself have ever had the ability to exploit.

He owed some of this new-found technical skill to his experiments with oil painting. Stories of early essays in oil are plentiful but difficult to substantiate, and although it is highly likely that he did execute some works in the medium before he first exhibited one at the Academy, nothing is traced between the

30 insouciant little oval of 1792–3 and the highly accomplished nocturne,

11 *Fishermen at sea*, which he showed at the Academy in 1796. The choice of a marine subject is perhaps surprising; certainly its effect of combined moonlight and firelight, and its depiction of the rocking swell of the night sea, are ambitious ideas for a first attempt; but he had produced several accomplished watercolour studies of the sea since 1792, and they proclaim an interest which was to establish itself as a dominant one in his life's work. He seems to have been anxious to make a point about the nature of his inspiration. An anecdote retailed to Thornbury gives some flesh to this interpretation. One of the artist's closest friends was with him 'one day looking over some prints. "This," said Turner, with emotion, taking up a particular one, "made me a painter." It was a green

38 mezzotinto, a Vandervelde – an upright; a single large vessel running before the wind, and bearing up bravely against the waves' (T., 1, p. 18). The exhibited canvas shows the influence of De Loutherbourg even more than that of Van de Velde. It is a summary of all that had been said about the sea by the artists of the eighteenth century; the manifesto of an artist who, although known solely as a topographical watercolourist, stakes his claim as a painter, a serious painter, and specifically a marine painter, all at once. There is a strange irony in the conclusion that Turner seems to have arrived at: despite his precocious mastery of watercolour, it would never be the medium in which he could fully express his feelings about water. The grandeur of the mountains could be compassed in a drawing; the ocean never.

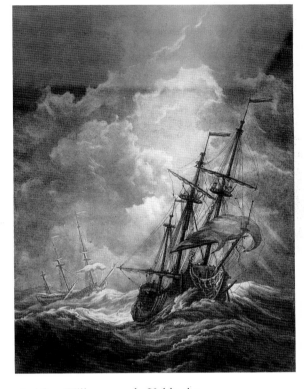

38 After Willem van de Velde the younger: *Shipping in a storm*, engraved in mezzotint by Elisha Kirkall, and printed in green ink, 1724.

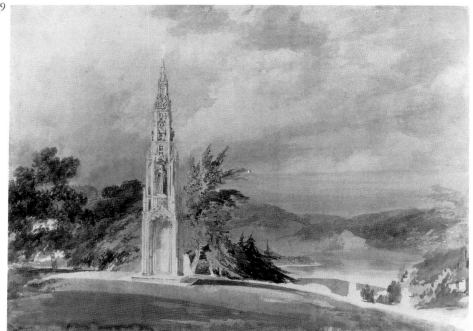

Three early patrons

Turner first visited Sir Richard Colt Hoare at Stourhead in 1795, and about 1797 began two watercolours of the famous garden with its ornamental lake, of which this view of the Bristol Cross (39) is one. Neither was finished. Colt Hoare continued to employ him, on a series of views of Salisbury (6), and of Hampton Court in Herefordshire, until about 1806.

40 *Harewood House from the south east,* watercolour, 1798.

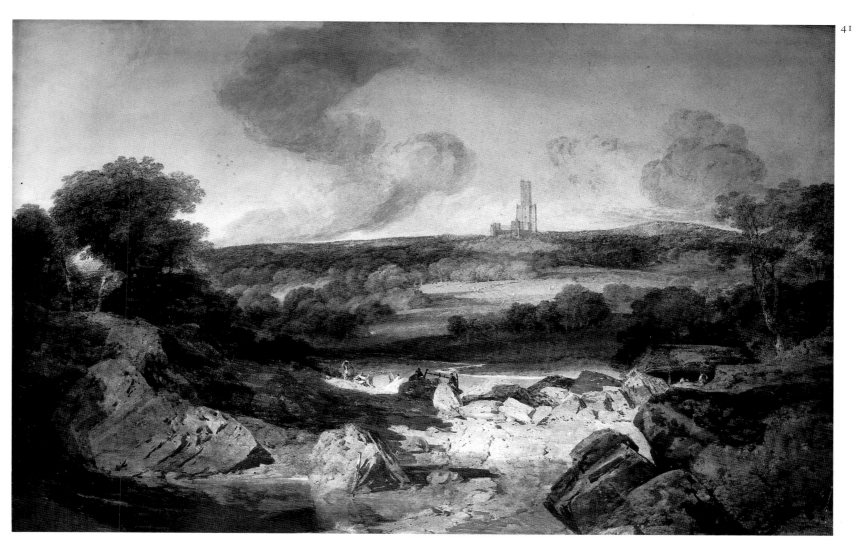

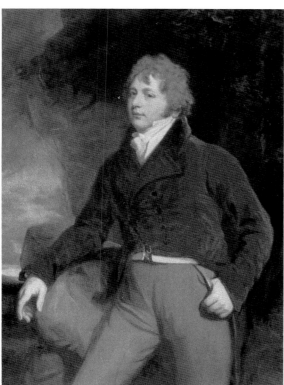

42

41 *East view of the gothic Abbey (Noon)
now building at Fonthill, the seat of W.
Beckford, Esq.*, watercolour, 1800.

Edward Lascelles (42, by John Hoppner,
1797) acquired a number of Turner's
watercolours between 1797 and about
1806, and employed him to make
several views of Harewood and its
neighbourhood (40). Turner visited the
house in 1797. William Beckford (43,
also by Hoppner) had been introduced
to Turner by Colt Hoare. He was heir to
one of the greatest fortunes of his day,
and a distinguished collector who had
employed Alexander and J. R. Cozens,
and acquired the two 'Altieri' Claudes
(see ill. 57). He invited Turner to make
views of his new Gothick 'Abbey' at
Fonthill while it was under construction
in the summer of 1799 (41). The
patronage of these men and the prices
they were prepared to pay for his work
(Lascelles gave 60 guineas for a
watercolour in 1806) were an index of
the high esteem in which he was held
among the cognoscenti.

43

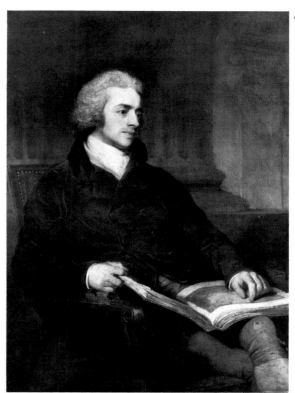

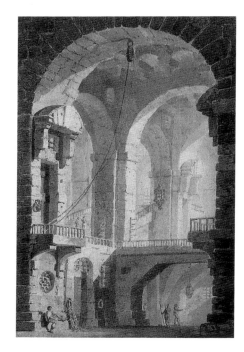

44 J. M. W. Turner after Piranesi: *The Interior of a Prison*, watercolour, *c*.1795. Both Turner and Girtin made copies of this subject, probably for John Henderson. Turner first saw Colt Hoare's Piranesi prints in 1795, and was soon using their effects of scale and interior lighting in his own work.

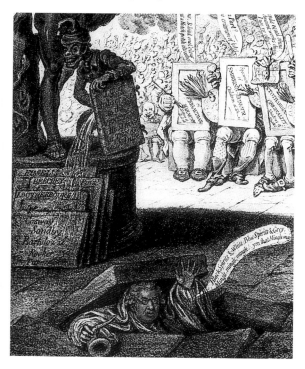

45 Gillray: *Titianus Redivivus* (detail), 1797. The gullible Academicians are railed at by Sir Joshua Reynolds, who rises from his grave ear-trumpet in hand, while a fashionable monkey micturates on the works of the unbelievers, among them Fuseli, De Loutherbourg and Turner.

Fishermen at sea immediately established his ability in the new medium. One 11 critic, Anthony Pasquin, in *A Critical Guide to the Exhibition of the Royal Academy for 1796*, went so far as to say:

> We recommend this piece, which hangs in the Ante-room, to the consideration of the judicious: it is managed in a manner somewhat novel, yet the principle of that management is just: we do not hesitate in affirming, that this is one of the greatest proofs of an original mind, in the present pictorial display: the boats are buoyant and swim well, and the undulation of the element is admirably deceiving. 655, 656, 699, 701, 702, 711, 715, by the same Artist, are all strongly indicative of the same inquisitive mind, and the same force of acquirement. (p. 15)

The critics now began to break regularly into passages of excited prose when his works were in question; not always favourably, for there was, as Pasquin remarked, a novelty in Turner's whole approach that could not be assimilated all at once. But whatever disapproval there may have been his work undoubtedly impressed its audience with the gravity and brilliance of the artist's mind, and ensured that anything he produced would be accorded serious attention. This was particularly true of the watercolours, which were revealing new wonders each year. There was no lack of enthusiastic support from the public, either, and during the decade he amassed a clientele of notable patrons, among them some of the most discerning connoisseurs in the country.

These men in their turn influenced his development; though the manner in which Turner incorporated their commissions and invitations into his own carefully planned tours, gradually spreading the tentacles of his topographical knowledge through a wider and wider area of Britain, often makes it seem that such chance developments were powerless to affect his own steady purpose. Edward Lascelles, son of the Earl of Harewood, asked for views of the family 42 house and estate near York, giving the starting-point for a long tour of the 40 north of England in 1797; Sir Richard Colt Hoare asked him to Stourhead 39 where he saw the powerful engravings of Piranesi and the highly theatrical 44 watercolours of Louis Ducros. Anthony Bacon, a steel-master of Cyfarthfa, Merthyr Tydfil, commissioned views of his steel-works, which Turner drew at the beginning of his comprehensive Welsh tour in 1798. Colt Hoare wanted a series of views of Salisbury Cathedral, then being restored by James Wyatt, and 6 was instrumental in obtaining a commission from another Wiltshire landowner, William Beckford, whose new Gothick house at Fonthill was also being built by 43 Wyatt. Turner made a set of five views of Fonthill for Beckford, deliberately 41 choosing a different time of day for each so as to display his virtuosity in the rendering of atmosphere and effect. He showed them at the Academy in 1800. This was renewing, as it were, the acquaintance he had made with the architect when the Pantheon was burnt in 1792; and he made drawings of other Wyatt buildings, on the Penrhyn estate near Bangor, during his productive second tour of North Wales, in 1799.

One of the most interesting indications of the prominence Turner had attained only a year after sending his first oil painting to the Academy in 1796 is his appearance in a satirical print of 1797 by James Gillray, *Titianus Redivivus*, 45 which comments on the affair of Mary Anne Provis and her claimed discovery of Titian's 'secret' of colouring. She succeeded in selling this discovery to a number of Academicians, who are treated to suitable mockery by Gillray; Turner figures as one of those who have resisted the blandishments of Provis and remain true to themselves and their common sense.

On the whole the Academicians themselves looked on him with great favour. He was unmistakably a rising star, an artist of imagination and variety.

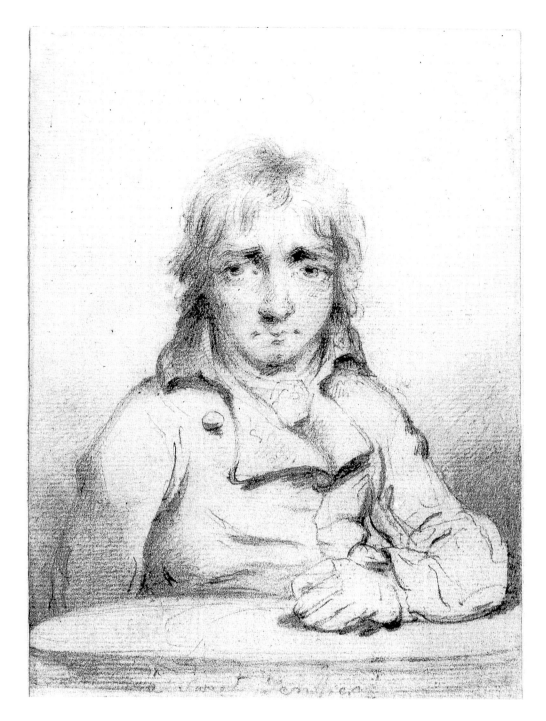

46 This study, inscribed 'A sweet temper', shows us Turner as he appeared to a fellow-student at the Royal Academy Schools. The draughtsman, Charles Turner (104), was later to become one of Turner's most important engravers (105, 110), and the drawing has sometimes been dated to about 1806 when the two men first collaborated on the *Liber Studiorum*. But it is clearly a record of their studenthood and probably dates from soon after they met in 1795.

However humble his background – and that must have been plain enough from his strong London accent – he behaved with decorum; his respect for the Academy and its members, and his great desire to join their number, dictated deference. He suffered, as Clara Wells admitted, 'the inevitable consequence of a defective education' (T., II, p. 56), and was, moreover, too much bound up in his art – carried away by the sheer pressure of his own creativity – to be punctilious as to behaviour at all times. His professional colleagues learnt to recognize a sometimes surly temper. But when soliciting votes for the Associateship in 1799 he was meekly nervous as to the result, and happy to go cap in hand to Farington and the others for their favour.

49 Indeed, Farington became a regular confidant in the months leading up the election of a new Associate in 1799. Turner frequently went to him for advice and reassurance: on 27 May

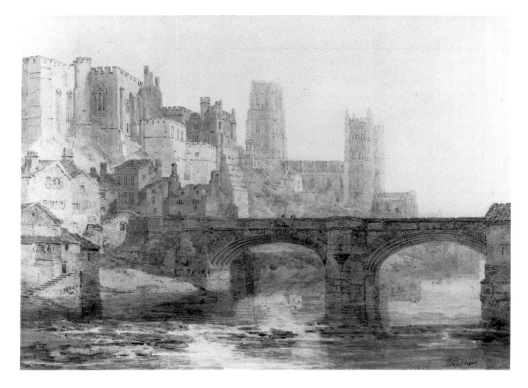

47 *Durham Cathedral from the River Wear*, watercolour, *c.*1798. Turner presented this drawing to Hoppner in gratitude for his support at the time of his first attempt to become an Associate of the Academy. On 24 October 1798, Farington noted in his Diary that Turner 'requested me to fix upon any subject which I preferred in his books, and begs to make a drawing or picture of it for me. I told him I had not the least claim to such a present from Him, but on his pressing it I said I would take another opportunity of looking over his books & avail myself of his offer. Hoppner, He said, had chosen a subject at Durham.' It had been noted in the *Tweed and Lakes* sketchbook, used on the tour of 1797.

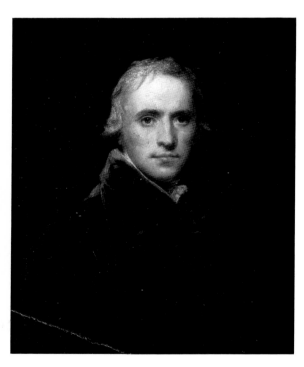

48 John Hoppner: *Self-portrait*, *c.*1800. Like Opie in his portrait of Girtin (35), Hoppner demonstrates here the rich Rembrandtian chiaroscuro that Turner too used in his own self-portrait of about the same date (ill. 2). The simple, frontal pose is also very similar in both.

Turner called. I told him there could be no doubt of his being elected an Associate if He put His name down. – He expressed himself anxious to be a member of the Academy.

Again, on 6 July

Turner called this morning – I told him He might be assured of being elected, to remove his anxiety. – He talked to me of removing from his fathers house in Hand Court, Maiden Lane, – I advised him to take Lodgings at first & not to incumber Himself with a House. Smirke & I, on our way to the Academy, drank tea with him, and looked over his sketch books. He said He had 60 drawings bespoke now by different persons.

Turner had already, during the previous year's elections, expressed his gratitude for Farington's support by offering to make him a watercolour from any subject he might choose from the sketchbooks. He paid Smirke and Hoppner the same compliment, and Lawrence too became the owner of a watercolour at about that time. The secrecy over his working methods that became so well-known a feature of Turner's character later does not seem to have prevented him, in these years, from sharing his technical discoveries with close colleagues both inside and beyond the Academy. They were fascinated. On 21 July Farington noted that

47, 48

Turner came to tea – He told me He has no systematic process for making Drawings, – He avoids any particular mode that He may not fall into manner. By washing and occasionally rubbing out, He at last expresses in some degree the idea in his mind.

Likewise, on 16 November

He reprobated the mechanically, systematic process of drawing practised by [John 'Warwick'] Smith & from him so generally diffused. He thinks it can produce nothing but manner and sameness . . . Turner has no settled

process but drives the colours abt. till he has expressed the idea in his mind.

This unwillingness to paint by 'formula' – a besetting limitation of most eighteenth-century landscape painting, of which Smith is a representative example – anticipates the efforts of Constable in the next decade to depict nature without 'handling', and is a very significant corollary of Turner's ambition to create sublime and often highly theatrical subjects. These he no doubt felt would help to impress his seriousness upon the Academy. On 30 October he called again on Farington, and told him he was 'Very anxious abt. the election. . . . I told him He had no reason to fear.' In the event, the election turned out as Farington had so confidently predicted. Turner gained ten votes in the first ballot, his nearest rivals among the six candidates getting only two each. At the second he beat George Garrard by ten votes to three. It was obviously a great relief, and a great triumph for him. He was quickly involved in Academy affairs, and on 8 November attended for the first time a meeting of the Academy Club, though it was not until 31 December 1799 that the Academy Council Minutes duly noted that 'Mr. William Turner Associate elect attended, the Secretary read the Obligation, which he signed, & the President gave him his Diploma.'

This was but a step, of course, towards the full membership of the Academy that he aspired to, and which was to follow before long. Meanwhile, his sense of his own worth had been corroborated by the judgment of the most influential artistic body in the land. His handling of patrons assumed a new authority, and he was able to stick firmly to his own terms when approached by men like the Earl of Elgin, who asked him to go as his draughtsman to Greece, but whose conditions did not suit him. Another prominent collector of antique sculpture, Charles Townley, also gave him work, both on his own account and, apparently, on behalf of a Lancashire neighbour, Dr Thomas Dunham Whitaker. Whitaker was a local historian and antiquarian who had been introduced to Turner by the printer and bookseller Thomas Edwards. He had recently asked Townley to commission a series of views to illustrate his *History of the Parish of Whalley*, as mentioned by Farington on 11 September 1799: 'Turner now engaged by C. Townley to go to Lancashire to make drawings of Whalley Abbey &c for a publication.' In a letter of 8 February 1800 Whitaker told a friend, the Rev. Thomas Wilson:

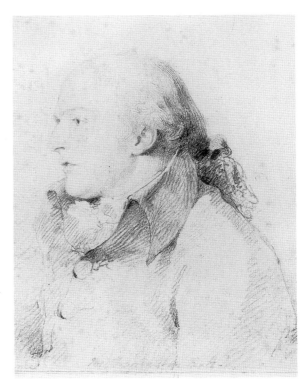

49 Joseph Farington, drawn by Thomas Lawrence in 1790. Farington, a pupil of Richard Wilson, had been an Academician since 1785. When Turner arrived at Somerset House he was one of the Academy's most influential members; indeed, he was known as its 'dictator'. Farington's support was valuable to Turner in his campaign to become an Associate, but it did not achieve that distinction for the less precocious John Constable, whom he also favoured in the late 1790s.

50 *Whalley Abbey*, watercolour, c.1799.

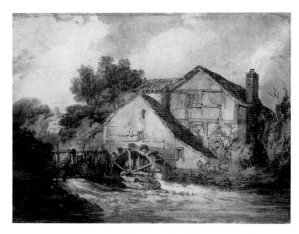

51 *Iffley Mill, near Oxford*, watercolour, *c.*1800, inscribed on the verso: *Efley Mill near Oxford/ This Drawing was made for Wm DelaMotte/ Oxford 1800*. A more informal work than the grand topographical views that Turner made for his Academic colleagues (47), this picturesque scene is perhaps a souvenir of a sketching-trip the two artists had made together while Turner was in Oxford working on the Almanack designs (see ill. 53).

52 Sketch-map of the Vale of Towy and Vale of Usk, from Turner's letter to William Delamotte, 1800.

I have just had a ludicrous dispute to settle between Mr. Townley and Turner, the draftsman. Mr. Townley it seems has found out an old and very bad painting of Gawthorpe [a Lancashire house] . . . as it stood in the last century . . . this he insisted would be more characteristic than Turner's own sketch, which he desired him to lay aside, and copy the other. Turner, abhoring the landscape and condemning the execution of it, refused to comply, and wrote to me very tragically on the subject. Next arrived a letter from Mr. Townley, recommending me to allow Turner to take his own way but while he wrote, his mind (which is not unfrequent) veered about, and he concluded with desiring me to urge Turner to the performance of his requisition, as from myself. I have, however, attempted something of a compromise which I fear will not succeed, as Turner has all the irritability of youthful genius.

Turner's own earliest extant letter dates from this year. It is addressed to his exact contemporary, the landscape painter William Delamotte, who was based in Oxford. Delamotte was another recipient of one of Turner's watercolours, from which fact we can deduce a fairly close friendship. He planned a tour in South Wales during the summer of this year, and must have asked advice from a painter who by now knew his Wales rather well, and evidently loved it. 52, 51

The point to which I would recommend your attention is the Vale of Towy and the Vale of Usk, commencing at Abergavenny, thence to Brecknock Tretowers – the Head of the Vale of Usk then commencing the Vale of Towy – Llandovery – thence to Landilo the Head Quarters in the Vale and Caerkinnon [Carreg Cennen] Castle, Drusslynn Castle, Dynevor Castle, thence to Carmarthen which affords only Quarters. You will find Lanstephen C and Langarn [Laugharne] Castle on the sea there with Kidwelly Castle 9 miles from Carmarthen, to which place a coach travels th[r]o the above mentioned Valley to Gloucester. Therefore this route I trust will tho cursory amply employ you for it is by far the most luxuriantly wooded and the River Towy in particular besprinkled with Castles or their Remains – [there follows a list of castles in the Vales of Usk and Towy, together with a sketch map of the region]
My respects to Mr Williams and family and believe me to remain

your obedient Srt
W. Turner (G. 2)

'Mr Williams' was a mutual friend, a printseller and engraver with whom Turner had stayed in Oxford while working on a set of views of the city to adorn the *Oxford Almanack*. 53

In compiling this information for Delamotte Turner probably had recourse to the notes he had had carefully copied for him by an amanuensis from a published guide into a sketchbook before his South Welsh journey of 1795. He will also have looked again at the splendid collection of drawings in both pencil and watercolour that he made in his large *Hereford Court* sketchbook during the long Welsh tour of 1798. After his visit to Snowdonia in 1799, on the way back from working in Lancashire on Whitaker's commission, he only once again, briefly, toured Wales; yet the landscape of that country had contributed significantly to the rapid development of his art in this first decade of his career, and it may have been with a due recognition of the benefits its wooded valleys and spectacular mountains had conferred on his vision that he chose a Welsh subject as his Diploma picture to be deposited in the Academy when, in 1802, he 14 finally achieved the full status of Royal Academician. The canvas that he selected, *Dolbadern Castle, North Wales*, was no doubt also intended to epitomize

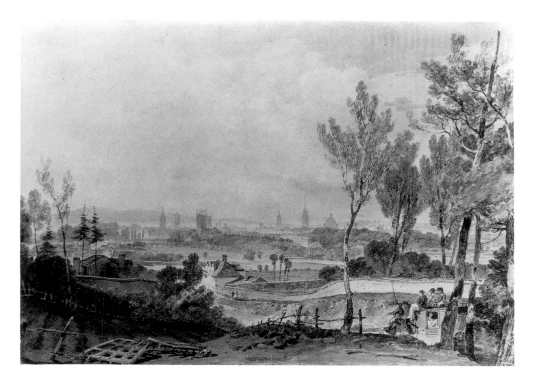

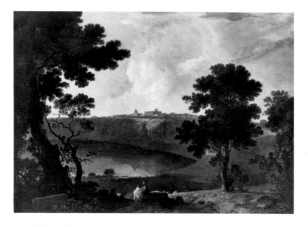

53 *Oxford from Headington Hill*, watercolour, *c.*1803, drawn for the *Oxford Almanack*. Turner worked on this commission from the Clarendon Press between 1798 and 1804. Most of the subjects, including this one, were engraved by James Basire, the master of William Blake.

his aspirations and achievements in landscape: it has strong historical overtones, with a reference (apparent in the lines of verse that appeared with it in the Academy catalogue when it was exhibited in 1800) to an incident in medieval Welsh history; and it is painted in the boldly sublime language of Richard Wilson, broad in handling with strongly organized elements of cloud, cliff and lonely tower.

Wilson's influence is clear in most of the early oil paintings after *Fishermen at sea*: the views of *Dunstanburgh Castle* and *Buttermere Lake with part of Cromackwater, Cumberland, a shower* which he showed in 1798 both display the richly applied paint and dark tonality of Wilson's work, as does *Kilgarren castle on the Twyvey, hazy sunrise, previous to a sultry day* of 1799. *Harlech Castle, from Twgwyn ferry, summer's evening twilight*, also exhibited in 1799, is an exercise in Wilson's consciously Claudian vein, boasting a serene golden sky and carefully balanced asymmetrical composition. The titles express Turner's concern to convey specific climatic effects, first noticed in his view of the Hotwells at Bristol of 1793; and from 1798 he was permitted by a new ruling of the Academy to introduce quotations as subtitles in the catalogues. He immediately availed himself of this facility to adduce Milton and Thomson, Mallet and Akenside in the cause of fuller and more explicit reference. The desire for accuracy of detail, of verifiable truth to nature, consorts strangely with the principles of ideal generalization that lie at the root of Wilson's style; but the combination surely reflects that early division between academic theory and topographical practice which formed his professional training. His whole career was to be a resolution of the conflicting interests of the two trains of aesthetic thought.

But if he was concentrating on mastery of Wilson's manner, he had his sights all the while on Wilson's own model – Claude. Often in his career he was to perceive in an admired contemporary the traces of some older master, the true gauge of excellence by which he wanted to be judged. Wilson led him to Claude by a natural progression; the test was waiting for him, and he was getting into training for it. When he went to see Beckford's new pair of Claudes, purchased from the Altieri collection in Rome and on show at Beckford's house

54 Richard Wilson: *Lake Albano and Castel Gandolfo*, *c.*1758. The breadth and 'generalization' of Wilson's approach to landscape corresponded to Reynolds's call for the same qualities in history and portrait painting, and gave Wilson great authority as a model for the ambitious Turner. This composition is based on a chalk drawing that Wilson made in Rome in 1754, probably using as his model a small view of the same subject by Claude which then hung in the Palazzo Barberini. The subject was a favourite one with classicizing landscape painters, and Turner was to make a watercolour of it in the 1820s.

55 *Æneas and the Sibyl, Lake Avernus*, oil, *c*.1798. Colt Hoare introduced Turner to the subject of Lake Avernus while he was at Stourhead, and may have suggested a picture based on a drawing of his own, made in Italy in 1786. It was natural for Turner to make use of the example of Wilson (54) in painting his first Italian subject. The theme, implying the lurking horrors of death and the underworld beneath the beauty of visible nature, had a long-lasting appeal for Turner who returned to it, not only in a reworking of this subject for Colt Hoare in 1814, but also in *The Bay of Baiæ* of 1823 (178) and *The golden bough* of 1834.

in Grosvenor Square, he felt to the full the nature of the challenge. The *Landscape with the Father of Psyche Sacrificing to Apollo* in particular stirred him: 57 'He was both pleased and unhappy while He viewed it, – it seemed to be beyond the power of imitation' (Farington, 8 May 1799). Another Claude, a sumptuous sunset harbour scene, had a similar effect on him. It belonged to John Julius 56 Angerstein, a merchant who was later to present his fine collection of old masters to the nation as the nucleus of the National Gallery:

When Turner was very young he went to see Angerstein's pictures. Angerstein came into the room while the young painter was looking at the Sea Port by Claude, and spoke to him. Turner was awkward, agitated, and burst into tears. Mr Angerstein enquired the cause and pressed for an answer, when Turner said passionately, 'Because I shall never be able to paint any thing like that picture.' (Jones, *Turner*, p. 4)

The anecdote is given added poignancy by Farington's entry in his Diary for 27 May 1799: 'Turner called. . . . Mr Angerstein is to give him 40 guineas for his drawing of Caernarvon Castle. The price was fixed by Mr A., & was much greater than Turner wd. have asked.' The work in question was the watercolour

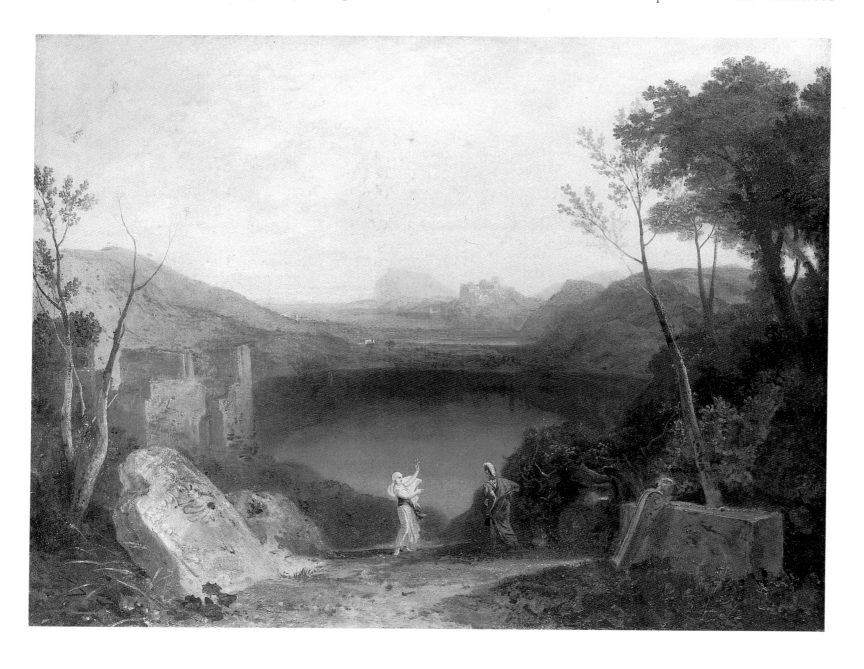

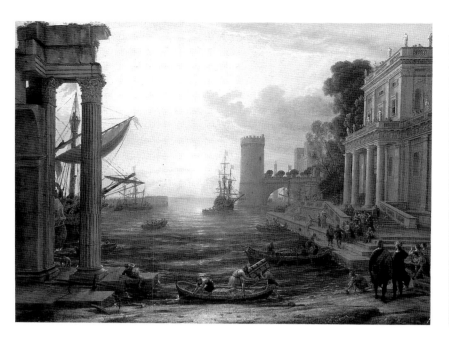

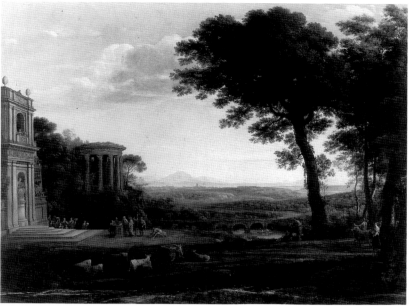

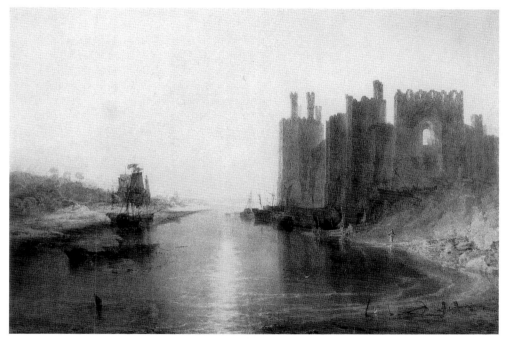

56 Claude Lorraine: *Seaport with the Embarkation of the Queen of Sheba*, 1648. This Claude, which Turner saw in Angerstein's collection, was one of the most influential of all paintings on his art. In his will he stipulated that his own *Dido building Carthage* (122) should hang beside it in the National Gallery. Two pictures that Turner exhibited in 1799 display its immediate impact on him: the large watercolour of *Caernarvon Castle* (58) and the oil painting of *Harlech Castle, from Twgwyn ferry, summer's evening twilight.*

57 Claude Lorraine: *Landscape with the Father of Psyche sacrificing to Apollo*, 1663. One of the two Claudes from the Altieri collection which were purchased by William Beckford in 1799.

58 *Caernarvon Castle*, watercolour, 1799. This moving paraphrase of a Claude seaport subject was bought by Angerstein. Turner exhibited it with lines from Mallet's *Amyntor and Theodora*.

58 of *Caernarvon Castle* that Turner had submitted to the Academy's exhibition; and it was his first attempt to paint a sea port at sunset in the manner of Claude. It is still very much like Wilson in its broad generalizations; but its balanced composition and warm tonality clearly imitate the French master. Whether it was before or after the purchase that Angerstein found him weeping in front of his *Embarkation of the Queen of Sheba*, there is a touching irony in the story.

Another picture of this date affords a parallel and equally delicate insight into Turner's response to the old masters through his contemporaries. He did not exhibit it, for it was a portrait of himself, a subject he knew no one could care for. Indeed, we may ask why he should have departed so radically from his fixed view to produce such a work. First, it must be said that he was in the habit of trying his hand at every type and genre of painting. If he thought he might imitate Wilson and Claude, he would certainly have liked to imitate Reynolds

59 *The Siege of Seringapatam*, watercolour, c.1800. Perhaps through the offices of his colleague the Indian topographer William Daniell, Turner apparently obtained a commission to make a set of views of the fort of Seringapatam, in South India, captured from Tippoo Sultan in May 1799. He seems to have made use of views taken on the spot by a military artist, Thomas Sydenham. The composition of this elaborate subject parallels in watercolour the oil painting of *The fifth plague of Egypt* which he showed in 1800, and is his first work in watercolour to tackle an ambitious subject of 'modern history'.

and Rembrandt. There is a story that in his youth (he must have been very young) he worked in Reynolds's studio, copying pictures there, though there is no evidence for this, beyond his known admiration for the President, who died in 1792. Nevertheless, he was surrounded by distinguished portrait painters, notably the brilliant and immensely successful Thomas Lawrence, six years his 230 senior; John Hoppner, Reynolds's pupil, to whom he presented a watercolour 48 of Durham in gratitude for his help in the elections; and John Opie, a painter of 35 portraits and histories whom Reynolds had hailed as 'like Caravaggio and Velasquez in one'. The rich chiaroscuro of Opie's portraits was as much Rembrandtesque as Italian, and Turner seems to have had his work in mind when he undertook the searching self-portrait that he painted about the turn of the century. Its unflinching, four-square regard, its rich impasto, its strongly contrasted lights and shadows, pay tribute jointly to Opie and to Rembrandt, and suggest something of the new self-confidence that his attainment of Associateship had brought him. The Academy clothed him in more glorious raiment, and rendered his 'little figure' acceptable, if not to the world, at least to himself.

The important developments in Turner's professional life during these closing years of the century were accompanied by no less significant, if less well publicized, changes in his domestic arrangements. His mother had been increasingly a prey to the mental illness which had made her so difficult to live with in Maiden Lane, and in December 1800 was admitted as a patient at Bethlehem Hospital, no doubt at the instigation and by the good offices of Dr Monro. It was he, too, in all probability, who in the following year had her transferred to a private asylum in Islington, where, since it had become clear that no cure was possible, the wretched woman could end her days in more humane surroundings than those of the state madhouse.

Before she left Maiden Lane, life for the family in that cramped house must have been almost intolerable. The elder Turner's stoical cheerfulness probably helped him through this testing time, but his son's more introverted temperament, which contained, as Turner must have been acutely aware, something of his mother's nervous make-up, was less well adapted to such strains. And in a personal crisis he found it natural to turn, not to his father but to a brother-artist. He escaped as often as he could to Wells's cottage at 60 Knockholt. As Clara said, 'In early life, my father's house was his second home, a haven of rest from many domestic trials too sacred to touch upon. Turner loved my father with a son's affection. To me he was an elder brother' (T., II, p. 55). It must have been during these flights from insanity that he took himself into the woods to study trees from nature, in oil on paper. Farington learned on 13 30 October 1799: 'Turner . . . Has been in Kent painting from Beech trees.' It was a new departure: he had never painted in oils out of doors before. Perhaps he derived from it some of the solace that he was later to find in angling.

Conditions at home being what they evidently were, it is not surprising that Turner was in search of his own separate accommodation. Also on 30 October, Farington reported: 'He has looked for lodgings in Harley St., which He may have at abt. 50 or £55 a year, and asked my opinion of that situation. I said if the lodgings were desirable, the situation is very respectable & central enough.' Shortly afterwards he took rooms at 64 Harley Street, at first sharing the house with John Thomas Serres, a landscape and marine painter who worked in both oil and watercolour – someone, therefore, with whom he had much in common. But Farington learned that the arrangement did not suit Turner. He noted on 16 November:

J. Serres is to have the use of a parlour & a room on the 2d. floor in the

60 William Frederick Wells by Henry Perronet Briggs, *c*.1814.

61 W. F. Wells: *View of Hastings from the north*, watercolour, *c*.1800

62 *A cottage*, watercolour, *c*.1799. This unidentified building has the air of a place Turner knew well; it does not seem to have been drawn for its picturesque qualities, and is very possibly the cottage of the Wells family at Knockholt. Wells's London home was in New Road, Gloucester Place, not far from the Harley Street area where Turner settled in 1799.

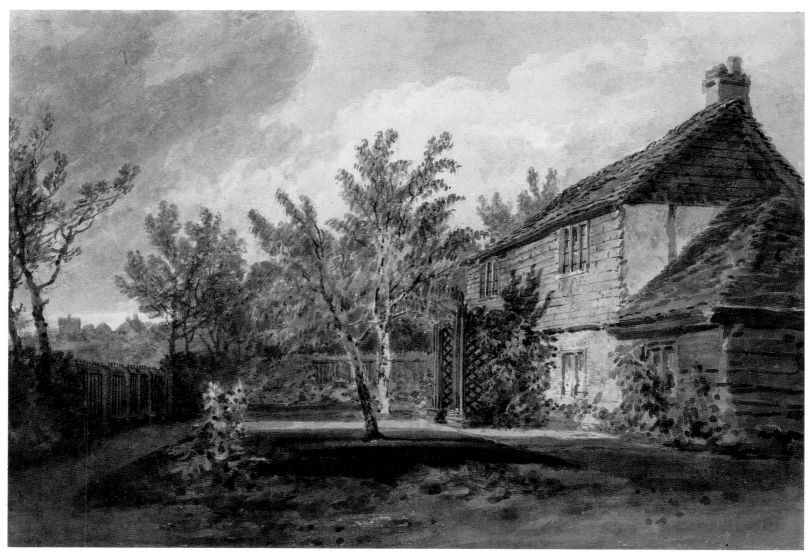

63 *The interior of the King's Theatre, Haymarket, from the gods*, pencil, *c*.1799. A lively and immediate record of Turner's lifelong pleasure in the theatre, which affected his whole approach to pictorial representation, and influenced his subject-matter until as late as 1846.

House in which Turner lodges in Harley St. Which He much objects to as it may subject him to interruption. – Serres to use these rooms from Ten in the forenoon till 3 or 4 in the afternoon, when the Revd. Mr. Hardcastle is to have the use of them, He being the Landlord.

Within a few years Turner was to take over the entire building himself and extend it.

There were other good reasons why he wished to be away from his family: he had become acquainted with the young wife of a Catholic composer and organist named John Danby, and in about 1798, presumably a little while after Danby's death in May of that year, she seems to have become his mistress. Since he was fond of convivial parties it is possible that they became acquainted at the glee clubs in which Danby was involved. A bit of musical notation in one of the sketchbooks (TB LXIII, inside cover) has encouraged the idea that Turner played the flute and may have taken part as an instrumentalist in such evenings; but there is little sign of extensive dedication to any instrument, and Ann Dart's testimony that he 'had for music no talent' can probably be relied on. He seems to have enjoyed singing with his friends and certainly possessed some music in score, but in other respects was a passive rather than an active member of music-making parties. At all events, his relationship with Sarah Danby flourished, and in the next few years she presented him with two daughters, Evelina and Georgiana. Her attentions were also largely responsible, no doubt, for that access of self-esteem which enabled him to paint his self-portrait with such unexpected confidence.

But he was averse to the idea of a settled family life of the kind that these new circumstances would naturally have suggested. He had seen enough of domestic discord to be more than a little cynical about marriage with even a composer's widow; and Sarah already had four children of her own. With two additional daughters the ménage must have been extremely demanding, an intrusion on the solitude which he temperamentally preferred and professionally required. Whether he even 'fell in love' with Sarah in any profound sense may be doubted: he kept her and all the children at arm's length, in a separate house at 46 Upper John Street. The determination to maintain a careful distinction between professional and private life is never more apparent than in Turner's treatment of his family. Apart from the existence of his two daughters there is no documentary evidence for his connection with Sarah except for a possible reference in a sketchbook (TB CXI, inside cover): 'Mrs D 4 – 4' (which may well refer to someone quite different), and Farington's report on 11 February 1809 that he had learned of Turner that 'A Mrs. Danby, widow of a Musician, now lives with him, she has some children.' That Farington should have regarded this snippet as news at so late a date demonstrates the thoroughness of Turner's measures to maintain secrecy on all matters relating to his most personal life.

Chronology 1775–1800

For abbreviations other than R.A. (Royal Academy, Royal Academician) and T.G. (Turner's Gallery) see the Bibliography, p. 249. Numbers in brackets without a letter prefix are those under which works appeared in exhibitions.

1775

23 April: Joseph Mallord William Turner born. His parents had married at St Paul's, Covent Garden, on 29 August 1773; in their application for a marriage license, on 27 August, they were described as William Turner, aged twenty-eight, and Mary Marshall, aged thirty-four. The couple settled at 21 Maiden Lane, where William had been a tenant since June, established as a barber and wig-maker.

14 May: baptised at St Paul's, Covent Garden.

1776

By Lady Day, the Turners no longer lived at 21 Maiden Lane; they appear to have moved into the parish of St-Martin-in-the-Fields.

1778

6 September: a daughter, Mary Ann, baptised at St Paul's, Covent Garden.

1785

Turner was sent to stay with his uncle, Joseph Mallord William Marshall, a butcher at Brentford, Middlesex. He attended John White's free school there, drawing 'birds and flowers and trees from the school-room windows' (T., I, p. 21). At this time he is said to have coloured plates in Henry Boswell's *Picturesque Views of the Antiquities of England and Wales* for a Brentford man named Lees.

1786

20 March: Mary Ann buried at St Paul's, Covent Garden.

Probably this year, Turner was sent to stay in Margate, where he attended Mr Coleman's school, and made several views in the town and vicinity, including St John's Church, Margate (W.1), and Minster Church, Isle of Thanet (W.3)

1787

First signed and dated drawings extant: a copy after one of Michael Angelo Rooker's designs for the *Oxford Almanack* (TB I-A), and a view of Nuneham Courtenay (TB I-B).

By this time almost certainly exhibiting his work in the window of his father's shop.

1788

Several early drawings preserved in the Turner Bequest perhaps date from this year: copies from William Gilpin's *Observations on a tour in the mountains and lakes of Cumberland and Westmoreland*, 1782 (TB I-D; now lost), and studies from prints by Paul Sandby of Eton College (TB I-C) and of St Vincent's Tower, Naples, after Lallemand (TB I-E).

1789

Summer: stayed with his uncle at Sunningwell, near Oxford; the first of the sketchbooks in the Bequest, the *Oxford* sketchbook (TB II), was used during this visit.

Already being employed as a draughtsman in the offices of various architects, among them Thomas Hardwick, and, possibly, William Porden and Joseph Bonomi. Another, a Mr Dobson, is mentioned by the Redgraves in *A Century of Painters*.

By the end of the year, he was working with Thomas Malton, 'my real master', as Turner described him in later life (T., I, p. 47).

11 December: admitted a member of the Royal Academy Schools after a term's probation.

1790

By this year the Turner family were at Hand Court, 26 Maiden Lane, Covent Garden.

Royal Academy exhibition: first watercolour shown, *The Archbishop's palace, Lambeth* (644; W.10)

1791

Royal Academy exhibition: 2 watercolours shown, *King John's Palace, Eltham* (494; W.12) and *Sweakley, near Uxbridge, the seat of the Rev. Mr Clarke* (560; W.14).

September: stayed with John Narraway, a friend of his father's at Bristol, and sketched extensively in the Avon Gorge at Clifton. He also visited Bath and Malmesbury. *The Bristol and Malmesbury* sketchbook (TB VII), used on this tour, contains evidence that Turner was planning a series of published views on the river Avon, though this did not materialize. He executed a miniature self-portrait in watercolour as a gift for the Narraway family.

1792

14 January: Turner made studies of the ruins of James Wyatt's Pantheon, Oxford Street, destroyed by fire in the early hours of the morning; 2 views were finished in watercolour (W.27, 28).

23 February: death of Sir Joshua Reynolds.

About this time, Turner is said to have been employed in colouring prints for John Raphael Smith and Paul Colnaghi. Smith also employed Thomas Girtin, whom Turner may first have met in his shop.

Royal Academy exhibition: 2 watercolours shown, *Malmsbury Abbey* (436; W.25) and *The Pantheon, the morning after the fire* (472; W.27).

June: began to study in the life class of the Academy Schools, where he formed friendships with Robert Ker Porter and John Soane. Porter introduced him to William Frederick Wells, a landscape watercolourist who was to become an intimate friend.

Summer: revisited the Narraway family at Bristol; went on to make his first sketching tour in South Wales, travelling through the Wye valley as far as the Black Mountains and returning via Hereford and Oxford.

A portrait of Turner by George Dance is dated to this year.

A small oval painting of a water-mill datable to the winter of 1792–3 (TB XXXIII-a) is probably his first essay in oil.

1793

27 March: awarded the 'greater Silver Palette' for landscape drawing by the Royal Society of Arts, no doubt on the strength of work submitted to the Academy exhibition.

Royal Academy exhibition: 3 watercolours shown, *Gate of St Augustine's Monastery, Canterbury* (316; w.31) and 2 views on the Avon, *View of the River Avon, near St Vincent's Rock, Bristol* (263; w.17) and *The rising squall – Hot Wells, from St Vincent's rock, Bristol* (323; w.18).

Summer: tour to Hereford, Great Malvern, Worcester, Tewkesbury and Tintern, possibly in response to commissions from John Henderson (see 1794), apparently in the company of 'a poor artist named Cook'. No sketchbooks are known from this tour, but some of the drawings in TB XII and XIII were probably made in the course of it.

Autumn: tour of Kent and Sussex, apparently in response to a commission from John Walker for views to be engraved for his *Copper-Plate Magazine*.

Turner's name first appears in the diary of Dr Thomas Monro for 1793, but it is likely that he had already come into contact with the physician and patron of young artists in the previous year.

1794

Royal Academy exhibition: 5 watercolours shown, *Second fall of the river Monach, Devil's Bridge, Cardiganshire* (333; w.48); *Porch of Great Malvern Abbey, Worcestershire* (336; w.49); *Christ Church Gate, Canterbury* (388; w.53); *Inside of Tintern Abbey, Monmouthshire* (402; w.57); and *St Anselm's chapel, with part of Thomas-a-Becket's crown, Canterbury Cathedral* (408; w.55). Turner's entry attracted the attention of the press for the first time, and *St Anselm's chapel* was bought by Dr Monro.

Turner's work of this time shows the influence of Edward Dayes and Thomas Hearne, both of whom he came to know through Monro.

Summer: tour through the Midland counties and into North Wales as far as Chester and Llangollen, Matlock and Lincoln, in search of material for Walker's engravings; the *Matlock* sketchbook (TB XIX) and loose sheets (TB XXI, XXII) were used.

Winter: Turner began to work regularly on Friday evenings at Dr Monro's house, 8 Adelphi Terrace, (where Monro have moved in 1793), making copies of drawings by J.R. Cozens, Edward Dayes and others; Girtin was a fellow 'pupil'. Another amateur and patron, John Henderson, also of Adelphi Terrace, lent Monro his own drawings of Dover harbour for Turner and Girtin to copy.

In this year, Turner probably began to take drawing pupils; he continued to teach privately until about 1798, thereafter only occasionally giving lessons.

1795

Royal Academy exhibition: 8 watercolours shown, all subjects derived from the tour in Wales and the Midlands. They were *St Hughe's the Burgundian's porch at Lincoln Cathedral* (411; w.123); *Marford Mill, Wrexham, Denbighshire* (581; w.125); *West entrance of Peterborough Cathedral* (585; w.126); *Transept of Tintern Abbey, Monmouthshire* (589; w.58); *Welsh Bridge at Shrewsbury* (593; w.82); *View near the Devil's bridge, with the river Ryddol, Cardiganshire* (609; w.128); *Choir in King's College chapel* (616; w.77); and *Cathedral Church at Lincoln* (621; w.124). The last was bought by John Henderson.

4 June: Turner's name appears in Farington's Diary for the first time.

June–July: tour in South Wales. He used the *Smaller South Wales* and *South Wales* sketchbooks (TB XXV, XXVI).

August–September: journey to the Isle of Wight to execute private commissions, including an order for 10 views from the engraver John Landseer, who subsequently engraved 5 of them (R.34–37a). One sketchbook was in use on the tour, the *Isle of Wight* book (TB XXIV).

Turner received a commission from Sir Richard Colt Hoare of Stourhead, Wiltshire, to make a series of drawings of Salisbury Cathedral and buildings in the city, and two of Hampton Court, Herefordshire. He probably visited Stourhead this year, and saw Colt Hoare's collection of old master paintings, watercolours by Ducros, and prints by Piranesi, and no doubt the famous gardens which had been created in the 1740s and 1750s to a Claudian model. Colt Hoare was a friend of Sir John Fleming Leicester, who was later to become a major patron.

1796

Royal Academy exhibition: 10 watercolours shown, and, for the first time, an oil painting – a nocturnal sea-piece, *Fishermen at sea* (305; B&J 1); it was well received by the press. Watercolours: *Close Gate, Salisbury* (369; w.20); *St Erasmus in Bishop Islip's Chapel* (395; w.138); *Woolverhampton, Staffordshire* (651; w.139); *Llandilo Bridge and Dinevor Castle* (656; w.140); *Internal of a cottage, a study at Ely* (686; w.141); *Chale Farm, Isle of Wight* (699; w.142); *Landaff Cathedral, South Wales* (701; w.143); *Remains of Waltham Abbey, Essex* (702; w.144); *Trancept and Choir by Ely Minster* (711; w.194); and *West front of Bath Abbey* (715; w.145).

Summer: he may have visited Brighton, perhaps to recover from an illness. A small sketchbook, *Studies near Brighton* (TB XXX), was used during this stay; he also possibly made a series of coastal and shipping subjects on coarse grey paper (TB XXXIII and elsewhere), though some of these seem to have been executed around Margate.

1797

Royal Academy exhibition: 2 oil paintings and 4 watercolours shown. Oils: *Moonlight, a study at Millbank* (136; B&J 2), *and Fishermen coming ashore at sun set, previous to a gale* (the 'Mildmay Sea-piece', 344; B&J

3). Watercolours: *Trancept of Ewenny Priory, Glamorganshire* (427; W.227), which a critic considered equal to the best of Rembrandt; *Ely Cathedral, South Trancept* (464; W.195), a similar composition to the view of Ely shown in 1796; and 2 views of Salisbury Cathedral executed for Colt Hoare, *North porch of Salisbury Cathedral* (517; W.196) and *Choir of Salisbury Cathedral* (450; W.197).

The Salisbury drawings were the first of nearly 30 made for a history of Wiltshire which Hoare never completed. Turner produced 17 Salisbury subjects between this year and about 1805.

Summer: first tour of the north, including much of Yorkshire, the Northumberland coast, the Tweed valley (where he made the first of many studies of Norham Castle), and the Lake District. On his way home he stayed at Harewood, to make drawings for the Hon. Edward Lascelles. He may also have visited Brocklesby in Lincolnshire, to make drawings of the Mausoleum there for Lord Yarborough, in the *Brocklesby Mausoleum* sketchbook (TB LXXXIII). The two principal sketchbooks used on this tour, the *North of England* and the *Tweed and Lakes* books (TB XXXIV, XXXV), provided subjects for watercolours as late as the *England and Wales* drawings of the 1830s.

After returning to London, Turner visited William Lock of Norbury Park, near Dr Monro's cottage at Fetcham, Surrey, and made a watercolour of the fern-house at Norbury which was to appear at the Academy exhibition in 1798. Lock was related to John Julius Angerstein, whose collection included works by Claude which were to have a special importance for Turner.

This year, Turner made a number of copies of classical landscapes by Richard Wilson and C.-J. Vernet in the *Wilson* sketchbook (TB XXXVII).

1798

April: Turner stayed with the Rev. Robert Nixon at Foots Cray, Kent, and there met Stephen Francis Rigaud; he accompanied them on a sketching tour along the Medway, and probably also visited Canterbury. He made use of pages in a partly filled sketchbook of 1795, the *South Wales* book (TB XXVI).

Royal Academy exhibition: 4 oil paintings and 6 watercolours shown. Oils: *Morning amongst the Coniston Fells, Cumberland* (196, B&J 5); *Winesdale, Yorkshire, an Autumnal morning* (118; B&J 4); *Dunstanburgh Castle, N.E. coast of Northumberland, Sun-rise after a squally night* (322; B&J 6); and *Buttermere Lake with part of Cromackwater, Cumberland, a shower* (527; B&J 7). Watercolours; *Refectory of Kirkstall Abbey, Yorkshire* (346, W.234); *Norham Castle on the Tweed, Summer's morn* (353; W.225); *Holy Island cathedral, Northumberland* (404; W.236); *Ambleside Mill, Westmoreland* (408, W.237); *The dormitory and transcept of Fountain's Abbey – Evening* (435; W.238); and *Study in September of the fern house, Mr Lock's Park, Mickleham, Surry* (640; W.239). A newly introduced Academy ruling allowed Turner to add citations of poetry to the titles of pictures in the catalogue; he appended a quotation from Milton's 'Paradise Lost' to his view of *Coniston Fells* and lines from Thomson's 'Seasons' to four subjects: the *Dunstanburgh, Norham, Fountains* and *Buttermere*.

16 May: death of John Danby, a composer of 26 Henrietta Street, Covent Garden, with whom Turner had become friendly. Shortly after this, he became the lover of Danby's widow; Sarah, who was to bear him two children, Evelina and Georgiana.

Turner entered his name as a candidate for election to Associateship of the Academy, but was unsuccessful. He was supported by, among others, Sawrey Gilpin, whose *Letter on Landcape Colouring* advocates the sombre palette suggested by Edmund Burke for landscape subjects, which Turner began to adopt in his watercolours of 1797–8.

Summer: tour to Malmesbury and Bristol, and thence, on a pony borrowed from the Narraways, to South and North Wales. Sketchbooks used on the tour are *Hereford Court* (TB XXXVIII), *North Wales* (TB XXXIX), *Dinevor Castle* (TB XL), *Cyfarthfa* (TB XLI) and *Swans* (TB XLII). The last of these contains drafts of several songs and ballads, often on nautical themes, and some perhaps by Turner himself. He also notes a 'Receipt for making an Efficable ointment for Cuts' which was 'Given by Miss Narraway of Bristol'. The songs may have been copied out for use on convivial occasions with the Narraways, and perhaps reflect the influence of the late John Danby.

28 November: told Farington that he was 'determined not to give any more lessons in drawing. He has only five Shillings a lesson'.

This year saw the completion of 2 views of Harewood Castle and 4 of Harewood House for Edward Lascelles, and probably also 2 oil paintings of *Plompton Rocks* for the library at Harewood.

Another commission of about this year was for the picture of *Æneas and the Sibyl* (B&J 34) executed for Colt Hoare as a pendant to a work by Wilson. It was not acquired by Hoare, but is important as Turner's first essay in fully-fledged classical landscape.

1799

April: recommended to Lord Elgin as a suitable artist to make drawings on his projected expedition to Athens. He demanded a salary of £400 per annum, while Elgin required to retain ownership of all drawings made. They therefore failed to agree, and Elgin employed the Italian G.B. Lusieri instead.

Royal Academy exhibition: 4 oil paintings and 7 watercolours shown. Oils: *Fishermen becalmed previous to a storm, twilight* (55; B&J 8); *Harlech Castle, from Twgwyn ferry, summer's evening twilight* (192; B&J 9); *The Battle of the Nile* (275, lost; B&J 10); and *Kilgarren castle on the Twyvey, hazy sunrise, previous to a sultry day* (305; B&J 11). Watercolours: *Sunny morning – the cattle by S. Gilpin, R.A.* (325; W.251); *Abergavenny bridge, Monmouthshire, clearing up after a showery day* (326; W.252); *Inside of the chapter house of Salisbury cathedral* (327; W.199) and *West front of Salisbury cathedral* (335; W.198), both for the Colt Hoare commission; *Caernarvon Castle* (340; W.254); *Morning, from Dr*

Langhorne's Visions of Fancy (356; w.255); and
*Warkworth Castle, Northumberland – thunder storm
approaching at sun-set* (434; w.256). In the catalogue
Harlech and *The Battle of the Nile* both had quotations
from 'Paradise Lost' appended, *Caernarvon Castle* lines
by Mallet, *Morning* a passage from Langhorne, and
Warkworth one from Thomson. *Caernarvon Castle* was
praised by one critic as having 'a depth and force of
tone . . . never before conceived attainable with such
untoward implements' (T. Green, *Extracts from the
Diary of a Lover of Literature*, 1810, pp. 137–8); it was
purchased by Angerstein for 40 guineas.

The *Oxford Almanack* for this year appeared with an
engraving after a design by Turner, who produced 10
drawings for it in all; the remainder were published
between 1801 and 1811.

Received a commission from the Lancashire antiquarian
Dr Robert Dunham Whitaker, through Charles
Townley, to make 10 watercolours to illustrate
Whitaker's *History of the Parish of Whalley*.

May: visited the exhibition of the Altieri Claudes,
Landscape with the Father of Psyche Sacrificing to Apollo
and *The Landing of Aeneas*, at William Beckford's
London house in Grosvenor Square, in the company
of Benjamin West, Farington and Robert Smirke.

6 July: told Farington he had commissions for 60
drawings in hand.

August–September: stayed for three weeks with
Beckford at Fonthill, Wiltshire, making preparatory
drawings for a series of 5 views (originally apparently
to have been 7) of the newly building Abbey at
different times of day. Farington says he at first
contemplated charging 40 guineas apiece for these,
perhaps on the hint supplied by Angerstein's offer of
40 guineas for the *Caernarvon Castle*, but the eventual
price was 35 guineas each (Diary, 13 April 1801).
Drawings on the spot were made in the *Fonthill*
sketchbook (TB XLVII) and he may possibly also have
used the *Smaller Fonthill* book (TB XLVIII).

September–October: tour to Lancashire and North
Wales, making use of the *Lancashire and North Wales*
and *Dolbadarn* sketchbooks (TB XLV, XLVI). Probably
now became acquainted with Thomas Lister Parker of
Browsholme Hall, near Clitheroe, whose house
Turner drew for the *History of Whalley* (w.291). Parker

may have been instrumental in introducing him to
Walter Ramsden Fawkes and Sir John Fleming
Leicester, both important later patrons.

October: visited his friend Wells at Knockholt, Kent,
where he made a series of small oil studies of trees out
of doors.

4 November: elected an Associate of the Academy.

November–December: took rooms at 64 Harley Street.
Sarah Danby was installed as a subtenant at 46 Upper
John Street, not far away.

1800

31 March: sat to George Dance for his portrait.

Royal Academy exhibition: 2 oil paintings and 6
watercolours shown. Oils: *Dolbadern Castle, North
Wales* (200; B&J 12); and his first historical picture,
The fifth plague of Egypt (206; B&J 13), bought by
Beckford. Watercolours: *Caernarvon Castle, North
Wales* (351; w.263); and the 5 finished watercolours of
Fonthill Abbey, *View of the gothic Abbey (afternoon)
now building at Fonthill, the seat of William Beckford, Esq.*
(328; w.335), *South-west view . . . (Morning) . . .* (341;
w.336), *South view . . . (Evening) . . .* (566; w.337),
East view . . . (Noon) . . . (663; w.338), and *North-east
view . . . (sun-set) . . .* (680; w.339). *Dolbadern Castle*
and *Caernarvon Castle* were accompanied by verses
possibly written by Turner himself.

Commissioned by the Duke of Bridgewater to paint a
large sea-piece as companion to a work by Willem van
de Velde the younger, acquired from the Orleans
collection; the price to be 250 guineas.

Summer: at Fonthill again, where William Hamilton met
him (Farington, 8 November); the *Smaller Fonthill*
sketchbook (TB XLVIII) probably in use; but see 1799.
He may also have visited Stourhead and Oxford
working on commissions.

Autumn: probably stayed with Wells at Knockholt.

27 December: his mother admitted to Bethlehem
Hospital.

Probably some time this year, he executed a series of
views in watercolour of the Indian fort of
Seringapatam, captured from Tippoo Sultan by
General Baird in May 1799. He seems to have used
drawings by Captain Thomas Sydenham as his
models. The source of the commission is unknown.

1801–1810

64 *The Devil's Bridge, Pass of St Gothard.* Turner's experience
of the Alps in 1802 confirmed and developed the technical
and conceptual advances that had begun in North Wales.
After his tour he completed a series of finished watercolours,
some very large, expressing his sense of the grandeur and
bleakness of the mountains. Unusually in his work, they
contain few or no human figures. This example was not
exhibited, and indeed may be unfinished: it is executed with
extraordinary panache and technical inventiveness, displaying
the processes of scraping-out and stopping-out that he had
by now brought to great sophistication.

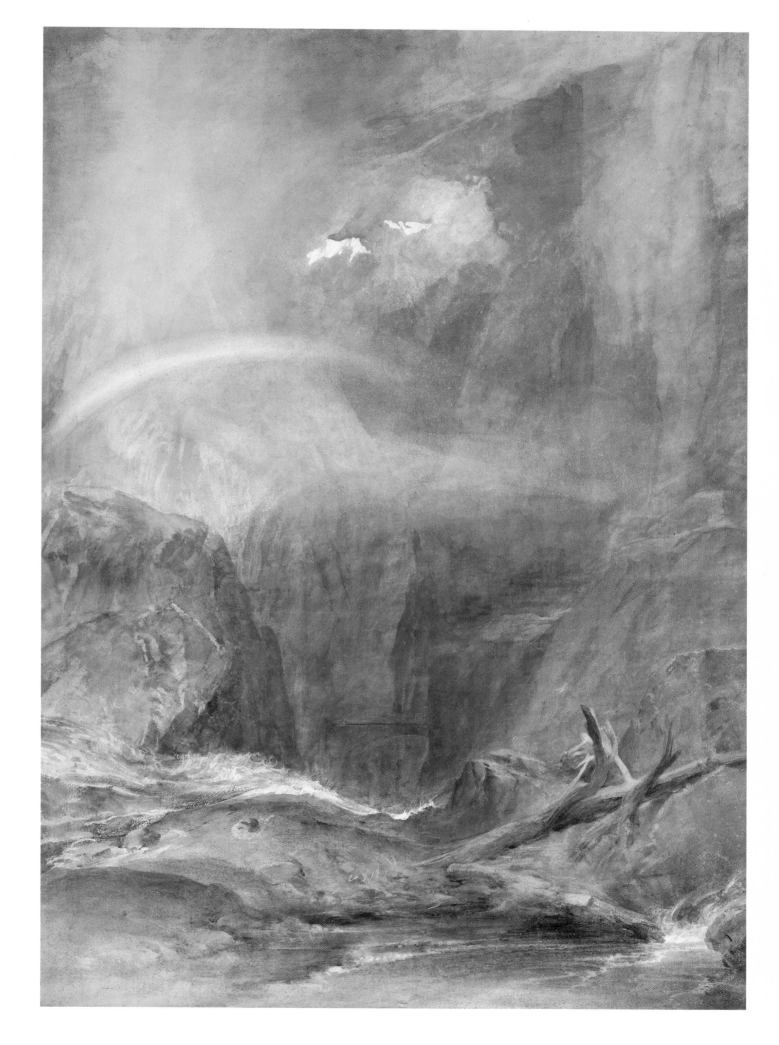

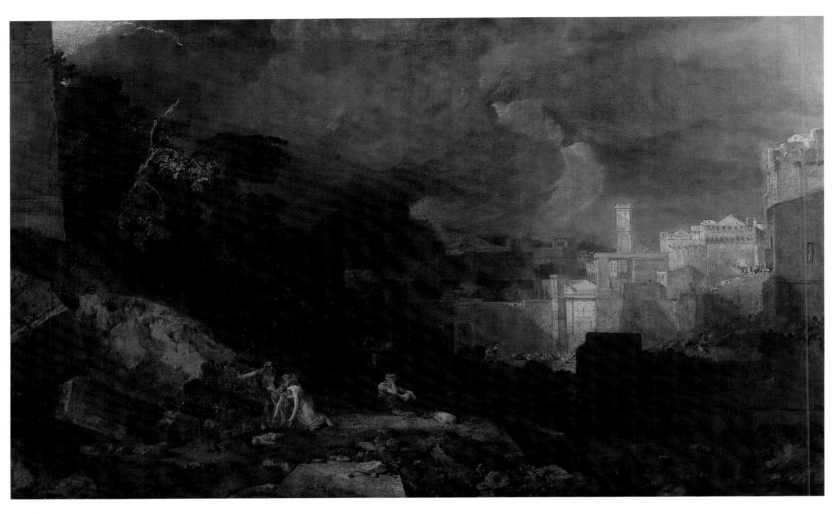

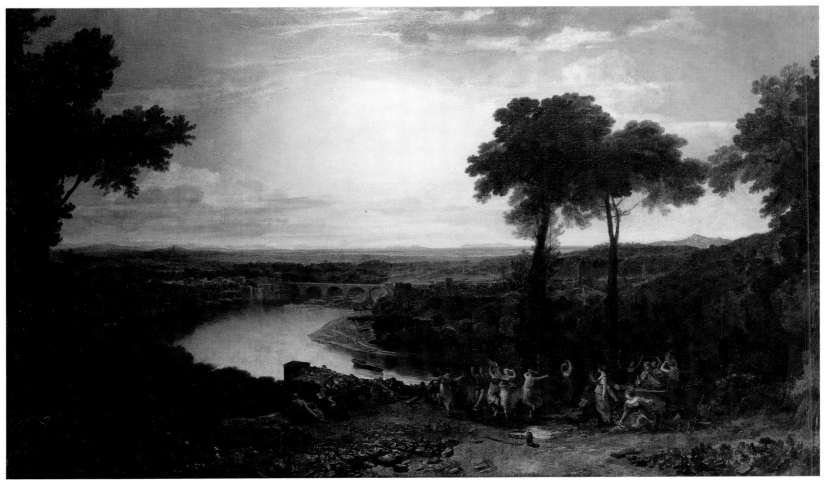

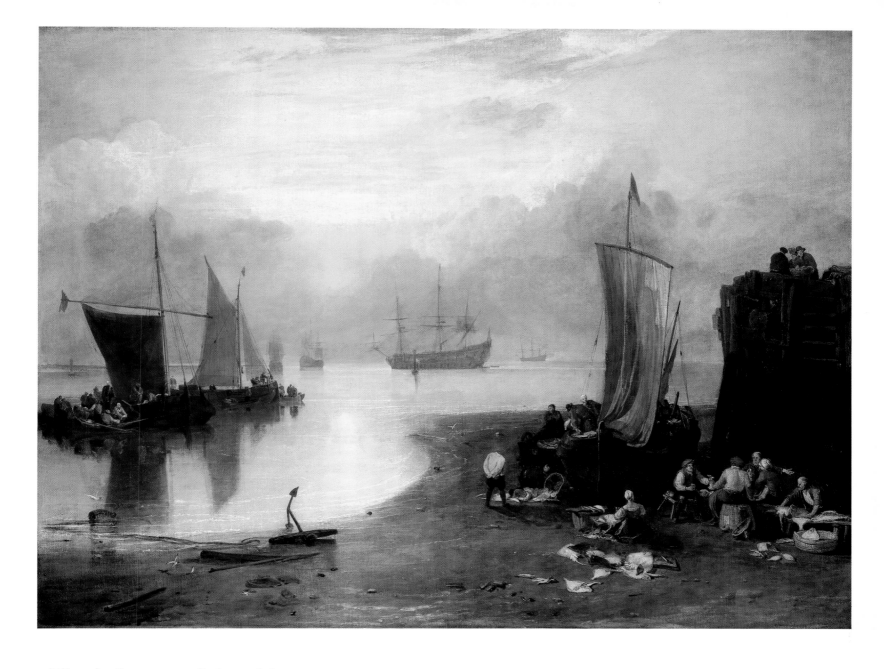

The influence of the old masters

Turner visited the Louvre during his stay in Paris in 1802, and was much affected by the works that he was able to study there. He had already shown a number of ambitious historical landscapes at the Academy: *The tenth plague of Egypt* (65) appeared in 1802; it blends the monumental classicism of Poussin with the hectic drama of Salvator Rosa.

A sequence of grand canvases followed his return to England. *The festival upon the opening of the vintage at Macon* (66) attracted much attention when it was shown in 1803. It is Turner's first full-scale essay in the manner of Claude Lorraine – 'borrowed from Claude but all the colouring forgotten', the hostile Sir George Beaumont told Farington on 3 May 1803.

Sun rising through vapour; fishermen cleaning and selling fish (67), shown in 1807, emulates the tranquil shipping subjects of Jan van de Cappelle, even to the extent of introducing figures in seventeenth-century Dutch costume. The picture was acquired in 1818 by Sir John Fleming Leicester, but bought back by Turner at his sale in 1827, and eventually bequeathed to the National Gallery to hang in perpetuity beside a work by Claude.

The early Swiss watercolours

In the large watercolours that he made after his return from the Continent in 1802 Turner adopted the same ambitious criteria that he applied to the oils. The large *St Huges denouncing vengeance on the shepherd of Cormayer, in the valley of d'Aoust* (69), shown in 1803, is a historical subject set in a part of the Alps that he had just sketched; its composition is founded on the firm geometry of Poussin (see ill. 90).

In order to reduce the complex subject-matter of these compositions to pictorial order, Turner made broadly-handled colour studies like the sombre 'colour structure' of the *Hospice of the Great St Bernard* (68). It was never used for a finished work, though he eventually made a vignette of the subject for Rogers's *Italy* in the late 1820s.

The richness and variety of his technique in the finished watercolours of this period can be seen in a detail of *Glacier and source of the Arveron, going up to the Mer de Glace* (70), shown at the R.A. in 1803.

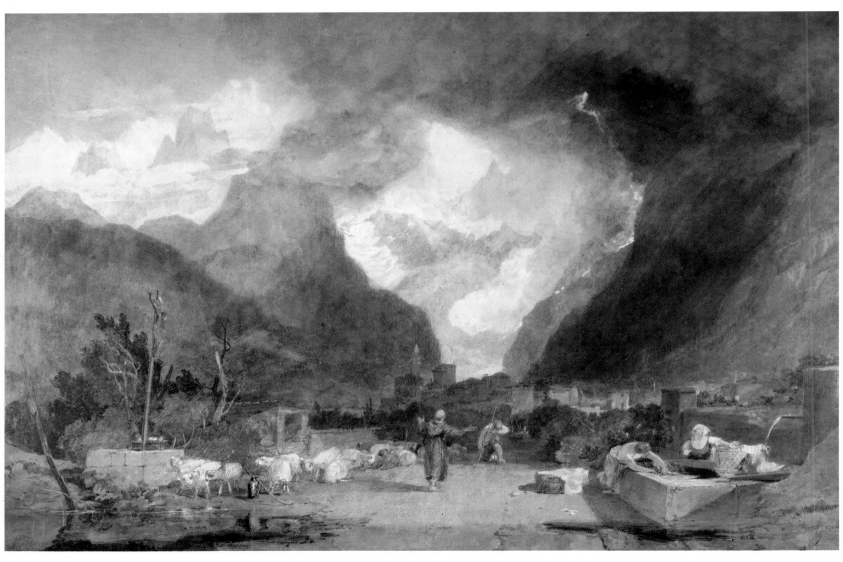

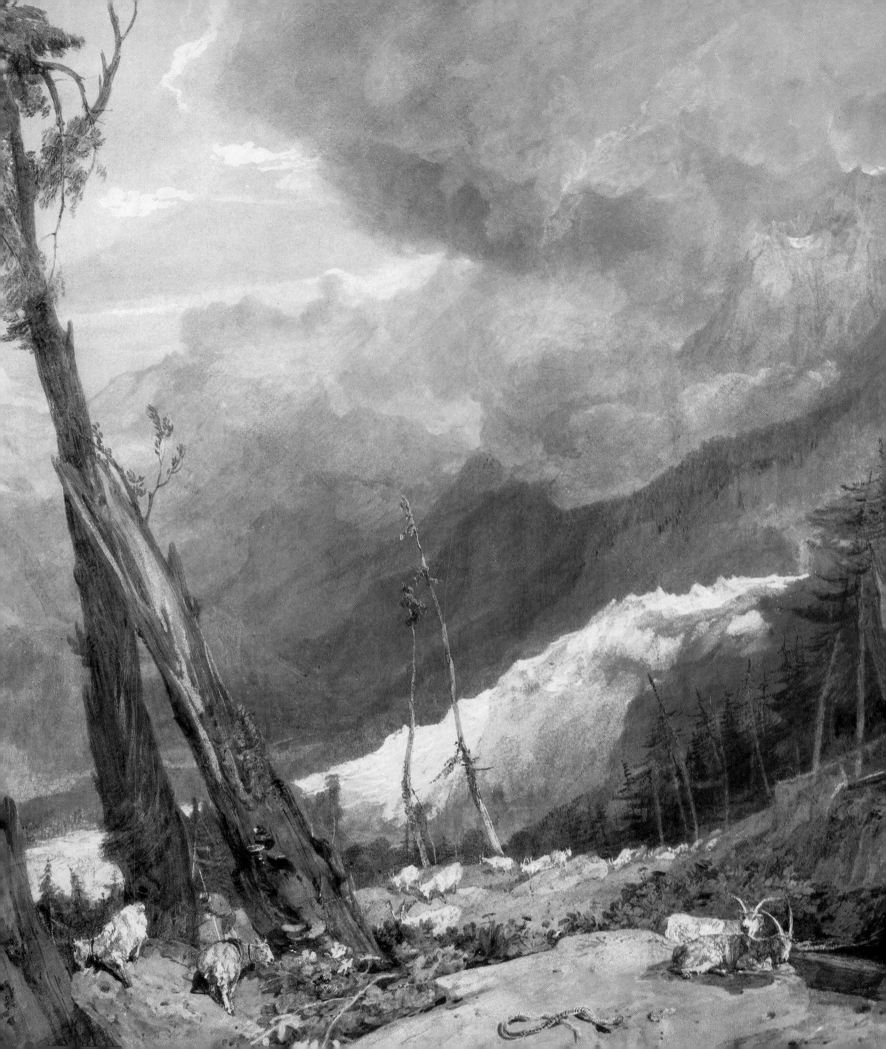

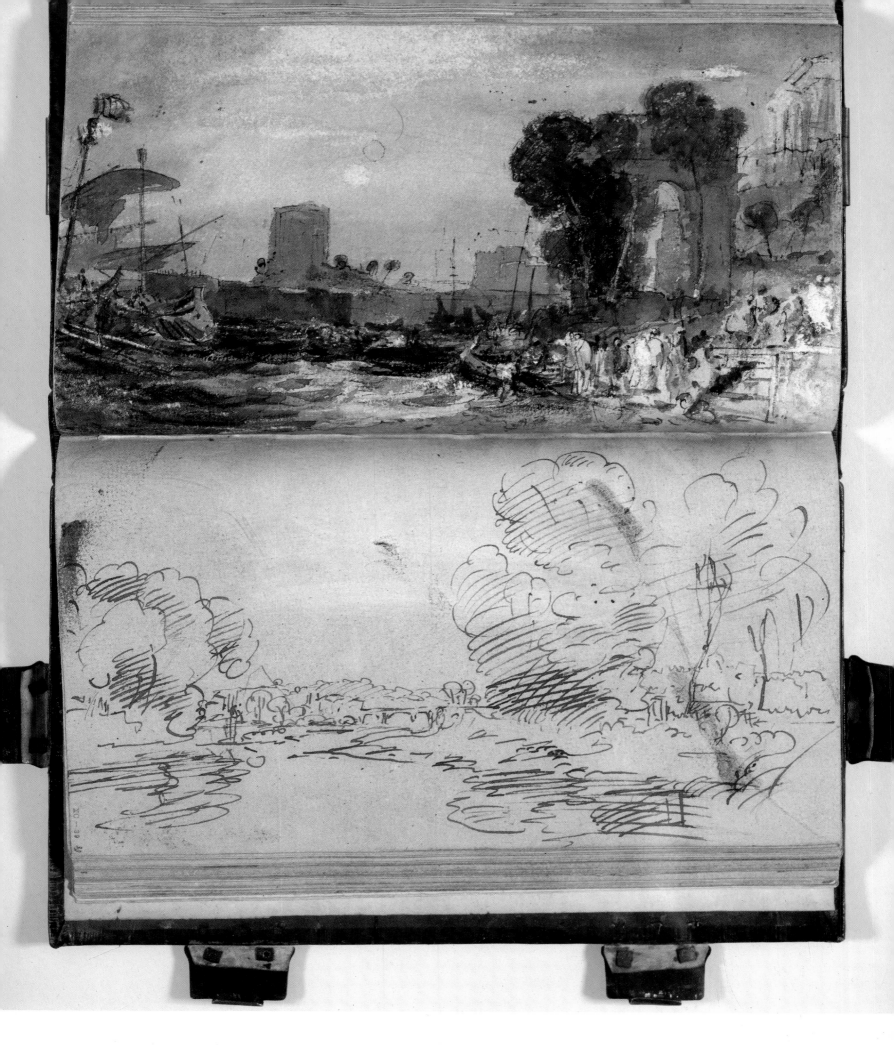

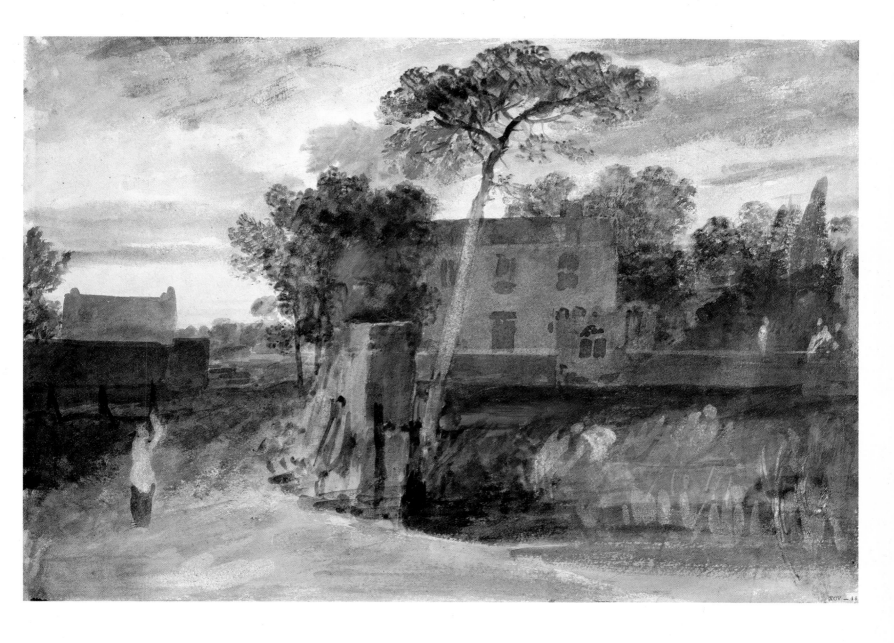

Thames sketches

After his move to Sion Ferry House at Isleworth in 1804–5 Turner made many sketching trips along the Thames and its tributary the Wey, noting details of the landscape and more general compositional effects. Even his most apparently informal notes, like the quick jottings in pen and ink in his *Studies for Pictures; Isleworth* sketchbook, seem to contain within them the possibilities of more elaborate and grandiose schemes. Such inventions are often counterposed on adjoining leaves (71), giving an insight into the way Turner's imagination transmuted nature into art as he worked.

If he could think of Claude while drawing at Windsor or Kew, he could equally infuse the spirit of Poussin into the fresh watercolour studies he made in the *Thames from Reading to Walton* sketchbook. This dignified design (72) may be a view along the lane between Isleworth village and the estate of the Duke of Northumberland at Syon, close to Sion Ferry House itself.

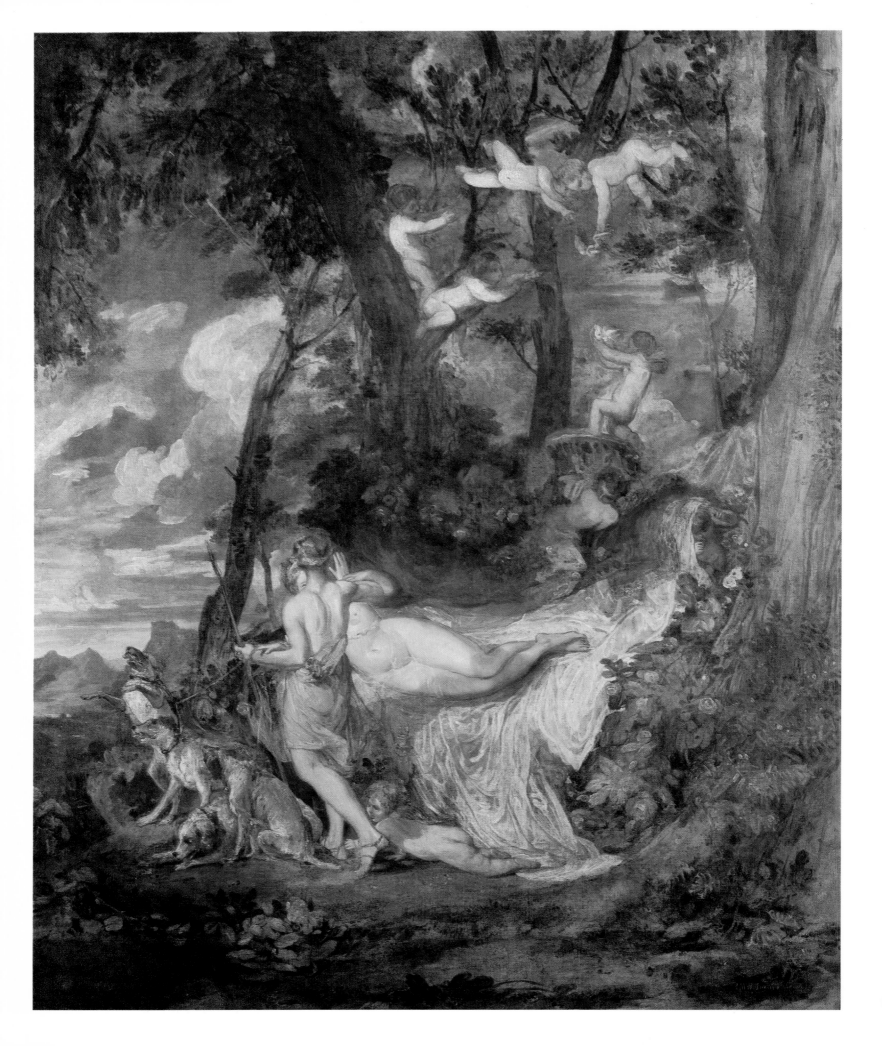

NOTHING BETTER ILLUSTRATES the awkward balance of Turner's professional feeling on the one hand, and his instinct for privacy and isolation on the other, than his attitude to the Academy in the years immediately after his election as Academician on 12 February 1802. It was a consummation he had devoutly wished. He marked it by painting, over the next few years, a series of particularly splendid canvases celebrating the achievements of the old masters to whom Reynolds in his Discourses had pointed as the proper models for serious artists; and he threw himself, with all his new-found confidence, assiduously into the administrative responsibilities of the Academy's Council, of which he became a member for a statutory two-year period at the start of 1803.

This was a time of much dissension and unpleasantness between the Academicians, who had become divided into two distinct factions on the issue of Royal intervention in Academy affairs. Hitherto Benjamin West, who had been President since the death of Reynolds in 1792, had enjoyed much favour from the King; but he was not a great man. His small-mindedness and disingenuous self-seeking had lost him much of the respect of his colleagues. Several members were anxious to drive a wedge between him and the Court, and so engineer his removal from office. In 1803 they achieved a majority on the Council, and having done so tried to increase its power by establishing, contrary to the provision of the Foundation Charter, that its decisions needed no ratification from the General Assembly of the Academicians. Turner, like most of his colleagues, supported West for the sake of peace and the benefit of the Academy as a whole; but the acrimonious atmosphere inevitably affected him. By May 1804 he too had had arguments with one or another of his colleagues, even with men of his own party. For the rest of that year he did not attend the Council meetings.

These quarrels may have had some bearing on the development of which Farington learned on 22 March, from James Ward: 'it was said Turner wd. not exhibit, but was painting pictures to furnish a Gallery 60 feet long in His own House where he means to make an Exhibition and receive money.' On 19 April, Farington says, 'Turner told me this evening that He shd. be glad to see me at his House having opened a Gallery of pictures 70 feet long & 20 wide.' This was at 64 Harley Street, where he was now consolidating his professional position in a most decisive way. He had moved out of Harley Street briefly: his address was given in the 1801 Academy catalogue as 75 Norton Street [now Bolsover Street], Portland Row. This was a house which he had taken jointly with a certain Roch Jaubert, a close friend of the Danby family who in 1798 had published on Sarah's behalf a volume of her recently deceased husband's glees. The house was very near her lodgings in Upper John Street, and Turner was later to install her in it. But the demands of art were stronger than mere personal ties, and he quickly re-established himself at his old Harley Street address, fitting out his gallery on the first floor. It was not uncommon for painters to hire rooms for the display of important new pictures, and the most successful of them, like Benjamin West, sometimes had their own galleries. But Turner's

OPPOSITE

73 *Venus and Adonis (Adonis departing for the Chase)*. This canvas may have appeared at Turner's Gallery when it opened in 1804. Of all the imitations of the old masters that he executed at that time this is the closest to pastiche, displaying as it does the strong influence of Titian's *Death of St Peter Martyr* (83), with perhaps a reminiscence of the Rococo nudes of Boucher.

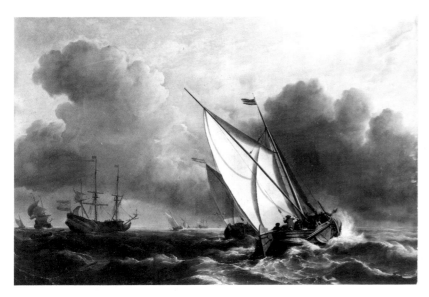

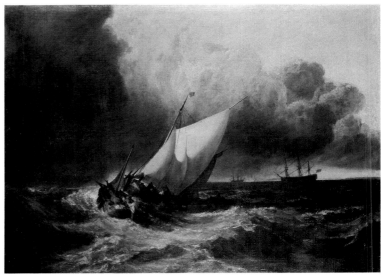

74 Willem van de Velde the younger: *A rising Gale*. The picture for which the Duke of Bridgewater asked Turner to provide a pendant.

75 The 'Bridgewater Sea-piece': *Dutch boats in a gale: fishermen endeavouring to put their fish on board*, oil, 1801.

gesture in opening a room large enough to hold some two or three dozen works, and his plan to include, as shortly became apparent, watercolours and drawings as well as oil paintings, was an extraordinarily bold move for a man still under thirty.

In his efforts to fill this new room, he was felt to have withheld his usual gamut of submissions from the Academy's own annual show: West told Farington on 10 April 1804 that 'Turner He thinks, only exhibits this year to keep his name in the list of those who do, as His pictures are inferior to His former productions'. Indeed, he sent nothing to compare in grandeur with the series of large canvases that he had been submitting since the beginning of the decade.

In 1801 his output of marines reached a first climax with *Dutch boats in a gale:* 75 *fishermen endeavouring to put their fish on board*, which he painted in response to a commission from the Duke of Bridgewater. The brief was to supply a pendant to a large Van de Velde in the Duke's collection. Turner succeeded in evoking 74 the Dutch master while producing the most original sea-piece ever painted by an Englishman to that date. It was the first of his pictures to impress the young John Constable, still unknown to the world, though encouraged by Farington. 77 'Constable called,' Farington wrote on 29 April, 'has been to the Exhibition and

76 The 'Egremont Sea-piece': *Ships bearing up for anchorage*, oil, 1802.

thinks highly of Turners picture of Dutch boats but says he knows the picture by W. Vandevelde on which it is formed.' It made a great impression on the connoisseurs. One of the most critical, as well as the most influential, was Constable's patron Sir George Beaumont, who according to Farington 'thinks very highly of Turners "Fishing boats in a gale of wind". – Some noble amateurs said it was taken from a picture of Backhuysen. – Sir George thinks sky too heavy and water rather inclined to brown' (Farington, 26 April). But if Turner's model was a Dutch shipping painter, it was of a more august name that the senior Academicians were reminded. On 18 April, Farington reported that 'West has spoken in the highest manner of a picture in the Exhibition by Turner, that it is what Rembrandt thought of but could not do.' And Fuseli likewise, on the 25th, 'spoke in the highest manner of Turners picture of "Dutch boats in a Gale" in the Exhibition as being the best picture there, quite Rembrantish. – the figures also very clever.'

In 1802, the two marines that Turner submitted were markedly contrasted. *Fishermen upon a lee-shore, in squally weather* pursued themes he had already
76 broached; but *Ships bearing up for anchorage* was an exquisitely composed and harmonized work which demonstrates that Turner's gifts, even within the bounds of sea-painting, were as much for the abstract and contemplative as for the sublime and dramatic. The canvas was bought at the exhibition by George
214 O'Brien Wyndham, third Earl of Egremont, an enthusiastic and discriminating collector of contemporary British art. It was the auspicious beginning of an important and fruitful relationship.

65 Turner submitted an equally ambitious history subject this year: *The tenth plague of Egypt*, which with its powerfully articulated design and atmosphere of brooding menace – 'Forests, cities, and storms . . . combined to excite the idea of grandeur', as the June *Monthly Mirror* put it – tellingly measures the strides his work had taken since the smaller and more compactly organized *Fifth plague of Egypt* of 1800. It acknowledges a debt to the classicism of Poussin with the proudest of Romantic nods; while *Jason*, also shown in 1802, disposes in one shadowy, suspenseful image of the rivalry of Salvator Rosa.

There were also some large watercolours, more elaborate than any he had previously designed, recording subjects gathered the year before on a visit to Scotland. This was the culmination of his tours round Britain, a logical sequel to the studies he had made in Wales and the north of England. He had planned to leave London on 20 June 1801, as he told Farington the day before, in the company of a Mr Smith of Gower Street. But on the 20th, Farington noted, 'Turner called, complained of imbecility [i.e. debility], on which acct. I advised him to postpone his journey a day or two. – I gave him directions to many objects in Scotland.' He eventually reached Edinburgh early in July, though we do not know whether Mr Smith went with him. He seems to have been pleased with his tour. He used several sketchbooks; one of them, which he labelled '39. Scotland', but which is now known as the *Scotch Lakes* book and records a circuit of the Highlands, has a note inside the cover: '18 of July left Edinburgh and on the 5 of August finish'd this book at Gretna Green'. He had been to Loch Lomond, Loch Awe, Loch Tay, up to Rannoch and Tummel Bridge, and south again through Killiekrankie, Dunkeld and Stirling. He had made sixty large drawings on separate sheets, and filled two sketchbooks; the whole tour, which included at least a week in Edinburgh and some time in the Border country, resulted in eight books of invaluable notes. He was justifiably proud of what he had achieved in the time, and was glad to show the work he had produced on tour to his London colleagues. Farington had himself been in Scotland this autumn and did not return until the end of January 1802, so it was not until 6 February that he heard about Turner's trip.

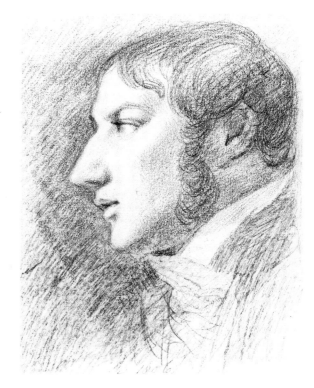

77 John Constable: *Self-portrait*, 1806. Constable, born a year later than Turner, was also a protégé of Farington by the end of the 1790s but did not meet Turner until 1813. He was sometimes critical of Turner's work, and once referred irritably to his 'liber stupidorum', but in the end could not help admiring. He praised Turner's submissions to the exhibition of 1826 (see ills. 179, 180) and in 1836 he was to remark, 'Turner has outdone himself – he seems to paint with tinted steam, so evanescent, and so airy. The public thinks he is laughing at them, and so they laugh at him in return' (*Constable*, p. 254).

78

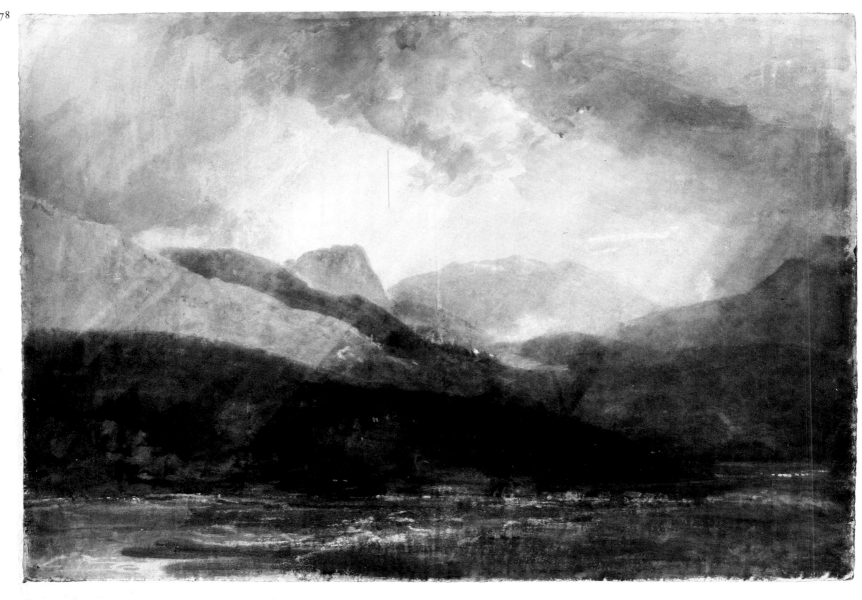

79

80

Scotland 1801

Several different kinds of drawing resulted from Turner's tour in the summer of 1801. He kept carefully segregated series of notes, of particular landscapes (81), of compositions, and of figures (79), in different books. He produced a set of larger, monochrome drawings in pencil – *Killiekrankie* (80) is one of these elaborate technical exercises – and made a few large colour studies, like the brooding view of mountains near Blair Atholl (78), derived from a pencil note in the *Scotch Lakes* sketchbook, in preparation for the full-scale finished watercolours he planned for exhibition at the Academy. At least three of these appeared there in 1803, and in 1804 he showed *Edinburgh, from Caulton-hill* (82), based on a pencil drawing in the *Smaller Fonthill* sketchbook.

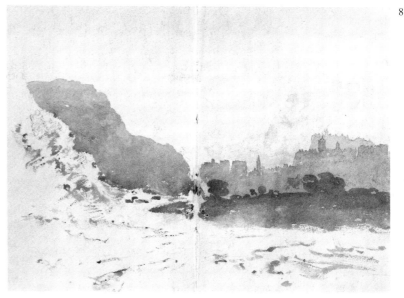

81

82

Turner I drank tea with. He shewed me his sketches made in Scotland. – Those made with Black Lead Pencil on white paper tinted with India Ink 80 and Tobacco water and touched with liquid white of his own preparing, are much approved. – Turner thinks Scotland a more picturesque country to study in than Wales. the lines of the mountains are finer, and the rocks of larger masses.

If history had not provided him with the opportunity to visit the Alps at this juncture, it is tempting to believe that he would nevertheless have found the means to go. In making the journey abroad, during the uneasy peace of Amiens signed between Britain and France on 27 March 1802, he followed the example of scores of brother artists, many of them from the Academy. But his very itinerary reflected the ambiguity of his relations with his colleagues. Working alongside them in the Louvre he underlined his sense of community with them, studying the paintings of Titian, Poussin, Correggio and Domenichino with an analytical fervour second to none. But in going off among the Swiss mountains on a long tour (this preceded his stay in Paris), he asserted his individuality, exploring scenery that few English artists had yet tackled, and storing up 64, subject-matter that was to transform landscape painting in the next decade. 68–70 Arrived in Paris, he met Farington in the Louvre on 30 September and outlined his impressions:

> I went to the Picture Gallery & saw Turner who returned from Switzerland two or three days ago. He found that Country in a very troubled state, but the people well inclined to the English. – Grenoble is abt. a day's journey beyond Lyons; in its vicinity there are very fine Scenes. – It took him four days to go from Paris to Lyons. The lines of the Landscape features in Switzerland rather broken, but there are very *fine parts*.

Next day, 1 October, Farington heard more details:

> Turner called. He was three days at Lyons. He thinks little of the River Rhone at that place; but the views of the Saone are fine. The buildings of Lyons are better than those of Edinburgh, but there is nothing so good as Edinburgh Castle.
>
> The Grand Chartreuse is fine; – so is Grindewald in Switzerland. The trees in Switzerland are bad for a painter, – fragments and precipices very romantic, and strikingly grand. The Country on the whole surpasses Wales; and Scotland too, though Ben [Arthur?] may vie with it. The Country to Lyons very bad, – and to Strasbourgh worse.
>
> The Great fall at Schaffhausen is 80 feet, – the width of the fall about four times and a half greater than its depth. The rocks above the fall are inferior to those above the fall of the Clyde, but the fall itself is much finer.
>
> He found the Wines of France and of Switzerland too acid for his Constitution being bilious. He underwent much fatigue from walking, and often experienced bad living & lodgings. The weather was very fine. He saw very fine Thunder Storms among the Mountains.

The two men met again in London on 22 November, when Farington took tea at Turner's with William Daniell:

> He shewed us his sketches made in France and in Switzerland, – viz: at Lyons, Grenoble, Defile of the Grand & Petit Chartreuse, abt. 9 miles long, abounding with romantic matter, – Grenoble two days journey from Lyons, also sketches at Schaffhausen, – in Chamonix, – of Mont Blanc &c. – of Aost, – St. Bernard &c. – was within a days journey of Turin, – repents

not having gone. Road & accomodations over St. Bernard very bad, afterwards very well. – Lyons very dear, 8 livres for a bed. – At Grenoble reasonable. – Bought a Cabriole at Paris for 32 guineas, & brot. it back there to dispose of, – well accomodated in it. – Walnut trees in Switzerland &c very fine. N. Poussin studied from them. – Houses in Switzerland bad forms, – tiles abominable red colour. – Lyons very fine matter, but did little there, place not settled enough. – Most of sketches slight on the spot, but touched up since many of them with *liquid white*, & black chalk.

Turner added a few comments the next day:

> He said that the expenses of living might be averaged while on their Tour at 7 Shillings a day – *all* their expenses *except* travelling at half a guinea a day. – They had a Swiss servant from Paris who they paid 5 livres a day & He bore his own expenses. – It is necessary to make bargains for everything everywhere, or imposition will be the consequence.

We do not know for certain who Turner's travelling companions were. The referee for his passport was a gentleman of County Durham, Newby Lowson, who may well have made the relatively luxurious arrangements for travelling on the Continent. Certainly it is hard to imagine Turner putting himself to the expense of a private carriage and servant: his later tours were undertaken on much more spartan principles. Lowson was an amateur artist, perhaps a pupil of Turner's. We are told that 'Turner suffered his company only on condition that he never sketched any view he himself chose. Turner did not show his companion a single sketch' (T., 1, p. 223).

The sketches were the very life-blood of his art. In them he concentrated everything that he experienced, distilled all that nature could offer the painter. The pages of his Swiss sketchbooks are paintings in plan, studies already more than half transformed into finished works. The book that he used in the Louvre contains plans of other men's pictures, diagrams of their colour schemes, notes on their chiaroscuro, their landscape effects, their emotional force. His own preoccupations were most strikingly echoed by the combination of landscape
83 with history in Titian's *Death of St Peter Martyr*, taken by Napoleon from SS. Giovanni e Paolo in Venice:

> This picture is an instance of his great power as to conception and sublimity of intelect – the characters are finely contrived, the composition is beyond all system, the landscape tho natural is heroic, the figure wonderfully expressive of surprize and its concomitate fear. The sanguinary assassin striding over the prostrate martyr who with uplifted arm exults in being acknowledged by heaven. The affrighted Saint has a dignity even in his fear . . . Surely the sublimity of the whole lies in the simplicity of the parts and not in the historical color which moderates sublimity in some pictures where the subject and *Nature* must accord . . . (TB LXXII, f. 28)

Having made a watercolour copy of Titian's *Entombment*, and judged that it 'may be ranked among the first of Titian's pictures as to colour and pathos of
84 effect' (TB LXXII, f. 31), he went on to analyse his *Christ crowned with Thorns*:

> This picture is wholly different as to effect the most power full is the flesh·the drapery consists only to extend the Light upon the Soldier to the right and by being yellow keep up warmth and mellows the flesh of Christ which is the Soul of the piece shrinking under the force of the Brutal Soldier with filial resignation yet with dignity he appears to bear th[e]ir insults while the position of the Legs indicates excesive pain and exertion to sustain it – This

83 After Titian: *The Death of St Peter Martyr*. The original altarpiece, painted in 1528–30, had an arched top. It was destroyed by fire in 1867.

84 Titian: *Christ crowned with Thorns*, c.1540.

85 Poussin: *The Deluge*, 'Winter' from a set of the Seasons painted for the Duc de Richelieu between 1660 and 1664.

86 Pierre Narcisse Guérin: *Le Retour de Marcus Sextus*, 1799.

87 A page from the *Studies in the Louvre* sketchbook, with Turner's copy of the central group in Guérin's picture (86).

on a Greeny Brown Ground Spanish Brown and Umber. The flesh is thicker than the Entombing but the same process. the Crimson drap[er]y is only a wash (VR) – the g[r]een d[rapery?] is thicker but Brown over it and the figure in Mail in Black with lights this figure keeps the Picture from being monotonously Brown . . . (TB LXXII, f. 51)

He was also fascinated by the Louvre's Poussins, notably the *Deluge* subject that 85 illustrates Winter in the set of Four Seasons; though he evidently felt himself entitled to be critical as well as appreciative of a fellow landscape painter:

The colour of this picture impresses the subject more than the incidents, which are by no means fortunate either to place, position or colour, as they are separate spots untoned by the dark colour that pervades the whole. The lines are defective as to the conception of a swamp'd world and the fountains of the deep being broken up. The boat on the waterfall is ill-judged and misapplied for the figures are placed at the wrong end to give the idea of falling. The other boat makes a parallel with the base of the picture, and the woman giving the child is unworthy the mind of Poussin she is as unconcerned as the man floating with a small piece of board. . . . Whatever might have been said of the picture by Rousseau never can efface its absurdity as to forms and the introduction of the figures, but the colour is sublime. It is natural – is what a creative mind must be imprest with by sympathy and horror. The pale luminary may be taken for the moon from its size & colour – but the colouring of the figures denies it, and the half light on the rock, &c., oppose the idea of its being the sun. Upon the whole the picture would have been as well without it, altho a beautiful idea – but by being so neutral becomes of no value. (TB LXXII, ff. 41–2)

Needless to say, the impact of these carefully studied masterpieces is very evident in the works that he sent to the Academy in 1803. The group was dominated by two typically contrasted compositions, both on a large scale: *Calais Pier* and *The festival upon the opening of the vintage at Macon*. Each was an 89, 66 epoch-making essay in the style of one of the old masters, Ruysdael and Claude

respectively; though oddly enough he had made no notes on Claude in Paris.
88 There was also a *Holy Family* – a 'Rest on the Flight into Egypt' – which derived
from his contemplation of Titian, and perhaps owed something as well to
Reynolds's treatment of the same subject. Reynolds's pupil, the somewhat
cynical painter of history and portraits James Northcote, recognized the nature
of Turner's inspiration when he spoke to Farington about the exhibition on 2
May:

> Of Turner, Northcote said His pictures had produced more effect from
> their novelty than they were entitled to: that they were too much
> compounded of Art & had too little of Nature: that they consisted of parts
> gathered together from various works of eminent Masters.

The judgment ironically echoes Turner's own view of contemporary French
painting, as recorded by Farington in Paris on 4 October 1802: 'I looked
generally over the French Exhibition with Turner. He held it very low, – all
made *up of Art*: but He thought Madame Gerards little pictures very ingenious.'
(The only work by a living Frenchman that Turner is known to have copied is
86, 87 Guérin's *Retour de Marcus Sextus*.) Notwithstanding Northcote, *Calais Pier* and
Macon were both admired. Also on 2 May, Farington found that Opie
particularly liked the *Macon*: he

88 *Holy Family*, oil, 1803. Studies in the
Calais Pier sketchbook show that this
composition began as a derivation from
Titian's *Peter Martyr* (83); its upper half,
however, was eliminated and adapted for
Venus and Adonis (73).

89 *Calais Pier, with French poissards
preparing for sea: an English packet arriving*,
oil, 1803. A study for this subject in the
Calais Pier sketchbook (f.59) is annotated
'Our landing at Calais. Nearly swampt'.

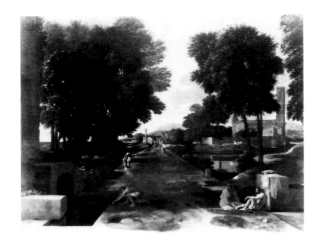

90 Poussin: *Landscape with a Roman Road*.

91 A sheet of compositional sketches, *c*.1802–3.

92 *Chateaux de St Michael, Bonneville, Savoy*, oil, 1803.

93 *Bonneville, Savoy, with Mont Blanc*, oil, 1803.

The two views of *Bonneville, Savoy* (92, 93) that Turner sent to the 1803 Academy seem to have been exercises in three-dimensional pictorial structure, worked out according to a scheme he had noted in a sequence of four rapid compositional sketches (91): the straight road of one had already appeared in his view of *Killiekrankie* (80) and is deliberately contrasted with the gentler recession of the curving river bank in the other. Poussin's *Landscape with a Roman Road* (90) evidently influenced Turner's deliberations. It was one of the superb group of Poussins assembled by Bourgeois and Desenfans; see ill. 95.

thought the large landscape very fine, perhaps the finest work in the room, – that is in which the Artist had obtained most of what he aimed at.

And Henry Fuseli, at this time Professor of Painting at the Academy, admitted his enthusiasm, though he was not uncritical:

> Fuseli commended both the 'Calais Harbour' and the large Landscape, thinking they shewed great power of mind, but perhaps the foregrounds too little attended to, – too undefined. – His Historical picture 'A Holy Family' He also thought appeared like the embrio, or blot of a great Master of colouring.

The criticism was reiterated the next day by Beaumont, who this year began to see Turner as symptomatic of a dangerous 'influenza' in modern art:

> Turner finishes his distances & middle distances upon a scale that requires *universal precission* throughout his pictures, – but his foregrounds are comparative *blots*, & faces of figures witht. a feature being expressed . . . The water in Turner's Sea Piece (Calais Harbour) like the veins on a marble Slab. – The subject of the large landscape borrowed from Claude but all the colouring forgotten.

The *Macon* was said to have been begun 'with size colour on an unprimed 66 canvas', as Claude himself was thought to have worked; 'when it was first painted it appeared of the most vivid greens and yellows' (Cunningham, p. 78).

Apart from the conspicuous large canvases, there were also two smaller works, pure landscapes, both views of Bonneville in Savoy, which at first glance strike one as too similar to have merited simultaneous showing at the Academy. But Turner seems to have designed them to exemplify contrasting methods of constructing pictorial space – a necessary exercise for the thoughtful landscape painter. One is a demonstration of gently serpentine recession from foreground 93 to middle distance, and all the forms in the picture complement that movement. The other is a more rigidly geometric structure, with recession defined by a 92 straight, empty road leading from the picture plane to the mountains in the background. The device was to recur in a significant number of Turner's compositions throughout his career, serving as a perpetual reminder of his debt to the intellectual rigour of Poussin. It was also the leading motif of a large 90 watercolour, *St Huges denouncing vengeance on the shepherd of Cormayer, in the valley of* 69 *d'Aoust*, which for the first time proclaimed Turner's intention of doing in watercolour what Poussin had done in oil. Farington as usual chronicled the responses of his colleagues. Constable was this year less favourably impressed: 'Turner becomes more and more extravagant and inattentive to nature. . . . His views in Switzerland fine subjects but treated in such a way that the objects appear as if made of some brittle material' (17 May). Most of the younger generation were on Turner's side, however: 'Philips, – Thomson. – Owen &c. – They all consider Turner's pictures as being of a very superior order, – & do not allow them to be in any extreme' (21 May).

In comparison with these challenging flights of intellect and imagination, his offering to the Academy in 1804 necessarily seemed slight. *Boats carrying out anchors and cables to Dutch men of war* was a relatively modest marine, and *Narcissus and Echo* an idyllic landscape of his usual subtlety, but of less than sensational interest. His own gallery opened in April this year, and it is not to be supposed that having embarked on a project so important to his professional reputation, he failed to assemble a fine group of works for its inauguration. The large *Macon* was probably there, for it had not been sold. Farington discovered something

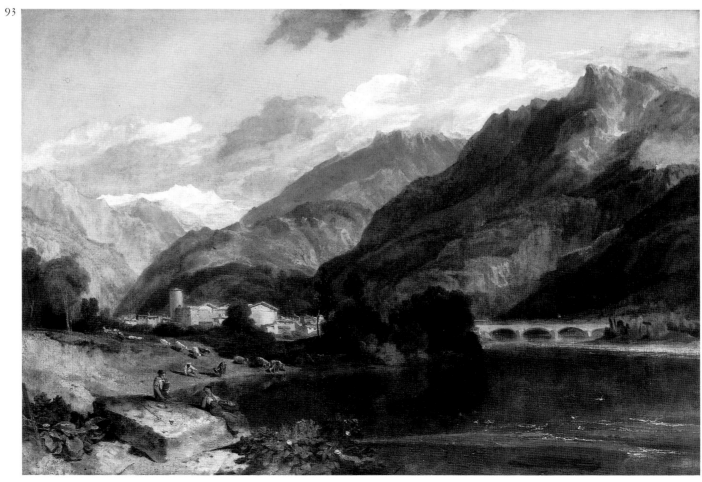

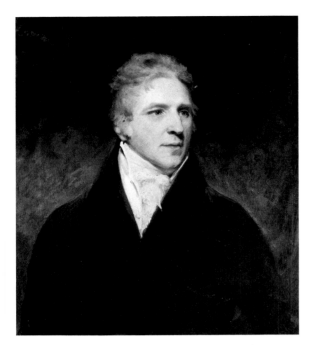

94 Sir George Beaumont by Hoppner.

about this from Henry Thomson on 22 May 1804: Sir John Fleming Leicester

was desirous of purchasing Turner's large landscape which was exhibited last year, & at that time offered 250 guineas for it. – Turner demanded 300. – This spring Sir John offered 300 for it but Turner now demanded *400 guineas* on which they parted. – Opie sd. to Thomson He did not see why Turner should not ask such prices as no other persons could paint such pictures.

Sir John Leicester, later Lord de Tabley, of Knutsford, Cheshire, built up a trail-blazing collection of modern British pictures at his London house, the first of its kind to be open to the public. He and Turner appear to have met in 1799; among his purchases from the artist during this decade were two views of his house, painted on a visit in 1808.

Now, however, *Macon* was bought by the Earl of Yarborough, justifying Opie's opinion, and, no doubt, confirming Turner in his hard-headedness. It seems likely that Lord Yarborough saw the picture in Turner's Gallery. We may assume that two imposing watercolours of Swiss subjects were also on view there: *The passage of Mount St Gothard* and *The great fall of the Riechenbach*; but beyond these surmises nothing is known of this historic exhibition. Like his works at the Academy, it drew the usual mixture of praise and blame. Beaumont, a power in the land when it came to aesthetic judgments, had already declared himself unsympathetic to Turner's work the previous year; now he visited the new gallery and reported back to Farington on 24 April: 'Sir George has been to Turner's Exhibition. He said Turner should not have shewn so many of his own pictures together. – He remarked on the strong skies & parts not corresponding with them.'

The Academicians knew that Turner was an exceptional figure amongst them; as Farington noted on 18 June 1804, Thomas Lawrence 'particularly dwelt upon His powers as being of an extraordinary kind' – but that perception did not prevent them from being highly critical. Hoppner, for instance, visited Turner's Gallery in May 1805 after having been to the Academy's show, and told Farington on the 11th: 'after having seen the delicate and careful works at the former Exhibition where so much attention to nature was shewn, Turner's room appeared like a *Green Stall*, so rank, crude & disordered were his pictures.' The same day Farington noted that 'West also spoke on Thursday evening of Turner's pictures. He said they were tending to imbecility. That His water was like stone . . .'

And the Academicians duly registered Turner's uncompromising business habits. Henry Edridge, a friend of Dr Monro's who specialized in small portraits and landscape watercolours, was discussing him with Farington on 17 July 1804. Edridge 'spoke of the narrowness of Turner's mind and said C. Long had mentioned that after the Marquis of Stafford had pd. him £250 guineas [*sic*] for "the Fishing boats" He afterwards applied several times to have 20 guineas for the frame, but it was not paid him.'

The frequency with which Turner's name crops up in conversations recorded by Farington about this time is proof enough of the impression he made, and newspaper reports, of course, gave due recognition to the great canvases he was producing. It is not surprising that his colleagues exerted themselves to find fault, and that in itself may have been one of the reasons why Turner provided himself with the option of exhibiting at a distance from them. His quarrel with Farington at a Council meeting on 11 May 1804 no doubt encouraged absence. Farington's account is as follows:

On our return to the Council we found Turner who was not there when we retired. He had taken *my Chair* & began instantly with a very angry countenance to call us to acct. for having left the Council, on which moved

by his presumption I replied to Him sharply & told him of the impropriety of his addressing us in such a manner, to which He answered in such a way, that I added His Conduct as to behaviour had been cause of Complaint to the whole Academy.

95 He had already been involved in an argument with the genre painter and landscapist Sir Francis Bourgeois, recounted to Farington by William Daniell after a Council meeting on Christmas Eve 1803: Bourgeois

had said that when Premiums for Architecture & for *Models* were to be adjudged He attended to the opinions of those who were more conversant in these respective studies, Turner hinted that [it] might be well that He shd. in what related to *the figure*, signifying His *incompetency*. This caused Bourgeois to call him a *little Reptile*, which the other replied to by calling Him a *Great Reptile* with *ill manners*.

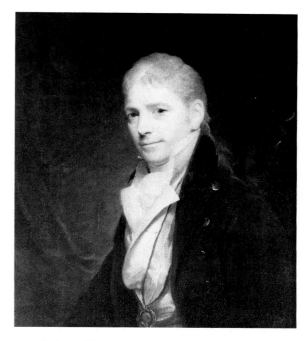

95 Sir Peter Francis Bourgeois by Sir William Beechey, *c.*1810. Bourgeois is shown wearing the Order of Merit conferred on him by King Stanislas II of Poland who appointed him court painter in 1791. It was this honour that George III confirmed as a knighthood. With Noel Desenfans, a picture-dealer, Bourgeois assembled for Stanislas the fine collection of paintings by old masters which eventually became the Dulwich Gallery.

It is a far cry from the deferential twenty-four-year-old who was looking for votes in 1799. Turner was evidently at least partly to blame in exacerbating what was only a natural professional jealousy. Even while *Calais Pier* and *Macon* were exciting general attention at the 1803 exhibition, Farington mentioned on 30 April that 'His *manners*, so presumptive & arrogant were spoken of with great disgust'. This behaviour was presumably largely defensive, the instinctive self-protection of someone who felt himself socially and physically inferior to his new colleagues. But there was a real, and not altogether ignoble, pride as well. Already in 1802, once elected an R.A., he had shed his humility: on being advised by Stothard to thank those Academicians who had voted for him 'he bluffly replied, that he "would do nothing of the kind. If they had not been satisfied with his pictures, they would not have elected him. Why, then, should he thank them? Why thank a man for performing a simple duty?"' (Watts, p. xvi). This again is expressive of his ambivalence. The Academy honours him; but he, conversely, bestows credit on the Academy by virtue of a genius of which he is perfectly aware. It is not so much the frank attitude that is hard to accept, as the youth of the man who thus, at the age of twenty-seven, places himself so confidently among his professional colleagues.

He made a further telling move in establishing his separateness from the body to which he had taken such pains to attach himself: he took a house out of London. He had, of course, excellent professional reasons for wishing to be close to the Thames; and it was natural enough for him to gravitate towards the reaches he must have known as a boy at Brentford. In 1804 or early 1805 he became a temporary tenant at Sion Ferry House, close to the church at Isleworth and on the very water's edge. The spot was almost the perfect embodiment of his aesthetic requirements: a group of village buildings clustered by the river, with its curving reaches, noble parkland bordering the water, and the Duke of Northumberland's shooting lodge in the form of a round and pillared classical 108 temple, 'The Alcove', providing a Claudian motif ready to hand among the English trees. His studies for pictures and longshore sketches alike at this time 72 reflect the magical intermingling of rustic and classic that he found here: a paradigm of his ambitions for landscape present to the eye. In the *Studies for* 71, 98 *Pictures; Isleworth* sketchbook (TB XC), which, significantly, records his address for us, the real and the ideal alternate on the pages as if contending for his attention. The modern Thames is peopled with Antique heroes in his teeming mind: 'Meeting of Pompey and Cornealia . . . Parting of Brutus and Portia . . . Cleopatra sailing down to . . .'; or 'Jason: arrival at Colchis Ulysses at Crusa . . . Females dancing and crowning the [?]ropes with flowers or the foreground Figures rejoicing the left – the Priests standing[?] attending to receive the

Fleece. Ulysses with Chryseis . . . offering her to her Father'. Or, on another train of ideas: 'Dido and Æneas. Nausicai going to . . . with the nuptial garments'; 'Latona and the Herdsmen . . . Phaeton's Sisters . . . Pan and Syrinx . . . Salamacis and Hermaphroditus'; or again, 'Pallas and Æneas departing from Evander . . . Return of the Argo' (TB XC, ff. 1, 49v, 52v, 55v, 59).

Even the freshly informal watercolours that he made along the river between Isleworth and Kew (TB XCV) are imbued with a Poussinesque dignity, a classic grandeur which signals his recognition of the achieved union of art and nature in his own domestic surroundings. Yet once again he strikes out simultaneously on a contrary tack: if he could render even the spontaneous watercolour sketch classical, he could paint in oil with the freedom from restraint of an outdoor sketcher. He took sizeable canvases, even wood panels, 96 in a small boat to work direct from nature – oil, as it were, on water. It was in these early years along the Thames at Isleworth and, from the end of 1806 until 1811, at Hammersmith, where he took a house at no.6 West End, Upper Mall, that Turner first got to know Henry Scott Trimmer, then living at Kew, but shortly to become Vicar of Heston, a village not far from Isleworth and close to Osterley Park. His son, F.E. Trimmer, provided Thornbury with numerous recollections. He remembered watching Turner start out on his boat on sketching expeditions, painting 'on a large canvas direct from nature'. He also testifies that

> Turner, when beginning his great classical subjects from the 'Æneid,' regretted his ignorance of Latin; my father undertook to teach him for instruction in painting in return. My father, who was accustomed to teaching, has told me Turner sadly floundered in the verbs, and never made any progress – in fact, he could not spare the time. (T., I, pp. 173–4)

For the Thames sketches, no less than the studies of classical subjects, were to be translated into finished works for exhibition. There are numerous Thames 97

96 *The Ford*, oil, *c.*1807. Turner's outdoor studies on the Thames and Wey fall into two categories: those on large canvases of about 1806, sometimes related to finished or abandoned pictures, and those on mahogany-veneered panels, which may date from somewhat later. *The Ford* is typical of the series on mahogany in its fresh, sparkling paint applied in the manner of watercolour. It looks forward to the explicit description of the Devon studies of 1813 (125).

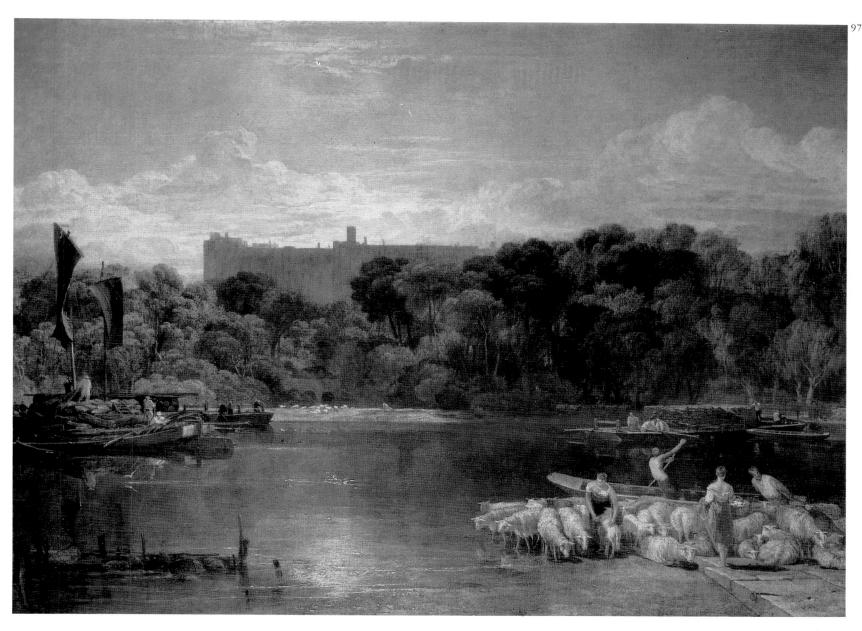

Windsor Castle from the Thames (97) was shown at Turner's own gallery, probably in 1805. It was based on a design in the *Studies for Pictures; Isleworth* sketchbook (98). He did not permit sketching in his gallery, but Thomas Rowlandson was evidently so impressed by this picture that he wished to recall its main features, and sketched it from memory (99). It is interesting that the satirist looked at Turner with such attention, and that he remembered the composition as considerably more orthodox than it actually is.

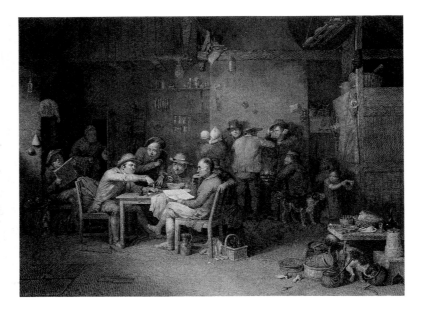

100 David Wilkie: *Self-portrait* (detail), 1805.

101 After David Wilkie: *Village Politicians*, 1806, engraved by Abraham Raimbach, 1814.

subjects among the completed works of the first decade of the century: *Windsor* 97 *Castle from the Thames* appeared at his gallery in about 1805, and two views of Walton Bridges probably in the following years. There were also *The Thames near Windsor*, *The Thames at Eton*, *Newark Abbey on the Wey* and a *View of Richmond Hill and Bridge*. In 1809 *Ploughing up Turnips, near Slough* embodied a new integration of rustic genre with landscape which is a significant development of this decade.

The expansion of Turner's sketching practice into these new channels coincided, not altogether coincidentally, with the exploration of new subject-matter in his finished works. His first interior genre scene in oils, for instance, appeared at the Academy in 1807; it was called *A country blacksmith disputing upon* 102 *the price of iron, and the price charged to the butcher for shoeing his poney*, an allusion perhaps to recent Parliamentary debate on the Pig Iron Duty Bill, and, like the subject-matter itself, a reference to a work that had caused a sensation in the previous year's exhibition, the twenty-one-year-old David Wilkie's *Village* 100 *Politicians*. An even more uncharacteristic subject appeared in 1808: *The unpaid* 101 *bill, or the Dentist reproving his son's prodigality*, in which rusticity is replaced by 103 bourgeois respectability. Both works owe much to Turner's instinct to imitate and improve on the work of his contemporaries, to his sense of the challenge implied by anything that he valued or admired.

But he was pursuing a new idea at this period, one which gave him a fresh incentive to demonstrate his range and originality. Hardly had he achieved his Academicianship and opened his own gallery, when he confronted himself with a test that demanded the most of him both technically and creatively. His friend William Frederick Wells seems to have had a considerable part in persuading him to embark on the scheme, but it is one that embodies so perfectly Turner's own grandiose notions that we may surely be forgiven if we believe that he himself first conceived it. Wells's daughter Clara recalled the birth of the *Liber* 107– *Studiorum* in a letter of 1853:
111

The world are almost as much indebted to my father as to Turner for the exquisite Liber Studiorum, for without him I am sure it never would have existed – he was constantly urging Turner to undertake a work on the plan of [Claude's] Liber Veritatis. I remember over and over again hearing him 106 say – 'For your own credits sake Turner you ought to give a work to the public which will do you justice – if after your death any work injurious to

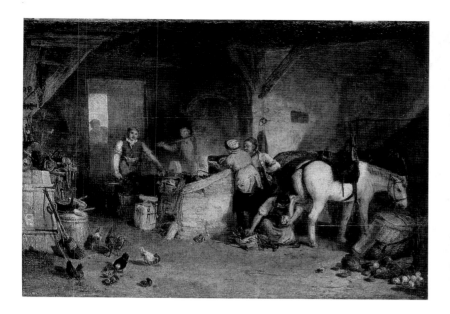

your fame should be executed, it then could be compared with the one you yourself gave to the public.' Turner placed implicit confidence in my father's judgement, but he required much and continued spurring before he could be urged to undertake Liber Studiorum. At last, after he had been well goaded, one morning, half in a pet he said, 'Zounds, Gaffer, there will be no peace with you till I begin, (he was then staying with us at Knockholt) – well, give me a sheet of paper there, rule the size for me, tell me what subject I shall take' – my father arranged the subjects, Pastoral, Architectural, &c., &c., as they now stand, and before he left us the first five subjects which form the first number were completed and arranged for publication greatly to my dear father's delight. This was in the October of 1806. (T., II, p. 55).

The rapidity with which the first designs were produced was typical of Turner's expedition. But it hints at a certain disingenuousness on his part: the plan to publish his work in an expansive programme of a hundred subjects that would 'do him justice' was so very much what he must have desired in the way of promotion that he may well have felt that it behoved him to affect a little indifference, or at any rate reluctance to begin. Whether the details were really Wells's invention we cannot know; it is likely that Turner had already rehearsed some of his own ideas with him before allowing himself to be 'won round' to the scheme. For it was to be more than the advertisement of his own powers which Wells apparently intended: by dividing the subjects into landscape types Turner supplied a manual for every young artist to learn from: his 'Book of Studies' was in fact just that: a complete education in landscape design. The young watercolourist David Cox noticed its appearance, as his biographer later recorded: 'With respect to the LIBER STUDIORUM Cox related that Turner hung up a prospectus of that work in his rooms on first opening an exhibition of his works, also a frame containing the drawings in sepia for the first proposed number' (Solly, p. 27). The prospectus is lost, but the *Review of Publications in Art* for June 1808 (after two issues of the *Liber* had already appeared) mentions

Proposals for the publishing one hundred Landscapes, to be designed and etched by J.M.W. Turner, R.A., and engraved in Mezzotinto. It is intended in this publication to attempt a description of the various styles of landscape, viz., the historic, mountainous, pastoral, marine, and architectural.

102 *A country blacksmith disputing upon the price of iron, and the price charged to the butcher for shoeing his poney*, oil, 1807.

103 *The unpaid bill, or the Dentist reproving his son's prodigality*, oil, 1808.

104 Charles Turner: *Self-portrait*, 1850.

The choice of medium, mezzotint, also chimes in well with the train of Turner's thought at this time. His great sea-piece, the *Shipwreck* of 1805, had just been engraved in mezzotint by Charles Turner, an old colleague from the Academy Schools who was no relation but who had paid the work the compliment of asking to engrave and publish it himself. The picture had been bought by Sir John Leicester, and both Turners must have known that a print of it would be a commercial success. It was the painter's first work in oil to be engraved – a significant step in the progress of his career. The prospectus for the plate was issued almost at once:

105

104

Proposals for publishing by subscription,
with permission of Sir John Leicester, Bart.,
a print of that celebrated picture of
A SHIPWRECK
WITH BOAT ENDEAVOURING TO SAVE THE CREW
BY J. M. W. TURNER, ESQ., R.A.

To be seen at his Gallery, No. 64 Harley Street, until July 1, 1805; and after at No. 50 Warren Street, Fitzroy Square. To be engraved in mezzotinto by C. Turner. Size of plate will be 33 inches by 23½ inches. Prints, £2.2s.; proofs, £4.4s. Those in colours to be under the direction of the artist. Half of the money to be paid on subscribing, and the other half on delivery, which will be in December next, 1805.

C. Turner has the pleasure to inform his friends, as it will be the first engraving ever presented to the public from any of Mr. W. Turner's pictures, the print will be finished in a superior style; and, as only fifty proofs will be taken, gentlemen desirous of fine impressions are requested to be early in their application, as they will be delivered in order as subscribed for. Subscriptions received by the engraver, No. 50 Warren Street, Fitzroy Square.

The subscription list was flattering: many of Turner's patrons, aristocratic and gentle, applied, as did several artists of the younger generation. In the event the plate did not appear until January 1807; so that the history of its publication was reaching a climax just when the *Liber Studiorum* project was being formulated. The coincidence is too great for us to credit Clara Wells's affectionate recollection of her father's crucial role: the *Liber Studiorum* was an integral part of Turner's own grand scheme for the advancement of his career and, vital corollary, the status of landscape painting in England.

It was only gradually that the *Liber* came to resemble so closely the edition of Claude's *Liber Veritatis* which Boydell had published with mezzotint plates by Earlom in the 1770s. Turner's first idea was to have the *Liber* engraved in aquatint, as so many collections of drawings and watercolours had been in the last twenty years. He planned to etch the outlines of the subjects himself, and F. C. Lewis, who had recently engraved a plate of the Brocklesby Mausoleum for him, was to put in the aquatint at a rate of five guineas a plate. Finding himself pressed, Turner asked Lewis to take over the etching of the outlines himself, or dispense with them altogether. Lewis wanted to retain the etching, but demanded a further three guineas for executing it. Turner would not hear of any increase in the rate, despite the addition to Lewis's work, and the two men parted:

106

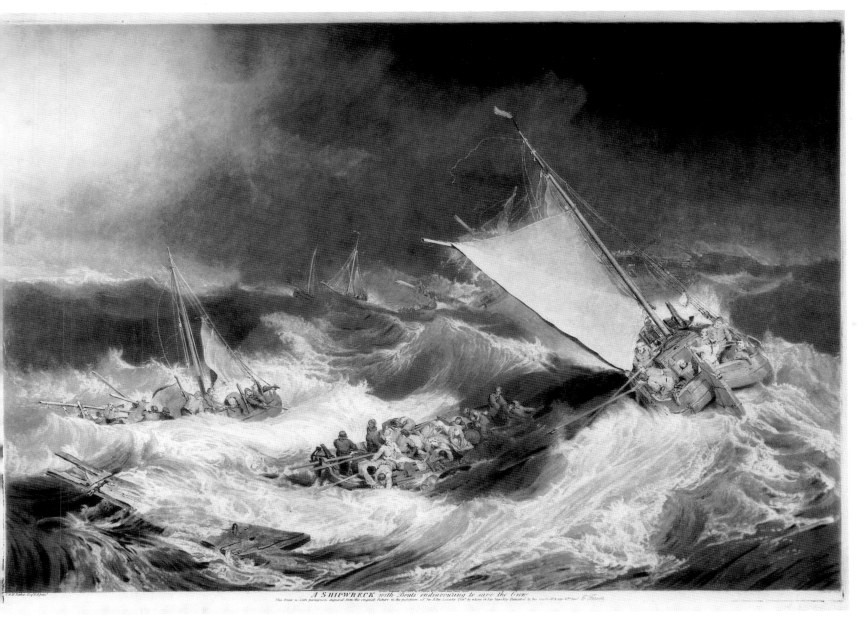

A SHIPWRECK with Boats endeavouring to save the Crew
This Print is with permission, engraved from the original Picture in the possession of Sir John Leicester Bart. to whom it is humbly Dedicated by his most Obt & humble Servt C. Turner

105 Charles Turner after J. M. W. Turner: *A Shipwreck*, mezzotint, 1807.

Sir

I received the Proof and Drawing – the Proof I like very well but do not think the grain is so fine as those you shewed me for Mr Chamberlain – the effect of the Drawing is well preserved, but as you wish to raise the Price to eight guineas I must decline having the other Drawing engraved therefore send it when you send the plate, when they have arrived safe, the five guineas shall be left in Salsbury St where you'll be so good as to leave a recept for same.

Yours,
J. M. W. Turner

14 Dec. 1807,
Hammersmith (G. 21)

It is an episode that preludes many similar ones punctuating Turner's relations with his engravers. Charles Turner, too, after having completed twenty plates in the medium of mezzotint on which Turner finally settled, fell out with him over an increase, modest enough, in his fee, from eight to ten guineas a plate.

106

The Liber Studiorum

Both in his title and in the technique on which he finally settled for the plates, Turner acknowledged his debt to Claude's *Liber Veritatis* as it had been engraved by Richard Earlom in the 1770s (106). Turner prepared each subject in a pen and wash drawing; the progress of the plates, from etched outline (often executed by Turner himself, 111) to completed mezzotint, can be traced in the many surviving proof impressions.

107 Progress proof, in etching with ink and wash, of the Frontispiece, published in 1812. The historical subject in the central cartouche is *The Rape of Europa*.

108 Design for *Isleworth*, published in 1819 as an 'Elevated Pastoral'. Executed in Claude's favourite drawing medium of brown wash, it shows Turner's own corner of Isleworth as a Claudian idyll with the Alcove in the foreground and the London Apprentice tavern in the left distance.

107

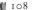

109 Design for *Lake of Thun, Swiss*, issued in 1808 and categorized as 'Mountainous'.

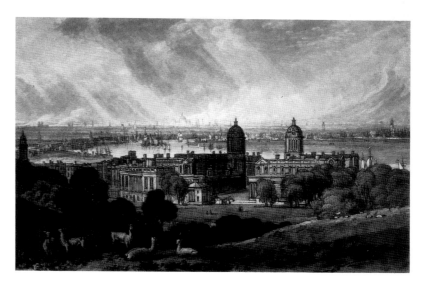

110 *London from Greenwich*, etched by Turner and mezzotinted by Charles Turner after the painting of 1809; it was issued in 1811 in the 'Architectural' category.

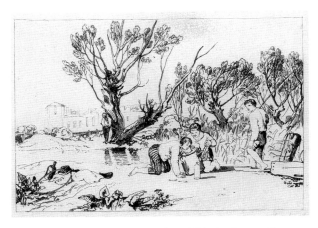

111 *Young Anglers.* This is the outline etched by Turner himself for Robert Dunkarton's *Liber Studiorum* mezzotint issued in 1811 and categorized as 'Pastoral'. The subject reflects Turner's fondness for children – three of the plates issued in 1811 showed children's pastimes – and his own enthusiasm for angling. The scene is Marylebone Fields, close to his house in Queen Anne Street, with the Jew's Harp tavern in Love Lane beyond.

Stories of Turner's sharpness, even meanness over money, emanate more from engravers than almost any other section of his acquaintance. In this area above all others he seems to have felt entitled to be rigidly particular about finances. No doubt he considered it an aspect of his work which was essentially commercial, in which the details of profit and loss were of absolute importance. Indeed, the ultimate failure of the *Liber* project (it was abandoned in 1819 after only seventy of the plates had appeared) perhaps justified him in his caution. Beyond this, he probably saw his relationship with the engravers as in many respects that of master to pupil: he kept a scrupulous eye on every stage of their work, and, as the more candid of them admitted, he turned them into better artists. Even at the stage of printing the *Liber* plates he was determined to be involved:

> Turner was in the habit of constantly visiting Lahee's printing-office to watch the results of his alterations, and the effects of new plates. Standing by the press, he would examine each impression as it came off, and with burin or scraper make such changes or retouches on the copper as he thought desirable; sometimes getting his plates into such a muddle that they had to be sent home to him to be seriously treated. (Rawlinson, p. xxviii)

The didactic streak in his nature came out in many respects of his life. He knew that he had much knowledge both of nature and of the techniques of his craft to impart to the world: his output, like all great art, is nothing less than a dispensation of wisdom. When, on 2 November 1807, he was elected Professor of Perspective to the Academy, he regarded this as yet another channel through which he could disseminate his ideas, and threw himself with energy into the quantity of reading required. In practice, the writing of a whole course of lectures on the subject almost defeated him, and it was not until 1811 that he was ready to deliver them. For when he moved outside his chosen medium of painting he found many obstacles to the communication he was so eager to make. Writing did not come naturally to him, as his letters repeatedly make apparent. It is not that he had nothing to say – far from it: his mind is alive with a wide range of thoughts and feelings, vivid with references literary and historical, often related one to another with wit and perception. But between the thoughts and the words in which they are clothed there intervened Turner's technical incompetence: he was not a master of language as he was with the brush.

The realization of this pained him. He planned two pictures on the theme of frustrated creativity: one was exhibited in 1809 as *The Garreteer's petition*; the other, showing the studio of an amateur artist, remained a sketch. It was a comic subject; he glossed it with some doggerel verses:

> Pleased with his work he views it oer & oer
> And finds fresh Beauties never seen before . . .
> While other thoughts the Tyro's soul controul
> Nor cares for taste beyond a butterd roll . . .

Repeated redraftings of the last couplet include the line: 'The master loves his art, the Tyro butter'd rolls' (TB CXXI-B). *The Garreteer's petition* likewise came with verses; these were included by Turner in his entry for the picture in the Academy's catalogue:

> Aid me, ye Powers! O bid my thoughts to roll
> In quick succession, animate my soul
> Descend my Muse, and every thought refine,
> And finish well my long, my *long-sought* line.

But here the comedy is more poignant; for the subject of the picture, an impoverished poet vainly praying for inspiration, comes close to the knuckle of Turner's own penchant for versifying.

The quotation in the 1809 catalogue marks a new departure: his own verses appear there probably for the first time. They bring into the open a dilettante interest of his which had already manifested itself in odd jottings in earlier sketchbooks; now it suddenly takes up a prominent position among his many activities. One of his notebooks is devoted entirely to draft verses, and includes poems on the subjects of several important paintings of these years, among them *The Goddess of Discord choosing the apple of contention in the garden of the Hesperides*, which he sent to the newly founded British Institution in 1806, 144 *Pope's Villa at Twickenham*, shown at his own gallery in 1808, *Thomson's Æolian* 117 *Harp*, which appeared there in 1809, and *Apollo and Python* (R.A. 1811). The sketchbooks are littered with notes and drafts for poems on many themes; and 147 in 1812 Turner was to gloss his great canvas *Snow storm: Hannibal and his army crossing the Alps* with eleven lines of poetry attributed to 'M.S.P. Fallacies of Hope'. This 'Manuscript Poem' would provide him with quotations for the rest of his life, and draw down on his head much ribald comment from his critics. Its style and content bear ample witness to Turner's admiration for James Thomson, whom the picture of 1809 celebrates, and whose poem 'The Seasons' he had cited often enough in Academy catalogues since quotation had been permitted by the ruling of 1798.

But the immediate cause of this burst of poetasting on Turner's part was, as one might guess, very close to home. In April 1806 one of his colleagues, the Irish portrait painter Martin Archer Shee, published a volume of *Rhymes on Art* which was favourably noticed in the *Edinburgh Review*. Shee's family even claimed that the attacks on modern connoisseurship embodied in the *Rhymes on Art* had directly influenced the founding of the British Institution at the beginning of the year in which they appeared. If Turner would not allow the newcomer David Wilkie to get away with a rustic genre scene unchallenged, he could certainly not bear to witness the success of a near-contemporary (Shee was six years his senior and had become R.A. in 1800) in a different form of communication altogether. Turner had always had the urge to write verse, and this was, for him, a throwing down of the gauntlet that he could not resist. He attempted a specific imitation of Shee's satirical-didactic verses on the flyleaf of a little eighteenth-century painting manual, *The Artist's Assistant*; but it

112 *The Garreteer's petition*, oil, 1809.

113 *The Amateur Artist*, pencil, pen and wash, *c.*1809.

114 Philippe Jacques de Loutherbourg: *Storm and Avalanche near the Scheideck*, 1804, bought by Lord Egremont. De Loutherbourg's accomplished scenes of catastrophe on land or sea set the standard against which Turner measured himself as a painter of the sublime.

115, 116 *The fall of an Avalanche in the Grisons* was shown at Turner's Gallery in 1810, accompanied in the catalogue by lines of verse, probably Turner's own.

TURNER'S
GALLERY, 1810.

1. Dutch Boats
2. Grand Junction Canal at Southall Mill
3. High Street, Oxford
4. Blyth Sand
5. Harvest Dinner
6. Lake of Geneva, from Montreux, Chillion, &c.
7. Sheerness, from the Great Nore
8. Lintithgow Palace, Scotland
9. Fish Market
10. Calder Bridge, Cumberland
11. Shobury-ness, Essex
12. Dorchester Mead, Oxfordshire
13. Cockermouth Castle, the Earl of Egremont
14. The fall of an Avalanche in the Grisons

The downward sun a parting sadness gleams,
Portenteous lurid thro' the gathering storm;
Thick drifting snow, on snow,
Till the vast weight bursts thro' the rocky barrier;
Down at once, its pine clad forests,
And towering glaciers fall, the work of ages
Crashing through all! extinction follows,
And the toil, the hope of man——o'erwhelms.

progressed no further than a largely illegible draft. A more coherent effort at art theory in verse is his poem 'Sir William Wootton', which humorously surveys and describes the orders of classical architecture, an idea perhaps suggested by his work on the Perspective lectures. Rather characteristically, Turner has misremembered the details of his subject's name and the gist of his argument: Sir Henry Wotton in his *Elements of Architecture* (1624) had written of the Corinthian order as 'lascivious' and 'decked like a wanton courtezan'.

> Sir William Wootton often said
> Tuscan like to the labourer is made
> And now as such is hardly used
> Misplaced mouldings much abused
> At Gateway corners thus we find
> That carriage wheels its surface grind
> Or placed beneath some dirty wall
> Supports the drunken cobler's stall
> Ioniac with her scrowl like fan
> The meretricious courtezan
> It now is used at front of houses
> To show those horns belong to spouses
> And at a place thats entre no[u]s
> Not many steps from Charing Cross
> Fast bind fast find it has been said
> Suit not the Mistress or the maid
> Yet architecture has her plea
> And the chaste matron keep the key
> But Chastity does sometimes lean
> And men doth slip alack between
> The painted column's at the door
> Prove Vice is strong and Virtue poor . . .

Hudibrastics like this are somehow more distinctively characteristic of his own wit than his more serious manner, which is essentially a pastiche of Thomson. The thirty-two lines that accompanied *Thomson's Æolian Harp* in the Academy catalogue for 1809 represent, we may suppose, his most considered achievement in this vein. They begin:

> On Thomson's tomb the dewy drops distil,
> Soft tears of Pity shed for Pope's lost fane,
> To worth and verse adheres sad memory still,
> Scorning to wear ensnaring fashion's chain.
> In silence go, fair Thames, for all is laid;
> His pastoral reeds untied, and harp unstrung,
> Sunk in their harmony in Twickenham's glade
> While flows the stream, unheeded and unsung.

His method seems to have been to invent a line, then rough out the rhymes for several more, and gradually fill in the remainder of the syllables as best he could. There are flashes of success, but these often rely heavily on Thomson, whose phraseology is shamelessly adapted; in general, the real strength of the ideas can only be glimpsed floundering in a roly-poly pudding of unformed syntax and muddled scansion. Brilliant as his mind was, so filled with the impulse to creation, and with the proven ability to paint, he could not believe that he was incapable of writing as well.

This sense of frustration was no doubt in part to blame for the somewhat

tetchy tone of his responses to Shee's second book of verse, *Elements of Art*, which was published in 1809. There were other reasons, too, for disagreements between the two men. Shee was a partisan of Sir George Beaumont, and defended the role of the amateur and connoisseur in the education of artists. Turner's reply is scribbled in his interleaved copy of the poem:

> Sir Joshua Reynolds says 'one small essay written by a painter is more instructive than a thousand volumes of impossible practice' . . . but the opinion of a painter is widely different from the opinions of a coniseur. The Painters ideas of practical knowledge would, if encouraged to give their thoughts, be usefull to the student but the coniseurs liberality makes him undertake to instruct the Painter the Student and correct the public taste and the words of Johnson has encouraged every vain man to set the worst of idols, Vanity to betray the students eager early zeal by asserting
>
> He that amends the public taste is a benefactor
>
> That there are more amendors than creators and the most fine spun syllogisms about shadows of difference and shades of doubt end at last in contrasting improperly the merits and defects of living artists, concernd and anxiously wishing they would Engraft the beauties which they by a refined perception see must be a benefit to the student . . (facing p. 26)

Turner was deep in his reading for the Perspective lectures by now, and obviously very conscious of his own role as teacher; and if we need proof that he took the task seriously these annotations to Shee supply it. He seems, naturally enough, to have felt the need to stake out his own position, to establish his credentials as a source of wisdom on these matters:

> Genius may be said to be the parent of taste as it gives that enthusiastic warmth to admire first nature in her Common Dress, to consider of the cause and effect of incidents to investigate not with the eye of erudition but to form a language of his own. With keeness sees what is most apt and apposite to what is a contrarity or would tend to destroy (if represented) the character of that incident, and to
>
>> Look with more keeness as the eye pursues
>> And gathers taste by knowing how to choose
>> By sentiment that quickens th[r]o the mind
>> And like the stream is by degrees refin'd (facing p. 6)

He was, indeed, particularly concerned to define the workings of Genius, and to relate it to the study of his own particular subject, landscape, especially in the context of the fashionable aesthetic theories of the Picturesque:

> True Genius rises with its subject its power amalgamates its self th[r]o everything and can never be said to feel more or less than its subject [so] that wildness thro all its degrees should impress its sentiment what may be said is every thing is that is not simple; but simplicity the impression upon the mind and simplicity of subject are to me widely asunder hence the difficulty of defining the picturesque. Uvedale Price upon the Picturesque infers unevenness broken and undulating lines, but all these may be found in common pastoral the broken bank and uneven road may be often *picture-like* but requires size to render it wild, while the appearance of a practi[ca]ble road reduces it[s] character. Mr Knight maintains that seeking for distinctions in external objects is an error, and that such distinctions only exist in a well organized mind; but surely they exist in both . . . in Nature or the Painter could not draw his conceptions of her incidents by descriptions

117 *Thomson's Æolian Harp* (detail), oil, 1809. The picture is a sequel to the *Macon* of 1803 (66) as a meditation on Claudian landscape, but this time applied to a favourite domestic view. The topography of the Thames at Twickenham is remodelled to create an entirely imaginary idyll.

however florid if they were not natural, or originate by her assistance in the Poets mind, or such descriptions did not exist in his transcript of Nature. how could they challenge the recognition of a well organized mind.

But picturesque is here but undefined it may be applied to Wildness – but rather hope it is prop[er] to say that tho

> Genius waves his raised shining wings
> Oer Wildness, yet the Picture like of things (facing p.7)

He sprinkles his observations with lines of his own verse, deliberate flexings of his literary muscles for a duel with Shee; quotes the authorities in which he has been immersing himself: Du Fresnoy, Richardson, Reynolds; and cites the practice of the sixteenth- and seventeenth-century masters whom Reynolds, Opie and Fuseli had all referred to in their lectures on Painting. Just as, like Shee, he wanted to use poetry to express another dimension of his thought, so he conceived the Perspective lectures as his chance to articulate the theoretical background to his art. His practical inarticulacy must have left him feeling still further isolated.

The discovery of a friend who could accord him the full measure of appreciation for all his qualities, who understood his genius as an artist, but, being outside the professional circle of his immediate colleagues, could love him as a man and close companion, was an epoch in his essentially lonely life. He had first come into contact with Walter Ramsden Fawkes about the turn of the 119 century, perhaps having been introduced through Edward Lascelles, a Yorkshire neighbour; and Fawkes had been a keen collector of his work since 1803. In 1808 Turner visited him at Farnley Hall, on the banks of the Wharfe near Leeds, and found there a second home. That art was the basis of their friendship we need not doubt; but they had more in common than the simple 150– recognition that Turner was a genius. A growing element in Turner's make-up 154 was the fact that he was gifted with qualities of mind that placed him outside the world of his own family upbringing but denied him the artifice to enter into other worlds, other social milieus. We have seen his professional confidence interpreted as arrogance by the Academicians; away from his art he was as unsure and self-conscious as any man.

Fawkes was a country gentleman of unaffected seriousness. He was six years older than Turner. Like him he did not conform to the expected norms of his class. In many ways he was a typical provincial landowner, with a longstanding Whig affiliation; but this had recently gone sour, and Fawkes had adopted more provocative political positions, notably on the abolition of slavery and the reform of Parliament. On the latter subject he aroused great hostility as a dangerous radical, though he put forward his recommendations for a constitutional monarchy with bicameral legislature more as a return to the principles of the Glorious Revolution of 1688 than as a step into the political 155 unknown. Turner, with his humane commonsense, no doubt sympathized with Fawkes's views, understanding from his own experience what it was like to be the subject of public execration for upholding a noble tradition in a progressive and enlightened way. On Fawkes's land he could indulge his favourite recreation of fishing, and take part in all manner of country activities – trying his 120 hand as a shot and bagging a cuckoo and a grouse, lunching on the moors and driving everyone home in a tandem and turning it over, 'amid shouts of good-humoured laughter'. He became one of the family, and, with his special affinity with children, formed lifelong friendships with Fawkes's son Hawksworth, his brother and sisters. And the Yorkshire landscape was to enter into his work in surprising ways. Farnley, standing as it does high above the Wharfe and facing 121 south across the dale, commands splendid views from its front door and 151

118 *Tabley, Cheshire, the seat of Sir J. F. Leicester, Bart.: Calm Morning*, oil, 1809. Turner stayed with Sir John Leicester at Tabley on his way to Farnley in 1808.

Walter Fawkes and Farnley

119 A portrait of Walter Fawkes drawn by John Varley, with the aid of the 'Graphic Telescope' patented by Varley's brother Cornelius.

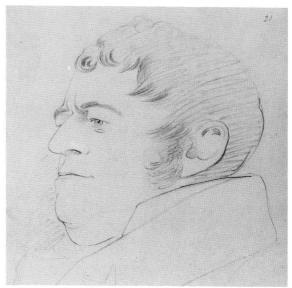

120 *Shooting-party on the Moors, 12th August*, watercolour, *c*.1815. A tarpaulin on the ground is inscribed 'W FAWKES FARN[LEY]'. All the equipment and preoccupations of a large shoot are precisely recorded in this drawing, a document of country life as socially observant as the urban view of Leeds that Turner drew a little later (130).

121 *Farnley Hall seen across Wharfedale from the West Chevin*, watercolour, *c*.1817.

windows. He was there again in 1810; during the visit, 'One stormy day,' Hawksworth later remembered,

> Turner called me loudly from the doorway, 'Hawkey – Hawkey! – come here – come here! Look at this thunder storm! Isn't it grand? – isn't it wonderful? – isn't it sublime? All this time he was making notes of its form and colour on the back of a letter. I proposed some better drawing-block, but he said it did very well. He was absorbed – he was entranced. There was the storm rolling and sweeping and shafting out its lightning over the Yorkshire hills. Presently the storm passed, and he finished. 'There,' said he, 'Hawkey; in two years you will see this again, and call it "Hannibal 147 crossing the Alps."' (T., II, pp. 87–8)

Although the wars prevented him from any further foreign travel for the time being, Yorkshire supplied the deficiency unexpectedly well. A new world was opening up to him.

He had firmer foundations for a secure personal life now. We know from a letter of about 2 May 1810 (G. 34) that he had by that date moved into a house at no. 47 Queen Anne Street West, adjoining his Harley Street premises. He had also bought, in 1807, a plot of land at Twickenham, not far from the Thames though further upstream than the reaches of Isleworth or Hammersmith; and in 1810 he began to build there. Solus Lodge, as he significantly called the villa at first, was to be another and more concrete symbol of his independence, a home out of London, after its completion in 1813, for himself and his 'Daddy', who was now a widower: Turner's mother had died in 1804. Sarah Danby and her brood were deliberately excluded, as far as we can tell, from the Twickenham retreat. They were apparently kept permanently in London, probably by this time at Harley Street itself – though they had remained at Norton Street until perhaps as late as 1809.

Whatever feelings he may have had for Sarah a decade earlier, they can hardly have been maintained at any great degree of intensity. At an early stage in their relationship he celebrated the sexual emancipation that she brought to him, in a sheet of drawings depicting erotic acts, made in his 'old master' style, large figure studies in pen and ink on blue paper (TB Add. CCCLXV-A). They are pure pornography; there is no hint of tenderness or aesthetic delight in them. Another, much more serious, erotic work of those years, the *Venus and Adonis* 73 that he painted in emulation of Titian's *Death of Peter Martyr*, presents the 83 female nude in a manner that is surely indicative of his subconscious attitudes to women. It shows the recumbent Venus on a draped bank beneath tall trees, her body turned towards us so that it is fully revealed – all but the head, which is almost entirely hidden by the upright figure of Adonis, seen from behind as he takes his leave of her to go to the chase. As an evocation of the female nude evolved by the Renaissance masters, this strange image of plump and desirable flesh, lacking its head and hence all its individuality, is one of the most disturbing in art. Possibly Turner intended a joke at the expense of his subject; but it is more probable that he here unwittingly revealed his true feelings for Sarah Danby. Who is to say what sad experiences of his unbalanced mother may have lain behind this state of mind? He may have found Sarah a necessary companion; but she was no indispensable friend. Ever since he had become involved with her, he had needed to find refuges elsewhere. The family's move to Harley Street must have sharpened his instinct to escape. Isleworth and Hammersmith answered his purposes for a time. Solus Lodge was to be a more permanent solution.

Chronology 1801–1810

1801

Early in the year, working on illustrations for Lysons's *Magna Britannia* with Farington and the engraver William Byrne.

Royal Academy exhibition: 2 oil paintings and 4 watercolours shown. Oils: *The army of the Medes destroyed in the desart by a whirlwind – foretold by Jeremiah, chap. xv, ver. 32 and 33* (281, lost, B&J 15); and the 'Bridgewater Sea-piece', *Dutch boats in a gale: fishermen endeavouring to put their fish on board* (157; B&J 14). Watercolours: *London: Autumnal morning* (329; W.278); *Pembroke castle, South Wales: thunder storm approaching* (343; W.280); *St Donat's Castle, South Wales: Summer evening* (358; W.279); and *Chapter-house, Salisbury* (415; W.201), one of the series executed for Colt Hoare.

In the Academy catalogue Turner's address was given as 75 Norton Street, Portland Row. He shortly moved back to Harley Street, but appears to have installed Sarah Danby at Norton Street; the house was sold in 1809.

June–August: tour of Scotland, with a stay in Edinburgh and circuit of the Highlands as far north as Rannoch and Tummel Bridge. He used up pages in the *Smaller Fonthill* sketchbook (TB XLVIII), and drew in 7 others: *Guisborough shore* (TB LII), *Helmsley* (TB LIII), *Dunbar* (TB LIV), *Edinburgh* (TB LV), *Scotch Lakes* (TB LVI), *Tummel Bridge* (TB LVII) and *Scotch Figures* (TB LIX). He also produced the 60 'Scottish Pencils' (TB LVIII). The *Chester* sketchbook (TB LXXXII) was used on the journey south.

Whitaker's *History of the Parish of Whalley* published, with 10 plates engraved by James Basire after Turner (R.56–61).

1802

12 February: Turner was elected a Royal Academician, replacing Francis Wheatley who had died the previous year. He presented *Dolbadern Castle* of 1800 as his Diploma work.

Royal Academy exhibition: 8 works shown. Oils: *Fishermen upon a lee-shore, in squally weather* (110; B&J 16), and *Ships bearing up for anchorage* (the 'Egremont Sea-piece', 227; B&J 18), bought by the third Earl of Egremont, Turner's first work to enter his collection; also 2 historical subjects, *The tenth plague of Egypt* (153; B&J 17), much admired by the critics; and *Jason* (519; B&J 19). Watercolours, all of Scottish subjects: *The fall of the Clyde, Lanarkshire: Noon. – Vide Akenside's Hymn to the Naiads* (336; W.343); *Kilchern castle, with the Cruchan Ben mountains, Scotland: Noon* (377; W.344); and *Edinburgh New Town, Castle, &c. from the Water of Leith* (424; W.347). Another Scottish subject, *Ben Lomond Mountains, Scotland: The Traveller – Vide Ossian's War of Caros* (862, lost) was probably a watercolour (W.346).

15 July–mid-October: first visit to the Continent, through France and Switzerland and returning via Paris. His itinerary took him to Chalon, Mâcon, Geneva, Bonneville, Chamonix, Courmayeur, Aosta, St Bernard, Martigny, Vevey, Thun, Interlaken, Lauterbrunnen, Grindelwald, Meiringen, Lucerne, St Gotthard, Zurich, Schaffhausen, Lauffenbourg and along the Rhine. The sketchbooks used on the tour are *Small Calais Pier* (TB LXXI), *France, Savoy, Piedmont* (TB LXXIII), *Grenoble* (TB LXXIV), *St Gothard and Mont Blanc* (TB LXXV), *Lake Thun* (TB LXXVI), *Rhine Strassburg and Oxford* (TB LXXVII), *Swiss figures* (TB LXXVIII), part of *Fonthill* (TB XLVII), and *Studies in the Louvre* (TB LXXII), the last filled with copies and notes from the pictures assembled in that gallery by Napoleon. There are also 19 large sheets with drawings made on the spot, mostly in black chalk or charcoal (TB LXXIX).

11 November: attended the funeral at St Paul's, Covent Garden, of Girtin, who had died on the 9th.

1803

Turner a member of the Academy Council during a year of severe internal disputes.

Royal Academy exhibition: showed 5 oil paintings and 2 ambitious watercolours derived from his tour of 1802, some obviously inspired by pictures seen in Paris. Oils: *Bonneville, Savoy, with Mont Blanc* (24; B&J 46); *The festival upon the opening of the vintage at Macon* (110; B&J 47); *Calais Pier, with French poissards preparing for sea: an English packet arriving* (146; B&J 48); *Holy Family* (156; B&J 49); and *Chateaux de St Michael, Bonneville, Savoy* (337; B&J 50). Watercolours: *St Huges denouncing vengeance on the shepherd of Cormayer, in the valley of d'Aoust* (384; W.364), acquired by Soane; and *Glacier and source of the Arveron, going up to the Mer de Glace* (396; W.365), bought by Walter Ramsden Fawkes, the earliest of his numerous purchases from Turner. Although arousing much admiration, these works were also criticized, especially by Sir George Beaumont, as sensational rather than accurate records of nature. Many of these subjects and others of the period were planned in the *Calais Pier* sketchbook (TB LXXXI).

Concern with Academy affairs and his work on several large-scale pictures apparently prevented him from travelling this year.

Engaged in building a gallery for the exhibition of his work at his house in Harley Street.

Britannia Depicta published between this year and 1810; for it William Byrne engraved 7 designs after Turner (R.65–71).

1804

March: death of Thomas Malton.

15 April: death of Turner's mother, in a private asylum in Islington.

Turner's Gallery, April: opening exhibition. The new gallery was 70 feet long, 20 wide (Farington, 19 April). The exhibition may have comprised 20–30 subjects, perhaps including the large Swiss watercolours *The passage of Mount St Gothard taken from the centre of the Teufels Broch (Devil's Bridge), Switzerland* (W.366) and *The great fall of the Riechenbach, in the valley*

of Hasle, Switzerland (w.367), and the oil painting of *Macon* shown at the Academy in 1803; possibly also the pastiche of Titian, *Venus and Adonis* (B&J 150).

Royal Academy exhibition: 2 oil paintings shown, *Boats carrying out anchors and cables to Dutch men of war, in 1665* (183; B&J 52) and *Narcissus and Echo* (207; B&J 53); and one watercolour, *Edinburgh, from Caulton-hill* (373; w.348).

11 May: quarrel with Farington and others on the Academy Council. Although Turner's term of office on the Council continued until the end of the year, he was subsequently absent.

28 May: Farington learned of the suicide of Edward Dayes.

This year or early in 1805 he became a tenant of Sion Ferry House, Isleworth. The address is written in the *Studies for Pictures; Isleworth* sketchbook (TB XC) in use *c.*1804–6, and first appears on a letter to Colt Hoare of 23 November 1805 (G.11).

1805

22 April: opening of the first exhibition of the Society of Painters in Water-Colours, founded in 1804.

Turner's Gallery, early May–1 July: pictures shown included a *Shipwreck* (B&J 54), which was very well received and engraved in mezzotint by Charles Turner (see 1807), and perhaps *The Deluge* (B&J 55; R.A. 1813), *The Destruction of Sodom* (B&J 56), and *Windsor Castle from the Thames* (B&J 149).

4 June: foundation by Thomas Barnard of the British Institution for Promoting the Fine Arts in the United Kingdom, with the Earl of Dartmouth as President and Sir George Beaumont among the Directors. West, under pressure to resign his Presidency of the Academy, supported the Institution, predicting that the Academy 'would be left a mere drawing school' (Farington, Diary, 21 July).

21 October: battle of Trafalgar.

22 December: the *Victory* with Nelson's body on board anchored off Sheerness. Turner made notes of her arrival in the *Nelson* sketchbook (TB LXXXIX), interviewing the men and drawing details of their costume, etc. He began working on a picture of the battle of Trafalgar almost immediately.

1806

British Institution exhibition, from 17 February: the Institution's first exhibition, held in its rooms in Pall Mall which had previously been occupied by Boydell's Shakespeare Gallery. Of about 250 works by living artists half were by Academicians or Associates of the Academy and had already been exhibited there. Turner showed *Narcissus and Echo* (225; 1804) and a new work, *The Goddess of Discord choosing the apple of contention in the garden of the Hesperides* (55; B&J 57).

Royal Academy exhibition: Turner showed an oil painting, *Fall of the Rhine at Schaffhausen* (182; B&J 61), and a watercolour, *Pembroke castle: Clearing up of a thunder-storm* (394; w.281), very similar to the *Pembroke Castle* shown in 1801.

April: publication of *Rhymes on Art* by the portrait

painter Martin Archer Shee, which seems to have stimulated Turner to extensive efforts at versification of his own; several of his pictures in the next few years had verses composed on their subject-matter.

Turner's Gallery, May–June: the exhibition included the still unfinished *Battle of Trafalgar* (B&J 58), and possibly the two views of Walton Bridges (B&J 60, 63), *The Victory beating up the Channel on its return from Trafalgar* (B&J 59), acquired by Fawkes, and *Windsor Castle from the Thames* (B&J 149), which may have been shown in 1805. There were probably also 2 watercolours: *Montanvert, Valley of Chamouni* (w.376) and *Mer de Glace with Blair's Hut* (w.371), both bought by Fawkes.

Late summer; stayed with Wells at Knockholt. At this time or perhaps earlier the idea of the *Liber Studiorum* was formulated in collaboration with Wells. The first 5 sepia drawings were executed at Knockholt in October.

Autumn, probably October: Turner took a house at 6 West End, Upper Mall, Hammersmith, with a garden down to the river and a summer-house by the water which he used as studio. De Loutherbourg was a neighbour. He kept the house until 1811, and during this time became friendly with the Rev. Henry Scott Trimmer, at Kew.

1807

January: mezzotint of the *Shipwreck* (T.G. 1805) by Charles Turner published. The plate, many impressions of which were printed in colour, played an important part in spreading the painter's reputation.

Turner's Gallery, 20 April or later–30 June: pictures shown probably included a series of Thames studies: *The Thames near Windsor: Evening – men dragging nets on shore* (B&J 64), which was bought by Egremont; *On the Wey* (B&J 65), bought by Sir John Leicester; *Clieveden on Thames* (B&J 66); *The Mouth of the Thames* (B&J 67); and *A View off Sheerness* (B&J 62). A watercolour of *Lausanne, Lake of Geneva* (w.377) was purchased by Fawkes, and other Swiss watercolours may also have been shown.

Royal Academy exhibition: 2 oil paintings shown, *A country blacksmith disputing upon the price of iron, and the price charged to the butcher for shoeing his poney* (135; B&J 68) and *Sun rising through vapour; fishermen cleaning and selling fish* (162; B&J 69). Both works were acquired by Sir John Leicester, though later sold by him. The former shows the influence of an innovatory rustic interior exhibited at the Academy in 1806, *Village Politicians* by David Wilkie. The price of Wilkie's entry for 1807, *The Blind Fiddler*, determined Turner to charge 100 guineas for his own *Blacksmith* (Farington, 9 January 1808).

11 June: Part I of the *Liber Studiorum* issued.

Engaged in making drawings of Cassiobury Park for the Earl of Essex (w.189–192).

Perhaps this summer, he made a number of oil sketches direct from nature along the Thames and Wey – 17 on canvas, 18 on mahogany veneered panels (B&J

160–194) – together with many watercolour studies of the same area (TB XCV etc.).

1 November: two prize-ships from the battle of Copenhagen reached Spithead. Turner made drawings of them in the *Spithead* sketchbook (TB C).

2 November: elected Professor of Perspective at the Royal Academy.

Bought a parcel of land at Twickenham for £400, with the intention of building himself a house near that of Sir Joshua Reynolds on Richmond Hill.

1808

British Institution exhibition, February: 2 oil paintings shown, *Jason* (394; R.A. 1802) and *The Battle of Trafalgar* (359), exhibited unfinished two years earlier at Harley Street. Although the latter was criticized by some, one reviewer, probably John Landseer, in the *Review of Publications on Art*, considered it 'a new kind of Epic Picture', which 'suggested the whole of a great victory', of a kind that had 'never before been successfully accomplished, if it has been before attempted, in a *single* picture'.

20 February: Part II of the *Liber Studiorum* issued.

Turner's Gallery, from 18 April: 12 paintings shown, and (according to the advertisement) as many as 50 of the sepia drawings made for the *Liber Studiorum*. Of the oils, *The Goddess of Discord* had already appeared at the British Institution in 1806. There were further views on the Thames: *Union of the Thames and Isis* (B&J 70); *Eton College from the River* (B&J 71), bought by Egremont; *View of Pope's Villa at Twickenham, during its dilapidation* (B&J 72), bought by Leicester; *View of Richmond Hill and Bridge* (B&J 73); *Purfleet and the Essex shore* (B&J 74), bought by the Earl of Essex; *Confluence of the Thames and Medway* (B&J 75), bought by Egremont; and *Sheerness as seen from the Nore* (B&J 76), possibly acquired by Samuel Dobree. The other paintings were *View in the forest of Bere* (B&J 77) and *View of Margate* (B&J 78), both bought by Egremont; an unidentified 'subject taken from the Runic superstitions' (B&J 79); and *Two of the Danish ships which were seized at Copenhagen entering Portsmouth Harbour*, a title which Turner later changed to *Spithead: boat's crew recovering an anchor* (B&J 80).

Royal Academy exhibition: only one oil painting shown, *The unpaid bill, or the Dentist reproving his son's prodigality* (167; B&J 81), commissioned by Richard Payne Knight as a companion, possibly in deliberately absurd contrast, to his Rembrandt *Holy Family* (then known as *The Cradle*; Bredius 568).

10 June: Part III of the *Liber Studiorum* issued.

Summer (probably July): stayed with Sir John Leicester at Tabley, Knutsford, Cheshire, to make views of Tabley House. Sketchbooks used on this visit are *Tabley 1, 2* and *3* (TB CIII, CIV, CV). TB CIV contains studies on the Dee, near Corwen, suggesting a journey into North Wales. Henry Thomson, R.A., told Augustus Wall Callcott that although Turner worked on his two views of Tabley and 'another picture' (probably *Trout fishing in the Dee*; see 1809) 'his time was occupied in *fishing* rather than painting'

(Farington, 11 February 1809). From Tabley he went into Yorkshire and stayed for the first time with Walter Ramsden Fawkes at Farnley Hall, near Leeds. The two men struck up a warm friendship; Turner was to visit Farnley almost annually until Fawkes's death in 1825.

1809

10 February: Turner voted for the election of Callcott as Academician, but Callcott did not succeed.

11 February: Farington noted in his Diary 'Mrs Danby, widow of a Musician, now lives with him [Turner]. She has some children.' She had been accommodated in a separate house in Norton Street, but this year that house was sold by auction; probably now she and the children moved to Harley Street. Hannah, her niece, may have come to live with her in this year, and was to remain with Turner as his housekeeper until the end of his life.

British Institution exhibition: Turner showed his marine of two years earlier, slightly differently titled as *Sun rising through vapour, fishermen landing and cleaning their fish* (269).

27 March: assisted at Soane's first lecture as Professor of Architecture helping display illustrations.

29 March: Part IV of the *Liber Studiorum* issued.

Turner's Gallery, from 24 April: the catalogue lists 16 oil paintings and 2 watercolours. Verses by Turner himself were appended to three of the titles: *Thomson's Æolian Harp* (B&J 86); *Near the Thames' Lock, Windsor* (B&J 88), bought by Egremont; and *London* (B&J 97), bought by Fawkes. The other paintings were *Sketch of a bank with Gipsies* (B&J 82); a 'Sketch of Cows, &c.' (B&J 83?); *Shoeburyness Fisherman hailing a Whitstable Hoy* (B&J 85); *Union of the Thames and Isis* (seen also in 1808); *Fishing upon the Blythe-sand, tide setting in* (B&J 87); *Ploughing up Turnips, near Slough* (B&J 89); *Harvest Dinner, Kingston Bank* (B&J 90); *Guardship at the Great Nore, Sheerness, &c.* (B&J 91); *Richmond. Morning* (exhibited in 1808 as *View of Richmond Hill and Bridge*); *Trout fishing in the Dee, Corwen Bridge and Cottage* (B&J 92), purchased by the Earl of Essex; 2 canvases entitled *Fishing-boats in a Calm* (B&J 93, 94); *Bilsen Brook* (B&J 96); and possibly a smaller version of the large *Sun rising through vapour* (B&J 95). The watercolours were *King's College Chapel, Cambridge* (see w.77) and *Cottage Steps, Children feeding Chickens* (w.490), which was to appear again at the R.A. in 1811.

Royal Academy exhibition: 4 oil paintings shown. They were the two views of Tabley commissioned by Sir John Leicester (105, 146; B&J 98, 99); *The Garreteer's petition* (175, B&J 100), accompanied, apparently for the first time, by his own verses; and the *Spithead* (22) exhibited at his own gallery the previous year.

Summer: Turner probably stayed for the first time at Petworth, working on a commission by Lord Egremont to make views of the house and using the *Petworth* sketchbook (TB CIX). This also contains studies made at Cockermouth Castle, Cumberland, visited this year on another commission by Lord

Egremont. While in Cumberland he collected material for two views of Lowther Castle, commissioned by the Earl of Lonsdale. Other sketchbooks used on the tour are *Cockermouth* (TB CX) and *Lowther* (TB CXIII).

November: commissioned to paint a view of Oxford High Street for James Wyatt, an Oxford frame-maker, carver and gilder who planned the publication of a large engraving of the finished work.

15 December: Turner showed the Royal Academy Council his proposals for lighting the lecture room, while Soane produced a plan for the improvement of the seating.

Shee's *Elements of Art* published.

Some Swiss watercolours acquired by Fawkes are dated to this year, and Turner seems to have received a commission to make some similar drawings for Sir John Swinburne, of Capheaton, Northumberland, perhaps through the good offices of Fawkes. Swinburne was to become an important patron, and his son, Edward, became a friend of Turner's, taking drawing lessons from him.

Postponed giving his lectures on Perspective until 1811.

1810

January: probably visited Oxford to make drawings for Wyatt's picture. By March the work was completed (B&J 102).

10 February: Callcott elected R.A.

Turner's Gallery, ?April–9 June: several of the works shown had already been seen by the public, including *Sun rising through vapour, Fishing upon the Blythe-sand* and *Shoeburyness Fisherman hailing a Whitstable Hoy*. The printed handlist also mentions *Linlithgow Palace* (B&J 104); *The fall of an Avalanche in the Grisons* (B&J 109); *Cockermouth Castle* (B&J 108) for Lord Egremont; *Hastings: Fish Market* (B&J 105), bought by John

Fuller, a new patron; *Lake of Geneva, from above Vevey* (B&J 103), bought by Fawkes; *Grand Junction Canal at Southall Mill* (B&J 101, the 'Windmill and Lock', an imitation of Rembrandt's *Mill*); *High Street, Oxford* (B&J 102); *Calder Bridge, Cumberland* (B&J 106); *Dorchester Mead, Oxfordshire* (B&J 107); and *Rosllyn* (lost; B&J 110), which might have been a watercolour.

Royal Academy exhibition: 3 oil paintings shown, 2 views of *Lowther Castle, Westmoreland, the seat of the Earl of Lonsdale*, one a *North-west view from Ulleswater lane: Evening* (85; B&J 111), the other *(the north front), with the river Lowther, Mid-day* (115; B&J 112); and *Petworth: Dewy morning* (158; B&J 113).

About this time the *Wreck of a Transport Ship* was painted for the Earl of Yarborough, then the Hon. James Pelham. Turner received £300 for it.

2 May: by this date he had acquired no. 47 Queen Anne Street West, where he planned a new gallery.

Early summer: probably visited John ('Jack') Fuller, M.P. for Sussex, at Rosehill Park, Brightling, Sussex, to begin work on a picture of Rosehill; Fuller may also have commissioned a series of watercolour views in West Sussex, to be published; but these were not executed until some years later. While in the region, Turner seems also to have gone to Somer Hill, near Tonbridge, Kent, seat of Major W. F. Woodgate, who is not known, however, to have commissioned the view of his house that Turner exhibited in 1811, nor did he acquire it.

Late summer: at Farnley Hall. During this visit he witnessed a storm which he used in *Snow storm: Hannibal and his army crossing the Alps*, exhibited in 1812.

Several calculations relating to his finances are jotted in notebooks used about this time, e.g. the *Hastings* sketchbook (TB CXI), indicating that he considered himself worth around £12,000–13,000 a year.

1811–1820

122 *Dido building Carthage; or the rise of the Carthaginian Empire* (detail). This supreme reinterpretation of the theme of the Claudian seaport was exhibited at the Academy in 1815. The paper boats floated by small boys in the foreground are emblematic of the transience of Dido's empire, and illustrate in the most heroic context Turner's delight in children's games. A familiar story about the painting was circulated by Turner's memorialists. Cunningham gives it as follows: 'When urged to part with his picture of Carthage, he replied, "No, I shall not sell *that*: I shall be buried in my Carthage." "But they will dig you up," was the reply, "and get your picture for nothing"' (p. 41). Turner early conceived the idea of bequeathing the canvas to the National Gallery, to hang next to Claude's own *Embarkation of the Queen of Sheba* (56).

The Perspective lectures

The substance of the lectures that Turner delivered as Professor of Perspective at the Royal Academy from 1811 was often obscure and poorly delivered, but the large drawings that he made to illustrate them were universally admired. They range from the driest of geometrical diagrams (see ill. 137) to works of elaborate and beautiful watercolour. The *Interior of a Prison* (123) is based on a design by Piranesi (see ill. 44). The *Interior of the Brocklesby Mausoleum* (124) derives from notes that Turner had made on the spot in about 1797 at Brocklesby, the Lincolnshire seat of his patron the Earl of Yarborough, of the Mausoleum recently completed by James Wyatt. Turner's drawing combines complex architectural perspective with an impressive effect of chiaroscuro. The painted glass with its ring of airy figures perhaps suggested to him the compositions of some of his later 'vortex' paintings, notably *Light and colour: the morning after the Deluge* of 1843 (ill. 278).

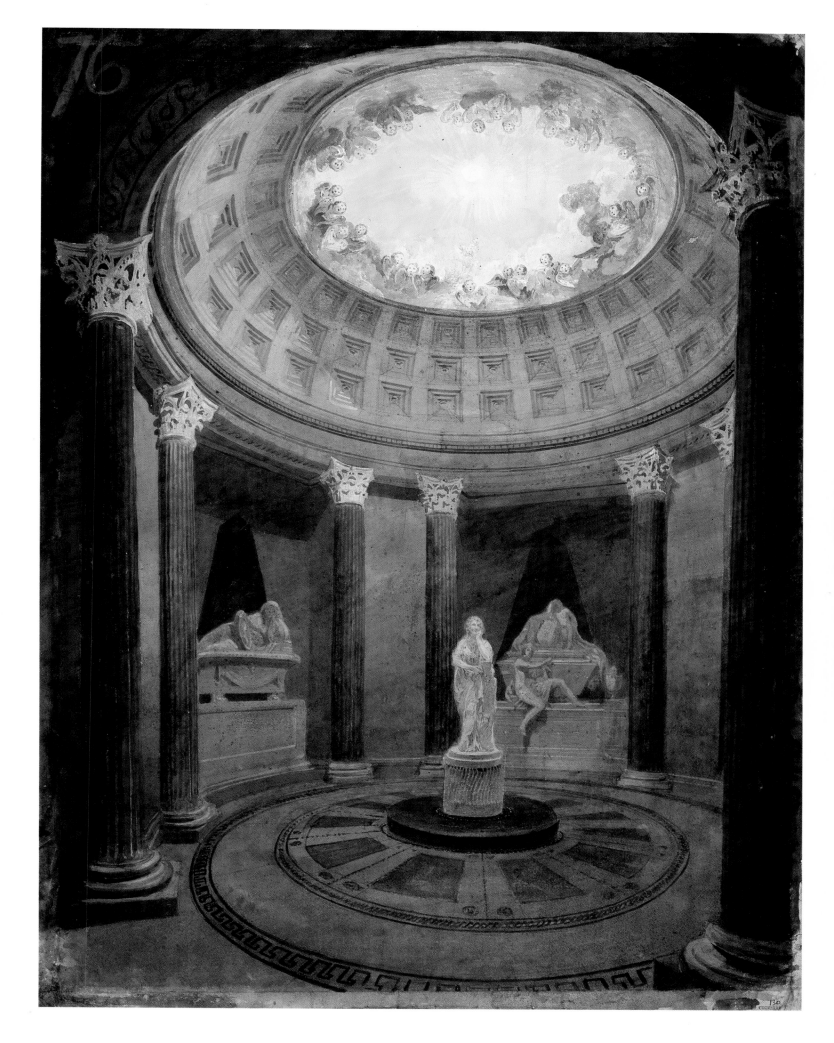

The West Country

Turner made two tours of the western counties of England, in connection with his work for the *Picturesque Views on the Southern Coast of England*. The first was in 1811, and supplied him with most of the material he was to use for that project. The second, in 1813, seems to have been a more relaxed affair, and the *plein-air* oil sketches on paper that he made in the neighbourhood of Plymouth at the instigation of Ambrose Johns, such as the *Distant view of Plymouth* (125), testify to his unselfconscious ease in the company of friends.

The large picture that also resulted from this tour, *Crossing the brook* (126), shown at the Academy in 1815, is equally gentle in mood; it is the first full-scale synthesis of the Claudian mode and pastoral English subject-matter. The landscape, though idealized, was sketched in the Tamar valley, in the *Plymouth, Hamoaze* sketchbook where he made a drawing of a stream and noted a 'Girl crossing'. For the picture his two daughters, Evelina and Georgiana, served as models.

Italy 1819

Turner's first experience of Italy, at the age of forty-four, was that of the student avid for information, and he collected a mass of reference material in some twenty notebooks. In Venice he made a few exceptionally delicate watercolours, such as *Looking east from the Giudecca, sunrise* (127), which were not used subsequently. The shimmering view of *Naples from Capodimonte* (128) was later worked up as a finished watercolour for Walter Fawkes.

Only one oil painting appeared immediately after his return: the huge canvas of *Rome from the Vatican. Raffaelle accompanied by La Fornarina, preparing his pictures for the decoration of the Loggia* (detail, 129). It is a manifesto of the artist's place in society, and alludes to all the elements of Italian art, architecture and landscape that Turner had so carefully studied. There is an implied parallel between himself and Raphael, as well as an act of homage to the Renaissance master.

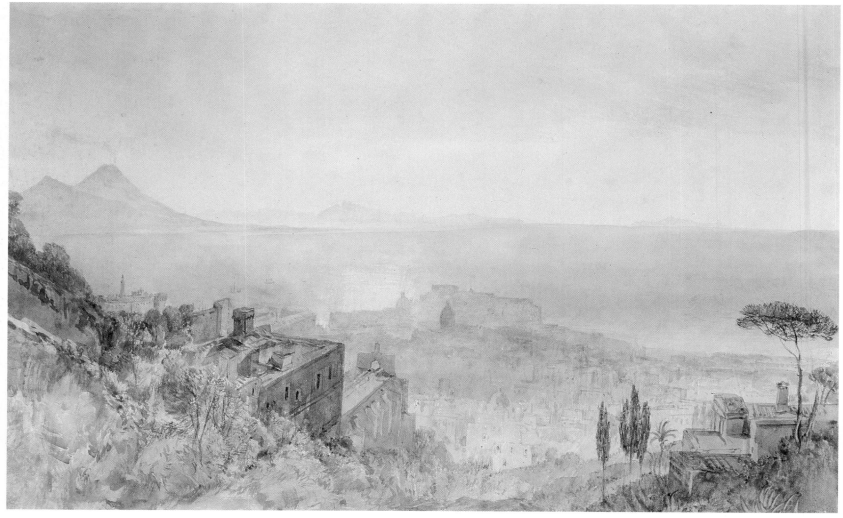

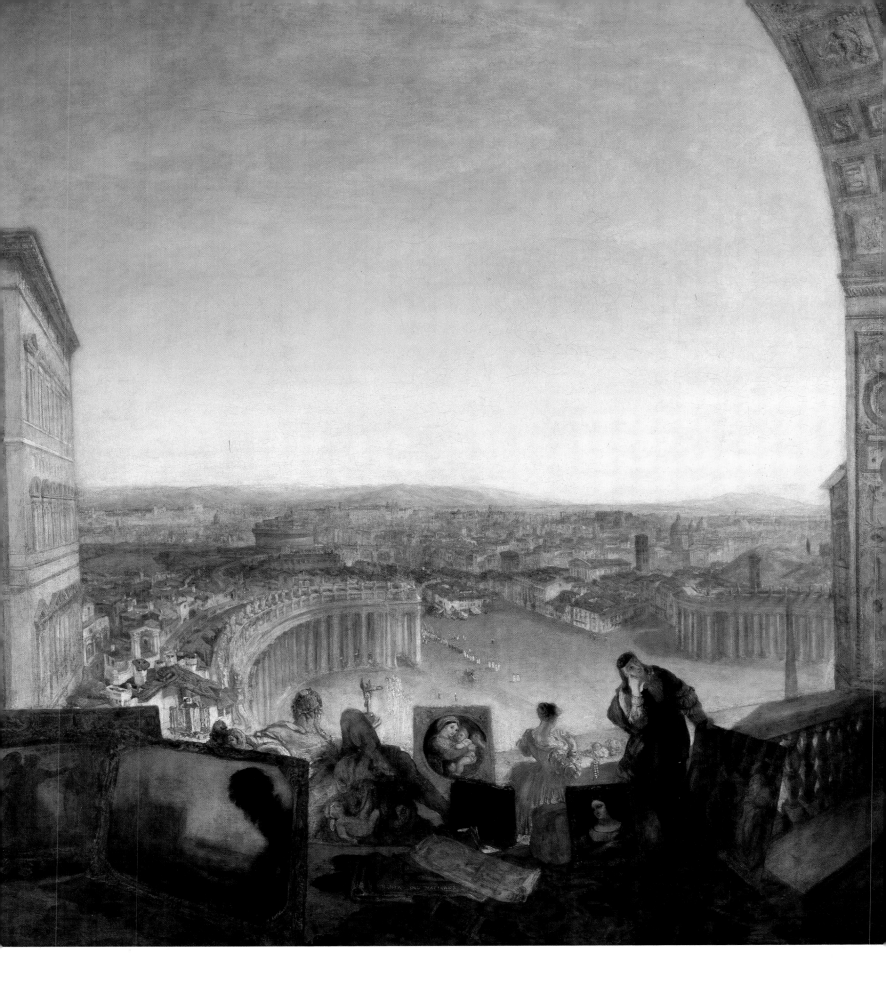

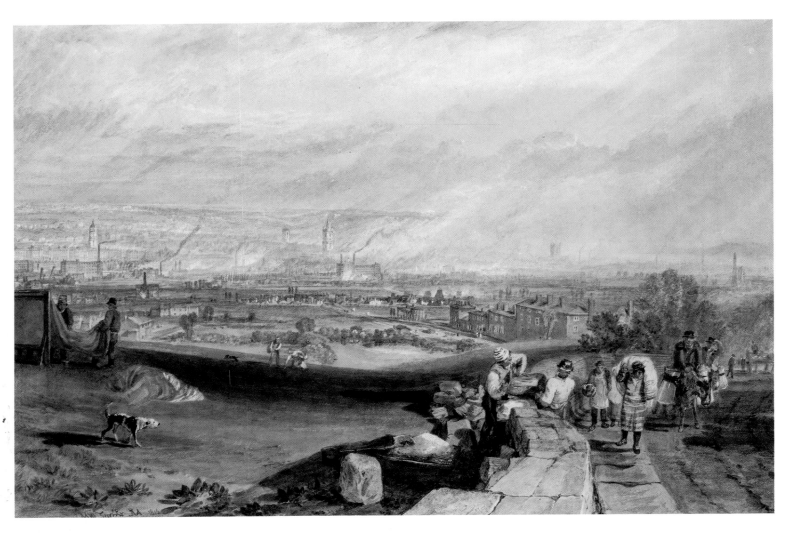

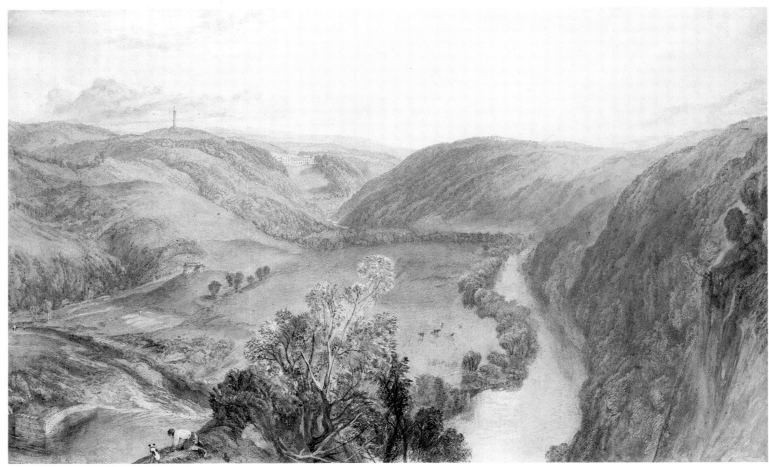

1811~1820

AT THE BEGINNING OF 1811 Turner at last delivered the course of lectures on Perspective that he had been delaying for so long. He gave his introductory paper on 7 January, starting at 8 o'clock in the evening. The exordium may have suggested to his audience that he had in mind to do more than his predecessors Samuel Wale and Edward Edwards had done:

> I cannot look back but with pride and pleasure to that time the Halcyon perhaps of my days when I received instruction within these walls, and listened, I hope I did, with a just sense and respect towards the institution and its then President, whose discourses must be yet warm in many a recollection.

His sketchy notes for the first address contain a lengthy, if disconnected, panegyric of Reynolds, celebrating

> the departed greatness of our late P. that he who lived and died the greatest ornament of British Art filled it . . . from the first foundation of this Academy, by our most gracious Patron, accompanied served with it onwards – its present attitude by precept & by more his practice. pointing out the Boundaries of Art . . . he left an aggregate of advice in the name of Michael Angelo to study the energetick connection of his thoughts. The dignifying manner of his expressing and substantiating those thoughts the . . . study the lofty working of his mind thro all his works. (MS A, f.1)

Thus involving in a breath both Reynolds and Michelangelo Turner showed that his aim, as in everything else, was not only to supply what his forerunners had supplied, but to give much more: he would teach mechanical perspective, but in the broad context of painting as a whole. Hence his allocation of one lecture to a study of 'Backgrounds' which, if nominally a discussion of the treatment of landscape, was, as so often in his own art, a discourse on the depiction of man in nature as perceived by the great European masters. These aims were duly noted by a friendly reviewer, John Taylor of the *Sun*:

> Mr Turner gave his first lecture since he has been appointed Professor of Perspective to the Royal Academy last night in the Great Room, before the President, many of the members, and a considerable number of auditors, naturally attracted by the high reputation of the Professor. The lecture itself was rather introductory than technical, and principally tended to show that the highest order of Historical Painters, as well as Architects and Sculptors, availed themselves of the principles of Perspective in their most distinguished productions. He illustrated this with success by a reference to the print of Raphael's celebrated Transfiguration and a geometrical diagram on the same subject. In the course of the lecture Mr Turner paid some high compliments to the merits of Sir Joshua Reynolds, and acknowledged with gratitude that he himself had been in a great degree indebted to the Royal Academy for his professional reputation. The lecture was written throughout in a nervous and elegant style, and was delivered with unaffected modesty.

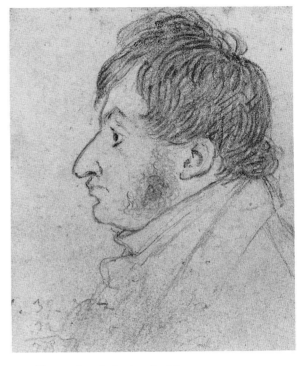

132 Turner in 1816, sketched by C. R. Leslie while he was lecturing at the Royal Academy.

OPPOSITE

Turner's friendship with Walter Fawkes, whose house at Farnley he visited frequently between 1808 and 1824, gave him many opportunities to explore Yorkshire and the neighbouring counties. Perhaps on this account he undertook a number of commissions to make topographical views in the north of England. Apart from his work on the *History of Richmondshire*, he also made designs for Whitaker's *Loidis and Elmete*, providing the richly informative panoramic watercolour of *Leeds* (130) which is dated 1816 and chronicles the rapid development of an important industrial centre, with its large mills and smoking chimneys. In 1817 he supplied three designs for Robert Surtees's *History of Durham*; shown here is *Gibside* (131), a very different panorama, in which the landscape is made more dramatic by a characteristic exaggeration of the drop from a high viewpoint.

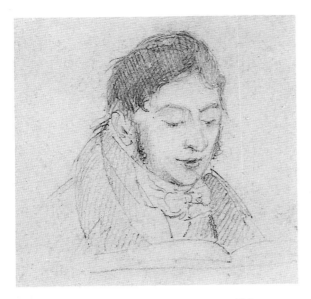

133 Turner delivering one of his lectures. This pencil sketch by Thomas Cooley, who entered the Academy Schools in 1812, is inscribed 'Mr Turner R A, a Landscape Painter & a Professor of Perspective'.

OPPOSITE

Turner used Raphael's *Transfiguration* as a demonstration of the inherent geometry of pictorial composition (134). Notes for his first lecture include these remarks: 'the proof of the admission of the principal Rule . . . may be exemplified in the Transfiguration the figures in front meet the eye . . . the two fig[ures] on the Mount diminish in a ratio to the deity placed in the top of the Picture which may be consider[ed] near a triangle whether he had an allegorical intention in placing the 3 figures on the top of the Pyramid[?] may be to[o] presuming in me to say but the whole he defined by or at least the relative proportion each fig bear to each other as dividing the triangle into 3 equal part[s] by the diagonal of a square . . .' (MS A, pp. 6, 7).

In further illustration of his lectures Turner used drawings of several modern buildings, among them the Pulteney bridge at Bath, William Kent's Admiralty, Hawksmoor's steeple of St George's, Bloomsbury (135) and the interior of the Royal Academy's own Great Room in Sir William Chambers's Somerset House (136; see also ill. 148). He also made careful diagrams of architectural features in perspective (137) and conducted a number of experiments in colour combination and reflection, noting the effect of light on curved, metallic and transparent surfaces, and its refraction by water (138).

The diagram that Turner displayed to illustrate his point about Raphael's *Transfiguration* survives in the artist's Bequest, as do the rest of the drawings that he made for the series. They were much admired, and for many of his audience compensated for the poor delivery and muddled presentation of the subject-matter itself. A later student, Richard Redgrave, remembered that

> Half of each lecture was addressed to the attendant behind him, who was constantly busied, under his muttered directions, in selecting from a huge portfolio drawings and diagrams to illustrate his teaching. Many of these were truly beautiful, speaking intelligibly to the eye if his language did not to the ear. As illustrations of aerial perspective of colour many of his rarest drawings were at these lectures placed before the students in all the glory of their first unfaded freshness . . . Stothard, the Librarian to the Royal Academy, who was nearly deaf for many years before his death, was a constant attendant at Turner's lectures. A brother member who judged of them rather from the known dryness of the subject and the certainty of what Turner's delivery would be than from any attendance on his part asked the Librarian why he was so constant. 'Sir,' said he, 'there is much to see at Mr Turner's lectures – much that I delight in seeing though I cannot hear him.' (R. and S. Redgrave, II, p. 95)

In his lecturing, as in much else that he ventured on outside his natural medium of painting, Turner's attitude seems to have been a curious mixture of diffidence and defiance. He was confident in the value of his matter, even while being conscious that his powers of expression left much to be desired. That awareness prompted him to go out of his way to thank John Taylor for his sympathetic review, and for publishing an obituary notice of his colleague Bourgeois, who had died that day (past quarrels were forgotten in the brotherly feeling of one Academician for another):

> Jan 8 1811
>
> Dear Sir
> Pray allow me to make my most sincere acknowledgement of *thanks* for your kind and honourable notice of my endeavours on Monday night in the Paper you were so good as to send me; permit me to add a scratch of thanks for your rememberance of Sir Francis Bourgeois,
> And believe me to be
> Your most truly obliged
> J. M. W. Turner (G. 37)

But Taylor, though still anxious to be friendly to Turner, was less sure of his praise when the second lecture was delivered the following week, on the 14th. Copley presided, as West had done the week before; Farington noted: 'At 8 oClock, the members of the Council went to Turner's lecture on Perspective, which Rossi sd. He got through with much hesitation & difficulty.' Taylor contented himself with remarking in the *Sun* the next day:

> The lecture, in the opinion of those best acquainted with the subject, manifested deep investigation, but from the nature of the subject it was not probable that it could afford much gratification to those who were unacquainted with the leading principles of Perspective, but to those who had made some progress in the study it was very satisfactory, and showed that the Professor, by scientific knowledge as well as by practical skill, is fully qualified to do honour to the situation.

Again Turner sent his acknowledgment to John Taylor, this time in doggerel verses, beginning

Illustrations for the Perspective lectures

134

135

136

137

138

139 Thomas Stothard, a faithful attender
of the Perspective lectures, painted by
James Green in 1830.

Thanks gentle Sir for what you sent
With so much kindness praise – 'besprente'
Upon a subject which forsooth,
Has nothing in it but its truth . . . (G. 38)

and plunging off into obscurities which both illustrate and parody Turner's difficulties with verbal expression, as lecturer and as poet alike. Indeed, it appears from his notes that even the basic principles of perspective, which he had conscientiously culled from a wide range of authorities, from the ancients to the most recent writers on the subject like Malton and Brook Taylor, were hardly more clearly understood than expressed; and as the years went by the shortcomings of his performance were less and less tolerated. Attendances dropped and criticism became open. In 1816 the *New Monthly Magazine* for 1 February published a vivid account of Turner as lecturer:

> On Monday the 8th January Mr. TURNER, the professor of perspective, commenced his course of lectures in the Royal Academy, and has continued them on subsequent Mondays. He began with a suitable introduction on the importance of this elementary branch of the fine arts to every description of artists, and elucidated his subject with a number of excellent diagrams. But excellent as are Mr. TURNER's lectures, in other respects there is an embarrassment in his manner, approaching almost to unintelligibility, and a vulgarity of pronunciation astonishing in an artist of his rank and respectability. Mathematics, he perpetually calls 'mithematics,' spheroids, 'spearides,' and 'haiving,' 'towaards,' and such like examples of vitiated cacophony are perpetually at war with his excellencies. He told the students that a building not a century old was erected by Inigo Jones; talked of 'elliptical circles;' called the semi-elliptical windows of the lecture room semi-circular, and so forth. – Mr. TURNER should not, in lectures so circumscribed as perspective, dabble in criticism; he is too great a master in his own art to require eminence in polite literature.

But it was the criticism of art generally that really interested Turner. Here was another field in which he wished to try his skill. He felt the dry theory of perspective to be inherently dull, and admitted as much when he justified his course to his audience:

> however arduous, however depressing the subject may prove; however trite, complex or indefinite . . . however trammeled with the turgid and too often repelling recourance of mechanical rules, yet those duties must be pursued and altho they have not the charms or wear the same flattering habiliments of taste as Painting, Sculpture or Architecture, yet they are to the full as usefull and perhaps more so for without the aid of Perspective Art totters on its very foundations. (MS C, f.2)

His plan for the course was therefore to progress gradually from the bare 'mechanical rules' to a discussion of their application in works of art. A jotted syllabus gives the broad outline:

1 Lecture
Introduction its origins use how far connected with Anatomy Painting Architecture and Sculpture Elements Parallel Angular Aerial Perspective
2 Vision Subdivision of the Elements and Forms of Perspective . . . Parallel Perspective the Cube by the Old Masters
3 Angular Perspective The circle colour[ing?] The difficulty attending the circle the impropriety of Parrallel explained

4 Aerial Perspective Light shade and color
5 Reflexies Reflections and color
6 Backgrounds. Introduction of Architecture and Landscape (MS B)

And so he related the geometry of perspective to the structural grandeur of
ancient architecture:

> parallel lines carry with them no idea of hight while the oblique line may rise
> to infinity consequently Perspective not Geometrical drawings can produce
> an appearance [of] altitude by lines which [in] elevation, or size of form,
> must be the feelings of the mind, the association of Ideas, upon viewing a
> fragment only of the Athenian Temples, a grain, a part of a whole or before
> the massy remnant of the Temple of Jupiter Stator but can he however
> collosal in interlect for a moment think he is so in the scale of form or of
> hight equal to the fragments how can it then be possible that a
> representation Geometrically considered as to lines can give . . . the least
> idea of the extent, the impression of hight, dignity and towering majesty of
> architecture . . . (MS K, f. 11)

Throughout the series he invoked the old masters: Van Dyck, Correggio,
the Carracci, Rembrandt, Titian, Veronese, Poussin, Claude, Cuyp, Wilson,
and a host of others; and in the last controversial lecture, on 'Backgrounds', he
pursued the analysis of individual works that he had begun in Paris. He was
fond of using the *Transfiguration* of Raphael as an illustration of pictorial
structure; and he frequently referred to the Titian *Death of St Peter Martyr* that
had so impressed him in the Louvre. He was ever anxious to prove the
importance of landscape as a vehicle for serious ideas, and that picture seemed to
him a perfect demonstration of its potential not merely as an 'assistant' to
History, but as an equal partner with it:

> History suffers only [from] a union with commonality[;] whatever is little
> mean and common place enters not or ought not in the Landscape of
> History as an Assistant or as an Historical Landscape . . . tho separately
> drawn from the same source each should separately for its subject combine
> what is truly dignified and Majestic and possising Nature of an elevated
> quality this is the class of Titian G[i]org[i]one . . . and other works elucidate
> the consiquent coalition of such powerful auxilary that in many instances it
> not only asserts its value but disputes the palm of celebrity . . . Bassano's
> Master [i.e. Titian] has left us the greatest specimen of Landscape for
> grandeur and dignified charrecter arising from the simplest forms in Nature
> but whose form seems to have rouzed the mind of Titiano in the
> composition of the St Peter Martyr to that point will be the standa[rd] of his
> powers of Landscape.
>
> Amplitude quantaty and space appears in this Picture given by the
> means of Trees opposed to a Blue Sky and deep sunk Horizon not more than
> one 6 of the whole picture across which rushes the knotted stems of trees
> with dark brown foliage stretching far their leafy honors and their heads lost
> in the efulgence of the descending angels to crown the dying Martyr whose
> looks are directed, and the sentiment is compleatly carried upward by the
> imense spreading trunks rearing their expireing and wounded branches . . .
> (MS I, ff. 10, 11)

Incoherent as Turner's prose is in this draft, the passage enshrines ideas that
were central to his conception of landcape painting. He affirms the intimate
connection between landscape and the more intellectually respectable medium
of History, while showing that even such apparently passive natural objects as

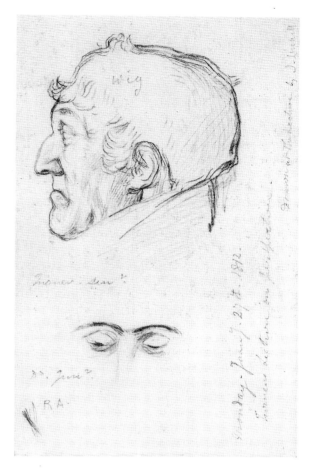

140 Studies of Turner's father, and of
Turner's eyes, made by John Linnell
during a Perspective lecture on 27
January 1812.

141 A leaf from *The British Itinerary or Travellers Pocket Companion* (*Devonshire Coast No. 1* sketchbook), with a rapidly noted view of Watchet.

142 *Watchet, Somersetshire.* The engraving, by George Cooke after Turner, published in 1820 for the *Picturesque Views on the Southern Coast of England.*

trees ought to be employed by the painter as vehicles of emotion. In suggesting this, he builds on the practice of Claude and, more particularly, Poussin, to formulate an essentially Romantic view of the relationship between nature and the human passions – a view that was to animate his work until the end of his life. His colleagues received an indication of the depth of his feelings on the matter just as the first series of lectures was getting under way. On 8 January 1811 the engraver Thomas Landseer called on Farington:

> He told me Turner is desirous of having a professorship of Landscape established in the Royal Academy; and to have the law which prevents landscape painters from being visitors [i.e. supervisors in the Schools] *repealed*. I told him there was no such law. He said He was at the Academy last night & heard Turner give His first Lecture on Perspective which, as Turner read too fast, & He (Landseer) being somewhat deaf, He could not well understand.

The Perspective course should probably be seen, then, as a trial run for one on landscape, the subject that really engrossed him – engrossed him to the extent that, as his strange misapprehension about the Visitorship of the Schools suggests, he was affected by a form of paranoia in connection with it.

Another important literary enterprise embarked on in 1811 was his longest sustained effort in verse: a work which he hoped might be published alongside engravings from his own designs in a series of *Picturesque Views on the Southern* 142, *Coast of England.* This commission came from the young engravers and newly 145 established print publishers William Bernard Cooke and George Cooke. These men, 'early impressed with an unbounded admiration of the works of Turner', and, no doubt, a lively sense of the commercial benefits to be derived from his collaboration, were continually devising means to involve him in their activities. Between now and 1826, when they quarrelled with him, they engaged him in numerous schemes, even asking him to correct their work for other artists in addition to 'touching' their engravings after his own designs. Their first project, ambitious enough, was a grand survey of the entire coastline of Britain, apparently conceived in rivalry with William Daniell's *Voyage round Great Britain*, which was begun at almost exactly the same moment. The Cookes' publication was launched in 1814 with a long series of issues comprehending the southern coast from Thames to Severn. Turner almost immediately planned a trip to that part of it with which he was least familiar, the western counties.

In mid-July, as soon as Academy business was over for the summer, he set off, armed with several notebooks, one of which was an interleaved copy of a 141 reference work, Nathaniel Coltman's *The British Itinerary or Travellers Pocket Companion*, the blank sheets of which he used for memoranda and drafts of his poem. This was conceived as a topographical tour of the south-west, with historical and moral reflections gathered together roughly according to the incidents of the road. After passing through Chelsea, Twickenham and Hounslow the traveller contemplates the significance of Runnymede, crosses 'the sandy tracks of Bagshot' heath and reaches Salisbury plain:

> There on the topmost hills exposed and bare
> behold yon battlements court the upper air
> to guard the road maintain the watch and ward
> Twas then old Sarum knew their high regard
> The [*illegible*] ditch but here where earth denyd
> her kind assistance well[?] supplyd
> Witness the inmost mount of labour all
> And still remains a monument and a wall
> What persiverance can attain and bind
> The unconquerable germ that sway the human mind
> Power on Obedience thus by mutual strife
> Of Priests and Soldiers Salisbury sprang to life (TB CXXIII, f.33v)

Arriving at the coast, Turner's traveller proceeds via Poole, Corfe Castle and Lulworth to 'rugged Portland'; and at Bridport

> Whose trade has flourished from early time
> Remarkable for thread called Bridport twine

(lines of a Wordsworthian directness, surely) he embarks on an interesting train of thought that typifies his perception of the interrelatedness of man and landscape, and concludes with some ringing patriotic affirmations:

> Behold from small beginnings like the stream
> That from the high-raised downs to marshy [*illegible*]
> First feeds the meadows where grows the line
> Then drives the mill that all its powers define
> Pressing dividing all vegetation pass
> Withdrawn high swell the shiny mass
> On the peopled town who all combine
> To throw the many strands in lengthened twine
> Then onward to the sea its freight it pours
> And by its prowess holds to distant shores
> The straining vessel to its cordage yields
> So Britain floats the produce of her fields
> Why should the Volga or the Russians
> Be coveted for hemp? Why thus supplied
> The sinew of our strength our naval pride?
> Have we not soil sufficient rich? . . .
> Plant but the ground with seed instead of gold
> Urge all our barren tracts with agricultural skill
> And Britain, Britain British canvas fill
> Alone and unsupported prove her strength
> By means her own to meet the direful length
> Of Continental hatred calld blockade . . .

The poem was not published, of course; but the tour produced more lasting fruit, even apart from the mass of drawings that he assembled for his work on

the *Southern Coast* subjects. He made a number of friends in the south-west, and was encouraged to return there in 1813. This second visit is recorded in some detail by Cyrus Redding, a journalist, who accompanied him on several excursions in Devon. Redding recognized in Turner 'a powerful, intelligent, reflective mind, ever coiled up within itself' – a perception that ought, in itself, to give credibility to his other observations. In all that he writes of Turner, indeed, the man is clearly and believably present:

> We once ran along the coast to Brough or Bur Island, in Bibury Bay. . . . Our excuse was to eat hot lobsters, fresh from the water to the kettle. The sea was boisterous, the morning unpropitious. . . . The sea had that dirty puddled appearance which often precedes a hard gale . . . and when running out from the land the sea rose higher, until off Stokes Point, it became stormy. . . . The artist enjoyed the scene. He sat in the stern sheets intently watching the sea, and not at all affected by the motion. Two of our number were sick. . . . In this way we made Bur Island. . . . At last we got round under the lee of the island, and contrived to get on shore. All this time Turner was silent, watching the tumultuous scene . . . absorbed in contemplation, not uttering a syllable. While the shell-fish were preparing, Turner, with a pencil, clambered nearly to the summit of the island, and seemed writing rather than drawing. How he succeeded, owing to the violence of the wind, I do not know. He, probably, observed something in the sea aspect which he had not before noted. (Redding 1858, I, pp. 199–200)

The description fits perfectly. The self-contained indifference to discomfort, the rapt attention to natural effects, the concentration; and the act of drawing as if writing – an entirely natural and instinctive use of the pencil to record what he sees: all this is Turner to the life. Redding continues:

> We rose at seven the next morning in Kingsbridge, and went before breakfast to see the house, at Dodbrook, in which Dr. Wolcot (Peter Pindar) was born. The artist made a sketch of it and of another house, a picturesque place not far distant. We had now more than twenty miles to travel home. A vehicle was provided, but we walked much of the way, for Turner was a good pedestrian, capable of roughing it in any mode the occasion might demand. When we came to the Lara passage, we met Lord Boringdon (afterwards Earl of Morley), who invited Turner, Demaria, and myself to Saltram, to dine and sleep, the following day. We went accordingly. . . . Among the guests at Saltram was Madame Catalani, who sang some of her favourite airs. Zuccarelli's best paintings adorn this hospitable mansion, but I could not extract from Turner any opinion regarding them. [In one of his lectures Turner referred to 'the meretricious Zuccarelly . . . without a grain of Watteaux taste' (MS I, f. 21).] In the billiard-room was Stubb's fine picture of 'Phaeton and the horses of the sun,' with which I remember the artist was much pleased, as, indeed, everybody must be; but it elicited no further remark than the monosyllable, 'fine.' Turner on retiring to rest had to pass my bedroom door, and I remarked to him that its walls were covered with paintings by Angelica Kauffman – nymphs, and men like nymphs, as effeminate as possible. I directed his attention to them, and he wished me 'Good night in your seraglio.' There were very fine pictures in Saltram by the old masters, but they seemed to attract little of his attention, though they might have drawn more than I imagined, for it was not easy to judge from his manner what was passing in his mind. (Redding 1852, p. 153).

With the friends that he made in Devon Turner seems to have felt particularly at

ease. On a memorable occasion, as Redding recounts, he gave a picnic luncheon. Such was his reputation for tight-fistedness, even then, that the story seemed incredible to some, though such convivial occasions were very much to his taste.

There were eight or nine of the party, including some ladies. We repaired to the heights of Mount Edgecumbe at the appointed hour. Turner, with an ample supply of cold meats, shell-fish, and wines, was there before us. In that delightful spot we spent the best part of a beautiful summer's day. Never was there more social pleasure partaken by any party in that English Eden. Turner was exceedingly agreeable for one whose language was more epigrammatic and terse than complimentary upon most occasions. He had come two or three miles with the man who bore his store of good things, and had been at work before our arrival. He showed the ladies some of his sketches in oil, which he had brought with him, perhaps to verify them. The wine circulated freely, and the remembrance was not obliterated from Turner's mind long years afterwards. (Ibid., p. 155)

125 Showing his sketches to others was an unusual gesture of confidence; but the oil sketches he made in the open air on this journey were in every way unusual for him. It was beginning to be quite normal for a landscape painter to take his paints out of doors and make studies of buildings, trees or sky; but it was not Turner's preferred way of working, despite his formidably successful experiments with it along the Thames in the previous decade. Another Devonshire man, his Academy colleague Charles Lock Eastlake, suggests that he was inveigled into producing his Devon studies in oil by the Plymouth landscape painter Ambrose Bowden Johns:

Turner made his sketches in pencil and by stealth. His companions, observing his peculiarity, were careful not to intrude upon him. After he returned to Plymouth, in the neighbourhood of which he remained some weeks, Mr Johns fitted up a small portable painting-box, containing some prepared paper for oil sketches, as well as the other necessary materials. When Turner halted at a scene and seemed inclined to sketch it, Johns produced the inviting box, and the great artist, finding everything ready to his hand, immediately began to work. As he sometimes wanted assistance in the use of the box, the presence of Johns was indispensable, and after a few days he made his oil sketches freely in our presence. . . . Turner seemed pleased when the rapidity with which those sketches were done was talked of; for, departing from his habitual reserve in the instance of his pencil sketches, he made no difficulty in showing them. . . . he himself remarked that one of the sketches (and perhaps the best) was done in less than half an hour. When he left Plymouth, he carried off all the results. We had reckoned that Johns, who had provided all the materials, and had waited upon him devotedly, would at least have had a present of one or two of the sketches. This was not the case; but long afterwards the great painter sent Johns in a letter a small oil sketch, not painted from nature, as a return for his kindness and assistance. On my enquiring afterwards what had become of those sketches, Turner replied that they were worthless, in consequence, as he supposed, of some defect in the preparation of the paper; all the grey tints, he observed, had nearly disappeared. Although I did not rely implicitly on that statement, I do not remember to have seen any of them afterwards. (T., I, pp. 219–20)

Eastlake's instinctive reading of Turner, like Redding's, is surely accurate. The 'defect' in the paper was an excuse; with the exception of a couple presented to

143 A study of the Tamar valley from Tavistock, from the *Plymouth, Hamoaze* sketchbook which records the scenery that Turner was to idealize in *Crossing the brook* (126).

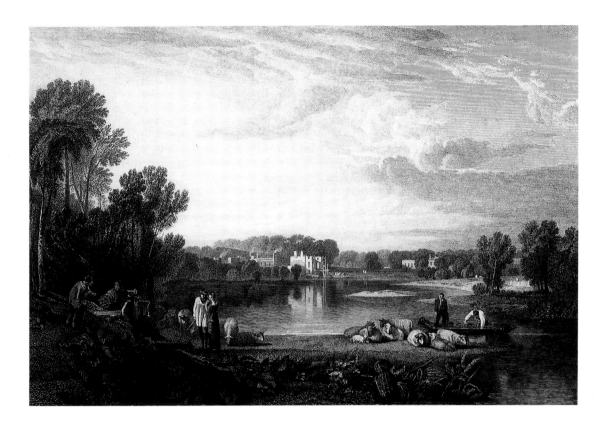

friends the oil studies were preserved in Turner's studio for future reference along with the notebooks that he had filled with pencil studies for the *Southern Coast* project. The series appeared in issues of three plates each, plus two vignettes and letterpress, in paper wrappers, until 1826, when forty-eight subjects had been published. Nine of the plates, and all the vignettes, were designed by other artists, including Peter De Wint, William Havell and Henry Edridge. Turner was paid £7.10s. a drawing for the first four issues, thereafter £10.10s. They set the pattern for his relationship with engravers for the rest of his career.

He had been jolted into recognition of the reproductive potential of line engraving in 1810, when, correcting John Pye's plate after the view of *Pope's Villa* for John Britton's *Fine Arts of the English School*, he had noticed its subtlety and accuracy in expressing airy luminosity: 'This will do!' he said to Pye, 'you can see the lights; had I known there was a man who could do that, I would have had it done before' (Bell, p. Eiv). The print was to appear with letterpress by Britton describing the subject. Despite his clumsiness in wielding words himself, Turner proved a most sensitive critic of the draft Britton submitted for his approval, and of the way in which he deployed a quotation from Robert Dodsley's 'The Cave of Pope'. In one passage Britton had championed topographical landscape as a serious genre, against the denigration of Fuseli, who had spoken in one of his Academy lectures on Painting of 'the last branch of uninteresting subjects, . . . the tame delineation of a given spot . . . this kind of map-work'; but Britton then seems to have deleted his remarks. Turner, with his ambition for all forms of landscape to be recognized as 'Elevated', was naturally disappointed. He wrote to Britton:

Sir,

I rather lament that the remark which you read to me when I called in Tavistock Place is suppressed for it espoused the part of Elevated Landscape against the aspersions of Map making criticism, but no doubt

you are better acquainted with the nature of publication, and mine is a mistaken zeal. As to remarks you will find an alteration or two in pencil [i.e. on Britton's copy]. *Two* groups of sheep, *two* fishermen, occur too close – baskets to entrap eels is not technical – being called Eel pots – and making the willow tree [in the foreground of Turner's view] the identical Pope's willow is rather strained – cannot you do it by allusion? And with deference: – 'Mellifluous lyre' seems to deny energy of thought – and let me ask one question, Why say the Poet and Prophet are not often united? – for if they are not they ought to be. Therefore the solitary instance given of Dodsley acts as a *censure*. The fourth and fifth line require perhaps a note as to the state of the grotto [in the grounds of Pope's house] that grateful posterity from age to age may repair what remains. – If I were in town, I would ask a little more to be added, but as it is, use your own discretion, and therefore, will conclude cavilling any further with Dodsley's lines.

Your most truly obedient
J. M. W. Turner (G. 43)

His ear for both the sense and the sound of English is revealed here as extremely acute: he knew he could improve on Britton's prose, and Britton accepted his suggestions. It was the same with the engravers. As with the *Liber Studiorum* he threw himself wholeheartedly into the creative business of teaching professional men to understand their work better; partly, no doubt, because in the process he himself learnt more of his craft. The translation of coloured images into monochrome gave him new insights into the value of black and white as colours in their own right, and spurred him on to bolder and more uncompromising chromatic effects in his watercolours.

His rigour in criticizing progress proofs of the engravers' plates became legendary; the 'touches' he made on them, and the comments he scrawled in their margins, were treasured by the printmakers and by collectors as rare evidence of the workings of his mind. In 1814 W. B. Cooke noted on one such 145 sheet (preserved in the British Museum):

On receiving this proof, Turner expressed himself highly gratified – he took a piece of *white chalk* and a piece of *black*, giving me the option as to which he should touch it with. I chose the white, – he then threw the black chalk to

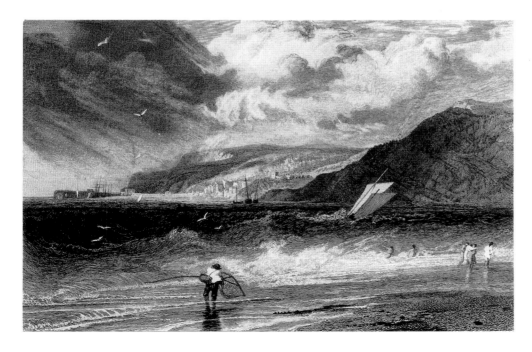

145 *Lyme Regis, Dorsetshire*, engraved by W. B. Cooke after Turner. This is the proof impression touched by Turner with white chalk, as recorded by Cooke in his note in the margin. The plate was published in 1814, in one of the earliest issues of the *Southern Coast*.

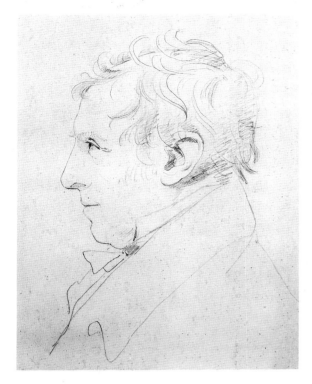

146 Augustus Wall Callcott, drawn by Chantrey probably about 1830, apparently with the aid of Cornelius Varley's 'Patent Graphic Telescope' (cp. ill. 119).

some distance from him. When done, I requested he would touch another proof in *black*, – 'No' said he, 'you have had your choice and must abide by it.'

Another engraver, Edward Goodall, had a similar exchange with him. His son, the painter Frederick Goodall, later wrote:

My father once asked how he should translate a bit of brilliant red in one of his pictures. He answered, 'Sometimes translate it into black, and at another time into white. If a bit of black give the emphasis, so does red in my picture. And in the case of translating it into white,' he said, after brief reflection, 'put a grinning line into it that will make it attractive.' (Goodall, p. 57)

If he modified his approach to watercolour in the light of lessons learned with the engravers, his oil painting too underwent significant changes in this decade. Sir George Beaumont's antagonism was as heated as ever, and comprehended not only Turner but several of his younger associates. Prominent among these was Augustus Wall Callcott, four years Turner's 146 junior, who had become an R.A. in 1810 and whose work, imitating the Dutch landscape and marine painters, borrowed its general style from Turner. Following his lead Callcott and others were by now working with a palette considerably lighter than the 'old-masterish' tonality that Sir George considered indispensable to serious art. Turner was long inured to Beaumont's outrage, but Callcott began to lose his nerve. Farington heard about this on 29 March 1813 from the animal painter James Ward:

Calcott said He should not exhibit this year. Westmacott sd. that He & Thomson had endeavoured to persuade Him to exhibit but in vain. The cause was understood to be that Calcott was mortified at the continued criticism of those who cry out against '*the White painters*' as they call them. – Ward said Turner meant to send one picture only & that conditionally viz: The having an assurance that it should be placed in a situation to be named by himself. – This, the Members of Council now present thought a very improper demand.

And on 15 April Farington told Beaumont 'that Calcott forbore exhibiting on account of the persevering run of criticism against Him, that Turner intended the same but afterwards determined to exhibit'. Sir George spoke for more than a reactionary minority. Even a sympathetic critic like Hazlitt found Turner's colouring difficult to take. He wrote in *The Examiner*:

If Turner, whom . . . we allow, most heartily allow, to be the greatest landscape painter of the age, were to finish his trees or his plants in the foreground, or his distances, or his middle distances, or his sky, or his water, or his buildings, or anything in his pictures, in like manner [to Claude], he could only paint and sell one landscape where he now paints and sells twenty. . . . It was a common cant a short time ago to pretend of him as it formerly was of Wilson, that he had other things which Claude had not . . . The public have seen to the contrary. They see the quackery of painting trees blue and yellow to produce the effect of green at a distance . . .

But in truth, these were the palmy years of Turner's success. At the end of his life, his critics looked back to the works of this decade as his characteristic masterpieces. Sir George Beaumont notwithstanding, the triumphs were palpable: *Snow storm: Hannibal and his army crossing the Alps* appeared in 1812, and 147 proclaimed the astonishing originality of his vision, and the commensurate power of his technique. He marked its significance by appending in the

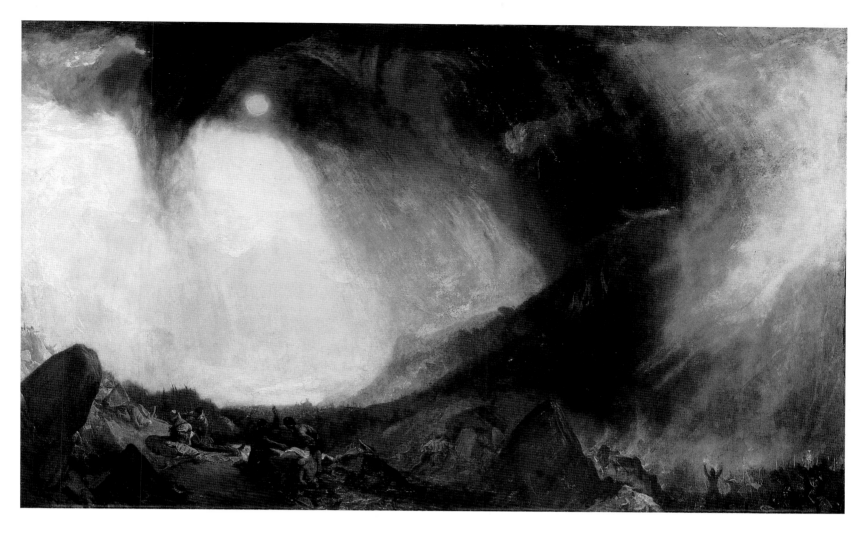

catalogue the first of many quotations from his amorphous 'Manuscript Poem', *Fallacies of Hope*:

> Craft, treachery, and fraud – Salassian force,
> Hung on the fainting rear! then plunder seiz'd
> The victor and the captive, – Saguntum's spoil,
> Alike became their prey; still the chief advanc'd,
> Look'd on the sun with hope; – low, broad, and wan;
> While the fierce archer of the downward year
> Stains Italy's blanch'd barrier with storms.
> In vain each pass, ensanguin'd deep with dead,
> Or rocky fragments, wide destruction roll'd.
> Still on Campania's fertile plains – he thought,
> But the loud breeze sob'd, 'Capua's joys beware!'

He took steps to ensure that the importance of *Hannibal* was brought to the attention of the public. Farington was on the hanging committee of the Academy that year, and on 10 April noted:

Turner's large picture of 'Hannibal crossing the Alps' was placed over the door of the new room (but in the great room) & it was thought was seen to great advantage. Mr West came & concurred in this opinion with Smirke, Dance & myself. Calcott came and remarked that Turner had sd. that if this picture were not placed under the line [i.e. at eye level] He wd. rather have it back; Calcott also thought it wd. be better seen if under the line. He went away & we took the picture down & placed it opposite to the door of

147 *Snow storm: Hannibal and his army crossing the Alps*, oil, 1812. As so often with his imaginative compositions, Turner evolved the grandiose atmospheric effects of this picture from his own experience; in this case, of a storm at Farnley a year or two earlier (see p. 84). Contemporary critics were not slow to discern an allusion to Napoleon's doomed invasion of Russia in the year that *Hannibal* was exhibited.

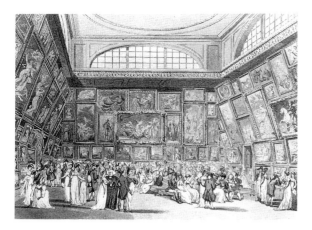

148 The Great Room at Somerset House during the Royal Academy Exhibition of 1807. This view from Rowlandson and Pugin's *Microcosm of London* shows the close hanging of the pictures from those low down on the walls ('below the line') to those 'skied' at the top. The 'line' itself marked the bottom edges of the most prominent exhibits. Compare Turner's study of the Great Room ceiling, ill. 136.

entrance, the situation which Calcott mentioned. Here it appeared to the greatest disadvantage, – a scene of confusion and injuring the effect of the whole of that part of the arrangement. We therefore determined to replace it which was done.

But the next day,

While we were at dinner Turner came and took a little only having dined early. He asked me 'What we had done with His pictures?' I told Him we had had much difficulty abt. His large picture 'Hannibal crossing the Alps'. He went upstairs & staid a while and afterwards returned to us with an apparently assumed cheerfulness but soon went away and took Howard out of the room, who soon came back & informed us that Turner objected to His picture being placed above the line. Howard assured Him it was seen there to better advantage, but He persisted in saying that if it were not to be placed below the line He would take it away; that as He saw us cheerfully seated He would not now mention His intention to us, but would come on Monday morning to have the matter finally determined.

And duly on the Monday Turner came and reiterated his determination to withdraw *Hannibal* if it were not placed as he wished. Farington hung it 'at the head of the *new room*' and, on Tuesday the 14th, Turner 'went upstairs & saw his large picture as it was placed in the new room, He appeared to be in a good humour, but said He would not decide till tomorrow when He shd. see it by daylight.' Finally on the Wednesday 'Turner came and approved of the situation of His large picture provided other members shd. have pictures near it.' He was alive to the importance of context, and studied to ensure that his work was always seen to advantage in relation to its neighbours. Ironically, when the American painter Charles Robert Leslie went to the exhibition he complained 271 that *Hannibal* could not be properly seen:

There is a grand Landscape by Turner, representing a scene in the Alps in a snow storm, with Hannibal's army crossing; but as this picture is placed very low, I could not see it at the proper distance, owing to the crowd of people. [Washington] Allston says it is a wonderfully fine thing: thinks Turner the greatest painter since the days of Claude. (C. R. Leslie 1860, II, p. 12)

Washington Allston, another American, had studied in London and practised both landscape and history. He was a principal link between Turner and the school of Transcendentalist landscape painters that was to flourish in America in the middle of the century. His opinion of *Hannibal* amplifies Leslie's testimony (which was corroborated by the press) that the work was the centre of much attention. Although Leslie could not get a good view of it, it evidently had its intended effect.

Turner's concern for the precise impact of his pictures on the walls of the Academy was at the root of his later exercises in painting during the varnishing days, when a whole subject might be executed, virtually from the lay-in, on the wall and with other pictures already in place. His fellow-Academicians were perfectly aware of what he was doing, and if sometimes irritated by his painting rather as Dr Johnson talked, 'for victory', were bound to admire the stream of fine subjects he produced. The *Frosty Morning*, shown in 1813, drew the 149 attention of Constable's close friend, Archdeacon John Fisher of Salisbury, who remarked to Constable, while praising his exhibits in a letter: 'I only like one better & that is a picture of pictures – the Frost of Turner. But then you

need not repine at this decision of mine; you are a great man like Bounaparte & are only beat by a frost—' (*Constable*, p. 42).

Turner's picture could hardly mark a sharper contrast with his *Hannibal* of the previous year: it records a journey in Yorkshire and features his own 'old crop-eared bay horse' and his elder daughter Evelina. F. E. Trimmer recalled, 'The girl with the hare over her shoulders, I have heard my father say, reminded him of a young girl whom he occasionally saw at Queen Anne-street, and whom, from her resemblance to Turner, he thought a relation' (T., 1, p. 171). There is an atmosphere of intimacy, of unaffected personal feeling, which makes the *Frosty Morning* an appropriate work to compare with Constable's. Two years later he again used Evelina as a model, with her sister Georgiana, in 126 *Crossing the brook*, a silvery English idyll based on a view across the Tamar valley that he had seen with Redding in 1813. The picture has recently been interpreted as an allegory of adolescence: the two girls are at different stages in their fording of the stream of puberty. And indeed, shortly afterwards, in 1817, Evelina left home to marry, 'with the consent and approbation of her father', a diplomat named Joseph Dupuis.

The paintings of this decade are full of contrasts. The great cycle of Carthaginian subjects that *Hannibal* inaugurated went on to touch the heights of 122 classical grandeur in *Dido and Aeneas* of 1814, *Dido building Carthage* of 1815, and *The decline of the Carthaginian Empire* of 1817. These subjects were set off against a pair of topographical views of Oxford, shown in 1812, *Crossing the brook* of 1815, 161 and the sweeping house portrait of *Raby Castle* of 1818. That year also saw the 160 appearance of Turner's great elegiac night-piece, *The Field of Waterloo*, and his 157 most spectacular tribute to the art of Aelbert Cuyp, *Dort or Dordrecht: The Dort packet-boat from Rotterdam becalmed*. This was bought by Fawkes, and Turner 153 was able to make a view of the drawing-room with the picture in position over the fireplace when he visited Farnley that autumn.

149 *Frosty Morning*, oil, 1813, exhibited at the Academy with a line from Thomson's *Autumn*: 'The rigid hoar frost melts before his beams'; so that even this wintry subject is perhaps a celebration of the power of the sun. Trimmer's son recalled that 'The "Frost Piece" was one of [Turner's] favourites. . . . He said he was travelling by coach in Yorkshire, and sketched it *en route*. There is a stage-coach in the distance that he was on at the time' (T., 1, pp. 170–71). This is, then, a further example of Turner's drawing on his own experience of travel for the subject of an important picture.

150

Farnley While staying at Farnley Turner made a complete record for Fawkes of the house and its setting, looking out over the Wharfe valley (151), where he had witnessed the storm that became *Hannibal crossing the Alps* (see p. 84). These drawings were the 'Wharfedales' of which Fawkes was particularly fond. In their freedom of handling and apparent spontaneity (though they were in fact carefully prepared), they express the warmth of the relationship between the two men.

151

15

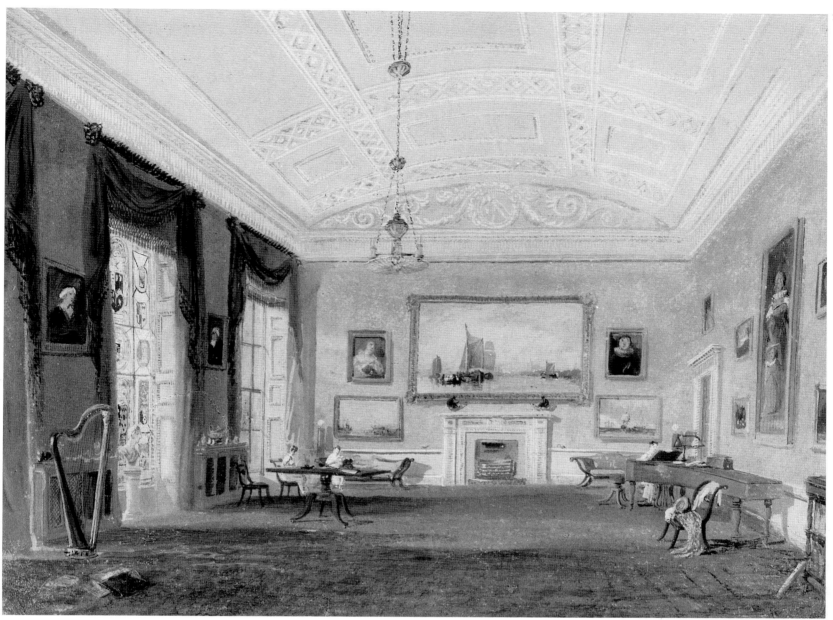

The East Gate lodges (150) were built to Turner's own design; he presents them with all the directness of his early work as a draughtsman for Hardwick. Farnley Hall can be seen beyond them in the distance. The seventeenth-century house had been extended in 1786–90 by Carr of York and Turner seems to have enjoyed the juxtaposition of styles both outside (152) and in. The Oak Panelled Room (154) contained relics of General Fairfax, including his wheelchair. In the great drawing-room (153) three of Turner's pictures are to be seen in their original positions: Fawkes's small version of *Sun rising through vapour* and *The 'Victory' beating up the Channel on its return from Trafalgar* of 1806 are to left and right of the fireplace, while above it is the newly-acquired *Dort* (see ill. 157).

154

155

155 A design from the set of trophies or 'Historical Vignettes' that Turner drew for Fawkes. Bearing the title 'Revolution 1688', it refers to the 'Book of Statutes', 'Magna Charta', the 'Bill of Rights', 'King William's Declaration for restoring the Liberties of England' and 'Parliament Full, FREE and FREQUENT'.

156 *A heron*, *c*.1815, from the 'Book of Ornithology' compiled for Fawkes's son Richard. According to Edith Mary Fawkes, they were 'originally painted to illustrate a curious book compiled by a brother of Walter Fawkes's of birds feathers, the book was also decorated with cuts from Bewick's Birds'. The drawings were later removed and bound separately.

It had become his habit to spend some time each year with the Fawkes family; Farnley was a second home throughout the decade. His fellow-feeling with Fawkes on the subject of Parliamentary reform found expression in a series of emblematic drawings portraying the history of Parliament from the time of Charles I and the Civil War to the Glorious Revolution of 1688. (It was illustrated by items from the Farnley collection of relics of Sir Thomas Fairfax, with whom Fawkes was particularly proud to be connected.) There was also a set of views of the house and its neighbourhood, executed in about 1815–18 – the 'Wharfedales', as Fawkes called them: fresh, spontaneous-seeming accounts in a liquid gouache of a spot that had become very important for Turner, records of his love of the place and the people there. One of them shows an entrance gate to the Farnley estate with a pair of lodges which Turner himself designed, in a simple classical style. For Hawksworth's young brother Richard he made a 'Book of Ornithology', some twenty coloured drawings of birds, including a heron with a fish in its beak, a peacock, a chicken and an owl. But despite his fondness for the children he was as secretive here as everywhere else about his working methods, and it was only by accident that the family learnt anything of them. The little girls confessed to being frightened of him, but once, 'When Turner's bed-room door was open, they saw cords spread across the room as in that of a washerwoman, and papers tinted with pink, and blue, and yellow, hanging on them to dry. Turner always had a sitting-room and bed-room provided for him at Farnley, and Mr Fawkes gave orders that he was to be received in them even if he himself were absent' (*The Athenæum*, 1894, p. 327).

But Hawksworth himself was once given the unique privilege of watching the creation of a complete watercolour:

> one morning at breakfast Walter Fawkes said to [Turner], 'I want you to make me a drawing of the ordinary dimensions that will give some idea of the size of a man of war.' The idea hit Turner's fancy, for with a chuckle he said to Walter Fawkes's eldest son, then a boy of about 15, 'Come along Hawkey and we will see what we can do for Papa', and the boy sat by his side the whole morning and witnessed the evolution of 'The First Rate taking in Stores'. His description of the way Turner went to work was very extraordinary; he began by pouring wet paint till it was saturated, he tore, he scratched, he scrubbed at it in a kind of frenzy and the whole thing was chaos – but gradually and as if by magic the lovely ship, with all its exquisite minutia, came into being and by luncheon time the drawing was taken down in triumph. (E. M. Fawkes, TS)

Beside the call of friendship he had good business reasons to travel north: there were watercolour commissions not only from Fawkes but also from his neighbours Sir William Pilkington and Sir John Swinburne; and in 1816 another important order for watercolour views had come from the Rev. Thomas Whitaker, as Turner told Farington on 17 May of that year, at a Mansion House dinner given by the Lord Mayor of London:

> Turner told me that He had made an engagement to make 120 drawings views of various kinds in Yorkshire, for a History of Yorkshire for which he was to have 3000 guineas. Many of the subjects required, He said, He had now in his possession. He proposed to set off very soon for Yorkshire to collect other subjects.

Farington had already heard (on 15 May) a rumour to this effect; and indeed, the commission was sufficiently munificent to have been much gossiped over: a very ambitious project, it was intended to fill seven volumes, and Turner originally asked forty guineas apiece for his drawings. The publishers,

155
150–154
150
156
158
170

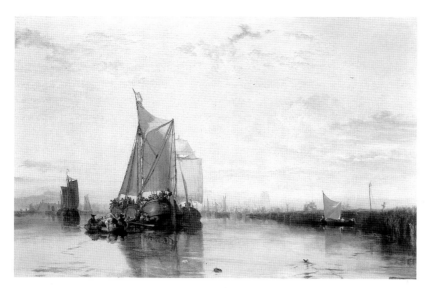

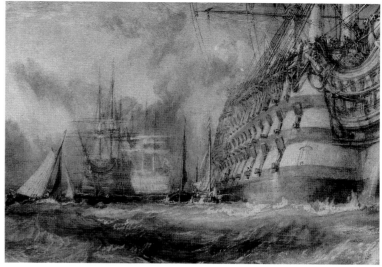

Longman, beat him down to twenty-five. Twenty designs eventually appeared, as the *History of Richmondshire*; the rest of the scheme came to nothing, for Whitaker died at the end of 1821. The tour that Turner made in connection with it in 1816 was marred by the constant heavy rain of that legendarily bad summer. The Fawkes family accompanied him some of the way, and Mrs Fawkes noted in her diary the 'Dreadful rain' that spoiled their trip. Eventually on 25 July she recorded: 'Heavy rain. Turner went on a sketching tour'; but despite the weather the artist collected his material across the Pennines to Lancashire and Westmorland, and back again. A postscript to a letter written to his friend the watercolourist James Holworthy on 31 July puts in a nutshell his attitude to the adverse conditions: 'Weather miserably wet; I shall be web-footed like a drake, except the curled feather; but I must proceed northwards. Adieu!' (G. 65). He was fond of associating himself with ducks, punning on his family name of Mallord as if it were 'mallard'. He signed a letter to Callcott with a drawing of the bird (G. 329). Another letter to Holworthy, written from Farnley and dated 11 September, returns to the subject of rain:

> As to the weather there is nothing inviting it must be confessed. Rain, Rain, Rain, day after day. Italy deluged, Switzerland a wash-pot, Neufchatel, Bienne and Morat Lakes all in *one*. All chance of getting over the Simplon or any of the passes *now* vanished like the morning mist, and in regard to my present trip which you want to know about, I have little to say by this post, but a most confounded fagg, tho on horseback. Still, the passage out of Teesdale leaves everything far behind for difficulty – bogged most compleatly Horse and its Rider, and nine hours making 11 miles – but more of this anon. The post calls me away, and only says tell Holworthy to write by the like return of mail. (G. 68)

He loved telling of his adventures on the road, and Holworthy was to hear more on the same theme, as we shall see. He was a favoured confidant who received some of Turner's most entertaining and unguarded letters. It is clear from the remarks Turner makes about Switzerland and Italy that by this date, with the war well and truly over, he was anxious to go abroad again. In the late summer of 1817 he managed to do so, visiting the battlefield of Waterloo and travelling up the Rhine as far as Mainz. When he got back, he had to go once more to the north of England, staying first at Raby Castle to make drawings for a view of that house for the third Earl of Darlington, and then at Farnley, where he sold a set of fifty-one watercolour studies on the Rhine to Fawkes for £500. On 21 November, at Farnley, he sent Holworthy a report of his doings:

157 *Dort or Dordrecht: The Dort packet-boat from Rotterdam becalmed*, oil, 1818. The keystone of Fawkes's collection, this picture was purchased at the insistence of Hawksworth, who 'went to the private view at the Royal Academy and saw the picture, and went home and told his father it must be bought. His father refused, saying, that he had already spent more money on pictures than he was justified in doing, and his son's answer was "I believe you want me to cut off the entail – that is my price" – so the picture went down to Farnley' (E. M. Fawkes, TS).

158 *A First-Rate taking in Stores*, watercolour, 1818.

159 An undated letter from Turner to Callcott, probably of about 1820.

115

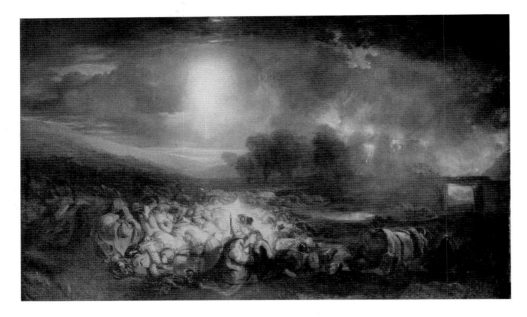

160 *The Field of Waterloo*, oil, 1818. The most full-bloodedly romantic of all Turner's statements about war, and one that anticipates the work of Delacroix in the 1820s, this picture was shown at the Academy with a stanza from Byron's *Childe Harold* in the catalogue. It was the first time Turner had made use of the poem, which was to be an important inspiration for him until the 1830s.

Dear Holworthy,

I hope no implacability will be placed to my long silence, almost as long as yours e'er you wrote to me or to Mr Knight [of Langold]: but your letter with his has been sent about after my fugitive disposition from place to place, and only overtaken my aberations at Farnley, too late for anything. Mr Knight's admonition to come e'er the leaves do fall leaves me like the bare stems (late so gay) to the gust of his displeasure, if he ever is displeased, for I do wish to return to town. 'No leaves', no day, no weather to enjoy, see or admire. Dame Nature's lap is covered – in fact, it would be forestalling Langold to look at the brown mantle of deep strewed paths and roads of mud to splash in and be splashed. – As you have got me in the mud, so you, I hope, will help me out again, and place me in as good a position as possible. Very likely he is in town by this time; if so, do call in my behalf, and you may say truly that I had written a letter to say I could be with him at Langold from the 23rd to the 29th October, but Lord Strathmore called at Raby and took me away to the north; that the day of the season is far spent, the night of winter near at hand; and that Barry's words are always ringing in my ears: '*Get home and light your lamp*'. So Allason found the art of construction

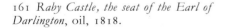

161 *Raby Castle, the seat of the Earl of Darlington*, oil, 1818.

practically arranged, its members defined and beautifully proportioned. When every one seems so happy, why do you delay? for the world is said to be getting worthless, and need the regenerating power of the allworthy parts of the community.

Yours most truly
J. M. W. Turner (G. 70)

The richness of reference in these letters to Holworthy amply demonstrates the quality that Constable had noticed most when he sat next to Turner at the Academy dinner in 1813: 'I was a good deal entertained with [him]. I always expected to find him what I did. He has a wonderful range of mind' (*Constable*, p. 44). They testify to his reading in the Bible, in Shakespeare, in contemporary poetry – there is an oblique reference to Thomas Hood's 'November' in the letter just cited – and in classic English fiction: his complicated pun on Holworthy's name includes a glance at Squire Allworthy in *Tom Jones*. But it is not so much the type of books that Turner knew as the vital and creative use that he makes of his reading when he writes, the lively and intricate texture of his thought. With this breadth of intelligence in mind we can understand better how to interpret his paintings, and see why his friends found him such exceptionally good value in company even though he was habitually shy and taciturn. What he did have to say was thoughtful, erudite and witty. Turner's allusion to Barry is particularly illuminating: although he had been expelled from the Academy in 1799, on the grounds that he had used his lectures on Painting as a platform for general abuse of the institution and its members, James Barry's was one of the most impressive minds of his age, and his practice as a history painter who had tried to elevate his subject-matter to the highest level of seriousness a potent inspiration to Turner in his own battle to win respect for landscape painting.

Perhaps the most touching and convincing of all tributes to Turner's qualities of mind and character was paid in the spring of 1819, when Walter Fawkes opened his London house, 45 Grosvenor Place, to the public. His collection of contemporary watercolours was on show, and its centre-piece was the display of some sixty or seventy works by Turner. The privately printed catalogue, which contained extracts from press reviews, was decorated by Turner, and he was the recipient of the dedication that Fawkes composed for it:

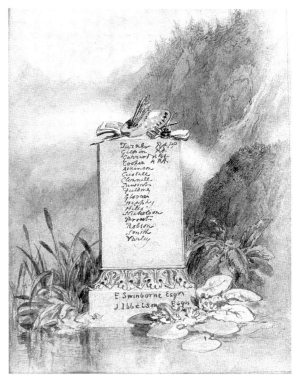

162 The cover of Fawkes's exhibition catalogue, 1819. Turner's watercolour decoration shows the equipment of a watercolour painter resting on a plinth inscribed with names of the artists represented in Fawkes's collection. Two 'amateurs' are included at the bottom. Edward Swinburne, a capable pupil of Turner's, was the son of a patron, Sir John Swinburne of Capheaton, Northumberland.

163 The drawing-room of Fawkes's London house at 45 Grosvenor Place. This watercolour by J.C. Buckler was inserted as a frontispiece in Fawkes's copy of the catalogue of his exhibition. Several of Turner's works are identifiable, including, in the centre of the back wall, the large view of *Scarborough Town and Castle* that Fawkes had bought from the Academy in 1811.

164 Sketch plan of Turner's land at Twickenham, with the large square 'Pond enlarged' which figures in accounts of the garden.

165 Alternative designs for Sandycombe Lodge, accommodating the steep fall of land from front to back of the house.

166 Sandycombe Lodge: the final form of the little villa with its two single-storey wings, seen from the garden, in an engraving of 1814 by W. B. Cooke after William Havell.

To J. M. W. TURNER, ESQ., R.A., P.P.

My Dear Sir

The unbought and spontaneous expression of the public opinion respecting my collection of water-colour drawings, decidedly points out to whom this little catalogue should be inscribed. To you, therefore, I dedicate it, first, as an act of duty; and, secondly, as an offering of Friendship; for, be assured, I can never look at it without intensely feeling the delight I have experienced, during the greater part of my life, from the exercise of your talent and the pleasure of your society.

That you may year after year reap an accession of fame and fortune is the anxious wish of

Your sincere friend,
W. Fawkes (G. 83)

The exhibition was so well received that Fawkes repeated it the next year.

The notion of showing his collection in this way seems to have been suggested to him by the completion of Sir John Leicester's gallery of British art in Hill Street, Mayfair, which was opened in March 1819. Leicester owned eight important oil paintings by Turner, a large enough number to attract much of the ecstatic praise that the exhibition provoked. They were *Kilgarren Castle* (R.A. 1799), *Fall of the Rhine at Schaffhausen* (R.A. 1806; exchanged by Turner for the *Shipwreck* of 1805), *A Blacksmith's shop* and *Sun rising through vapour* (both 102, 67 R.A. 1807), *On the Wey* (Turner's Gallery, 1807), *Pope's Villa* (Turner's Gallery, 1808), and two views of his house, Tabley (R.A. 1809). 118

Altogether 1819 was a year of success for Turner, and he relished it. On 7 July 1819, for example, the Academy Club (which existed solely as an excuse for eating and drinking on the part of the Academicians) had an outing up the river; Farington described the occasion:

At 10 oClock I went to Westminster Bridge and there found the Ordnance Shallop and several members of the Academy Club. We rowed down the river to look at the Iron Bridge and then proceeded up the river. Till noon the weather was rather bleak, but it then cleared up and was very pleasant. We had 10 rowers. The river was a scene of much gaiety from the display of City Barges & Pleasure Boats. We stopped at Barnes, and in the Boat had a loaf and cheese while the Boatmen had fare in the Inn. We then proceeded to the *Eel Pye house* at Twickenham where we landed, a little after 3 oClock and about 4 we sat down to excellent fare brought from the Freemasons Tavern under the management of a Clever Waiter. The members of the Club present were,
Messrs. Dance – Farington – Bone – Turner – Mulready – Chalon – Owen – Thomson – Smirke Senr. – Westmacott – Chantrey.

We dined in the open air at one table and removed to another to drink wine and eat fruit. Every thing went off most agreeably. Before 7 oClock we again embarked and rowed down the river, – the tide in our favour, and a full moon. Turner and Westmacott were very loquacious on their way back. We landed at Westminster Bridge at 20 minutes before 10 . . .

Twickenham was a stretch of the Thames bank always associated with conviviality. By this time Turner was well established at his house there, now renamed Sandycombe Lodge. This small villa had been constructed to his own 166 design, of brick and stucco, with broad Italian overhanging eaves proclaiming its rural character, and unusual details of brickwork cornices and sunk panels that recall contemporary work by Sir John Soane. The entrance vestibule is a remarkable arched and domed space with delicate incised and gilt mouldings.

Turner had of course worked briefly as an architectural draughtsman, at the beginning of his career, for Thomas Hardwick and perhaps also William Porden and Joseph Bonomi, and had retained an interest in the subject; in 204 addition, he and Soane were good friends: the architect had bought two of Turner's grandest watercolours, a Yorkshire subject of 1798 and the earliest of 69 the great Swiss watercolours, *St Hugh denouncing vengeance on the shepherd of Courmayeur*, shown at the Academy in 1803. It is more than likely that Soane 167 contributed the elegant entrance to Turner's modest house. The drawings that 164–5 Turner made for his new country retreat are mostly contained in a sketchbook used about 1812 (TB CXXVII) in which he also noted financial memoranda, detailing the cost of doors, windows, brickwork, roof, walls, floor, slates, plastering, and ornament. In all his outlay was to amount to about £1,000.

According to F. E. Trimmer, the villa was

168 an unpretending little place, and the rooms were small . . . There were several models of ships in glass cases, to which Turner had painted a sea and background. They much resembled the large vessels in his sea pieces . . .

164 Here he had a long strip of land, planted by him so thickly with willows that his father, who delighted in the garden, complained that it was a mere osier-bed. Turner used to refresh his eye with the run of the boughs from his sitting-room window.

At the end of his garden there was a square pond – I rather think he dug it himself – into which he put the fish he caught. The surface was covered with water-lilies. I have been out fishing with him on the Old Brent, with a can to catch trout for this preserve; but the fish always disappeared; at last he discovered that a jack was in the pond: and Turner would have it that it had been put in to annoy him.

I have dined with him at Sandycombe Lodge, when my father happened to drop in, too, in the middle of the day. Everything was of the most modest pretensions, two-pronged forks, and knives with large round ends for taking up the food; not that I ever saw him so use them . . . The table-cloth barely covered the table, the earthenware was in strict keeping. (T., I, pp. 167–8)

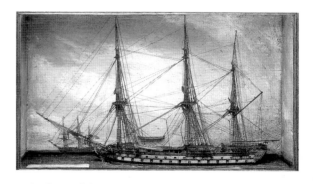

168 One of the models of ships that Turner kept at Sandycombe, in a glass case with background painted by himself.

193 Here his devoted 'Daddy' acted as factotum, and apparently went with him backwards and forwards between London and Sandycombe to act as studio assistant, gardener and cook. He was, F. E. Trimmer says, 'much respected, and I was told by the vicar that he was a regular attendant at the parish church'. (T., I, p. 163).

Shortly after the house was finished Turner had severe misgivings about keeping it up, and even seems to have found a prospective buyer. In a letter to Henry Scott Trimmer dated 1 August 1815 he admitted that

Sandycombe sounds just now in my ears as an act of folly, when I reflect how little I have been able to be there this year, and less chance (perhaps) for the next in looking forward to a Continental excursion, & poor Daddy seems as much plagued with weeds as I am with disappointments, that if Miss — would but wave bashfulness, or – in other words – make an offer instead of expecting one – the same might change occupiers – (G. 56)

But he could not dispense with a bolt-hole of some kind; and beside, the riverside spot suited his passion for angling. Trimmer's son remembered the fishing expeditions they embarked on together when he was a boy, and Turner's unaffected delight in the company of the young, who did not drive him back into himself by their expectations or assumptions:

169 Francis Chantrey, by Thomas Phillips, c.1817 (detail).

170 *Wycliffe, near Rokeby*, watercolour, for Whitaker's *Richmondshire*, c.1819. Of the engraving Pye recounted that 'Turner, when touching the Proof, introduced a burst of light (the rays seen above the Hall) which was not in the Drawing. On being asked his reason he replied: – "That is the place where Wycliffe was born and the light of the glorious Reformation." "Well," said Pye, satisfied, "but what do you mean by the large geese?" "Oh, they are the old superstitions which the genius of the Reformation is driving away!"' (R. 177). A few impressions of the plate are inscribed, apparently by Turner himself, with a caption summarizing the history of the vernacular Bible in England, in terms of the punishments meted out to those who read it illegally. The caption may well have been added at the request of Fawkes, for circulation among a select group of his radical friends.

When a child, I have been out fly-fishing with him on the Thames; he insisted on my taking the fish, which he strung on some grass through the gills, and seemed to take more pleasure in giving me the fish than in taking them. These little incidents mark character. He threw a fly in first-rate style, and it bespeaks the sportsman wherever the rod is introduced into his 111 pictures. (T., I, p. 169)

Turner's colleague George Jones, who became an intimate friend and fellow-fisherman, reported that

His success as an angler was great, although with the worst tackle in the world. Every fish he caught he showed to me, and appealed to me to decide whether the size justified him to keep it for the table, or to return it to the river; his hesitation was often almost touching, and he always gave the prisoner at the bar the benefit of the doubt. (T., II, p. 123)

And Turner could go out with his great companion the sculptor Francis 169 Chantrey, who was, he claimed, a more 'scientific' angler, if not a more successful one, than himself. They

used to hire a boat at Isleworth, and after an early lunch of bacon and eggs, would angle out the day. In Turner's villa at Twickenham there is a pretty little piece of sculpture, (Paul at Iconium, from the Cartoon, but with variations), supposed to have been given him by Chantrey. It is let into the wall over the dining-room chimney. (Watts, p. xlv)

There were more professional matters to be attended to in the neighbourhood as well. Young Trimmer was again sometimes of the party:

Besides his boat, he had a gig and an old horse: an old crop-eared bay horse, or rather a cross between a horse and a pony. In this gig he used to drive out sketching, and take my father and myself with him. His sketching apparatus was under the seat. I remember once going on an expedition of this kind to Staines, and from thence to Runnymede, where he made some sketches; from there [? = them] he painted a picture which strongly resembles the place to this very day. We went, I remember, a very steady pace, as Turner painted much faster than he drove. He said, if when out sketching you felt at a loss, you had only to turn round or walk a few paces further, and you had what you wanted before you. (T., I, p. 170)

The horse, or pony, 'old crop-ear', was a familiar at Sandycombe. Its portrait accompanied that of Evelina in *Frosty morning*. It 'would climb a hill like a cat 149 and never get tired', and so was well-matched to Turner's own indefatigability.

He was much attached to it; but there seems to have been little return of affection, as the restive creature was always at issue with him. Once, when the pony was ill, Turner prescribed for him himself, having a great objection to farriers' bills. In struggling one night to free himself from his toils, for he had to be fastened up with chains, he got strangled. Turner grieved over him sincerely, and gave him decent burial in his garden. (Watts, p. xxvii)

His love for animals, like his fondness for children, was a recurrent memory of those who knew him. Watts mentions that when Turner lived at Sandycombe he was 'nicknamed "Blackbirdy" by the boys, from his habit of chasing them away from the blackbirds' nests which were plentiful in his garden' (Watts, p. xxvii).

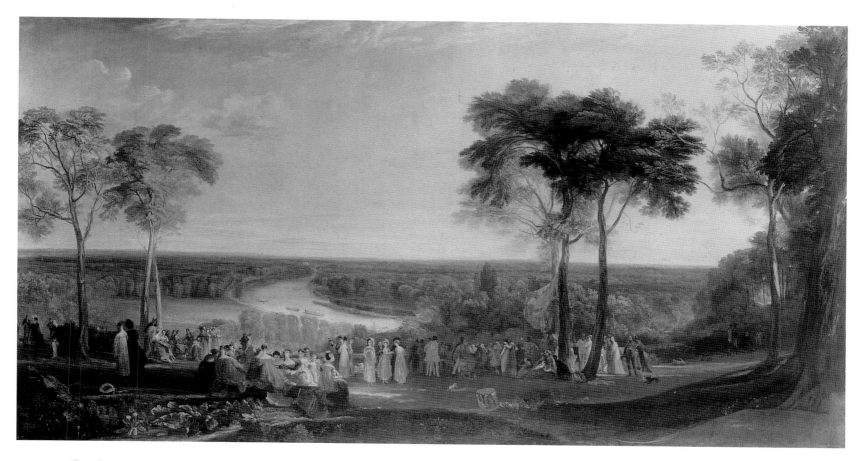

By the summer of 1819 he was at last on top of his commissioned work; the *History of Richmondshire* designs were finished, and a set of views in Sussex that had been commissioned by the eccentric M.P. Jack Fuller of Rosehill were in the press; and he had sent two particularly large and splendid canvases to the 171 Academy exhibition, *Entrance of the Meuse* and *England: Richmond Hill, on the Prince Regent's Birthday*, works which summed up the developments in his art of the past few years. Paying homage respectively to Van de Velde and to Claude, they were manifestly novel: brilliant in colour, grand with an almost complete dismissal of the old 'Sublime' histrionics, they sang out from among the surrounding works in the exhibition with a lyrical assurance that preluded the mood of his work throughout the ensuing decade. He had already occasionally made alterations to pictures while they were on the walls during varnishing days, and this year he seems to have done so with a boldness that foreshadows his future practice. His colleagues were unsure whether they approved. Farington reported on 2 May:

> Hayes called and having been at the Exhibition private view, defended the merits of [Richard] Cooke's picture, which like others suffers from the flaming colours in Turner's pictures. – He spoke of the pernicious effects arising from Painters working upon their pictures in the Exhibition by which they often render them unfit for a private room.

Turner's entries stated his position with optimism and confidence; he was ready for fresh challenges. His affairs being in order, he could finally gratify his long-held wish to see Italy, and, at the beginning of August, he set out. The stimulus of this adventure was such that he was impelled, most unusually for him, to begin a diary. It was not his accustomed method of making notes and he abandoned it after one scrappy entry; but that entry is enough to communicate his sense of the excitement of being on the Continent again, among unpredictably varied people and their equally varied views on life.

171 *England: Richmond Hill, on the Prince Regent's Birthday*, oil, 1819. One of the largest of Turner's canvases, this view from near Sir Joshua Reynolds's house towards Sandycombe Lodge seems deliberately to link his own name with that of the Prince Regent, perhaps as a bid for royal patronage. With its echoes of Watteau as well as Claude it anticipates the lyrical developments in his painting of the 1820s.

Left Dover at 10 arr. Calais at 3 in a Boat from the Packet Boat. beset as usual. began to rain [next morn. *inserted*] on the setting out of the Dil[igence] Conversation in the diligence the Russe 2 Frenchmen and 2 English Cab. 3 Engl. Russe great par Example the Emperor Alexander tooit part tout the French tres bon zens but the English everything at last was bad, Pitt the cause of all, the Kings death and fall and Robespierre their tool. Raind the whole way to Paris. Beaumont sur Oise good

The last remark is presumably his comment on a possible landscape subject. He is back in his old touring habit, the diary set aside. His first reactions on seeing Italy were, inevitably, to compare it with the paintings he knew: 'The first bit of Claude', he jotted against a sketch of scenery near Loreto (TB CLXXVII, f.6). And when he reached Rome, he did not mingle much with the English artists and connoisseurs who swarmed there, but worked to a gruelling self-imposed schedule of travelling and sketching: Tivoli and the Abruzzi, Naples, Paestum, and the whole of Rome, including its antiquities, its buildings and its collections of Renaissance art he devoured steadily, filling over a dozen notebooks with pencil drawings, and making some gloriously fresh and unaffected records in watercolour of his delight and wonder at the light and the landscape. Finberg 127 counted some 1,500 drawings made in and around Rome alone, mostly the pencil notes with which he crammed his sketchbooks; but among them are about 200 more substantial studies, in pencil or watercolour, often on the grey 128 washed ground that he had adopted since his youth as a means of obtaining 174–5 tonal coherence and pictorial unity while working direct from nature. The coloured subjects were worked up in his lodgings; Sir John Soane's son wrote his father a letter on 15 November which gives us a glimpse of Turner at work:

> Turner is in the neighbourhood of Naples making rough pencil sketches to the astonishment of the Fashionables, who wonder of what use these rough draughts can be – simple souls! At Rome a sucking blade of the brush made the request of going out with pig Turner to colour – he grunted for answer that it would take up too much time to colour in the open air – he could make 15 or 16 pencil sketches to one coloured, and then grunted his way home. (Soane, pp. 284–5)

But he did take part in some social events, and was recommended as an honorary member of the Academy of St Luke by no less a figure than Antonio Canova. He penned his thanks to the great sculptor on 27 November 1819, giving as his address the Palazzo Poli:

> My Dear Sir
> I have sent the letter addressed to the President of the Academy of St Luke's as you directed me and I beg leave that you will allow me the opportunity of offering you my most sincere thanks for the distinguished honour of your Nature in recommending me. Your approbation of my Indeavours in the Art will be very long felt believe me, My Dear Sir, by Your most truly obliged Ser[t].
>
> J. M. W. Turner (G. 86)

He had arrived in Rome on 27 October; he returned to London on 1 February 1820, having spent all of January on the road home. The weather was bad, and he was involved in an accident in the snow on top of the Mont Cenis 176 Pass. With his customary relish of travellers' tales, he made a watercolour of the incident for Fawkes, and long afterwards recounted it in a letter to Holworthy written in January 1826:

172 Turner prepared himself for his Italian tour by copying out passages from the Rev. J. C. Eustace's *Tour through Italy* (1813) and by making thumbnail sketches from plates in *Select Views in Italy* by Smith, Byrne and Emes (1792–6), including the Castel St Angelo, the Colosseum, the Forum, and subjects at Tivoli.

173 *Turin: the Cathedral*, pencil, 1819.

Mont Cenis has been closed up some time, tho the papers say some hot-headed Englishman did venture to cross a pied a month ago, and what they considered *there* next to madness to attempt, which honor was conferred once on me and my companion de voiture. We were capsized on the top. Very lucky it was so; and the carriage doors so completely frozen that we were obliged to get out at the window – the guide and Cantonier began to fight, and the driver was by a process verbal put into prison, so doing while we had to march or rather flounder up to our knees nothing less in snow all the way down to Lancesllyburgh [Lanslebourg] by the King of Roadmakers' Road, not the Colossus of Roads, Mr MacAdam, but Bonaparte, filled up with snow and only known by the precipitous zig-zag . . . (G. 112)

All that he had ingested in Italy still had to be properly digested. He might have been expected to produce a series of Italian subjects for the Academy's exhibition; but that would scarcely have been possible in the time before the sending-in day in March, even if he had been able to marshall his newly won knowledge sufficiently rapidly. In the event his single entry, a huge canvas of
129 *Rome from the Vatican. Raffaelle accompanied by La Fornarina, preparing his pictures for the decoration of the Loggia,* was in itself a miracle no less of industry than of imagination. It is a comprehensive tribute to the eternal city, seen in a panorama framed by the architecture and treasures of the Vatican, with the snow-capped Apennines in the distance, and celebrating one of the greatest of Rome's painters. In the sweep of its view, and the wealth of the ideas that it advances, it is an avowal of what Italy meant to Turner. It demonstrates that he had acquired a new perception of his art: more flexible and more universal than before, and embracing all aspects of life and thought, as the art of the Renaissance had done.

He had produced three enormous canvases in the last two years, and was under pressure of space at 64 Harley Street. The last exhibition held there seems to have been in 1816, and he had been negotiating for some time to acquire the lease of 47 Queen Anne Street after it expired in 1818. (He had of course been a tenant there since 1810.) This he succeeded in doing, and from 1819 to 1822 he was once more in the throes of building, constructing a new, larger gallery to accommodate his work and the public who were to come and see it. He wrote to Wells, on 13 November 1820, alluding in his most intricate punning style to Wells's own school days in a room on the site:

Many thanks to you for your kind offer of refuge to the Houseless, which in the present instance is humane as to cutting, you are the cutter. Alladins palace soon fell to pieces, and a lad like me can't get in again unsheltered and like a lamb. I am turning up my eye to the sky through the chinks of the Old Room and mine; shall I keep you a bit of the old wood for your remembrance of the young twigs which in such twinging strains taught you the art of wiping your eye of a tear purer far than the one which in revenge has just dropt into mine, for it rains and the Roof is not finish'd. Day after day have I threatened you not with a letter, but your Mutton, but some demon eclypt Mason, Bricklayer, Carpenter &c. &c. &c. . . . has kept me in constant osillation from Twickenham to London, from London to Twit, that I have found the art of going about doing nothing – 'so out of nothing, nothing can come'. (G. 89)

These upheavals were the prelude to a new order, which dawned as the next decade proceeded.

174 *Rome: the Portico of St Peter's and the Via della Sagrestia,* watercolour, 1819.

175 *The Colosseum and the Arch of Constantine from the Via di San Gregorio,* watercolour, 1819.

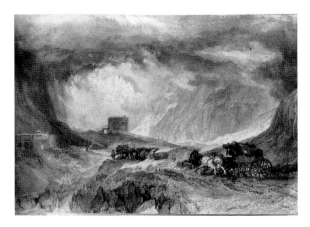

176 'Passage of Mt Cenis Jan 15 1820', watercolour, 1820.

Chronology 1811–1820

1811

1 January: Part V of the *Liber Studiorum* issued.

7 January: Turner delivered the first of his Perspective lectures, one of a course of six given at weekly intervals, at a fee of £10 per lecture. It was fairly well received, though the audience became gradually less tolerant of his awkward delivery and attendance fell off. The coloured diagrams and drawings illustrating his matter are in the Turner Bequest (TB CXCV); notes and sketches for the lectures are in the *Perspective* sketchbook (TB CVIII).

Royal Academy exhibition: 4 oils and 5 watercolours shown. His most praised contribution was *Mercury and Hersé* (70; B&J 114), to which the Prince Regent, speaking at the annual dinner, was thought to refer when he alluded to 'landscapes that Claude would have admired'; but he did not buy it. Other oils were *Apollo and Python* (81; B&J 115); *Somer-Hill, near Tunbridge, the seat of W. F. Woodgate, Esq.* (177; B&J 116); and *Whalley Bridge and Abbey, Lancashire: Dyers washing and drying cloth* (244; B&J 117). Watercolours: *Windsor Park, with horses by the late Sawrey Gilpin, Esq. R.A.* (295; W.414; Gilpin had died in 1807); *November: Flounder-fishing* (312; W.491) and its companion, *May: Chickens* (351; already shown at Turner's Gallery in 1809 under the title *Cottage Steps: Children feeding Chickens*); *Scarborough Town and Castle; Morning: Boys catching crabs* (312; W.528); and *Chryses* (332; W.492). *November, May* and *Scarborough* were acquired by Fawkes.

Turner's Gallery was closed this year, pending alterations.

1 June: Parts VI and VII of the *Liber Studiorum* issued.

July: publication of the first two cantos of Byron's *Childe Harold's Pilgrimage*, a poem in which Turner seems to have perceived a literary equivalent of his own vision. He was frequently to quote from it in exhibition catalogues.

July–September: tour of Dorset, Devon and Cornwall, in connection with a commission from William Bernard Cooke and his brother George to make drawings for a publication, *Picturesque Views on the Southern Coast of England*. His itinerary was Salisbury, Christchurch, Poole, Corfe Castle, Lulworth, Weymouth, Bridport, Lyme Regis, Sidmouth, Exeter, Teignmouth, Torbay, Brixham, Totnes, Ivy Bridge, Plymouth, Looe, Fowey, Lostwithiel, Falmouth, Penzance, St Michael's Mount, Land's End, Redruth, Bodmin, Wadebridge, Padstow, Tintagel, Boscastle, Bude, Clovelly, Bideford, Barnstaple, Ilfracombe, Combe Martin, Minehead and Watchet, returning via Wells, Frome and Stonehenge to Salisbury. Sketchbooks used on this tour are *Devonshire Coast No. 1* (TB CXXIII), *Corfe to Dartmouth* (TB CXXIV), *Ivy Bridge to Penzance* (TB CXXV) and *Somerset and North Devon* (TB CXXVI).

Late autumn: stayed for a short time at Farnley.

4 December: attended an Academy Council meeting.

10 December: elected a Visitor in the Royal Academy Schools with Callcott, Shee and Thomas Phillips.

Began work on a companion to the *Oxford High Street* for Wyatt, *Oxford from the Abingdon Road* (B&J 125).

This year he left Upper Mall, Hammersmith.

1812

January–February: second course of Perspective lectures delivered.

1 February: Part VIII of the *Liber Studiorum* published.

23 April: Part IX of the *Liber Studiorum* published.

Royal Academy exhibition: 4 oil paintings shown, the 2 views of Oxford painted for Wyatt (161, 169); *A view of the Castle of St Michael, Near Bonneville, Savoy* (149; B&J 124), a repetition of the subject exhibited in 1803; and *Snow storm: Hannibal and his army crossing the Alps* (258; B&J 126). The last title was accompanied in the catalogue with eleven lines of blank verse, citing a 'Manuscript Poem', *Fallacies of Hope* (by Turner himself). He objected to the high position allocated *Hannibal* by the hanging committee, and had it placed below the line, i.e. at eye level.

Turner's Gallery, 11 May–6 June: the gallery reopened, now approached from Queen Anne Street West. Pictures shown were the re-exhibited *Calder Bridge* (T.G. 1810) and *Mercury and Hersé* (R.A. 1811); also *The River Plym* (possibly *Hulks on the Tamar*, B&J 118), bought by Lord Egremont; *Teignmouth* (B&J 120), also bought by Egremont; *Saltash with the Water Ferry* (B&J 121); *Ivy Bridge Mill, Devonshire* (B&J 122); and *St Mawes at the Pilchard Season* (B&J 123).

25 May: Part X of the *Liber Studiorum* published; this issue included the Frontispiece, which depicts a composition of the Rape of Europa, framed, and in an elaborate architectural cartouche.

Summer: Turner supervised the building of his Twickenham house, Solus Lodge, later renamed Sandycombe Lodge (see drawings in the *Windmill and Lock* sketchbook, TB CXIV, and *Sandycombe and Yorkshire* sketchbook, TB CXXVII).

4 November: Farington recorded that Turner 'complained much of a nervous disorder, with much weakness of the stomach. Everything, he said, disagreed with him – turned *acid*. He particularly mentioned an aching pain at the back of his neck.'

November–December: visited Farnley for a month, returning by 16 December.

28 November: wrote to the Secretary of the Academy asking for a postponement of his next course of Perspective lectures, due in January, on account of illness. This was agreed.

Whitaker's *History of Craven*, including a plate by James Basire after Turner's *South Transept of Fountains Abbey, Yorkshire* of 1798 (W.238), appeared this year.

1813

No Perspective lectures given.

February: *Mercury and Hersé* (R.A. 1811, T.G. 1812) bought by Sir John Swinburne for 550 guineas.

Solus (Sandycombe) Lodge completed early this year.

Royal Academy exhibition: 2 oil paintings shown,

Frosty Morning (15; B&J 127); and *The Deluge* (213; B&J 55), probably seen at Turner's Gallery in 1805.

Turner's Gallery: the exhibition may have included *Windsor Castle from the* Thames (executed c.1805 and possibly shown then; B&J 149) and *The Thames at Weybridge* (B&J 204), both bought by Egremont.

28 June: at the annual dinner of the Academy Constable sat next to Turner, with whom he was 'a good deal entertained'.

Summer: second tour of the West Country, principally Devon, collecting further material for the *Southern Coast* and for another project of the Cookes, *The Rivers of Devon* (for which only 4 designs were engraved (W.440–444; R.137–140) and none was published). The tour was centred at Plymouth, and made partly in the company of Cyrus Redding. His itinerary included the following places, probably in roughly this order: Ashburton, Sharpham, Dartmouth, Plymouth, Saltram, Bigbury Bay, Dodbrook, Sheep's Tor, Tavistock, Gunnislake, Calstock, Weir Head, Endsleigh, Launceston, Okehampton, Hatherleigh, Torrington, Bideford and Appledore; perhaps also, to visit relatives, Barnstaple and South Molton. Sketchbooks used are *Plymouth, Hamoaze* (TB CXXXI), *Devon Rivers No. 1* (TB CXXXII), *Devon Rivers No. 2* (TB CXXXIII), and *Devon Rivers No. 3 and Wharfedale* (TB CXXXIV). Turner made a number of small oil sketches on prepared paper during this tour (B&J 213–225).

1 November: attended a meeting of the Academy Council. Shortly afterwards he travelled to Farnley.

Finberg notes (*Life*, pp. 204–5) that Turner's accounts for this year show only a modest increase of income since 1810 – just above £2,000. He suggests that this may have been due in part to the continuing hostility of Sir George Beaumont.

1814

10 January–6 February: Turner gave a new series of Perspective lectures, after having left the manuscript in a hackney coach, and recovered it by placing an advertisement in the *Morning Chronicle*.

British Institution exhibition, from 7 February: the Directors had offered a premium for the best landscape 'proper in Point of Subject and Manner to be a Companion' to a work by Claude or Poussin; Turner submitted *Apullia in search of Appullus* (168; B&J 128), closely modelled on Lord Egremont's Claude *Landscape with Jacob and Laban*; but the picture arrived late, and the premium was awarded to T. C. Hofland. It has been suggested that the late entry was a gesture of defiance to the Directors of the Institution, especially Sir George Beaumont. Nevertheless, despite Turner's theoretical ineligibility, since he was an Academician, his name was among those considered as candidates for the premium.

22 or 23 April: visited the exhibition of the Society of Painters in Oil and Water-Colours (a temporary reconstitution of the Water-Colour Society – see 1805 – which lasted only from 1812 to 1818), where Benjamin Robert Haydon's *Judgment of Solomon* was on

show. Haydon considered that Turner 'behaved well and did me justice'.

Royal Academy exhibition, from 2 May: one oil painting shown, *Dido and Æneas* (177; B&J 129).

Turner's Gallery, 9 May–20 June: the exhibition was announced as the 'last Season but two', an indication of his plans to enlarge and improve his gallery.

20 June: at Portsmouth, sketching a review of the Fleet in the presence of the Emperor of Russia, the King of Prussia and the Prince Regent; used the *Review at Portsmouth* sketchbook (TB CXXXVI).

November: probably visited Farnley, returning to London by 10 December.

A second version of the subject of *Æneas and the Sibyl, Lake Avernus*, which Turner had painted for Colt Hoare in about 1798 (B&J 34), dates from this year (B&J 226). Although Hoare had failed to acquire the earlier canvas, this one was bought by him; in it, Wilsonian pastiche is replaced by Turner's mature Claudian manner.

The first four parts of the *Picturesque Views on the Southern Coast of England* appeared in the course of this year; they included 7 plates after Turner (R.88–94), all engraved by the Cookes (see 1811).

The Artists' General Benevolent Institution was inaugurated this year, with Turner as a founder member.

1815

2 January: the course of Perspective lectures began.

Royal Academy exhibition: 4 oil paintings and 4 watercolours shown, including several works previously seen at his own gallery, or executed much earlier. There were 3 of Fawkes's large Swiss watercolours, *The passage of Mount St Gothard* and *The great fall of the Riechenbach* (281, 292; both probably T.G. 1804), and *Lake of Lucerne, from the landing place at Fluelen, looking towards Bauen and Tell's chapel, Switzerland* (316; W.378); a new Alpine subject in watercolour, the most ambitious of the series, was *The Battle of Fort Rock, Val d'Aouste, Piedmont, 1796* (192; W.399); this was accompanied in the catalogue by ten lines from the *Fallacies of Hope*. Oils: *Bligh Sand, near Sheerness: Fishing boats trawling* (6), shown at Turner's Gallery in 1809; *Crossing the brook* (94; B&J 130); *Dido building Carthage; or the rise of the Carthaginian Empire. – 1st book of Virgil's Æneid* (158; B&J 131); and *The eruption of the Souffrier Mountains, in the island of St Vincent, at midnight, on the 30th of April, 1812, from a sketch taken at the time by Hugh P. Keane, Esq.* (258; B&J 132). Both *Dido* and *Crossing the brook* attracted enthusiastic praise from artists and public alike. *Dido* was apparently considerably modified during the three varnishing days that preceded the exhibition, since once critic noticed that 'When we first saw this Picture, the yellow predominated to an excessive degree . . . the Artist has since glazed it down in the water.' This may be an early instance of Turner's use of the varnishing days to make important changes to his pictures on the Academy's walls.

March–July: the exiled Louis Philippe was a neighbour at Orleans House, Twickenham.

4 May: an exhibition of Flemish and Dutch pictures opened at the British Institution. It was much resented by the Academicians, who regarded it as a rival to their own annual show and a perversion of the original purpose of the Institution. An attack on the Directors appeared in the form of a pamphlet entitled *A Catalogue Raisonné of the Pictures now exhibiting at the British Institution*. Among other things, this defended Turner against the slurs cast on his work by Beaumont, who at first thought of suing the author. (The writer's identity was not discovered, though Callcott and Henry Thomson were named. Fawkes was also mentioned as a possible instigator.)

Turner's Gallery: probably opened in May, but there is no record of an exhibition.

1 August: a letter to the Rev. H. S. Trimmer suggests Turner was contemplating selling Sandycombe Lodge.

August: to Farnley in time for the grouse shooting. It is probably now that he made a series of drawings of Fawkes's collection of 'Fairfaxiana' and designs for trophies illustrating the history of Parliament, also the bird drawings that comprise the 'Book of Ornithology'; and that he began to gather material for a series of watercolour views of Farnley and its neighbourhood, a pet project of Fawkes's which he referred to as 'the Wharfedales'. Sketching in Yorkshire, Turner used the *Yorkshire No. 1* sketchbook (TB CXLIV).

Summer: possible visit to the south coast, collecting material for the *Views in Sussex* commissioned by Jack Fuller (see 1810). Sketchbooks used in connection with this project are the *Vale of Heathfield* (TB CXXXVII), *Views in Sussex* (TB CXXXVIII), *Hastings* (TB CXXXIX) and *Hastings to Margate* (TB CXL).

28 November: Haydon took Canova to Turner's studio; 'He exclaimed "grand Genie" as he looked at his pictures.'

9 December: elected a visitor to the newly established School of Painting at the Academy.

1816

1 January: Parts XI and XII of the *Liber Studiorum* issued, containing 3 plates engraved in mezzotint by Turner himself (R.55, 58, 60).

The course of Perspective lectures was delivered.

Royal Academy exhibition: 2 oil paintings shown, *The temple of Jupiter Panellenius restored* (55; B&J 133), and *View of the Temple of Jupiter Panhellenius, in the island of Ægina, with the Greek national dance of the Romaika: the Acropolis of Athens in the distance. Painted from a sketch taken by H. Gally Knight, Esq. in 1810* (71; B&J 134).

Turner's Gallery: the last of the exhibitions before the enlargements of 1819–21 probably took place this year, though no record of it survives.

15 and 17 May: Farington reported that Turner had been commissioned to make 120 drawings for Dr Whitaker's *History of Yorkshire*, for a fee of 3,000 guineas. This was later quoted (Farington, 20 December 1817) as 2,000 guineas with expenses, which Turner insisted should be paid extra. The work was never finished, but he supplied 20 designs for the first part of it, a *History of Richmondshire*, published between 1819 and 1823 (W.559–580; R.52–61).

Summer: to Farnley in July. Made a short tour with Fawkes, his second wife (who kept a journal) and four of his children; it rained a great deal, but Turner made a number of drawings in the *Yorkshire No. 2* sketchbook (TB CXLV). He went on alone, in pursuit of material for Whitaker's commission, travelling through Yorkshire and Lancashire on horseback through very wet weather; his notes were made in the *Yorkshire 1, 2, 3, 4, 5* and *6* sketchbooks (TB CXLIV–CXLIX), which he used extensively when making the finished watercolours for the project. He was back at Farnley by 11 September.

Also this summer, a second *Catalogue Raisonné* (see 1815) appeared, using the excuse of an exhibition of Italian and Spanish painting at the British Institution to attack Beaumont and his colleagues, especially the four men (Beaumont among them) appointed by Government as a Committee of Taste to judge the Waterloo monument competition. They were defended by Haydon and Hazlitt, who lampooned the Academy in *The Examiner*.

November: the third Canto of Byron's *Childe Harold* published.

This year the *History and Description of Cassiobury Park* was published with aquatint plates after drawings made by Turner in 1807 (R.818–821).

The 13 watercolour views in Sussex for Jack Fuller were probably finished this year. Engravings by W. B. Cooke from 6 of them, with an emblematical cover design probably etched by Turner, were published as the first part of *Views in Sussex* between 1816 and 1820 (W.423–438; R.128–134). (Two parts had been advertised, but the second did not appear on account of a quarrel between Cooke and the publisher, John Murray.)

Whitaker's *Loidis and Elmete* (on Leeds and its neighbourhood) published, with 3 designs after Turner.

1817

Turner gave no Perspective lectures this year, probably because of pressure of work for the engravers.

April: he attended the anniversary dinner of the Artists' General Benevolent Institution, subscribing 11 guineas to its funds. He may have been one of its founders.

Royal Academy exhibition: only one canvas shown, *The decline of the Carthaginian Empire – Rome being determined on the overthrow of her hated rival, demanded from her such terms as might either force her into war or ruin her by compliance: the enervated Carthaginians, in their anxiety for peace, consented to give up even their arms and their children* (195; B&J 135). The catalogue entry included these lines from *Fallacies of Hope*:

... At Hope's delusive smile,
The chieftain's safety and the mother's pride,
Were to th'insidious conqu'ror's grasp resign'd;
While o'er the western wave th'ensanguin'd sun,
In gathering haze a stormy signal spread,
And set portentous.

The picture was a sequel to *Dido building Carthage* of 1815.

10 August–mid-September: sailed from Margate to Ostend, to visit the battlefield of Waterloo, and travelled up the Rhine from Cologne to Mainz; his itinerary was Bruges, Ghent, Brussels, Liège, Aix-la-Chapelle (Aachen), Cologne, Bonn, Remagen, Coblenz, St Goar and Mainz, returning via Antwerp, Rotterdam, the Hague, Amsterdam, Utrecht and Dordrecht. He sailed home from Rotterdam. Sketchbooks used on the tour are *Itinerary Rhine Tour* (TB CLIX), containing a list of principal towns and names of inns, *Waterloo and Rhine* (TB CLX), *The Rhine* (TB CLXI), and *Dort* (TB CLXII).

Back in England, he visited Raby Castle, collecting material for a picture of the castle commissioned by Lord Darlington, and toured County Durham for Surtees's *History of Durham*. He used two sketchbooks; *Raby* (TB CLVI) and *Durham, North Shore* (TB CLVII).

Mid-November–early December: at Farnley. While there he made or finished a set of 51 colour studies of views on the Rhine (w.636–686), bought by Fawkes, apparently for £500.

In the latter part of the year his daughter Evelina was married to Joseph Dupuis 'with the consent and approbation of her father'. (Dupuis left England in November 1818 to take up residence in Ashanti as Consul. Evelina accompanied him, and bore him children.)

1818

5 January: the course of Perspective lectures began. This year they were given twice-weekly.

Royal Academy exhibition: 3 oils and one watercolour shown. His entries were dominated by *Dort or Dordrecht: The Dort packet-boat from Rotterdam becalmed* (166; B&J 137), which was bought by Fawkes for 500 guineas. The other oils were *Raby Castle, the seat of the Earl of Darlington* (129; B&J 136) and *The Field of Waterloo* (263; B&J 138), with lines from Byron's *Childe Harold* in the catalogue. The watercolour was the large *Landscape: Composition of Tivoli* (474; w.495), executed for John Alnutt.

4 May: William Owen told Farington that Callcott 'could not [paint] such a picture as the "View of Shields" [exhibited this year] in less than 6 months, whereas Turner could paint such as the "View of Dort" in a month'.

15 June: the publisher John Murray paid Turner 200 guineas for 10 watercolour views in Italy, made from camera-lucida pencil outlines by James Hakewill, to be engraved for Hakewill's *Picturesque Tour of Italy*. This appeared between 1818 and 1820 with 18 plates in all (w.700–717; R.144–161). Turner was employed in preference to other artists including John Varley, whose designs were judged unsuitable.

6 August: Turner purchased some freehold land on Twickenham Little Common, perhaps already intending to build there, as stipulated in his will, almshouses for indigent artists. He was now Chairman and Treasurer of the Artists' General Benevolent Institution. A sketchbook (TB CLXIII) contains notes concerning the use of the Institution's Fund and its connection with the Artists' Annuity Fund.

End of October: to Scotland to collect material for *The Provincial Antiquities of Scotland*, to be written by Sir Walter Scott, whom he met. Sketchbooks used on the tour are *Bass Rock and Edinburgh* (TB CLXV), *Edinburgh 1818* (TB CLXVI), *Scotch Antiquities* (TB CLXVII), and *Scotland and London* (TB CLXX). The drawings were completed in 1821. The work began to appear in 1819 and concluded in 1826, with a total of 10 plates and 2 title-page vignettes after Turner (w. 1058–1069; R. 189–200).

November: on his journey back from Scotland Turner stayed at Farnley, where he painted the *First Rate taking in Stores* (w.499) and probably several of the views of Farnley, including one of the drawing-room with the newly acquired *Dort*. The 'Wharfedales' and other local views were now mostly finished.

10 December: elected, with his friend the sculptor Chantrey, to serve on the Royal Academy Council.

Sir John Leicester bought the *Sun rising through vapour* of 1807. Turner told him he would not mind if the picture were renamed 'Sun dispelling the morning haze or mist' (G. 78).

J. C. Stadler probably made his large aquatints of 4 of the Fuller *Views in Sussex* this year (R.822-825).

George Field's *Chromatics or, An Essay on the Analogy and Harmony of Colours* published. Turner had known Field, who had been a friend of Girtin, since the beginning of the century; he took a considerable interest in Field's theories.

This year Turner acquired the lease of No. 47 Queen Anne Street West; he also secured the leases of nos. 65 and 66 Harley Street, and annexed the ends of their gardens to his land in Queen Anne Street. He then began to rebuild the property. His new gallery opened in 1822, and a new lease was then granted until 1882.

1819

1 January: Parts XIII and XIV of the *Liber Studiorum* issued, the last to appear.

4 January: the course of Perspective lectures began.

9 February: Turner signed an agreement to make 36 drawings of views on the Rhine, to be engraved by W. B. Cooke and J. C. Allen. The engravers were to get 50 guineas a plate, Turner 17 for each drawing. The work was not completed, probably because of the publication by Rudolph Ackermann of a *Tour of the Rhine*; but at least 4 drawings for it are traced (w.687, 688, 689, 689a).

March: Sir John Leicester's collection of modern British pictures opened to the public at his house in Hill Street, Mayfair. Among them were 8 works by Turner: *Kilgarren Castle* (R.A. 1799), *Fall of the Rhine at Schaffhausen* (R.A. 1806), *On the Wey* (T.G. 1807), *A Blacksmith's Shop* and *Sun rising through vapour* (both R.A. 1807), *Pope's Villa* (T.G. 1808), and the 2 views of Tabley (R.A. 1809).

13 April–mid-June: perhaps inspired by Leicester, Fawkes showed his collection of watercolours at his London house, 45 Grosvenor Place. The saloon was

devoted to 40 by Turner; elsewhere, 20 or 30 of the 'Wharfedale' series were on show, as well as work by other artists, including prominent members of the Water-Colour Society.

Royal Academy exhibition: 2 oil paintings shown, *Entrance of the Meuse: Orange-merchant on the Bar, going to pieces; Brill Church bearing S.E. by S. Masensluys E. by S.* (136; B&J 139), and *England: Richmond Hill, on the Prince Regent's Birthday* (206; B&J 140).

7 July: Farington records an outing on the river with ten other members of the Royal Academy Club.

1 August–end January 1820: travelling on the Continent, to Italy and back. From Dover he went via Calais, Paris, Lyons, Grenoble and the Mont Cenis pass. After visiting Turin, Como and Milan he explored the Simplon pass, then to Verona, Venice, Bologna, Rimini, Ancona, Macerata and Foligno, arriving at Rome on 27 October. From Rome he visited Tivoli, and made a journey south to Naples, Herculaneum, Pompeii, Amalfi, Sorrento, Salerno and Paestum. He probably spent Christmas in Florence. The journey was planned in the *Route to Rome* and *Italian Guide Book* sketchbooks (TB CLXXI, CLXXII); the former also contains sketches made on the journey. Other books used on the tour are *Paris, France, Savoy 2* (TB CLXXIII), *Turin, Como, Lugarno, Maggiore* (TB CLXXIV), *Passage of the Simplon* (TB CXCIV), *Milan to Venice* (TB CLXXV), *Como and Venice* (TB CLXXXI), *Venice to Ancona* (TB CLXXVI), *Ancona to Rome* (TB CLXXVII), *Tivoli and Rome* (TB CLXXIX), *Vatican Fragments* (TB CLXXX), *Albano, Nemi, Rome* (TB CLXXXII), *Tivoli* (TB CLXXXIII), *Gandolfo to Naples* (TB CLXXXIV), *Pompeii, Amalfi, Sorrento and Herculaneum* (TB CLXXXV), *Naples, Paestum and Rome* (TB CLXXXVI), *Naples, Rome C[olour] Studies* (TB CLXXXVII), *St Peter's* (TB CLXXXVIII), *Rome: C. Studies* (TB CLXXXIX), *Small Roman C. Studies* (TB CXC), *Rome and Florence* (TB CXCI), *Return from Italy* (TB CXCII) and *Remarks (Italy)* (TB CXCIII). In Rome he may have met Byron, through the offices of the poet Tom Moore.

1 November: Constable elected an Associate of the Royal Academy.

This year he inherited, through his mother, a third share of land and houses at Shadwell, and undertook to act as rent collector. He later converted his cottages into a tavern, the Ship and Bladebone.

1820

1 February: arrived in London, having travelled from Italy over the Mont Cenis Pass, where the coach was overturned in a snowstorm.

2 February: attended the Academy Club dinner.

11 March: death of West. Lawrence elected to replace him as President of the Academy.

Royal Academy exhibition: only one oil painting shown, *Rome from the Vatican. Raffaelle accompanied by La Fornarina, preparing his pictures for the decoration of the Loggia* (206; B&J 228). It was not favourably received.

Made several watercolours of Italian subjects, purchased by Fawkes (W.719–724).

Worked up some of the Rhine subjects of 1817 into finished watercolours for Sir John Swinburne, who probably chose views from the drawings in Fawkes's collection.

April–22 June: Fawkes's London house again open to the public, every Thursday, for the inspection of his watercolours.

2 August: at the Academy Council meeting, Turner proposed that larger pensions should be awarded to Associates and their widows. The proposal was adopted.

Work on the new exhibition gallery at Queen Anne Street went forward this year, preventing him from making a summer tour. He refers in an undated letter (G. 92) to an 'accident': this may have been the snapped Achilles tendon mentioned by F. E. Trimmer (T., I, p. 178).

1821–1830

177 *Ulysses deriding Polyphemus – Homer's Odyssey* (detail). The subject, in which the hero and his comrades sail off, leaving the giant impotently shaking his fist on the mountain top, was one of the classical themes that Turner had mulled over along the Thames in the early years of the century: an idea for it is sketched in the *Wey, Guildford* sketchbook (TB XCVIII, f.5r). Painted immediately after his return from Rome in 1829, it was exhibited at the Academy that year, and must reflect the renewed impact of the Renaissance and Baroque masters he had seen there. It is perhaps the most gloriously sensuous of all his mythological subjects, celebrating the grandeur of a primeval world of good and evil, colour and light. It represents the high point of his experiments with pure colour, the watershed of his development. From this date on, his work is more concerned with the atmosphere than with the substance of landscape.

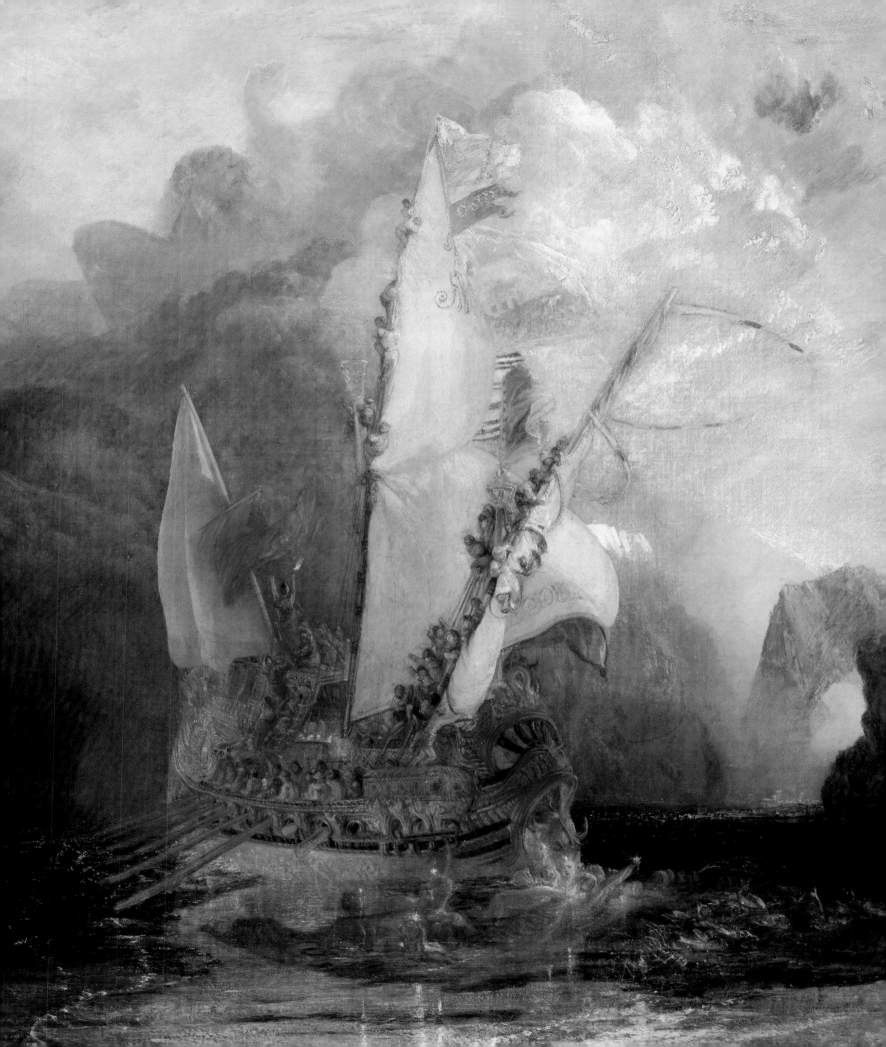

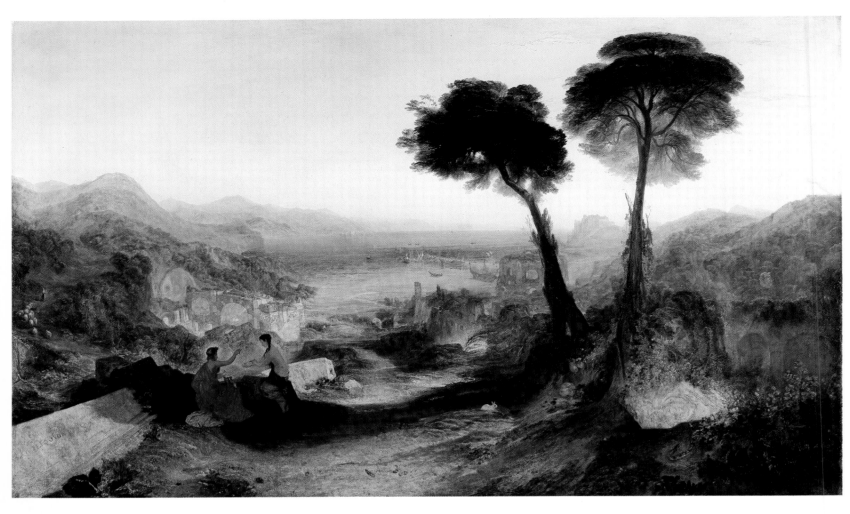

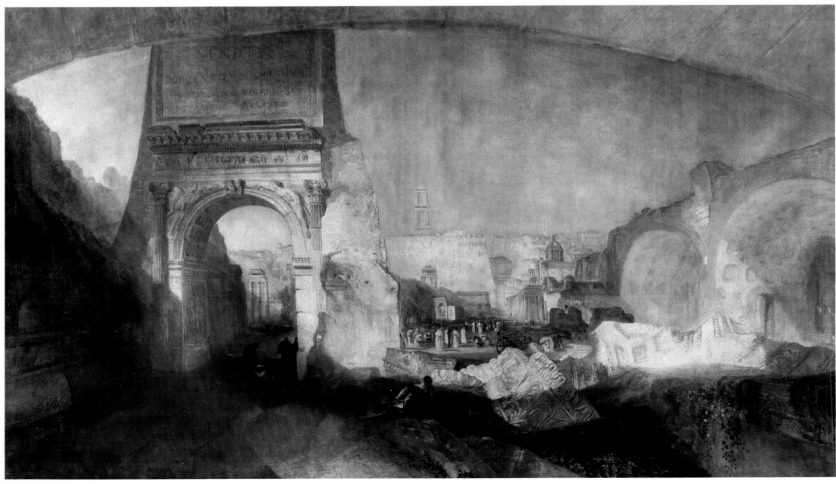

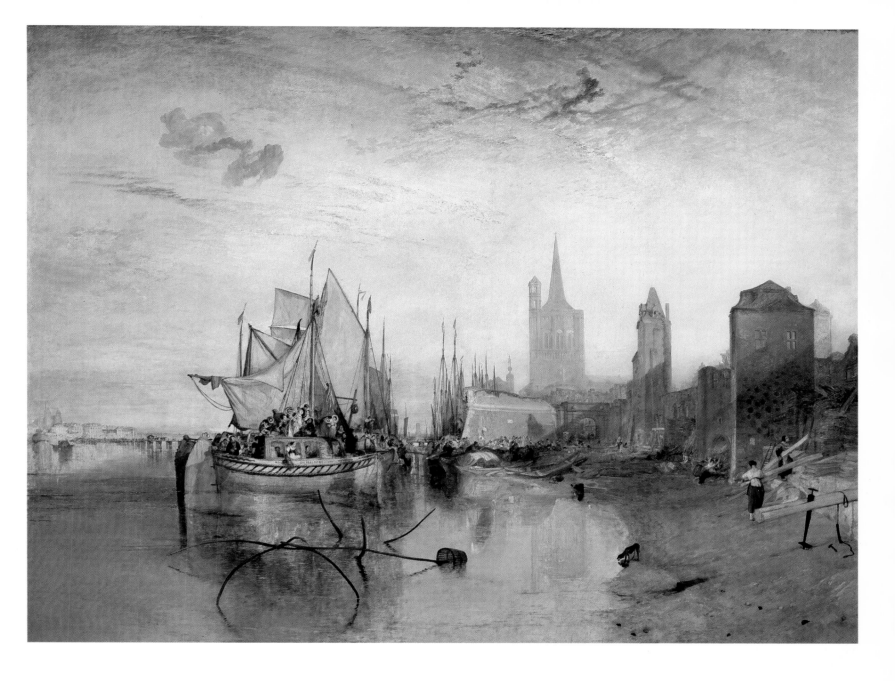

Exhibited oil paintings of the 1820s

Turner's contributions to the Academy exhibitions were less prodigal in the 1820s than in other decades: he was assimilating the lessons of his Italian journey, and steadily evolving, largely by means of experiments in watercolour, the new language of his later output. *The Bay of Baiæ, with Apollo and the Sybil* (178), shown in 1823, restated his longstanding fascination with the Claudian ideal of Italy in the light of his recent experience on the spot. In 1826 the last of his three Italian canvases, *Forum Romanum, for Mr Soane's Museum* (179), appeared at the Academy with a northern subject, *Cologne, the arrival of a packet boat. Evening* (180). Constable was particularly impressed by the exhibits of 1826: 'Turner has some golden visions, glorious and beautiful; they are only visions, but still they are art, and one could live and die with such pictures' (*Constable*, p. 166).

Ruskin liked to recount an anecdote about the *Cologne* which illustrated Turner's generosity. The picture was hung with a portrait by Lawrence on each side: 'The sky of Turner's picture was exceedingly bright, but it had a most injurious effect on the colour of the two portraits. Lawrence naturally felt mortified . . . On the morning of the opening of the exhibition, at the private view, a friend of Turner's who had seen the Cologne in all its splendour, led a group of expectant critics up to the picture. He started back from it in consternation. The golden sky had changed to a dun colour. He ran up to Turner, who was in another part of the room. "Turner, what have you been doing to your picture?" "Oh," muttered Turner in a low voice, "poor Lawrence was so unhappy. It's only lamp-black. It'll all wash off after the exhibition!"' (R., XII, pp. 130–31).

Turner and the publishers

Throughout the 1820s Turner was engaged in a series of ventures, from the *Rivers of England*, published as a set of mezzotints on steel between 1823 and 1825, to the ambitious *Picturesque Views in England and Wales* on which he was to work until the mid-1830s. The Cookes, who were responsible for the former, mounted exhibitions of watercolours in 1822 and 1823 at their Soho Square premises. In the second appeared the large watercolour, *Margate. Sunrise* (181), which displayed all the virtuosity of Turner's mature technique.

Among the subjects supplied for the *Rivers of England* was *Shields on the River Tyne* (182), a nocturnal view of coal-heavers, which was particularly suited to the warm tonal medium of mezzotint into which it was to be translated. The subject was adapted by Turner in 1835 for *Keelmen heaving in coals by night* (253).

The *Picturesque Views in England and Wales* were begun in 1825 for Charles Heath (see ill. 225), like the Cookes an engraver as well as a publisher. The scheme called forth the whole range of Turner's creative powers. He prepared many subjects by means of 'colour structures', like that for a view of *Cockermouth Castle* (183, never realized).

Typical of the series in its lively social comment is *Richmond Hill and Bridge* (184), engraved in 1832. It was the first of Turner's watercolours to be acquired by Ruskin, who considered 'that it had nearly everything *characteristic* of Turner in it, and more especially the gay figures!' (R., XIII, p. 436). The view towards Richmond Hill, where Reynolds had lived, from a spot not far from his own Twickenham, was one particularly dear to Turner.

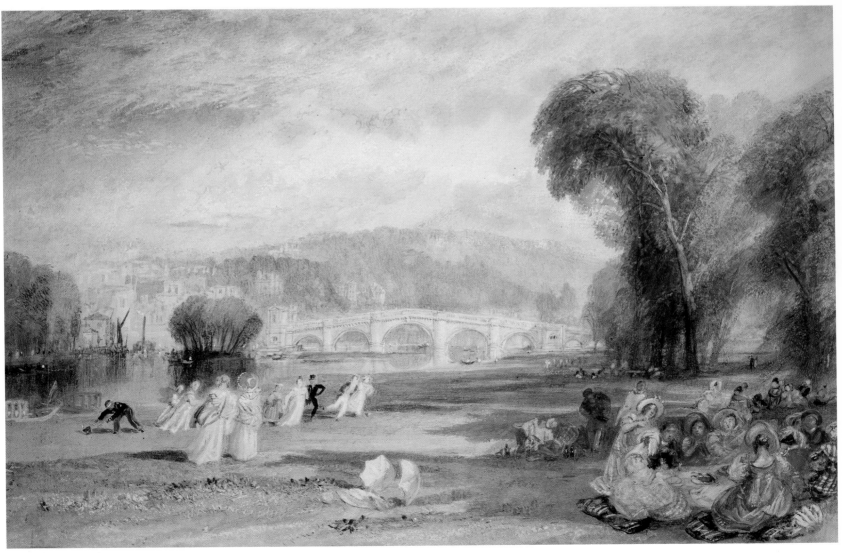

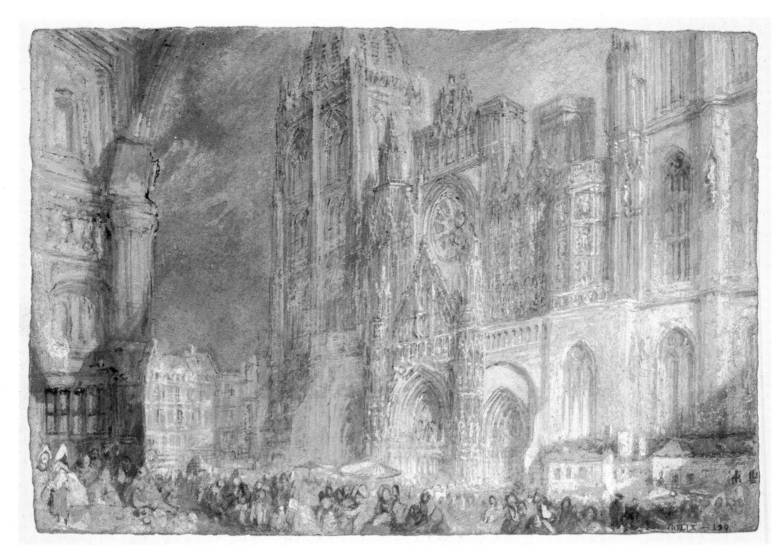

A further important project of the 1820s
was the series of views of the 'Great
Rivers of Europe' for which Turner
travelled widely, making studies and
finished designs alike on small sheets of
blue paper. Some of the most
astonishing of his colour experiments are
to be found among the sketches for
views on the rivers Meuse and Moselle
(186); in the event, only two Rivers
were published, under the title of
*Turner's Annual Tour – Wanderings by the
Loire* (1833) and *Wanderings by the Seine*
(1834, 1835). Although most are general
views of scenery and towns, there are
occasional studies of particular
buildings, like the spectacular façade of
Rouen Cathedral (185), with its bustling
market below, from the Seine series.
Some of these drawings were later
worked up as finished watercolours –
the view of *Saumur* (187), on the Loire,
is an example.

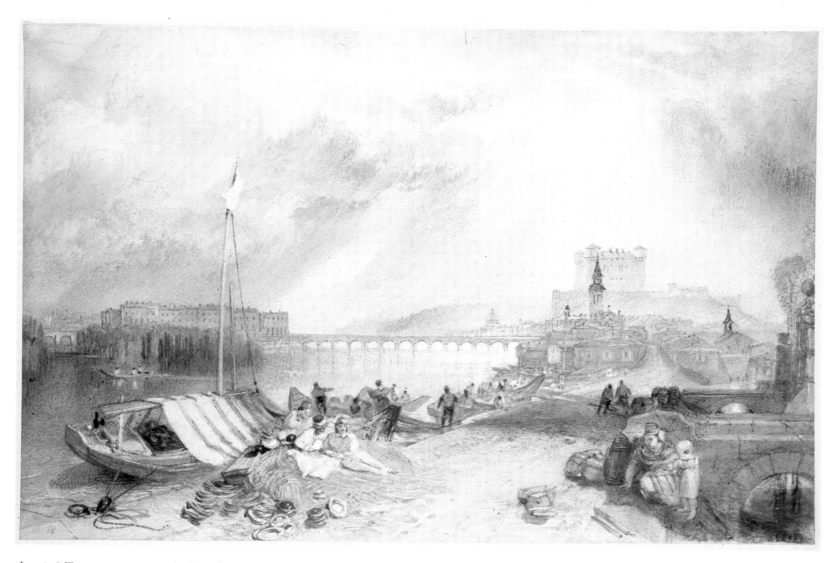

In 1826 Turner was approached by the banker, collector and poet Samuel Rogers to make illustrations for a new edition of his poem *Italy*; by 1828 he had produced a series of exquisite vignettes, executed on a miniature scale but with all the richness and intensity of his larger watercolours. Such was the success of the volume, published in 1830, that a further book of Rogers's *Poems* followed in 1834. Turner's *cul-de-lampe* for this was the idyllic evening river scene, *Datur Hora Quieti* ('Now is the hour of peace'; 188, actual size). Ruskin was to recall 'on my thirteenth birthday, 8th February 1832, my father's partner, Mr Henry Telford, gave me Rogers' Italy, and determined the main tenor of my life. . . . I had no sooner cast eyes on the Rogers vignettes than I took them for my only masters' (R., XXXV, p. 79).

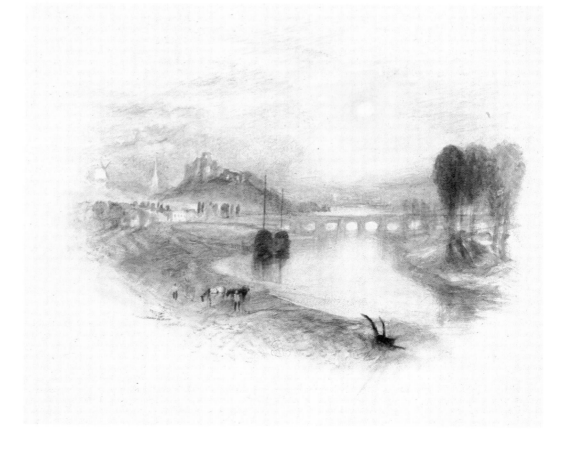

189 *Funeral of Sir Thomas Lawrence, a sketch from memory.* A
spontaneous impression of the scene outside St Paul's
Cathedral on 7 January 1830; Turner wrote to a friend, 'It is
something to feel that gifted talent can be acknowledged by
the many who yesterday waded up to their knees in snow
and muck to see the funeral pomp swelled up by carriages of
the great'. The watercolour, shown at the Academy in 1830,
illustrates Turner's deep-seated affection not only for an
eminent colleague but for the Academy as a whole, which
Lawrence in his capacity as President had represented.

1821~1830

BY THE EARLY 1820s Sarah Danby had ceased to play any important part in Turner's life. She lived on until at least 1829, when in his first will he allowed her an annuity of £10 – a sum so small as to imply no more than a nominal relationship. At all events, by then their connection, such as it was, had been a mere formality for a long time. If Sarah remained at Queen Anne Street, she was kept out of sight with almost sinister success. It was her niece Hannah, probably aged about thirty-five in 1820, who admitted visitors and became a familiar member of the ménage there.

191 Turner now had yet more property to attend to. He had inherited from an uncle on his mother's side of the family some buildings in Shadwell, near Wapping. They consisted of two small cottages, nos. 7 and 8 New Gravel Lane. His cousin Henry Harpur, a solicitor, inherited two others, nos. 9 and 10. In due course Turner had his cottages converted into a public house, the Ship and Bladebone, and used to make regular journeys out there to collect the rents. These excursions, taken with the colourful reputation of riverside Wapping in those days, were interpreted by gossip as furtive searches for sexual gratification among the dockland brothels; and indeed, if the state of his emotional affairs at this period can be deduced from the evidence (or lack of it) afforded by Sarah's role in his life, it would not be entirely surprising if he had used the opportunity to seek out a little pleasure incognito. It is evident from occasional bouts of erotic scribbling in his notebooks that he had a lively sexual appetite, which may well have driven him into casual relationships. That would have been almost to be expected in a man as temperamentally solitary as Turner. It has been claimed that on these clandestine expeditions he made erotic studies of 'the sailors' women, painting them in every posture of abandonment' – and that these were the 'grossly obscene drawings' destroyed in December 1858 by the Keeper of the National Gallery 'for the sake of Turner's reputation (they having been assuredly drawn under a certain condition of insanity)' and for the peace of mind of the officials responsible for them. But since he must have been well known at the Ship and Bladebone he is unlikely to have used it as a locale for any such adventures.

184 Meanwhile, he 'osillated' between London and Twickenham, between his working life in the city and the relaxation of the country. He was said to have chosen his site at Twickenham because it was within view of Richmond Hill where Sir Joshua Reynolds had lived. In May 1821 he had an opportunity to pay homage to Reynolds in a more practical fashion. At Christie's sale of Sir Joshua's effects from the estate of the Marchioness of Thomond there occurred what the *Morning Herald* described as 'a warm contested bidding between Mr. Soane, R.A., Mr. Turner, R.A., and Mr. Herschel' for an Italian notebook; this was acquired by Herschel (the astronomer), and Turner instead bought a portrait sketch of Admiral Keppel, a portrait of a lady, possibly the Duchess of Devonshire, and a portrait of Reynolds himself.

So much at his ease did Turner feel at Twickenham that he even felt uninhibited about entertaining his professional colleagues. A letter from him to

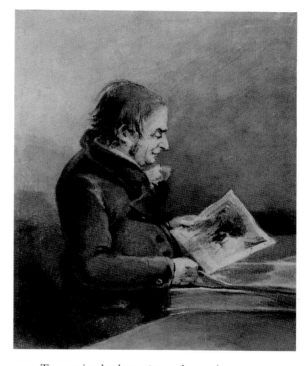

190 Turner in the late 1820s, drawn by J. T. Smith. Smith, a topographical draughtsman and writer, was Keeper of Prints and Drawings at the British Museum from 1816 till his death in 1833. This study of Turner leafing through prints (he perhaps holds a Claude etching) in the Print Room is one of the most revealingly intimate of all portraits of the artist.

191 Plans of nos. 7, 8, 9 and 10 New Gravel Lane, Shadwell. From the Indenture of Partition of 19 March 1821, whereby Turner and his cousins Henry and Eleanor Harpur divided between them the freehold they had inherited from the Marshall family. New Gravel Lane ran between Wapping Wall and Ratcliffe Highway along the east side of Eastern Dock.

the animal painter and Academician Abraham Cooper, dated 7 August 1821, proposes a jolly gathering of artists:

> Dear Sir
> The *second* meeting of the Pic-nic-Academical Club will take place at Sandycombe Lodge, Twickenham, on Sunday next, at about three o'clock. Pray let me know in a day or two that the *Sec^y* may get something to eat.
> Yours truly,
> Jos. Mallord Wm. Turner

For map, turn over to the other side. (G. 96)

The map shows Sandycombe Lodge in its lane off the road from Isleworth to Twickenham, with, in the other direction, the main road curving down to the Thames and Richmond Bridge.

In the early 1820s Turner seemed to be reliving, as it were, his first years of success in London: his eye refreshed and reinvigorated by its experience of Italy, which he had approached with a deliberate innocence, and his exhibiting habits interrupted, as they had been in 1804, by the opening of his gallery. Among his colleagues he was genial and popular. He had formed some close friendships, notably that with Chantrey, and his oddities were by now known and allowed for. After he had dined with Wilkie in mid-December 1821, Wilkie wrote to Andrew Geddes of a 'jollification at which Turner was a distinguished guest . . . we found him a good-humoured fellow, neither slack in wit himself, nor loth to be the cause of wit in others' (*Wilkie*, p. 14).

It was a brief caesura before he pushed forward into what was to prove the second half of his career. There is a feeling of balance about these years, of a level plain of achievement having been reached; of the natural yet brilliant and purposeful flowering of a leisurely-opened blossom. He produced fewer important paintings, though *Rome from the Vatican* stands at the beginning of 129 the decade and *Ulysses deriding Polyphemus* at its end. On the other hand, his work 177 as a watercolourist approached its apogee, following a course that led him by the inexorable process of his own technical logic to a new language of colour. His later developments were founded on the experiments he made in this field during the 1820s.

In this last decade of his father's life, Turner seems to have enjoyed a closer relationship with him than ever. Even though he was now elderly, 'Daddy' 193 never failed to give his services without stint for his son. F. E. Trimmer recalled that

> he was to be seen daily at work in his Garden, like another Laertes, except on the Tuesday, which was Brentford market day, when he was often to be seen trudging home with his weekly provisions in a blue handkerchief, where I have often met him, and asking him after Turner, had answer, 'Painting a picture of the battle of Trafalgar, &c. &c.' (T., 1, pp. 6–7)

In Queen Anne Street old William was kept at work in both professional and household tasks:

> The old man latterly was his son's willing slave, and had to strain his pictures, and varnish them when finished, which made Turner say that his father began and finished his pictures for him. But I doubt if he varnished many pictures; few of them, I believe, were varnished at all; still, he was of great assistance to his son, and I think it was Mr Turner, the engraver, who told me that once making bold to enter Turner's studio, he found the old man on his knees colouring a canvas, when Turner made his appearance, and good-humouredly trundled out the visitor, telling him he was on forbidden ground . . . (T., 1, p. 163)

It was on a thoroughly domestic matter that Turner wrote to Wells in September 1823:

> Dear Wells
>
> My Daddy cannot find the recipe, but I have puzzled his recollection out of two things . . . Poppies and Camomile . . . $\frac{1}{2}$ a cup of poppy seeds to a good handfull of Camomile flowers simmer'd from a Quart of water to a pint in a glazed vessel . . . and used by new-flannel as hot as can be . . . alternately one piece soaking, while the other is applied . . . to keep up equal warmth.
>
> Yours most truly
> J. M. W. Turner (G. 99)

In 1826 Turner sold Sandycombe to Joseph Todd, a retired haberdasher, against his father's wishes. At first the old man had resented the move out of town – mainly because of the expense involved in commuting – but now he was loath to return. According to F. E. Trimmer,

> As he advanced in years, his son had him with him in London, and sold the place in Richmond, much to the old man's dislike. I have heard Turner censured for it; but he told my father that 'Dad' was always working in the garden and catching cold, and required looking after. . . . The father and son lived on very friendly terms together; and the father attended to the gallery, showed in visitors, and took care of the dinner, if he did not himself cook it. (T., 1, pp. 163–4)

Ruskin recalled the story,

> which I daresay you have heard, of how Turner was one day showing some great man or other round his gallery, and Turner's father looked in through a half-open door and said, in a low voice, 'That 'ere's done,' and that Turner taking no *apparent* notice, but continuing to attend this visitor, the old man's head appeared again, after an interval of five or six minutes, and said, in a louder tone, 'That 'ere will be spiled.' I think Landseer used to tell the story as having happened when he and one of his many noble friends were going the round of Turner's gallery about the time that Turner's chop or steak was being cooked. (R., xxxv, p. 577)

192 *A couple on a bed* and *Two figures watching a sleeping woman*, c.1830, an opening from the *Colour Studies No. 1* sketchbook.

193 William Turner senior; a portrait attributed to Charles Turner. 'I have found a way at last,' he told a friend, 'of coming up cheap from Twickenham to open my son's gallery – I found out the inn where the market-gardeners bait their horses, I made friends with one on 'em, and now, for a glass of gin a-day, he brings me up in his cart on the top of the vegetables' (T., 1, p. 165).

194 No. 47 Queen Anne Street West, showing Turner's studio windows on the first floor. The rebuilding of 1819–21 reflected his idiosyncrasy in its parsimonious fenestration. (The two lights on either side of the door were probably added by a later owner.) The façade conforms to the requirement of his landlord the Duke of Portland that it should be 'built with new-picked Stocks neatly pointed, it is not to be stuccoed'. Clara Wells had 'often heard Turner say that if he could begin life again he would rather be an architect than a painter' (T., II, p. 57).

The fashionable world was anxious to see the new gallery that he opened in 1822. No. 47 Queen Anne Street West had been extensively remodelled, 194 including the whole of the façade – as simple and plain as possible, with an austere, well proportioned front door which in George Jones's opinion was 'the best architecture in the street' (Jones, *Turner*, p. 6) – to Turner's own design. In May, the *Repository of Arts* noted that 'Mr. Turner has rebuilt and newly arranged his private gallery and opened it to the public inspection. Some of the 291, best of his pictures can now be seen there.' As had happened twenty years 307 previously, the Academy suffered while his energies were focused on his own display. Farington had learnt from Chantrey on 6 April 1821 'that *Turner* has no picture for the Exhibition this year, and that he has not a single commission for a picture at present'. Chantrey added 'alluding to his being in good circumstances, "He can do very well without any commission."' The fact was that Turner had sold nothing since the *Dort* had been acquired by Fawkes in 1818. He had made a deliberate decision, it seems, to concentrate on practicalities. Having sent nothing to the Academy in 1821 he submitted only the small Watteau-inspired capriccio *What you will!* in 1822 (which was bought by Chantrey); in that year he also missed giving his series of Perspective lectures. Even in the new gallery he seems to have had little that was new to show, and

there were no reviews to supply information. It is difficult to know what the selection of 'some of the best of his pictures' mentioned by the *Repository of Arts* would have been, unless, as Finberg conjectures, they were unsold works from previous years – a construction that the wording of the report seems to invite.

163 At such a time of pause and reassessment it was appropriate that he should be particularly involved in his activities as a watercolourist. It was in that medium that he worked out many of his purposes as an artist, and revitalized his relationship with nature. The exhibitions at Grosvenor Place in 1819 and 1820 had helped to lay a new emphasis on his achievements in watercolour. In 1822, perhaps spurred on by Fawkes's example, the Cookes held their own show of British drawings in their gallery at 9 Soho Square. This display too revolved round a large group by Turner, including, of course, a number of the *Southern Coast* subjects that they had been working on and hoped to sell. The prints

142, themselves were also on view, and came in for their share of admiration. Further

145 selections appeared in 1823 and 1824: there were some finished views on the Rhine, worked up for the Cookes from subjects in the set he had sold to Fawkes in 1817; and examples of the Sussex views done for Jack Fuller.

 In the 1823 show there appeared a particularly spectacular pair ('Two superb Drawings', as the Cookes' advertisement billed them): a *Shipwreck* and

181 *Margate. Sunrise*, which fortunately preserve their virtuoso technical effects and rich colour intact to this day. One, the Margate subject, was engraved in mezzotint by Thomas Lupton, a thirty-year-old printmaker who had worked with Turner on some plates for the *Liber Studiorum* and had formed a high opinion of him, his professionalism and 'his moral rectitude'. At this very time Lupton was perfecting a process of mezzotinting on a steel instead of a copper surface, which promised greatly to enhance the life, and hence the commercial viability, of the plates. Thanks partly to this development and partly to Turner's continuing interest, after the demise of the *Liber Studiorum* in 1819, in the aesthetic implications of mezzotint – the most sensuous and purely tonal of all forms of engraving – the two men were involved together on another project for the Cookes: the *Rivers of England*. Lupton was responsible for five out of the nineteen subjects engraved after Turner (only sixteen were actually published). Four other prints in the series were after drawings by Girtin, and Turner is said to have touched the proofs of these plates, out of respect for his long-dead colleague.

 Lupton's enthusiasm for Turner was not satisfied with this, however, and later in the decade he mezzotinted all twelve of an unfinished series of *Ports of*

182 *England*. The watercolours that Turner made for these two publications are of a jewel-like richness and concentration that anticipates his work on the tiny scale

188 of a book-illustrator. But even more significant is his engagement with the problem of translating the brilliancy of watercolour into the velvety chiaroscuro of mezzotint. He was so taken up with the idea that in about 1826 he designed

197 and himself executed a group of mezzotints which embody the whole essence of the medium: scenes of night, or storm, or opalescent sunset rendered in pure black and white, mysterious and elusive images that have no explanation beyond the artist's fascination with the medium and the technical problems it posed, they form the very pivot of his life's work, an enigmatic clue to much of his later development as a colourist. They are usually referred to as the 'Little Liber Studiorum'.

 His concern with printmaking as one of the great channels of British art is the theme of a letter to the printseller and publisher J. O. Robinson, of Hurst, Robinson & Co., dated 28 June 1822. He refers particularly to some famous subjects by Richard Wilson, engraved by the eighteenth-century master William Woollett:

195, 196 Furnishings from Queen Anne Street, mentioned in the Inventory (see p. 248): 'China figure, Water Carrier' (*c.*1740) from the parlour, a 'Pair of Mahogany Pedestals with Vases' from the dining-room, and two of several 'Mahogany Hall Chairs'.

My dear Sir

 In the conversation of yesterday respecting prints, you said that if I would have engraved a plate worthy of any of my pictures, that you would take 500 impressions, provided none were sold to any other person for two years. If you really meant the said offer for me to think of, it appears to me that my scheme, which I mentioned to you in confidence, would hold – viz. four subjects to bear up with the 'Niobe', 'Ceyx', 'Cyledon', and 'Phaeton' (in engraving as specimens of the British school). Whether we can in the present day contend with such powerful antagonists as Wilson and Woollett would be at least tried by size, security against risk, and some remuneration for the time of painting. The pictures of ultimate sale I shall be content with; to succeed would perhaps form another epoch in the English school; and, if we fall, we fall by contending with giant strength. (G. 97)

Although he had produced relatively few prints himself – a handful of the *Liber* mezzotints, several of which were never published, and the experimental sequel to these, the 'Little Liber' series, which remained equally unknown – he 197 clearly regarded his work, and that of the engravers who translated his designs, as an integral part of the tradition of English printmaking, just as he belonged to the English school of painting. Yet his acute sense of the value of his own pictures was sometimes at odds with his wish to have them engraved, and contributed to the history of his conflicts with the printmakers. For instance, Alaric Watts recounts a visit to Queen Anne Street with J. O. Robinson, in 1825,

by appointment, to look at a picture which had been recommended by Mr John Pye for engraving as a companion to the 'Temple of Jupiter' purchased by that firm for 500 guineas, and splendidly engraved by Mr John Pye [completed in 1828]. But although 750 guineas was the sum Mr Turner had himself named for this picture (his 'Carthage') only a few days before, he had in the interim increased his demand to 1000 guineas. Mr Robinson objected that he could not consent to so large an increase of price, without obtaining the sanction of his partners; but before they had had time to make up their minds, Mr Turner sent them a verbal message, declining to dispose of it at all: he considered it, he said, his *chef d'oeuvre*. (Watts, p. xxix)

His vacillation, his alternating wish to sell his work and to retain it, his conflicting instincts to disseminate his ideas by every available means of publicity, and to hoard and save them until they could be presented *in toto* to the nation, all reveals not doubt but a profound inner conviction that his work was of supreme importance. His uncertainty was how best to promote it. Watts noted that for the 'Carthage' picture (*Dido building Carthage*, of 1815), 'Turner 122 afterwards refused 5000 guineas, offered for it by a party of gentlemen who were anxious to purchase it for the purpose of presenting it to the National Gallery' (Watts, p. xxix).

 It was only just at this time, in 1824 to be precise, that the National Gallery had come, somewhat hesitantly, into being (though it would not have a building of its own until the 1830s); by the end of the decade he had taken the hint given by these gentlemen, and made a decisive move towards placing *Dido building Carthage* among the masters of the past in that new collection. But he simultaneously pursued a more immediate and practical course in bringing his work to the public attention. He devoted much of his creative time in the 1820s to the production of designs for engravers, and one of his most ambitious schemes of the period may be best explained as a new departure for him into the

197 *Shields Lighthouse*, c.1826. One of
Turner's own mezzotints for the 'Little
Liber' in which he continued the
experiments of the *Liber Studiorum*
to a logical conclusion of tonal
expressiveness.

198 Francis Danby: *Sunset at Sea
after a Storm*, a picture exhibited at the
Academy in 1824 and mezzotinted by
F. C. Lewis in 1826. In the latter form
this composition may have had consider-
able influence on Turner's 'Little Liber'
mezzotints of about the same date.

field of engraved historical subjects such as those he had discussed in his letter to Robinson.

In 1822 he travelled to Edinburgh with a plan to paint a series of pictures illustrating the Progress of George IV during his ceremonial visit to Scotland: nearly twenty compositions, to be engraved *en suite*, depicting all stages of the highly theatrical pageant which Sir Walter Scott evolved for the occasion. A small group of sketches, more or less incomplete, are all that materialized of this 199 ambitious project. It may have been relinquished for an even more promising venture: in 1823 Sir Thomas Lawrence managed to secure for him a commission from the King himself, to contribute to a grandiose decorative scheme celebrating the house of Hanover in a series of battle subjects, to be hung in St James's Palace. His was *Trafalgar*, for the King's Levée Room. He went to great 200 pains to obtain detailed information about the ships he was to paint, consulting the notes he had made in 1805 when the *Victory* came back from the battle, making various preliminary sketches in oil – a sign of his particular concern with the picture – and borrowing drawings from George IV's Marine Painter in Ordinary, John Christian Schetky. A letter from him to Schetky on the subject is dated 3 December 1823 (it also seems to refer to the discontinued Scottish project, and gives an explanation for its abandonment):

Dear Sir

I thank you for your kind offer of the Téméraire; but I can bring in very little, if any, of her hull, because of the Redoubtable. If you will make me a sketch of the Victory (she is in Hayle Lake or Portsmouth harbour) three-quarter bow on starboard side, or opposite the bow port, you will much oblige; and if you have a sketch of the Neptune, Captain Freemantle's ship, or know any particulars of Santissima Trinidada, or Redoubtable, any communication I will thank you much for. As to the former offer of yours, the Royal Barge, I beg to say that I requested your brother to give you my thanks, and that whatever you sent to him the same would be in time; but

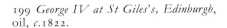

199 *George IV at St Giles's, Edinburgh*, oil, *c.*1822.

200 *The Battle of Trafalgar*, oil. 1824: the largest of all Turner's canvases, this heroic attempt to satisfy royalty did not meet with the approval he so anxiously sought.

there is an end to that commission owing to the difficulty attending engraving the subjects –

<div style="text-align:right">

Your most truly obliged
J. M. W. Turner

</div>

P.S. – The Victory, I understand, has undergone considerable alterations since the action, so that a slight sketch will do, having my own when she entered the Medway (with the body of Lord Nelson), and the Admiralty or Navy office drawing. (G. 101)

While painting the picture he 'was criticized and instructed daily by the naval men about the Court, and during eleven days he altered the rigging to suit the fancy of each seaman, and did it with the greatest good-humour' (T., II, p. 133). This was witnessed by another of the artists working on the King's commission, his friend George Jones, who had the battles of Vitoria and Waterloo to paint:

When I was working with him at our respective pictures in St James's Palace, he often joked about what we were to be paid for about a fortnight's work after the pictures were delivered, and quoted the well-known jest on the Calendar: "Give us back our eleven days," and so the joke ended. (Jones, *Turner*, pp. 9–10)

Unfortunately for Turner's ambition to be noticed by the King, the picture was not approved. Benjamin Robert Haydon noted in his Diary for 27 May 1824: 'in [the] case of the recent commission to Turner for the battle of Trafalgar, the Government was not satisfied. This has done great injury.' No doubt the 'naval men about the Court' were intolerant of the liberties Turner had taken with the strict chronology of the action, bringing together, as he had done, several key moments in the progress of the battle. The picture was banished to the Royal Naval Hospital at Greenwich, where it remains today.

If it was felt that Turner had overreached himself in his bid to impress Royalty in *The Battle of Trafalgar*, there is undeniably an element of striving in other oil paintings of these years, which can be explained not so much by

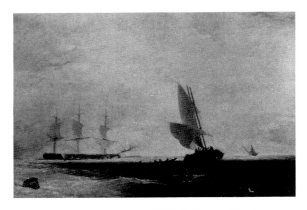

201 Augustus Wall Callcott: *Dutch Fishing-boats running foul, in the endeavour to board, and missing the painter-rope*, 1826.

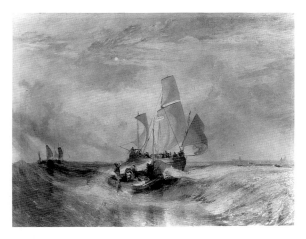

202 *'Now for the painter' (rope). Passengers going on board*, oil, 1827. Turner's humorous response to Callcott's picture of 1826 (201), this large canvas continues the tradition of the *Dort* of 1818 (157), which had itself been painted in rivalry with a work of Callcott's: his highly successful *Entrance to the Pool of London*, shown in 1816.

reference to hoped-for patronage as by the continuing impact of Italy. The miscellaneity of *Rome from the Vatican* was superseded in 1823 by a more 129 coherent statement, *The Bay of Baiæ, with Apollo and the Sybil*, in which he 178 reiterated with the authority of an eye-witness the glories of the Neapolitan coast that he had previously had to invent. But he gave the picture a line of nostalgic Horatian verse in the catalogue – 'Waft me to sunny Baiæ's shore' – which betrays its far from documentary intentions. The evocation of a paradisal dream could perhaps only have been so effective after he had seen the truth of the place: he had to enact for himself the pilgrimage of Byron's Childe Harold in order to arrive at so complete a statement of the classic myth of Italy, amplified by its mythological dramatization, in the story of Apollo and the Sibyl, of that slow decay which Byron had found so beautiful. And so, despite its reliance on recently made drawings on the spot, it struck George Jones as a fiction, albeit magnificent. He wrote on the frame: '*Splendide Mendax*'.

> Turner saw it, and laughed. His friend told him that where he had planted some hills with vineyards, there was nothing in reality but a few dry sticks. Turner smiled, and said it was all there, and that all poets were liars. The inscription remained on the frame of the picture for years; Turner never removed it. (T., I, p. 229)

The statement of the obvious was never his intention. He sought to express his sense of the poetical in the experienced world, and admired that intention in other artists. He defended Francis Danby against the Rev. William Kingsley, who had criticized a *Sunset* of his, by replying 'Don't say that; you don't know how such things hurt. You only look at the truth of the landscape: Mr Danby is a poetical painter' (R., VII, p. 443); and indeed, it seems that he was himself influenced by Danby at this time. His 'Little Liber' mezzotints are very much in 197 Danby's vein of rapt nocturnal meditation. The contrast between Turner's 198 vividly heightened perception of the world and the more sober records of his contemporaries was constantly being drawn. He himself sent (or returned) a press cutting on the subject to Robert Balmanno in 1826; it was from the *British Press* of 30 April:

> It is impossible there can be a greater contrast of colour than is found between Mr Constable and Mr Turner who exhibits three pictures – *Cologne*, 180 No.72; *The Forum Romanum* (for Mr Soane's Museum), No.132; and 179 another. In all, we find the same intolerable yellow hue pervading every thing; whether boats or buildings, water or watermen, houses or horses, all is yellow, yellow, nothing but yellow, violently contrasted with blue. With greater *invention* in his works than any master of the present day – invention which amounts almost to poetry in landscape, Mr Turner has degenerated into such a detestable manner, that we cannot view his works without pain. He is old enough to remember Loutherbourg, whose red-hot burning skies were as repulsive as these saffron hues of his own. We mention this not unkindly, and would wish Mr Turner to turn back to Nature, and worship her as the goddess of his idolatry, instead of his 'yellow bonze' which haunts him.
>
> Mr Callcott has two pictures of large size and high rank, the *Quay at Antwerp, during the fair-time*, No. 102, and *Dutch Fishing-boats running foul, in the endeavour to board, and missing the painter-rope*, No. 165. It is astonishing to see under what various aspects different artists view nature. Here we have, in Mr Callcott, the cool fresh breeze of European scenery, while in Mr Turner's pictures we are in a region which exists in no quarter of the universe. (G. 115)

Turner was not too disturbed by this criticism; he responded to Callcott's
201 *Missing the painter* by sending a picture to the 1827 exhibition with the title '*Now*
200 *for the painter' (rope). Passengers going on board* – the kind of punning joke between
friends that he loved. The reference, indeed, was still more complex. Callcott's
title, Thornbury tells us, was framed as a reply to yet another picture by a
younger follower of Turner, Clarkson Stanfield. Stanfield's marine subjects in
particular were held to pose as serious a challenge as Callcott's to Turner's own.
He had just failed to submit a canvas called *Throwing the Painter* to the exhibition
of 1826.

Turner was equally cheerful on the subject of the 'yellow bonze'. On 5 May
1826 he wrote to Holworthy in Derbyshire, where he was about to settle:

> Dear Holworthy
>
> Many thanks for your letter and the trout fishing invitation to Hatheread
> but that is quite impossible now at least, so I shall expect to see you first in
> Town, and then we may talk *how* and when – I am glad to hear you have got
> so far with your architectural [*illegible*] as to be talking of moving <u>in</u> at
> Midsummer; but mind you get the plaister'd walls tolerably dry before you
> domicile a camera. These things are not minded so much as formerly, and
> particularly in London, but when the *walls* weep there is some hazard.
> Thirty men, and not in Buckram, have made your Ducats move, but you
> have something for their departure – While the crash among the Publishers
> have changed things to a stand still, and in some cases to loss – I have not
> escaped; but more when I see you. Professor [Thomas] Phillips returned
> quite a carnation to what he went jumbling about did him good, at least in
> complection. Tho the executive, alias hanging committee at the Royal
> Academy this year has brought him back to his original tone of colour – but
> I must not say yellow, for I have taken it <u>all</u> to my keeping this year, so they
> say, and so I meant it should be . . . (G. 116)

The commercial crash of 1825–6, to which he refers here, affected everyone
in some degree; Hurst, Robinson and other print publishers went out of
business, and the Fawkes family seem to have suffered as well, for Turner is said
to have loaned them a large sum to extricate them from difficulties. He had
visited Farnley in 1824 but could not bring himself to go there again after Walter
Fawkes's death on 25 October 1825. He revealed his sense of loss in the course
of a letter to Holworthy, unconstrained as usual, written in January 1826 – the
letter in which he described his journey over the Mont Cenis in 1820:

> Alas! my good Auld lang sine is gone . . . and I must follow; indeed, I feel as
> you say, near a million times the brink of eternity, with me daddy only steps
> in between as it were, while you have yet *more* and long be it say I. Whether I
> ever see her or not in London, don't think that that promise of bringing
> drudgery [?] or your tremendous mountains will prevent my trudging up
> some Summer's day I hope, tho they are all winter days now, to see how
> your farm goes on. (G. 112)

179 His large Roman picture of this year, the *Forum Romanum*, which he had
painted with Sir John Soane's house in mind, had been one of those criticized by
the *British Press*; and like *The Battle of Trafalgar* it failed to suit its intended
destination. It was carefully calculated to conform very precisely to the
203 atmosphere of Soane's extraordinary London home, with its collection of
classical fragments and works of art of all periods cluttering a light-filled well
with vistas framed in delicate segmental archways. Turner accordingly gave his
view of the Forum a similar segmental arched top and littered his foreground

203 *The Crypt of Sir John Soane's house in
Lincoln's Inn Fields* by Joseph Michael
Gandy, 1813. Just as Soane's house must
have inspired Turner's gallery, the
cluttered classical grandeur of Gandy's
architectural watercolours may have
influenced Turner's brooding oil studies
of architectural interiors around 1830.

204 John Soane, sketched during a lecture on Architecture at the Royal Academy by Thomas Cooley. Turner and Soane had been friends since the 1790s, and Turner had helped display the illustrations to Soane's first lecture in 1809.

205 *View from the terrace of a villa at Niton, Isle of Wight, from sketches by a lady,* oil, 1826.

with moulded Roman masonry. He was most anxious to please Soane, and 204 wrote to him about the picture on 1 May 1826:

> My Dear Sir
>
> I have altered the inscription upon the Arch of Titus and it is said to be now quite right, and as I must say something about the price of the Picture I will say 500 G⁵ if you like what I have done, for without your intire approval I, or rather let me say *we*, shall not be happy. I have a Tickit in reserve for the private view on Friday – so have the goodness to let me know in the course of tomorrow if you can conveniently – if you would like to have it, and believe me my dear Sir
>
> Yours most truly
> J. M. W. Turner (G. 114)

But on 8 July he received a note from Soane explaining that 'the picture did not suit the place or the place the picture', and asking instead for one of the smaller ones in the current Academy exhibition. Turner replied the same day:

> My Dear Soane
>
> As there appears by your note of this morning some kind of disapprobation of my Picture it is needless to me to say how I intended to make its oversize accommodate to the place.
>
> I like candour and my having said that if you did not like it when done I would put it down in my book of Time!! My Endeavour to please you, and which I beg leave now to do – in regard to the smaller pictures they are not mine, one belongs to W. Moffatt Esqʳ of Mortlake and the other to Lady Gordon. Believe me to remain
>
> Yours most truly
> J. M. W. Turner (G. 117)

'Lady Gordon' was Julia Bennet, an early pupil of Turner's who had married James, later Sir James, Willoughby Gordon in 1805. Her little picture was a view from the terrace of their home at Niton, Isle of Wight; it was based on her 205

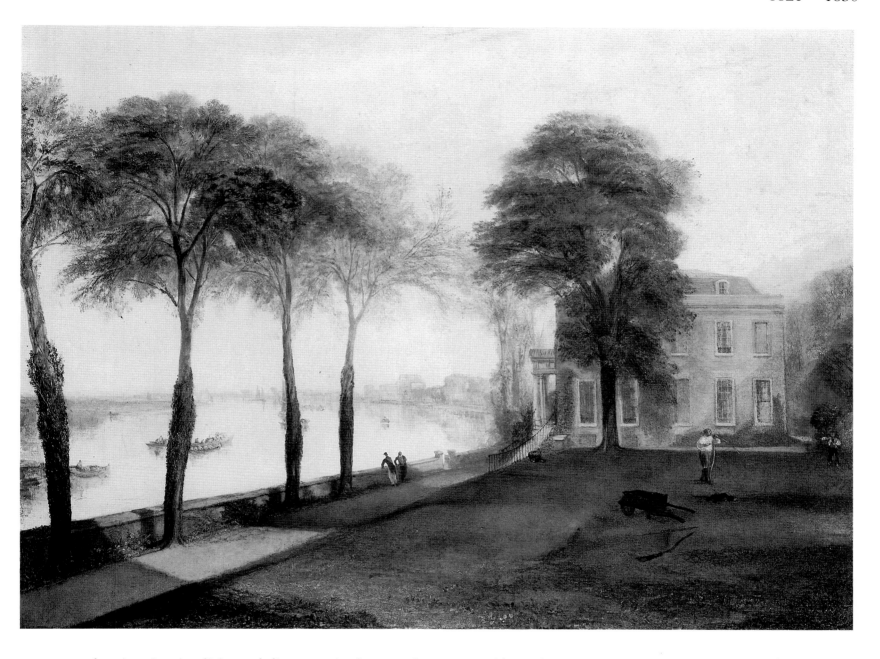

206 *The seat of William Moffatt, Esq., at Mortlake, Early (Summer's) Morning*, oil, 1826.

own drawing. Its simplicity and directness is almost unique among Turner's mature paintings, though with its telling still-life of chair, shawl, painting-box and mandoline on a sunny lawn, replacing any human figures, it has much in common with some of the more intimate of the vignettes that he was to embark on as illustrations to poetry in the early 1830s. It affords an insight into the artist's delight in those pleasant, well-appointed domestic surroundings that his well-to-do patrons could offer him, and which he had modestly emulated for himself at Twickenham. The same enjoyment of homeliness, displayed in similarly felicitous outdoor still-life, pervades the two pictures William Moffatt had commissioned to portray his house and garden by the Thames at Mortlake. They appeared at the Academy in 1826 and 1827, a pair unified by their graceful patterns of trees against golden light, house-portraits invoking the Italianate Dutch landscape painters, especially Cuyp and Jan Both. At the same time they bring to a climax a tradition of painting tree-lined Thameside views that had begun with the Sandbys, James Miller and Rowlandson, and was popular with Turner's contemporaries William Havell and John Varley.

On a much grander scale he encountered the same relaxed domestic environment at another Isle of Wight house, one to which he was invited as a guest: East Cowes Castle, the home of the architect John Nash. He stayed there 207 for several weeks in the summer of 1827, and painted two views of the castle for 210 Nash, both showing the newly instituted Cowes Regatta taking place in the foreground. Another, more fanciful, subject, *Boccaccio relating the tale of the* 208 *birdcage*, exhibited with them in 1828, seems, with its deliberate suggestion of the Decameron, to be a direct expression of Turner's enjoyment of elegant surroundings and congenial company. It expands ideas contained in a series of drawings in pen and ink with white heightening that he made while he was at 209 East Cowes, and may have been painted at least partly as a tribute to Thomas Stothard, whose illustrations to the *Decameron* had been published in Pickering's 1825 edition of Boccaccio. C. R. Leslie claimed that it was done 'in avowed imitation' of Stothard; and '"I only wish," said Turner to one of the Academy Professors, "he thought as much of my works as I think of his. I consider him the Giotto of the English School"' (Watts, p. xliv). Turner must actually have said 'Watteau' not 'Giotto', for Stothard's work is often strikingly Watteauesque; and Turner was particularly interested in the French master at this date. *What you will!* of 1822 had already announced that. Watteau's elegant *fêtes champêtres*, with groups of figures in rich fancy dress, were perhaps the quintessential expression of what Turner perceived as an ideal aristocratic existence – an existence of which he could never be more than fleetingly a part, though he might from time to time glimpse and relish it as a visitor. He summed up the atmosphere of East Cowes in his unexhibited oil sketch of a music party, a 212 dream of fair women, music, and romantic costumes. The music might have been 'Midsummer Day A New Divertimento, for the Piano Forte, Composed & Dedicated to Mrs Nash of East Cowes Castle. by J. B. Cramer'; and the lady in black seated at the keyboard among guests in fancy dress is perhaps Mrs Nash herself.

Turner was evidently inspired by East Cowes to paint a number of canvases on the spot, including sketches of the Regatta. During his stay he sent an urgent 211 message to his father at Queen Anne Street:

> I wrote yesterday to Mr Newman to get a canvass ready – size 6 feet by 4 feet. I wish you to call and ask him if he has it by him and if he get it done by Middleton in St Martins Lane or at home, if by Middleton, then let two be sent; if he does it a[t] home, then he will be some time about it – and then tell him if he has by him a whole length Canvass to send it instead of preparing the 6 feet 4 canvass . . . if he has not then go to Middleton and if he has one a Whole Length Canvass let him send it me immed[i]ately – I want the canvass only. I don't want the stretching frame made in town if Middleton or Newman has the canvass ready done even if a whole length let either send it down to me

<div align="center">

at J. Nash Esq^re
East Cowes Castle
Isle of Wight
</div>

> if they are both ready send them together rolled up on a small roller and put the linen things I wrote for on the outside.
>
> I want some scarlet Lake and dark Lake and Burnt Umber in powder from Newman [½ *deleted*] one ounce each

<div align="right">

JMWT (G. 124)
</div>

> 1 ounce of mastic

Another letter to his father from East Cowes deals with other matters professional and personal, beginning with a reference to the large *Cologne, the* 180

207 East Cowes Castle, the baronial Gothic house that Nash built for himself in 1798.

208 *Boccaccio relating the tale of the birdcage*, oil, 1828, a fantasy making use of the medievalizing architecture of East Cowes Castle (207). No tale of a birdcage occurs among the stories of the *Decameron*. The reference may be a private joke.

209 One of a series of drawings in pen and ink and white bodycolour on blue paper that Turner made during his stay at East Cowes in 1827.

arrival of a packet boat. Evening, which he had shown at the Academy in 1826, the second of a pair of European river and harbour subjects (the other was *Harbour of Dieppe* of 1825) that followed in the wake of the *Dort* of 1818:

> Mr Broadhurst is to have the Picture of Cologne, but you must not by any means wet it, for all the Colour will come off. It must go as it is – and tell Mr Pearse, who is to call for it, and I suppose the frame, that it must not be touched with Water or Varnish (only wiped with a silk handkerchief) until I return, and so he must tell Mr Broadhurst. I wrote a day or two ago to say that I shall want more light Trouzers – and so I do of White Waistcoats. I ought to have 4, but I have but 2, and only 1 Kerseymere [*in the margin:* 2 washing or color'd]. Do therefore manage to send some down, if I do not write to desire you to send them to Newman's, which I think I must do, for I must I believe send for some more canvass. However do get them ready and when they are so send them down either by Southampton or Portsmouth coach, – the direction you will find again written [?within].
>
> <div align="right">J. M. W. T. (G. 123)</div>

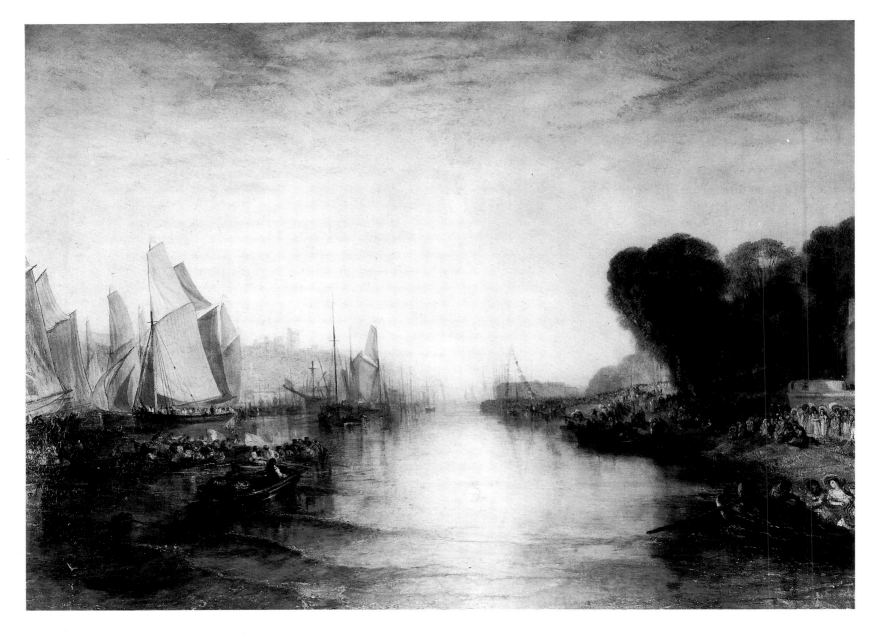

East Cowes

210 *East Cowes Castle, the seat of J. Nash, Esq.; the Regatta starting for their moorings,* oil, 1828. One of two pictures of the Cowes Regatta, with the architect's house in the background, painted for Nash after Turner's visit in 1827. Like others of the period, this canvas was prepared by Turner with a tempera ground – an experiment which led to its rapid deterioration.

211 *Between Decks,* an oil study made at the Cowes Regatta in 1827.

212 *A Music Party.* The architectural setting of this oil sketch, in the glowing colour of Turner's Rembrandt imitations of around 1830, has recently been identified as East Cowes Castle. One of the ladies is very possibly Mrs Nash herself.

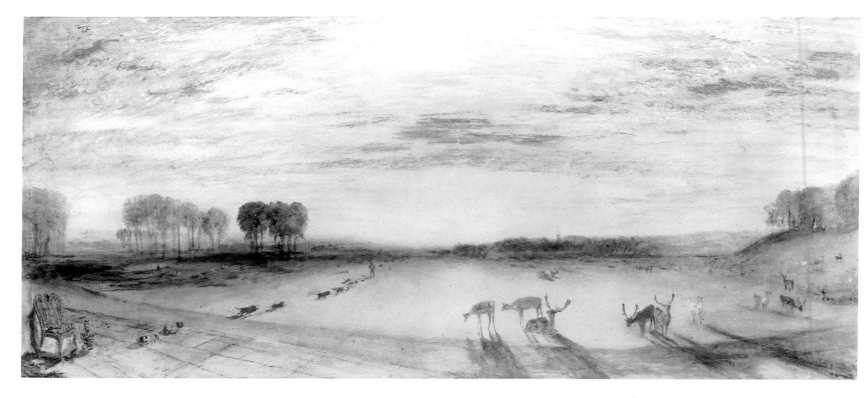

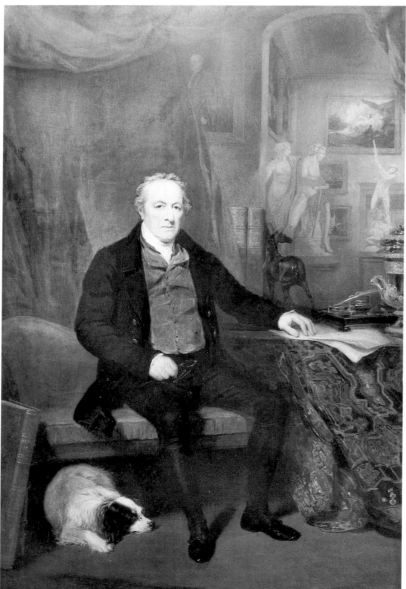

213 *Petworth Park: Tillington Church in the Distance*, oil, *c.*1828. This is one of the first series of pictures painted to fit below the portraits in the dining-room (the Grinling Gibbons room) at Petworth, later replaced by another set. On the left Lord Egremont is greeted by his nine dogs. In this view of Capability Brown's park from the south front of the house, Turner has given the neighbouring church greater prominence than it has in reality.

214 *George O'Brien Wyndham, Third Earl of Egremont*. In Thomas Phillips's canvas Egremont is seen sitting before his gallery at Petworth, with examples of modern painting and sculpture from his collection on view. Conspicuous against the far wall is Flaxman's sculpture *St Michael overcoming Satan*, completed in 1826, which Turner also showed in his views of the gallery.

He was asked to paint a yet more important country house about this time: Petworth. He had not had dealings with Lord Egremont for many years, but visited the house in the summer and autumn of 1827, and by August the following year had completed some views to be placed in the panels of the dining-room, under the full-length portraits. Lord Egremont 'always has artists ready in the house', one of his guests, Thomas Creevey, reported; and so 'in one of these compartments, you have Petworth park by Turner, in another Lord Egremont taking a walk with nine dogs, that are his constant companions, by the same artist'. Egremont provided him with a studio, as he liked to do for his many painter guests, and the pictures were probably painted there and then. George Jones corroborates this:

213
214

234,
274

> When Turner painted a series of landscapes at Petworth, for the dining-room, he worked with his door locked against everybody but the master of the house. Chantrey was there at the time, and determined to see what Turner was doing; he imitated Lord Egremont's peculiar step, and the two distinct raps on the door by which his lordship was accustomed to announce himself: and the key being immediately turned, he slipped into the room before the artist could shut him out, which joke was mutually enjoyed by the two attached friends. (*Chantrey*, p. 122)

Another picture painted for Egremont, though it never entered his collection, was the large Italian landscape exhibited in 1830 as *Palestrina – composition*. This was begun in Rome in 1828. Turner had gone there in the late summer to set up a studio and show his work. He wrote from Paris (the letter is postmarked 23 August) to Eastlake, already in Rome, where they were to share a house:

215

Dear Signor Carlo

Being at last off from the loadstone of London, I venture to apologize for not being with you by the time I expected to be in Rome and likewise with you no 12 Piazza Mignanelli which our friend Maria Callcott has given such a remarkable account of that I am delighted to have an entrance from the Clouds[?] in practice, but how far I can keep pace with her remembrance of past days by my remembring of her love of art and Endeavours to be in nubibus – by reflections [I cannot say]

However it may be I must trouble you with farther requests viz . . . that the best of all possible grounds and canvass size 8 feet $2\frac{1}{2}$ by 4 feet $11\frac{1}{4}$ Inches to be if possible ready for me, 2 canvasses if possible, for it would give me the greatest pleasure independant of other feelings which which [*sic*] modern art and of course artists and I among their number owe to Lord Egremont that the my [*sic*] first brush in Rome on my part should be to begin for him con amore a companion picture to his beautiful *Claude* – Tho I cannot say when I can arrive in Rome owing either to my passing by way of Turin to Genoa or by Antibes yet our agreement from the 1st of Sept holds good and I hope then you have een now seen Roma for I have been delay'd longer than I ought – but do pardon me in saying order me what ever may be [*tear*] to have got ready that you think right and plenty of the useful – never mind Gim Cracks of any kind even for the very Easel I care not
 So wishing you are in good health
 & & & Believe me truly J. M. W. Turner (G. 140)

(Egremont's Claude was the *Landscape with Jacob and Laban*, of which Turner had made a close pastiche, *Apullia in search of Appullus*, for the British Institution's premium of 1814.) Meanwhile, Eastlake was anticipating his arrival with relish, writing to a fellow artist, Thomas Uwins:

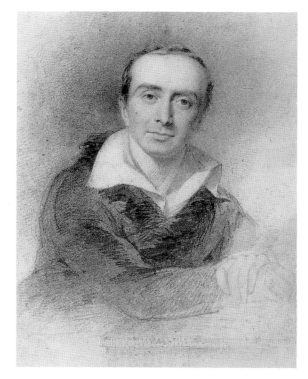

215 Charles Lock Eastlake, drawn by John Partridge in 1825. Eastlake's family was from Plymouth, where he encountered Turner on at least one occasion. His conception of an elevated classical landscape style was highly congenial to Turner. He lived in Rome from 1816 to 1830, and was elected Academician in 1829, succeeding Shee to the Presidency in 1850. According to the *Dictionary of National Biography*, his life was one of 'singular purity, loftiness of aim, and unremitting industry'; but he was considered by some of his colleagues to be ambitious and manipulative, characteristics which seem eventually to have coloured Turner's attitude to him.

Turner will be here in a few days and will perhaps occupy a spare study I have got; at any rate he will paint a large picture, perhaps two. I talk too confidently even within range of the magician's circle, but within it 'none dare walk but he,' and a very few who have felt like him always. (Uwins, II, p. 296)

Turner's journey to Rome was protracted through the south of France and along the Corniche to Genoa. He made exotically coloured sketches of the cliff-towns on the route, registering his sense of the antique grandeur and opulent warmth of that coast. But his excitement at returning to Italy is perhaps the leading emotion. When he eventually reached Rome he wrote to George Jones, on 13 October:

Dear Jones

Two months nearly in getting to this Terra Pictura, *and at work*; but the length of time is my own fault. I must see the South of France, which almost knocked me up, the heat was so intense, particularly at Nismes and Avignon; and until I got a plunge into the sea at Marseilles, I felt so weak that nothing but the change of scene kept me onwards to my distant point.

Genoa, and all the sea-coast from Nice to Spezzia is remarkably rugged and fine; so is Massa. Tell that fat fellow Chantrey that I did think of him, *then* (but not the first or the last time) of the thousands he had made out of those marble craigs which only afforded me a sour bottle of wine and a sketch; but he deserves everything which is good, though he did give me a fit of the spleen at Carrara. (G. 141)

If he had devoted his first stay in Rome to the rigorous pursuit of information, this time, most unusually on any trip abroad, he was occupied in painting finished pictures. But he also joined in the life of the English community – 'He made himself very social and seemed to enjoy himself, too, among us,' Peter Powell wrote to C. R. Leslie (C. R. Leslie 1860, II, p. 205) – and he took an interest in the activities of the large and cosmopolitan artists' colony. For Chantrey's benefit he wrote, on 6 November, a report on the current state of sculpture:

My Dear Chantrey

I intended before this (but you will say Fudge) to have written; but even now very little information have I to give you in matters of Art, for I have confined myself to the painting department at Corso; and having finished *one*, am about the second, and getting on with Lord E's, which I began the very first touch at Rome; but as the folk here talked that I would show them *not*, I finished a small three feet four to stop their gabbling: so now to business.

Sculpture, of course, first, for it carries away all the patronage, so it is said, in Rome; but all seems to share in the goodwill of the patrons of the day. Gott's Studio is full. Wyatt and Rennie, Ewing, Buxton, all employed. Gibson has two groups in hand, 'Venus and Cupid', and 'The Rape of Hylas,' three figures, very forward, though I doubt much if it will be in time (taking the long voyage into the scale) for the Exhibition, though it is for England. Its style is something like 'The Psyche', being two standing figures of nymphs leaning, enamoured, over the youthful Hylas, with his pitcher. The Venus is a sitting figure, with the Cupid in attendance; if it had wings like a dove, to flee away and be at rest, the rest would not be the worse for the change. Thorwaldsten is closely engaged on the late Pope's (Pius VII) monument. Portraits of the superior animal, man, is to be found in all.

216 John Gibson: *Hylas and the Nymphs*, seen by Turner in Rome in 1828. Gibson, one of the most uncompromising of Neo-classical sculptors, dreamt that he would be transported to Rome by an eagle. He went there in 1817 and studied under both Canova and Thorwaldsen, remaining in the city until 1844.

216

In some the inferior – viz. greyhounds and poodles, cats and monkeys, &c. &c. . . . (G. 142)

For Lawrence, on the other hand, he sent a discussion of the old masters:

Dear Sir Thomas

. . . I have but little to tell you in the way of Art and that little but ill calculated to give you pleasure. The Sistine Chapel Sybils and Prophets of the ceiling are as grand magnificent and overwhelming to contemplation as ever, but the Last Judgement has suffer'd much by scraping and cleaning particularly the sky on the lowermost part of the subject so that the whole of the front figures are in consequence one shadde. And it will distress you to hear that a Canopy (for the Host, the Chapel now being fitted up for divine service) is fixed by 4 hoops in the Picture, and altho' nothing of the picture is obliterated by the points falling in the sky part, yet the key note of the whole – sentiment is lost, for Charon is behind the said canopy, and the rising from the dead and the Inferno are no longer divided by his iron mace driving out the trembling crew from his fragile bark.

Before quitting the subject it is but justice to a departed spirit, whose words and works will long dwell in your remembrance – and I hope so in mine – to acknowledge my error in shirking his remark, viz. 'To my eye it doth possess some good Colour of Flesh, – that a second look at the Last Judgement I must admit of for there are some figures in the Inferno side worthy of our friend Fuseli's words.

Orvieto I have seen and Signorelli there shining preeminent, father of the rising of the Dead and Inferno, and Michael Angelo has condescended to borrow largely, and not in the case [*tear*] demon flying away with the finial [*tear*] improved it. Mr Ottley will call me to account for so daring an opinion but I must defend myself with all due humility – in person, I hope, about the beginning of February – when I shall feel truly happy to pay my respects to you in Russel Square. In the mean time

Believe me most truly yours
J. M. W. Turner (G. 144)

217 Luca Signorelli: *The Damned*, *c.*1500–1504. Signorelli's frescoes in Orvieto Cathedral had been publicized in England just before Turner's second visit to Italy by William Young Ottley in his *Series of Plates after the early Florentine Artists* (1826–8). Turner drew the Cathedral in his *Florence to Orvieto* sketchbook.

218 Michelangelo: *The Last Judgment*, 1536–41, on the altar wall of the Sistine Chapel in the Vatican. The baldacchino that distressed Turner was subsequently removed.

218

217

219 *Vision of Medea*, oil, 1828. One of the canvases that Turner exhibited at the Palazzo Trulli in Rome, this picture demonstrates a new interest in Italian Baroque masters such as Guido Reni and Domenichino. He also had in mind, no doubt, Reynolds's large *Macbeth and the Witches* in Egremont's collection. *Medea* was shown again at the Academy in 1831.

220 An Italian print attacking Turner's exhibition in Rome, which outdoes his English critics both in vehemence and in indelicacy. The personification of Fame, flying over London, trumpets Turner's name from her posterior; a dog defecating in the foreground claims 'I too am a painter', while the figure of Minerva cries 'O charlatan, excrement is not painting!'

The climax of his stay in Rome was his one-man show. He can hardly have expected it to be enthusiastically received, though he could count on a great deal of curiosity, as his remark about stopping the 'gabbling' indicates. Eastlake told Thornbury:

> He painted there the 'View of Orvieto,' the 'Regulus,' and the 'Medea.' 236 Those pictures were exhibited in Rome in some rooms which Turner 219 subsequently occupied at the Quattro Fontane. The foreign artists who went to see them could make nothing of them. Turner's economy and ingenuity were apparent in his mode of framing those pictures. He nailed a rope round the edges of each, and painted it with yellow ochre in tempera. When those same works were packed to be sent to England, I advised him to have the cases covered with a waxed cloth, as the pictures without it might be exposed to wet. Turner thanked me, and said the advice was important; 'for,' he added, 'if any wet gets to them, they will be destroyed.' This indicates his practice of preparing his pictures with a kind of tempera, a method which, before the surface was varnished, was not waterproof. (T., I, p. 221)

Eastlake elsewhere reported that

> More than a thousand persons went to see his works when exhibited, so you may imagine how astonished, enraged or delighted the different schools of artists were, at seeing things with methods so new, so daring, and excellencies so unequivocal. The angry critics have, I believe, talked most, 220 and it is possible you may hear of *general* severity of judgment, but many did justice, and many more were fain to admire what they confessed they dared not imitate. (See Whitley, II, p. 159)

Turner travelled home in January 1829. During the journey he fell into the company of a young businessman who knew nothing of art or artists, and who reported their meeting in the Rome–Bologna coach as a piquant anecdote:

> I have fortunately met with a good-tempered, funny, little, elderly gentleman, who will probably be my travelling-companion throughout the journey. He is continually popping his head out of the window to sketch whatever strikes his fancy, and became quite angry because the conductor would not wait for him whilst he took a sunrise view of Macerata. 'Damn the fellow!' says he. 'He has no feeling.' He speaks but a few words of Italian, about as much French, which two languages he jumbles together most amusingly. His good temper, however, carries him through all his troubles. I am sure you would love him for his indefatigability in his favourite pursuit. From his conversation he is evidently *near kin to*, if not absolutely, an artist. Probably you may know something of him. The name on his trunk is, J. W. or J. M. W. Turner. . . . (Uwins, II, pp. 239–40)

The recipient of this letter was Eastlake's correspondent Thomas Uwins, who was to become an A.R.A. in 1833, and who of course well knew the character his unnamed friend had described. Conditions were bad the whole way home, and, just as on the return from Italy in 1820, Turner's carriage was involved in an accident in the snow, this time on Mont Tarare, near Grenoble. He gave an 221 account of the journey in a letter to Eastlake of 16 February 1829:

> Now for my journey *home*. Do not think any poor devil had such another, but quite satisfactory for one thing at least, viz. not to be so late in the season of winter again, for the snow began to fall at Foligno, tho' more of ice than snow, that the coach from its weight slide about in all directions, that walking was much preferable, but my innumerable tails would not do that

service so I soon got wet through and through, till at Sarre-valli the diligence zizd into a ditch and required 6 oxen, sent three miles back for, to drag it out; this cost 4 Hours, that we were 10 Hours beyond our time at Macerata, consequently half starved and frozen we at last got to Bologna, where I wrote to you. But there our troubles began instead of diminishing – the Milan diligence was unable to pass Placentia. We therefore hired a voitura, the horses were knocked up the first post, sigr turned us over to another lighter carriage which put my coat in full requisition night and day, for we never could keep warm or make our day's distance good, the places we put up at proved all bad till Firenzola being even the worst for the down diligence people had devoured everything eatable (Beds none) . . . crossed Mont Cenis on a sledge – bivouaced in the snow with fires lighted for 3 Hours on Mont Tarate while the diligence was righted and dug out, for a Bank of Snow saved it from upsetting – and in the same night we were again turned out to walk up to our knees in new fallen drift to get assistance to dig a channel thro' it for the coach, so that from Foligno to within 20 miles of Paris I never saw the road but snow! (G. 147)

And, just as he had done in 1820, he made a watercolour of his experience. *Messieurs les voyageurs on their return from Italy (par la diligence) in a snow drift upon*

221 *Messieurs les voyageurs on their return from Italy (par la diligence) in a snow drift upon mount Tarrar, 22nd of January, 1829.* With *Calais Pier* of 1802 (89), *Mont Cenis* of 1820 (176) and *Rain, Steam and Speed* of 1844 (285) this watercolour is one of the great works that arose directly from Turner's experience of travelling. They record his delight in the unusual adventures that travel in his day was liable to supply. It is noteworthy that in each case autobiographical detail is subsumed in a dramatic account of climatic conditions, though here, unusually, Turner introduces an evident self-portrait in the top-hatted figure closest to the spectator, silhouetted against the fire.

mount Tarrar, 22nd of January, 1829 was shown at the Academy that year: it is a visual complement to the ebullient sense of drama and comedy that the letter conveys, and includes a self-portrait. It is nearly always in the context of travel that Turner introduces himself into his subjects. Travel was evidently a central experience for him, a necessary thread on which his manifold ideas for pictures were hung. Here he shows himself with his back to the viewer, huddled before a blazing fire in the snow-swept dark, hat crushed down on his head, one of a crowd of enduring travellers who nevertheless keeps his observant distance, watching, enjoying, and planning a work of art on the subject all the while.

There were three oil paintings at the Academy in 1829: *The banks of the Loire*, *The Loretto necklace*, and a work that Ruskin was later to call 'the *central picture* in Turner's career' (R., XIII, p. 136). *Ulysses deriding Polyphemus* earned a mixed 177 critical reception, but was much derided itself for its rich and saturated colour. The *Morning Herald* for 5 May wrote:

> This is a picture in which truth, nature and feeling are sacrificed to melodramatic effect. Had it been from an unknown person we should not have noticed it, but the name of Mr Turner might give authority to errors which would have the effect of misleading the young and the inexperienced. If the French fail in want of colour, this artist equally departs from nature in the opposite extreme. He has for some time been getting worse and worse and in this picture he has reached the perfection of unnatural tawdriness. In fact it may be taken as a specimen of colouring run mad – positive vermilion – positive indigo; and all the most glaring tints of green, yellow and purple contend for mastery on the canvas, with all the vehement contrasts of a kaleidoscope or a Persian carpet.

In fact, as the *Morning Herald* pointed out, the brilliance of *Ulysses* was the culmination of a gradual change that had been apparent in Turner's work for two decades, accelerated by his first visit to Italy and now, after his second visit, given a further stimulus by the early Renaissance painting that he had been looking at in Rome and Orvieto. William Young Ottley, to whom he referred in his letter to Lawrence, was a champion of the painters of the Quattrocento, and the clear bright colour of their frescoes seems to have impressed Turner. It was something which other artists in Rome were aware of, notably the German 'Nazarenes' who had been working there since the beginning of the century; it would have been characteristic of Turner to have gained his insights into the generation of Signorelli and Pinturicchio through a study of their work. And there were young artists in London, too, who were pursuing similar ideas: Daniel Maclise, a young Irishman whose virtuoso draughtsmanship brought 305 him some acclaim this year, was to be the most obviously influenced by German ideals of crisp draughtsmanship and clear colour, but for Turner a more important figure at this date was the Yorkshireman William Etty, whose sumptuous essays inspired by Titian and the other Venetians were attracting much attention in London, and whose more painterly approach was probably in closer accord with Turner's own taste and practice.

He gave no lectures on Perspective this year, and never again gave any. His audiences had dwindled almost to nothing; only his old father regularly attended, and now he was too ill to come. Turner was somewhat restricted in his movements on this account, but managed a journey to Paris, Normandy, 222–4 Brittany and the Channel Islands in August, one of a series of tours he had been making in search of material for various publications. Having perfected a watercolour technique of miniature delicacy and precision, that could encompass the grandest landscape ideas on the smallest scale, he seems to have wooed the publishers of illustrative engravings in order to find scope to

222 Detail of a map of Brittany, with pencil sketches of Breton peasants by Turner. It was presumably purchased in France and probably used during his tour of Normandy, Brittany and the Channel Islands in 1829.

223 *La Chaise de Gargantua, near Duclair,* on the Seine, *c.*1830–32. An example of the small though elaborate finished drawings in bodycolour on blue paper that Turner made for engraving in the 'French Rivers' series. The subject was sketched on the tour of 1829.

224 *Soldiers in the upper room of a café,* bodycolour, *c.*1830. One of several studies connected with Turner's tours in France which record the incidents of life on the road. The subject was obviously not intended for topographical use; it is a document of his fascination with the people he met and observed wherever he went.

225 The engraver and publisher Charles Heath, after a drawing by Mrs Dawson Turner, 1822.

226 The *Rivers Meuse and Moselle* sketchbook, in use in 1826. The cramming of numerous small pencil sketches onto a single page of a small book is characteristic of Turner's activity when touring. Here he notes successive panoramas as his boat takes him up the Meuse, from below Huy to Namur and beyond. He had perfected this highly concentrated system of sketching during his Rhine tour of 1817.

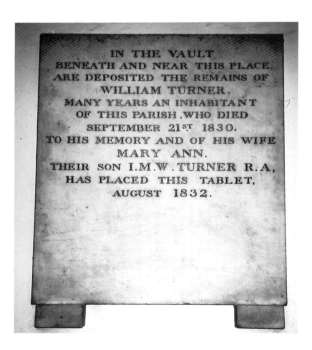

227 The monument to the artist's parents that he erected in St Paul's Church, Covent Garden. In addition to its clumsiness, the wording is inaccurate: Turner has misremembered the year of his father's death.

demonstrate his mastery. Several projects were in hand, apart from the great series of *Picturesque Views in England and Wales* on which he was working for Charles Heath, and of which the first plates had begun to appear in 1827. A 'work to be entitled THE ENGLISH CHANNEL, or LA MANCHE' had also been advertised to appear that year, but never did so; and he was assembling a mass of subjects for a grand programme to illustrate the scenery of the 'Great Rivers of Europe'. He had been to France with some such scheme in mind as early as 1821, and was there again in 1826, exploring the Meuse, the Moselle and the Loire. The 1829 trip to Normandy added the Seine to his list of rivers. Meanwhile a further plan for 'Picturesque Views in Italy' had been promulgated, begun and died. During the summer Heath exhibited a large number of the drawings Turner had made for him at the Egyptian Hall, Piccadilly. On top of all this, he had just completed his set of vignette illustrations for Samuel Rogers's *Italy*, which was to be published in 1830. Rogers, rather more successful as a banker than as a poet, had first approached Turner in 1826 with the proposal that he should illustrate his long poem for a new edition. The decision was a wise one; Lady Blessington crystallized popular opinion in a famous squib:

> Of Rogers's *Italy*, Luttrell relates
> That it would have been dished were it not for the plates.

The book was so much admired that Rogers asked Turner to perform a similar office by his collected *Poems*. They appeared in 1834, embellished by a further series of exquisite miniatures.

Turner's father died aged eighty-five on 21 September 1829. On the 29th he was buried at St Paul's, Covent Garden. Turner erected a monument to his memory, composing the epitaph himself.

When Turner erected the tablet in St Paul's, Covent Garden, there was some mason's work done to it, which came to 7s. 6d.; this amount Mr Cribb, the churchwarden, paid, feeling certain that Turner would re-pay him when he came to look at the tablet. Turner called, and seemed satisfied with

everything; until Mr Cribb mentioned the 7s. 6d., when Turner told him to come some day and bring a receipt for the money, and said 'he shouldn't pay it without he did.' The money was not worth the trouble, so Turner got the mason's work without paying for it. (Miller, p. xxxix)

This kind of story, emphasizing the niggardliness rather than the bluntly businesslike nature of Turner's behaviour, was frequently repeated as an example of his meanness; though the will that he signed the day after his father's funeral puts such fault-finding in perspective. Its central provision was that a group of almshouses should be built on some freehold land at Twickenham Little Common, for 'decayed English artists (Landscape Painters only) and single men'. He seems to have had this purpose in mind when he first acquired the land in August 1818, and it is worth noting that, however instinctive his tight-fistedness, it was probably justified in his mind by the ulterior charity into which, all his life, he intended to put his money. He directed that the complex should include a picture gallery to house his own works. (This scheme was perhaps influenced by the combination of art gallery and almshouses that Soane had completed at Dulwich in 1814.) Two pictures, however, were to go to the

122 National Gallery: *Dido building Carthage*, his '*chef d'oeuvre*', which had already been proposed as suitable for the new public collection; and its pendant, *The*

56 *Decline of Carthage*. These were to be 'placed by the side of Claude's "Seaport" and "Mill" that is to hang on the same line same height from the ground and to continue in perpetuity to hang'. If these conditions were not met the two pictures were to join the rest at Twickenham. Two professional bodies close to his heart were to benefit: the Artists' General Benevolent Institution, in which he had been prominently involved probably since its foundation, was to receive £500, and the Royal Academy was to have funds for the endowment of a Professorship of Landscape Painting, and a Turner Gold Medal, to be awarded to the best landscape picture each year. Various members of his family were named as minor beneficiaries: Sarah and Hannah Danby, Evelina and Georgiana, and some others.

Within six months two more deaths occurred which affected him closely. When Harriet Wells died at the beginning of 1830 he wrote on 3 January to condole with her sister Clara. It is a letter of true brotherly tenderness:

Dear Clara

Your forboding letter has been too soon realized. Poor Harriet, dear Harriet, gentle patient amiability. Earthly assurances of heaven's bliss possesst, must pour their comforts and mingle in your distress a balm peculiarly its own – not known, not felt, not merited by all.

I should like to hear how they are at Mitcham, if it is not putting you to a painful task too much for your own misery to think of, before I go on Friday morning. Alas I have some woes of my own which this sad occasion will not improve, but believe me most anxious in wishing ye may be all more successful in the severe struggle than I have been with mine. (G. 159)

Then, on 7 January, Lawrence died unexpectedly. He was buried with much

189 pomp in St Paul's Cathedral on the 21st. Turner was much moved, and made a large watercolour of the occasion, though, as Constable noticed, 'During the service, Wilkie, who was next to Turner, whispered into his ear, "Turner, that's a fine effect!" from which untimely observation Turner turned away with disgust' (T., 1, p. 177). The account of the funeral that he sent to George Jones, who was in Italy, is replete with a sense of personal mourning: he is bereaved both individually, of a friend and admired colleague, and as a member of the Academy that has lost its head and is now undergoing the usual political manoeuvring for the election of a new President. He is reminded that another

COMO.

I LOVE to sail along the LARIAN Lake
Under the shore—though not to visit PLINY,
To catch him musing in his plane-tree walk,
Or angling from his window : * and, in truth,
Could I recall the ages past, and play
The fool with Time, I should perhaps reserve
My leisure for CATULLUS on *his* Lake,

* Epist. I. 3. ix. 7.

228, 229 Vignettes for Samuel Rogers. Top, from *Italy*, 1830, engraved by Edward Goodall. Above, for the *Poems*, 1834: Turner's drawing, to illustrate lines 'Written in Westminster Abbey, after the Funeral of the Right Hon. Charles James Fox', shows Fox's seat, St Anne's Hill, in Surrey.

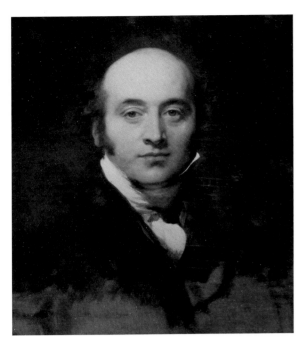

230 Sir Thomas Lawrence: *Self-portrait*, *c*.1825 (detail). In 1791, at the age of twenty-two, the urbane and charming Lawrence had, at the King's special request, been made a Supplemental Associate of the Academy – an extraordinary and indeed unique honour. The young Turner at that time had his eye on the achievements of new Academicians and may well have taken Lawrence's advance to heart as a model to be emulated. It perhaps lay behind his lifelong wish to be noticed by royalty. Lawrence's self-portrait follows the modest but effective formula employed by Turner in his own youthful essay (2).

Academician, George Dawe, had only recently died; and yet again contemplates encroaching old age and its attendant loneliness. The letter is dated 22 February 1830:

> Dear Jones
> I delayed answering yours until the chance of this finding you in Rome, to give you some account of the dismal prospect of Academic affairs, and of the last sad ceremonies paid yesterday to departed talent gone to that bourne from whence no traveller returns. Alas! only two short months Sir Thomas followed the coffin of Dawe to the same place. We were then his pall-bearers. Who will do the like for me, or when, God only knows how soon. My poor father's death proved a heavy blow upon me, and has been followed by others of the same dark kind. However, it is something to feel that gifted talent can be acknowledged by the many who yesterday waded up to their knees in snow and muck to see the funeral pomp swelled up by carriages of the great, without the persons themselves. *Entre nous*, much could be written on this subject; much has been in the papers daily of anecdotes, sayings, and doings, contradictory and complex, and nothing certain, excepting that a great mass of property in the unfinished pictures will cover more than demands. The portraits of the potentates are to be exhibited, which will of course produce a large sum. The drawings of the old masters are to be offered to his Majesty in mass, then to the British Museum. Thomas Campbell is to write Sir Thomas's life at the request of the family, and a portrait of himself, painted lately and engraved, for which great biddings have been already made. I wish I had you by the button-hole, notwithstanding all your grumbling about Italy and yellow. I could then tell more freely what has occurred since your departure of combinations and concatenations somewhat of the old kind, only more highly coloured, and to my jaundiced eye not a whit more pure. . . . Chantrey is as gay and as good as ever, ready to serve; he requests, for my benefit, that you bottle up all the yellows which may be found straying out of the right way; but what you may have told him about the old masters which you did not tell me, I can't tell, but we expected to hear a great deal from each other, but the stormy brush of Tintoretto was only to make 'the Notte' more visible. May you be better in health and spirits.

> Adieu, adieu; faithfully yours,
> J. M. W. Turner (G. 161)

The note of consolation that Turner sounds in reflecting that 'gifted talent can be acknowledged by the many' was to become a recurrent theme of his thoughts during the remaining two decades of his life. He was to experience greater isolation, receive more virulent criticism; and yet he was to see his work rediscovered, defended and collected by a younger generation. If his great ambition for official recognition – the Presidency of the Academy, or a knighthood – was baulked, he found himself the doyen of the R.A.s. These were, perhaps, some unexpected benefits of longevity. And so, although many of his later paintings may be elegiac in mood, they carry with them an unmistakable sense of the revivifying power of man's creative spirit.

Chronology 1821–30

1821

January–February: Turner gave his Perspective lectures.
At the Royal Academy exhibition he showed nothing.
The series of Italian watercolours was completed, and sold
 to Fawkes at 25 guineas each.
Work was also concluded on the *Provincial Antiquities of
 Scotland*. The drawings were acquired by Scott and
 hung in one frame in the breakfast-room at
 Abbotsford.
September: probably in the middle of this month
 Turner travelled to Paris, apparently contemplating a
 series of engravings of the Seine, perhaps on the
 model of the *Southern Coast* (an idea taken up again in
 1826). Two sketchbooks were used on the tour, *Paris,
 Seine and Dieppe* (TB CCXI) and *Dieppe, Rouen and Paris*
 (TB CCLVIII).
Christmas: at Farnley.
30 December: death of Farington.

1822

No Perspective lectures given.
1 February: the Cookes opened an exhibition at 9 Soho
 Square of 'the most splendid Collection ever exhibited
 of Drawings by English Artists'. The focus was the
 group of 17 watercolours made by Turner for the
 Cookes' various ventures, together with some others:
 Hastings from the Sea (9; w.504), *Cologne* (20; w.690), 2
 small views of Vesuvius (w.698, 699), and an early
 Westminster Bridge (w.96).
Turner's Gallery, from April: the new gallery in Queen
 Anne Street opened to the public with a display
 apparently consisting of unsold earlier works.
Royal Academy exhibition: only one canvas shown,
 What you will! (114; B&J 229), bought by Chantrey.
June: Turner proposed that Messrs Hurst & Robinson,
 print publishers, should engrave four of his pictures.
 The idea was not accepted.
Two new projects were initiated this year: a series of
 plates for W. B. Cooke illustrating *Rivers of England*,
 and a sequel, *Ports of England*, both to be engraved in
 mezzotint on steel.
Early August: in pursuit of material for the engraved
 series, and to draw at Edinburgh during George IV's
 ceremonial visit to Scotland, Turner sailed up the east
 coast of England using two sketchbooks, *King's visit to
 Scotland* (TB CC) and *King at Edinburgh* (TB CCI);
 4 unfinished oil paintings of events during the King's
 visit exist (B&J 247, 248, 248a, 248b).
September/October: Turner possibly explored the
 Thames and Medway estuaries in search of material
 for the *Rivers* and *Ports* series; see the *Medway*
 sketchbook (TB CXCIX).

1823

No Perspective lectures given.
1 January: the Cookes opened the second of their exhibi-
 tions of drawings. It contained 11 by Turner,
including 3 recent large watercolours: *Dover Castle
from the Sea* (26; w.505), *Margate, Sunrise* (w.507), and
the *Shipwreck* or *Storm* (w.508); the latter two did not
appear in the printed catalogue as they were not
added until May. Dr Monro and Jack Fuller each lent
2 drawings.
Royal Academy exhibition: only one picture shown, *The
 Bay of Baiæ, with Apollo and the Sybil* (77; B&J 230).
March–April: Rubens's *Chapeau de Paille* exhibited in
 London; Turner made a sketch of it in the *Old London
 Bridge* sketchbook (TB CCV, f.44).
1 August: Part I of the *Rivers of England* published,
 comprising 3 plates, 2 after Turner, the other after
 William Collins. Turner made 5 more drawings for
 the work this year. A further 10 plates were engraved
 from his designs, and 4 after Girtin, but only 7 of the
 12 projected parts were issued (w.732–749; R.752–
 769). The plates are dated between 1823 and 1827.
Late August/September: Turner, Chantrey and Soane
 elected as Auditors to the Academy for the following
 year. Turner had sought the office in 1822.
Occupied with a commission from George IV to paint
 The Battle of Trafalgar for St James's Palace.
An article by the Rev. James Skene in the *Edinburgh
 Encyclopædia* (XVI, pt 1) referred to Turner whose
 'scrutinizing genius seems to tremble on the verge of
 some new discovery in colour which may prove of the
 first importance to the art.'

1824

January–February: the Perspective lectures resumed.
At the Royal Academy exhibition Turner showed nothing.
April: the Cookes' third watercolour exhibition held at 9
 Soho Square: 15 by Turner were on view, including
 some early examples, *Porch of St Hugh the Burgundian,
 Lincoln Cathedral* (1795) and *Morning – An Effect of
 Nature in the neighbourhood of London* (R.A. 1801 as
 London: autumnal morning), and a work specially
 finished for the exhibition, *Twilight – smugglers off
 Folkestone fishing up smuggled Gin* (41; w.509).
May: *The Battle of Trafalgar* (B&J 252) hung at St James's
 Palace. It was soon removed to Greenwich.
Summer: Turner seems to have toured along the south
 coast, to collect some of the final subjects for the
 Southern Coast, and in East Anglia for a projected
 series of 'Picturesque Views on the East Coast of
 England' for which only a few plates were engraved.
 The finished drawings, in bodycolour on blue paper
 (w.896–905), may date from a year or two later.
19 November: Turner visited Farnley, the last time that
 he did so. (He gave a sketchbook used on the visit to
 Munro of Novar in 1836.)

1825

The course of Perspective lectures was given.
27 March: Soane exhibited his newly-acquired Egyptian
 sarcophagus of Seti I; Turner 'with his red face and
 white waistcoat' was seen at a soirée in Lincoln's Inn
 Fields by Haydon.
Royal Academy exhibition: one oil painting shown,
 Harbour of Dieppe (changement de domicile) (152; B&J

231); and one watercolour, *Rise of the River Stour at Stourhead* (465; w.496), which was intended as a pendant to the *Tivoli* of 1817 (R.A. 1818) and may have been painted at that time. Critics considered the *Dieppe* grand but unnatural in colouring.

An important new project was initiated this year: the *Picturesque Views in England and Wales*, under the proprietorship of Charles Heath, an engraver and print publisher, who commissioned 120 designs from Turner. About 12 watercolours were ready by the summer of 1826, including several completed for other projects, notably Whitaker's *Richmondshire*.

28 August: Turner began a tour of the Low Countries; his itinerary was Dover, Rotterdam, Delft, The Hague, Leyden, Amsterdam, Utrecht, Cologne, Aix-la-Chapelle (Aachen), Liège, Antwerp, Ghent, Bruges, Ostend. He used the *Holland* sketchbook (TB CCXIV).

25 October: death of Walter Fawkes after an illness of several months.

By the end of the year Turner and his father had probably left Sandycombe Lodge to live at Queen Anne Street.

1826

No Perspective lectures given.

Royal Academy exhibition: 4 oil paintings shown, *Cologne, the arrival of a packet boat. Evening* (72; B&J 232); *Forum Romanum, for Mr Soane's Museum* (132; B&J 233); *View from the terrace of a villa at Niton, Isle of Wight, from sketches by a lady* (297; B&J 234); and *The seat of William Moffatt, Esq., at Mortlake, Early (Summer's) Morning* (324; B&J 235). *Cologne*, a companion to the *Dieppe* of the previous year, was an early instance of Turner's using tempera as the medium for the ground of an oil painting. It was attacked for its 'very free use of chrome yellow' (*Morning Post*, 9 May).

June: the publishers J. and A. Arch concluded the *Southern Coast* series, using engravers other than the Cookes to finish the plates. Publication had been repeatedly delayed over the past nine years owing to W. B. Cooke's mismanagement, and this year Turner violently quarrelled with him.

Samuel Rogers commissioned Turner to make illustrations for a new edition of his poem *Italy*, to which Stothard was also to contribute.

A survey of the great rivers of Europe begun, to include views along the Rhine, Moselle, Meuse, Seine and Loire, and probably the Danube, Saône and others. Turner combined his investigations for it with another scheme, sponsored by Arch, to publish 'a work to be entitled THE ENGLISH CHANNEL, OR LA MANCHE, to consist of views taken by him from Dunkirk to Ushant, and places adjacent'.

The *Ports of England* began to appear this year. Thomas Lupton mezzotinted 12 plates in all: only 6 were published between 1826 and 1828; the remainder did not appear until 1856 (w.750–762; R.778–790).

10 August–September: tour of the Meuse and Moselle, the north French coast and the Loire. He travelled to Brussels, Liège, Huy, Namur, Dinant, Givet, Verdun, Metz, Trèves (Trier), Cochem and Coblenz, then down the Rhine to Cologne; he was at Calais on 9 September, and went from there to Abbeville, Dieppe, Morlaix, Nantes and up the Loire to Orléans, returning through Paris. On this tour he probably used for the first time a new, soft-covered 'roll' sketchbook that he was to adopt extensively for his later continental journeys: this was the *Treves and Rhine* sketchbook (TB CCXVIII). Other books in use were *Holland, Meuse and Cologne* (TB CCXV), *Rivers Meuse and Moselle* (TB CCXVI), *Huy and Dinant* (TB CCXVII), *Moselle (or Rhine)* (TB CCXIX), *Morlaise to Nantes* (TB CCXLVII), *Nantes, Angers, and Saumur* (TB CCXLVIII), and *Loire, Tours, Orleans, Paris* (TB CCXLIX). In a letter of 4 December (G. 119) he referred to the explosion of a powder-magazine near Ostend on 20 September which had prompted fears for his safety.

By this date Turner had become acquainted with Hugh Andrew Johnstone Munro of Novar, who was to be a close friend and one of his most assiduous patrons.

Sir John Leicester created Lord de Tabley.

Sandycombe Lodge sold.

Either in this year or shortly afterwards Turner made the 12 mezzotints known as the 'Little Liber Studiorum' (R.799–809a), his only sustained performance as a printmaker on his own account.

1827

22 January: the course of Perspective lectures began. Turner delivered only four this year, owing to the illness of his father.

March: the first part of the *Picturesque Views in England and Wales* published for Heath by Robert Jennings.

Royal Academy exhibition: 4 or perhaps 5 paintings shown, '*Now for the painter' (rope). Passengers going on board*, also known as the *Pas de Calais* (74; B&J 236); *Port Ruysdael* (147; B&J 237), a tribute to the Dutch master; *Rembrandt's daughter* (166; B&J 238), a pastiche based on a Rembrandt belonging to Lawrence (*Joseph and Potiphar's Wife*); and *Mortlake Terrace, the seat of William Moffatt, Esq. Summer's evening* (300; B&J 239), a pendant to the view of the same garden from the opposite side shown in 1826. According to the catalogue, Turner showed another work, *Scene in Derbyshire* (319; B&J 240), but this is untraced and the entry may have been misprinted. All the pictures were attacked by the critics for 'so sad, so needless a falling off' (*John Bull*, 27 May); *Mortlake Terrace* was castigated as a case of the 'yellow fever' (*Morning Post*, 15 June).

7 July: part of the collection of Lord de Tabley, who had died on 18 June, was sold at auction; Turner bought back *The Blacksmith's shop* and *Sun rising through vapour* (both R.A. 1807) for 140 and 490 guineas respectively.

August: visited Petworth; Samuel Rogers was also there, and noted that Turner made at least one of the vignettes for his *Italy* during the visit.

August-September: visited John Nash at East Cowes Castle, Isle of Wight. Nash commissioned two pictures of the Cowes Regatta and gave him a room in which to paint undisturbed. While at Cowes he used the *Windsor and Cowes, Isle of Wight* (TB CCXXVI) and *Isle of Wight* sketchbooks (TB CCXXVII). He also

made about 100 drawings in pen and white chalk on small sheets of torn grey or blue paper (TB CCXXVII(a) and CCXXVIII), and may have worked on colour studies derived from the Meuse-Moselle tour of 1826 (TB CCXXI, CCXXII), and perhaps the 'East Coast' subjects begun in 1824: all make use of tinted paper and bodycolour. He made a series of 9 oil sketches (B&J 260–268) on two pieces of canvas, and may also have begun a large classical subject, *Dido directing the equipment of the fleet*, for a Mr Broadhurst.

October: again at Petworth.

10 December: elected a member of the Academy Council for 1828, and re-elected as one of the three auditors.

1828

7 January–11 February: the last of the courses in Perspective. He retained the Professorship until 1837.

Royal Academy exhibition: Turner was on the Exhibition Committee this year. He contributed 4 oil paintings: *Dido directing the equipment of the fleet, or the morning of the Carthaginian Empire* (70; B&J 241); 2 views of Nash's house, *East Cowes Castle, the seat of J. Nash Esq.; the Regatta beating to windward* (113; B&J 242) and *East Cowes Castle, the seat of J. Nash, Esq.; the Regatta starting from their moorings* (152; B&J 243); and *Boccaccio relating the tale of the birdcage* (262; B&J 244). Again his unnatural colour was attacked, the *Boccaccio* described by the *Athenæum* for 21 May as 'the *ne plus ultra* of yellow, and gaudiness, and of corrupt art'. 'Mr Turner is determined not merely to shine, but to blaze and dazzle. Watteau and Stothard, be quiet! Here is much more than you could match' (*Literary Gazette*, 17 May).

John Pye's print of *The Temple of Jupiter* (R.208) published.

Turner visited Petworth, to work on a commission from Lord Egremont to paint a series of subjects to hang in the dining-room. In a letter of 18 August Thomas Creevey mentioned having just seen two. Turner in fact completed two sets, one of which (B&J 282–287) seems to have been rejected by Egremont. The other, now at Petworth, consists of *The Lake, Petworth: sunset, fighting bucks* (B&J 288), *The Lake, Petworth: sunset, a stag drinking* (B&J 289), *Chichester Canal* (B&J 290) and *Brighton from the Sea* (B&J 291). (Lord Egremont had interests in both the Chichester canal and the Brighton Chain Pier.)

An exhibition in Newcastle at the Northern Academy of Arts included 2 watercolours of Rhine subjects made for Swinburne in 1820 (W.691, 692).

Completed the vignette designs for Rogers's *Italy* and his quota of *England and Wales* subjects, together with some similar watercolours for a projected set of 'Picturesque Views in Italy' which did not materialize.

Early August–February 1829: second journey to Italy. By 11 August he had reached Paris. His route took him to Orléans, Clermont-Ferrand, Lyons, Avignon, Nîmes, Arles, Marseilles, Nice, Genoa, Spezzia, Florence and Siena; he reached Rome early in October. He lodged for the first part of his stay with Eastlake at 12 Piazza Mignanelli, where he worked on 'eight or ten' pictures, some of which he exhibited in

rooms at the Quattro Fontane. They included *View of Orvieto* (B&J 292), *Vision of Medea* (B&J 293) and *Regulus* (B&J 294). More than 1,000 people attended the exhibition, which was received with mixed admiration and bewilderment. Other works in progress at Rome were *Palestrina* (B&J 295), painted for Egremont, who did not acquire it, a *Reclining Venus* (B&J 296) and an *Outline of Venus Pudica*, neither finished, and several small landscape studies in oil, some perhaps relating to the *Ulysses deriding Polyphemus*. His sketchbooks were: for the outward journey, *Orleans to Marseilles* (TB CCXXIX), *Lyons to Marseilles* (TB CCXXX), *Marseilles to Genoa* (TB CCXXXI), *Coast of Genoa* (TB CCXXXII), *Genoa and Florence* (TB CCXXXIII) and *Florence to Orvieto* (TB CCXXXIV); in Rome, the *Roman and French Note Book* (TB CCXXXVII) and *Rome, Turin and Milan* (TB CCXXXV); the latter was also used on the return journey, with the others, *Rome to Rimini* (TB CLXXVIII) and *Viterbo and Ronciglione* (TB CCXXXVI).

1829

January: Turner travelled north from Rome via Foligno, Macerata, Loreto, Ancona, Bologna, Milan and Turin, crossed the Mont Cenis Pass, and on 22 January, on Mont Tarare, his diligence overturned in a snowdrift.

10 February: at an Academy Council meeting, Constable was elected an Academician. Turner and George Jones visited him after the meeting and stayed till one o'clock in the morning, parting 'mutually pleased with one another', as Constable said.

Royal Academy exhibition: 3 oil paintings and one watercolour shown. The oils were *Ulysses deriding Polyphemus – Homer's Odyssey* (42; B&J 330); *The Loretto necklace* (337; B&J 331), possibly an earlier picture reworked; and *The banks of the Loire* (19; B&J 329). The watercolour commemorated his experience on the way home: *Messieurs les voyageurs on their return from Italy (par la diligence) in a snow drift upon mount Tarrar, 22nd of January, 1829* (W.405). *The Times* responded favourably to *Ulysses*: 'no other artist living . . . can exercise any thing like the magical power which Turner wields with so much ease' (11 May). He had hoped to show the pictures he painted in Rome, but they did not arrive until late July.

This year Turner may have met Mrs Mary Somerville, a friend of Chantrey's and an amateur painter, who visited his studio a number of times. Her paper 'On the magnetizing power of the more refrangible solar rays' was published in *Philosophical Transactions* for 1829, and known to Sir David Brewster, whose *Treatise on Optics* appeared in 1831. Turner was interested in her theory that certain colours, particularly violet and indigo, could magnetize a needle.

Early June–18 July: Charles Heath held an exhibition at the Egyptian Hall, Piccadilly. About 40 of Turner's watercolours were shown, principally subjects for the *England and Wales* series, but with a few 'for a projected work of a similar kind on Italy'. Many of the drawings were acquired by Thomas Griffith of Norwood, later to become Turner's agent.

20 July: Turner's 3 pictures arrived from Rome. He decided not to return there this year as he had planned, but hoped to go in 1830.

August: visited Paris, collecting material for the 'Rivers of Europe' project, then travelled down the Seine to Honfleur, along the Normandy coast to St Malo, and across to Guernsey, perhaps in connection with the 'Channel' scheme. Sketchbooks used on the journey are *Coutances and Mont St Michel* (TB CCL), *Caen and Isigny* (TB CCLI), *Rouen* (TB CCLV) and *Guernsey* (TB CCLII). He seems also to have worked extensively on small sheets of torn blue paper in pencil, chalk and pen, sometimes adding watercolour or bodycolour, though the more elaborate drawings were evidently worked up later (TB CCLIX, CCLX). He was in London again by early September.

21 September: death of Turner's father. He was buried in St Paul's, Covent Garden, on the 29th. After the funeral, Turner stayed with the Rev. H.S. Trimmer.

30 September: signed his first will, bequeathing small legacies to a few relatives, Sarah and Hannah Danby, and his two daughters. There were also bequests to the Royal Academy for the creation of a Professorship of Landscape Painting, and for a biennial award for landscape, a Turner Gold Medal; and to the Artists' General Benevolent Institution. Almshouses were to be built on Turner's land at Twickenham for 'decayed English artists (landscape painters only) and single men'. The building was to include a picture gallery for his works; but *Dido building Carthage* and *The Decline of Carthage* were to be hung in the National Gallery beside Claude's *Mill* and *Seaport*. Chantrey, Wells and Charles Turner were named as executors.

15 October: death of George Dawe, R.A. Turner was a pall-bearer at his funeral in St Paul's Cathedral.

An exhibition at the Birmingham Society of Arts included 5 of the drawings shown earlier at the Egyptian Hall.

This year Turner may have begun to stay at Margate at the lodging house of Sophia Caroline Booth.

1830

1 January: death of Harriet Wells.

7 January: death of Lawrence. Turner witnessed the funeral at St Paul's on the 21st, and made a large watercolour 'sketch from memory' of the scene (TB CCLXIII-344; W.521).

25 January: Shee elected President of the Academy.

10 February: Eastlake elected an Academician.

Royal Academy exhibition: 6 oil paintings and one watercolour shown. Oils: *Pilate washing his hands* (7; B&J 332); *View of Orvieto, painted in Rome* (30; B&J 292); *Palestrina – composition* (181; B&J 295); *Jessica* (226; B&J 333); *Calais sands, low water, Poissards collecting bait* (304; B&J 334); and *Fish-market on the sands – the sun rising through a vapour* (432, destroyed; B&J 335), a variant of the composition of the large picture of 1807. Watercolour: *Funeral of Sir Thomas Lawrence, a sketch from memory* (439). *Palestrina*, like the *Orvieto*, had been begun in Rome, as a companion to the Petworth Claude of *Jacob and Laban*, but Egremont did not acquire it, buying instead the *Jessica* which

provoked critical fury, as did *Pilate washing his hands*. Both works were called 'imitations' of Rembrandt.

Other pictures begun or planned in Rome were probably worked on about now, though none seems to have reached completion. The most important are *Christ and the woman of Samaria* (B&J 433), and 2 large oil sketches, *The Arch of Constantine* (B&J 438) and *Tivoli: Tobias and the Angel* (B&J 437). The fantasy in the manner of Tintoretto, *The vision of Jacob's Ladder* (B&J 435), also probably belongs to the years immediately after the second visit to Italy.

26 June: death of George IV.

This year Munro of Novar made his first recorded purchase of a painting by Turner, the *Venus and Adonis* of c.1804 (B&J 150).

7–21 July: the auctioneers Southgate and Co. of Fleet Street sold W. B. Cooke's entire stock of prints and plates, with their copyrights.

Rogers's *Italy*, illustrated with 25 vignettes by Turner (W.1152–1176; R.348–372) and others by Stothard, published by Thomas Cadell. Its success was out of all proportion to that of the first edition of the poem.

Political unrest on the Continent prevented travel abroad.

August–September: tour of the Midlands in search of material for the *England and Wales* project, visiting Oxford, Warwick, Kenilworth, Coventry, Tamworth, Ashby-de-la-Zouch, Lichfield, Birmingham, Dudley, Worcester, Bridgnorth, Shrewsbury, Chester, Haddon Hall, Castleton and Chesterfield. Sketchbooks used are *Kenilworth* (TB CCXXXVIII), *Worcester and Shrewsbury* (TB CCXXXIX) and *Birmingham and Coventry* (TB CCXL).

1 December: Turner proposed rescinding a measure that the Academy subscribe £1,000 towards the purchase of Lawrence's collection of old master drawings; he apparently considered it improper since the Academy would not become the owner of the collection. His proposal was carried.

Christmas and New Year: perhaps at Petworth.

This year Turner resigned from the Artists' General Benevolent Institution after disagreements over the use of funds.

1831–1840

231 *Juliet and her nurse* (detail). Shown at the Academy exhibition of 1836, this picture, in which Juliet looks out over St Mark's Square in Venice instead of Shakespeare's Verona, was the butt of virulent abuse in *Blackwood's Magazine*. It inspired the young John Ruskin to Turner's defence (see p. 187). Ruskin had seen Venice for the first time in 1835 and was actually planning 'a tragedy on a Venetian subject . . . the fair heroine, Bianca, was to be endowed with the perfections of Desdemona and the brightness of Juliet, – and Venice and love were to be described, as never had been thought of before' (R., XXXV, p. 182). Turner's picture might almost have illustrated the play.

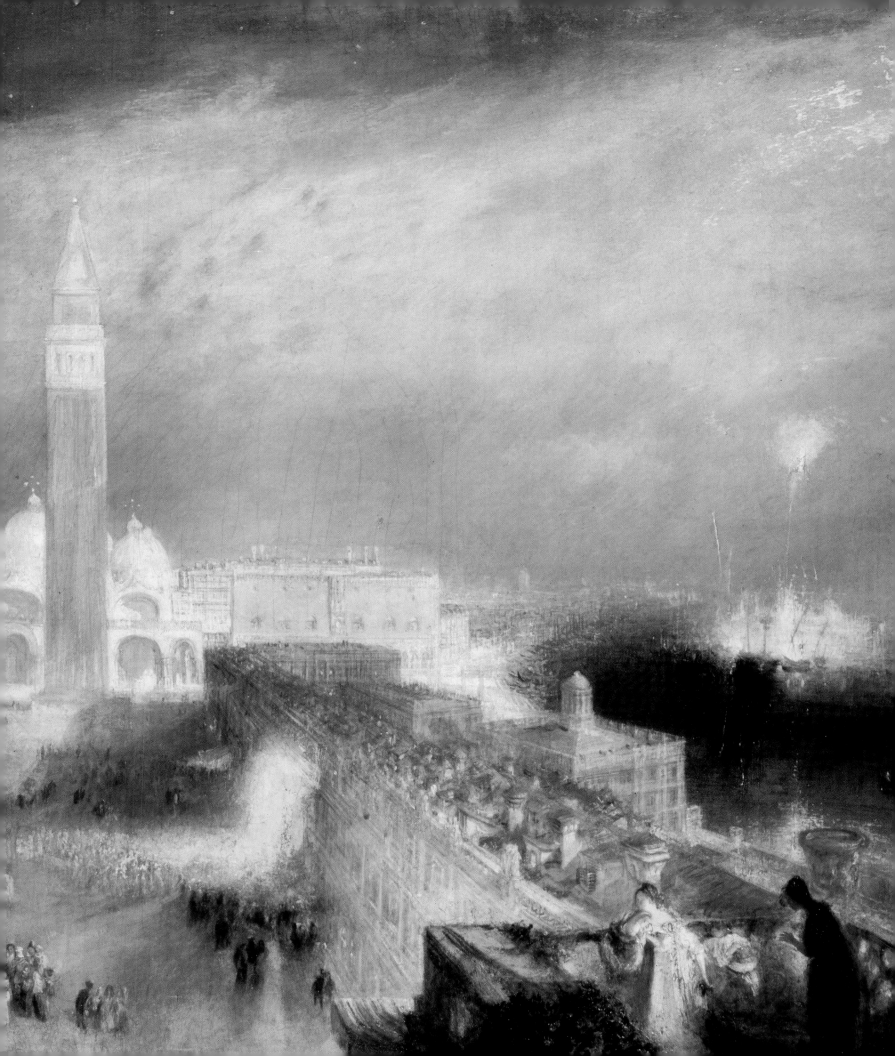

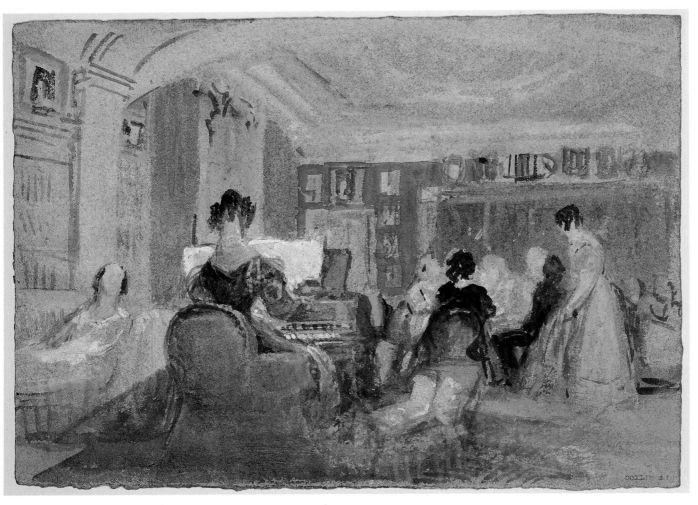

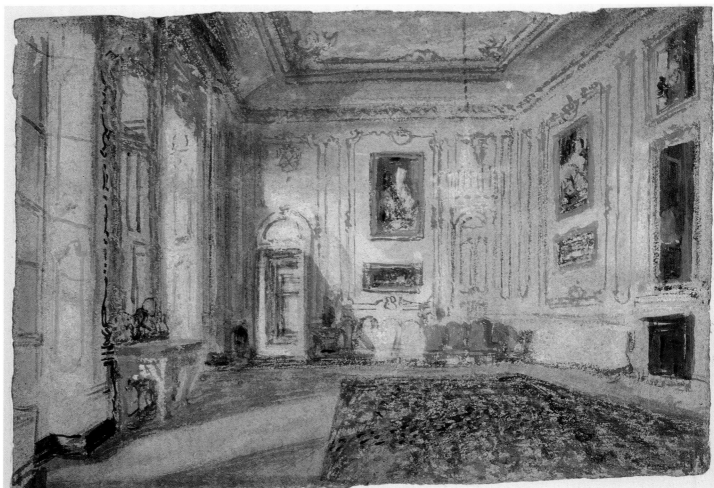

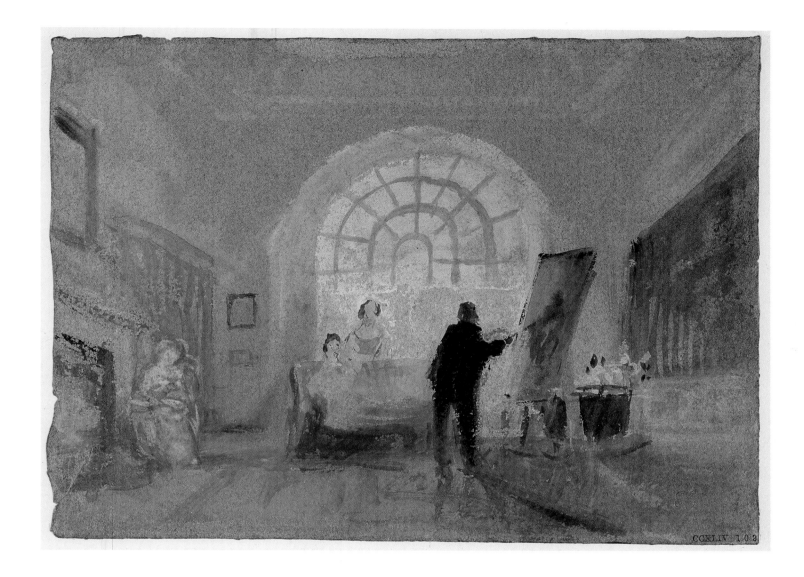

CCXLIV 1 0 2

Petworth

The sketches that Turner made at Petworth in watercolour
and bodycolour on blue paper during one of his visits,
probably in the early 1830s, were apparently never conceived
as more than personal memoranda, records of an
environment 'solid, liberal, rich, and English', as Haydon
evoked it, in which the artist found himself particularly
happy. They afford glimpses of many aspects of the
unregulated life of Lord Egremont's household: shown here
are an evening recital in the White Library (232); a luminous
view of the White and Gold Room (233), with some of the
Van Dyck portraits for which the Petworth collection is
famous, and beneath them a pair of landscapes in very much
the positions that Turner's own Petworth views of 1828
were intended to occupy in the carved dining-room; and a
scene in the Old Library (234), above the Chapel, which was
used as a studio by Turner and others.

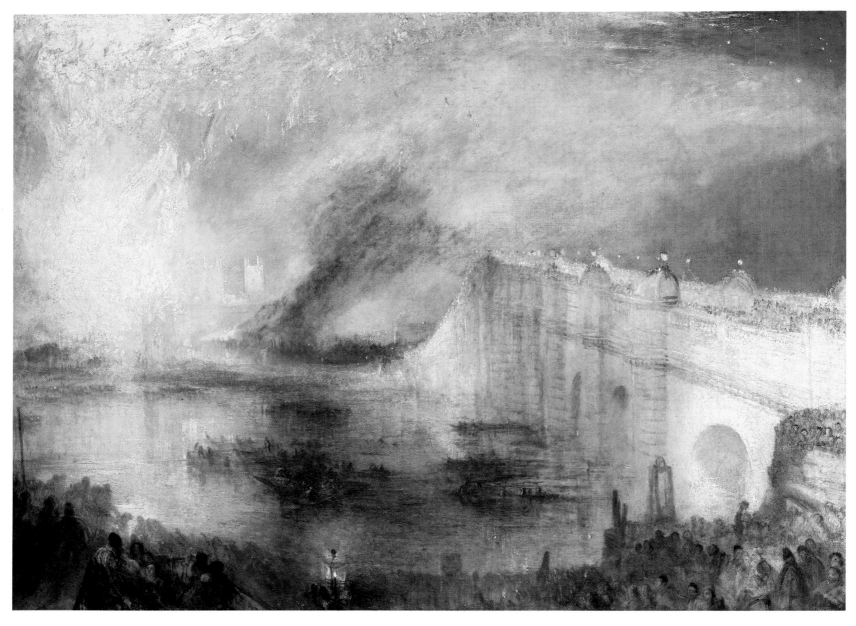

After the experiments of the 1820s, Turner's Academy pieces of the 1830s exhibit a new bravura, combining freedom of execution with boldly distorted perspective and a brilliance of colouring which continued to shock his public.

235 *The Burning of the House of Lords and Commons, 16th of October, 1834* was shown at the British Institution in 1835, and a second treatment of the same subject appeared at the Academy in the same year. Turner's preoccupation with effects of moonlight and firelight, which reached a climax in this decade, here finds its most operatic expression. He is known to have watched the fire from a boat on the Thames, and may also have wandered among the huge crowds on the banks and bridges, which he represents here as the audience at a grand public spectacle. His use of the gamut of colours, from thickly applied masses of intense yellow and red to black and white in touches as delicate as watercolour, is a direct consequence of his experiments with colour and monochrome in the designs for engraving of the 1820s. He was also experimenting with a new vehicle, megilp, which achieved highlights of exceptional intensity; but it was an unstable medium and has subsequently darkened, leaving many of his later paintings sadly out of harmony. For an account of the 'creation' of this picture on the varnishing days, see pp. 183–4.

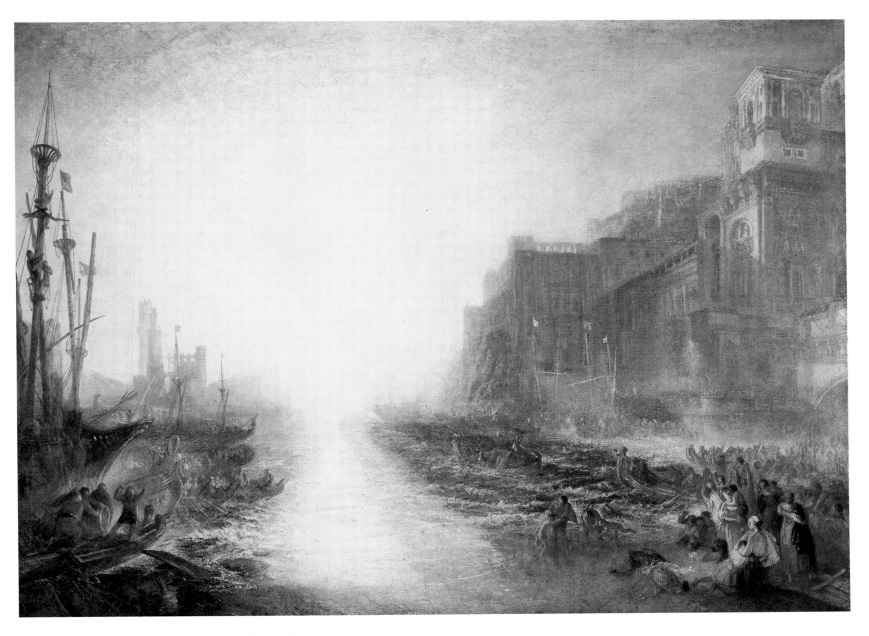

236 *Regulus*, which he showed at the British Institution in 1837, was a reworking of one of the pictures he had painted in Rome: like *The Burning of the House of Lords and Commons*, it was transformed by extensive treatment on the varnishing days (see pp. 184–5). The subject is another chapter in his Carthaginian cycle: the Roman general Regulus, captured by the Carthaginians, was sent back to Rome to negotiate a peace. Once there he refused to do so, and his re-embarkation for Carthage, in the knowledge that he will be put to death, is the theme of Turner's picture. His punishment included having his eyelids cut off, and it has been suggested that the annihilating glare of sunlight in the reworked painting enacts his fate.

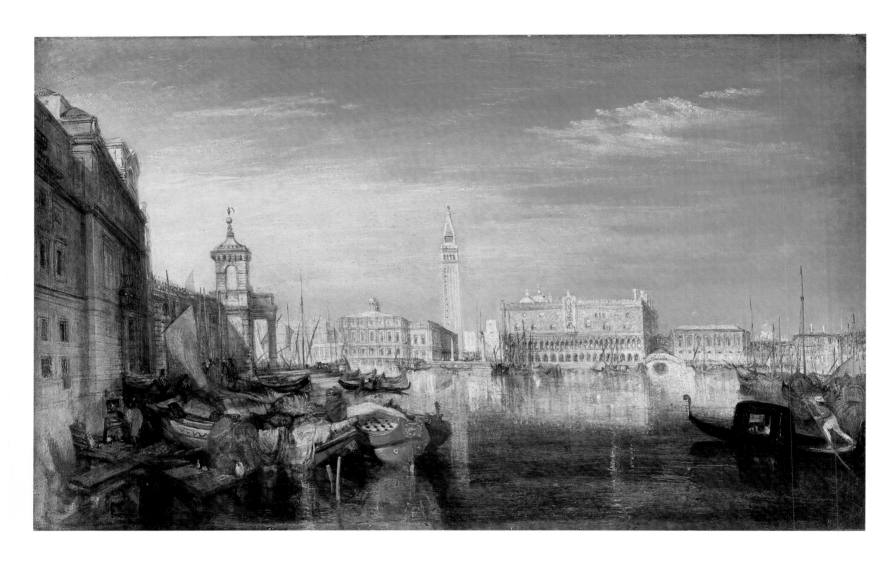

Venice

In the spring of 1833 Turner showed *Bridge of Sighs, Ducal Palace and Custom-house, Venice: Canaletti painting* (237) at the Academy. It was a direct allusion in style and subject-matter to the great eighteenth-century *vedutista*, Canaletto. In the autumn of that year Turner himself was back in Venice, and in 1840 he made his third and last visit. That stay resulted in a long series of paintings and watercolour studies, including numerous views of the buildings of the city seen across the waters of the Lagoon, exploring different effects of light, as in a sketch of *Venice: Moonrise* (238). He also drew views from the window of his bedroom in the Hotel Europa, the interior of which was sufficiently splendid, with its painted ceiling, to have inspired a watercolour study (239).

240 *The Fighting 'Téméraire' tugged to her last berth to be broken up, 1838*, oil, 1839. The *Téméraire* was a veteran of Trafalgar. When Turner saw her by chance, being towed to the breaker's yard against a sunset sky, he was much affected by the poignant implications of the scene. He showed his picture at the Academy in 1839 with a tag which misquotes Thomas Campbell's poem 'Ye mariners of England':

The flag which braved the battle and the breeze
No longer owns her.

There may have been a wry comment here on his failure to obtain any recognition from the Crown. Chantrey had been knighted in 1835 and Wilkie in 1836; Turner was very conscious that he had been passed over.

1831~1840

His recent bereavements were only the beginning of that steady and continuous bereavement which is old age. But with the death of his father Turner had lost, as Finberg says, 'an essential part' of himself. F. E. Trimmer observed that 'Turner never appeared the same man after his father's death; his family was broken up' (T., I, p. 164). And he could no longer visit Farnley either. Hawksworth would certainly have been glad to see him there, but for Turner there was no question of returning to the scene of so important a relationship as his had been with Fawkes. A sketchbook that he had used during his last visit to Farnley in 1824 was given away to a new friend and patron, the
244 Scottish landowner Hugh Munro of Novar, very likely, as has been suggested, because Turner could not bear the associations it carried with it. Solitary as he was by nature, or by the circumstances of his special calling, he depended very heavily on the friendships that mattered to him; indeed, society of some sort was essential to his existence. His isolation was the necessary condition for the realization of his profound engagement with the world: they were concomitants of each other.

One function of this engagement and isolation was the ability to travel widely and freely, observing and studying the life of many places. Once 'his family was broken up' he began to spend more time away on tours, and in the
238–9 1830s not only returned to Venice but penetrated to parts of Europe he had never before visited: Copenhagen, the eastern German states, Austria and the Danube valley. In 1832 he found himself on the committee to consider a building to house the new National Gallery, and it has recently been suggested that an important motive for his long journey through Denmark, Germany and Austria in 1833 was to look critically at the design and layout of European
242 picture galleries, especially those in Berlin, Dresden and Vienna. He returned in 1834 to the Rhine and Moselle, and in 1836 revived his acquaintance with Switzerland in a tour which was the prelude to a new relationship with that country in the 1840s.

Anecdotes of Turner on the Continent were circulated with the same curiosity as those of his domestic life. His habits when travelling were as solitary and independent as usual, and when he had a companion the fact was noted.

> An intimate friend, while travelling in the Jura, came to an inn where Turner had only just before entered his name in the visiting book. Anxious to be sure of his identity and to be in pursuit of him, he inquired of the host what sort of a man his last visitor was. 'A rough, clumsy man,' was the reply; 'and you may know him by his always having a pencil in his hand.' (Reeve)

In the course of one of his visits to Paris, probably in 1832, he seems to have called on Eugène Delacroix, then aged thirty-four, in the Quai Voltaire. The visit was evidently brief. Turner was presumably taken there by a mutual acquaintance, for, though it is likely that he was interested in Delacroix's work, he would not of his own accord have imposed himself on any other painter without persuasion. Much later, in his Journal for 6 February 1852, Delacroix

241 A silhouette of Turner taken, according to an old label, 'on board the *City of Canterbury* steamboat, 23 September 1838'.

242 *The Altes Museum and Domkirche, Berlin*: a detail from a pencil sketch in the *Berlin and Dresden* sketchbook, 1833. K. F. Schinkel's museum, which housed both painting and sculpture, had been opened in 1830. Turner's sketch, though slight and elliptical, records the principal masses of the façade, and even notes the unusual double staircase behind the colonnade.

243 *The Boulevard des Italiens,*
bodycolour, *c.*1832. Turner made five
finished views of Paris for his *Wanderings
by the Seine*; they were published in 1835.
This one typically shows the everyday
life of the crowded city, in a
composition which combines two
parallel vistas divided by a conspicuous
group of trees.

recalled the meeting; his reaction was superficial, no doubt partly at least because fluent communication between the two men was difficult: 'I was not particularly impressed. He looked like an English farmer, with black clothes, rather coarse, big shoes and a hard, cold manner.' Turner, like many Englishmen, was guarded and defensive with strangers.

Even with friends his warmest impulses were sometimes disguised as indifference or simple professionalism. 'One of the points in Turner which increased the general falseness of impression respecting him', Ruskin noticed, 'was a curious dislike he had to *appear* kind' (R., VII, p. 446, n.). In 1836 he went to Switzerland with Hugh Munro of Novar, who had been suffering from severe depression. Munro was a keen amateur draughtsman, and would sit and sketch at Turner's side. He later recounted to Ruskin a telling incident from the tour:

Drawing, with one of his best friends [i.e. Munro of Novar], at the bridge of St Martin's, the friend got into great difficulty over a coloured sketch. Turner looked over him a little while, then said, in a grumbling way – 'I haven't got any paper I like; let me try yours.' Receiving a block book, he disappeared for an hour and a half. Returning, he threw the book down, with a growl, saying – 'I can't make anything of your paper.' There were three sketches on it, in three distinct stages of progress, showing the process of colouring from beginning to end, and clearing up every difficulty which his friend had got into. (R., VII, p. 446, n.)

Ruskin adds, by way of amplification:

When he gave advice, it was also apt to come in the form of a keen question, or a quotation of someone else's opinion, rarely a statement of his own. To the same person [Munro again] producing a sketch, which had no special character: 'What are you in *search* of? . . . Sometimes, however, the advice would come with a startling distinctness. A church spire having been left out in a sketch of a town – 'Why did you not put that in?' 'I hadn't time.' 'Then you should take a subject more suited to your capacity.' (Ibid., p. 447, n.)

He was not one to articulate a point nicely, but he could go to the heart of a problem and make a decisive gesture – speak a word or make a brush-mark – with all the accuracy and perspicacity of long experience. Although he had abandoned the job of drawing-master as uncongenial in the 1790s, Turner was an instinctive teacher. The *Liber Studiorum* had been conceived precisely as a comprehensive course of tuition in all branches of landscape painting. And his wish to institute a Lectureship in Landscape to the Academy, like his concern with the Perspective lectures, indicated his enthusiasm for instructing others, as did his willingness to act as Visitor to the Life Academy, a post to which he was elected at the end of 1833. Yet he was a proselytizer as much as a pedant. His old refusal to indulge the ignorance of his pupils was still apparent; but his advice was no longer directed at largely unteachable amateur ladies and gentlemen: it was for serious young professionals. Ruskin's observation was that

In teaching generally, he would neither waste his time, nor spare it; he would look over a student's drawing, at the Academy, – point to a defective part, make a scratch on the paper at the side, saying nothing; if the student saw what was wanted, and did it, Turner was delighted, and would go on with him, giving hint after hint; but if the student could not follow, Turner left him. . . . Explanations are wasted time. A man who can see, understands a touch; a man who cannot, misunderstands an oration. (Ibid., p. 445)

But by far the most effective and spectacular of his exercises in pedagogy were the demonstrations of creative authority that took place each year on the Academy's varnishing days, and sometimes at the British Institution as well. The Academy had instituted varnishing days in 1809; during three or four days before the opening of each exhibition its members were granted the exclusive privilege of adjusting and finishing their submissions, to take account of the manner in which the paintings were hung. Turner's innate competitiveness gave him incentive enough to take advantage of such a dispensation, and there are plenty of stories to show that he had no scruple in ensuring that his pictures were conspicious. C. R. Leslie recounted a famous instance:

246

> In 1832, when Constable exhibited his 'Opening of Waterloo Bridge,' it was placed in the school of painting – one of the small rooms at Somerset House. A sea-piece, by Turner, was next to it – a grey picture, beautiful and true, but with no positive colour in any part of it. [This was his *Helvoetsluys – the City of Utrecht, 64, going to sea.*] Constable's 'Waterloo' seemed as if painted with liquid gold and silver, and Turner came several times into the room while he was heightening with vermilion and lake the decorations and flags of the city barges. Turner stood behind him, looking from the 'Waterloo' to his own picture and at last brought his palette from the great room where he was touching another picture [this was *Childe Harold's pilgrimage*], and putting a round daub of red lead, somewhat bigger than a shilling, on his grey sea, went away without saying a word. The intensity of the red lead, made more vivid by the coolness of his picture, caused even the vermilion and lake of Constable to look weak. . . . 'He has been here,' said Constable, 'and fired a gun.' 'A coal has bounced across the room from Jones's picture,' said Cooper, 'and set fire to Turner's sea.' The great man did not come again into the room for a day and a half; and then in the last moments that were allowed for painting, he glazed the scarlet seal he had put on his picture, and shaped it into a buoy. (C.R. Leslie 1860, I, p. 202)

Such acts of self-assertion were not malicious so much as demonstrations of Turner's strong belief in professional *sauve qui peut* – the spirit to which Ruskin alluded when speaking of his teaching methods. More often than not, they seem to have been exercises in good-humoured rivalry as between equals. That the other Academicians may not have felt themselves to be his equals probably did not come into his calculations: he treated them all as colleagues, and expected them to enter into the comradely sport with him. This is not to say that he did not perceive the separate and special quality of his genius. That knowledge must be taken for granted in all that he did. It would not be consistent with an exceptional intellect that it was unconscious of its own worth: such ignorance would be a crippling limitation of its power. Cyrus Redding with his customary percipience saw that this was so in Turner's case:

> Some have said that Turner was not conscious of his own superiority. I believe he was conscious of it. I believe him, too, the first landscape painter that has existed, considering his universality. That he did not share in every-day susceptibilities, nor build upon things which the mass of artists esteem, is to his honour rather than demerit. His mind, too, was elevated. He did not wish to appear what he was not. He exhibited none of the servile crawling spirit of too many of his brethren. . . . A painter, said to me that an artist could often see something amiss in his own picture he could not tell what, but Turner would instantly explain the defect; a single glance at the canvas from his eye was enough. He spoke little, but always to the point. (Redding 1858, I, p. 203)

244 Hugh Andrew Johnstone Munro of Novar, by John Raphael Smith, *c.*1815. Munro of Novar was one of the most distinguished connoisseurs of his generation, and accumulated an important collection of pictures, largely by modern artists. His patronage of Turner spanned the period between the death of Fawkes in 1825 and the emergence of Ruskin in the 1840s. He remained a close friend and was named one of Turner's executors.

245

Varnishing days

So central a feature of the varnishing days did Turner's performances become in the 1830s and 40s that a caricature of him appears in the right background of a sketch by John Everett Millais (247) that is dated 1850 – the last year Turner contributed to the Academy exhibition. His transformation at the Academy in 1832 of *Helvoetsluys; – the City of Utrecht, 64, going to sea* (246), in response to a neighbouring work by Constable, is a celebrated instance of his often disconcerting practice (see p. 179).

Significantly, Turner also used the British Institution (245) as a forum for his virtuoso performances, since he could reach a wider audience of artists there than at the Academy, where only the members were allowed to attend. The Institution possessed a notable collection of masterpieces by British and foreign artists, some of which can be seen in this view by John Scarlett Davis, including Gainsborough's *Market Cart* at the left and, prominent on the right, Reynolds's *Holy Family*. In the foreground the elderly James Northcote, a pupil of Reynolds, reminisces over a self-portrait by his master.

246

24

180

248 *Turner on Varnishing Day*, by S. W. Parrott, *c*.1846, an oil study inscribed 'from life'. Robert Leslie told Ruskin of his memories of Turner, 'as he stood working upon those, to my eyes, nearly blank white canvases in their old Academy frames. There were always a number of mysterious little gallipots and cups of colour ranged upon drawing stools in front of his pictures; and, among other bright colours, I recollect one that must have been simple red-lead. He used short brushes, some of them like the writers used by house decorators, working with thin colour over the white ground, and using the brush end on, dapping and writing with it those wonderfully fretted cloud forms . . .' (R., xxxv, p. 572).

249 One of Turner's palettes.

250 *'Then Nebuchadnezzar came near to the mouth of the burning fiery furnace, and said, Shadrach, Meshach, and Abednego come forth of the midst of the fire.' – Daniel, chap. III, ver. 26.*, oil, 1832. In their little competition Turner seems to have set himself to imitate Jones's style of composition as well as his subject and format. The picture also takes its place naturally among the group of Rembrandtesque works that he showed between 1827 and 1832, and it may have been Jones who reintroduced Turner to Rembrandt, just as Stothard had inspired him with a new interest in Watteau.

These observations shed much light on Turner's intentions and motives in 'competing' with his colleagues, and 'performing' on varnishing days. He knew, as he had always done, the immense value of what he had to offer; and respected his colleagues the more for identifying it themselves. George Jones, 252 at any rate, took his behaviour in good part. The 'coal of fire' that Abraham Cooper referred to was an allusion to a picture which Jones painted in deliberate 250, competition with Turner, and certainly without acrimony: 251

> Another instance of Turner's friendly contests in art arose from his asking me what I intended to paint for the ensuing Exhibition. I told him that I had chosen the delivery of Shadrach, Meshech and Abednego from the Fiery Furnace. 'A good subject, I will paint it also, what size do you propose?' Kitcat. 'Well, upright or lengthways?' Upright. 'Well, I'll paint it so. Have you ordered your panel?' No, I shall order it tomorrow. 'Order two and desire one to be sent to me; and mind, I never will come into your room without enquiring what is on the easel, that I may not see it.' Both pictures were painted and exhibited; our brother Academicians thought that Turner had secretly taken advantage of me and were surprised at our mutual contentment, little suspecting our previous friendly arrangement. They justly gave his picture a much superior position to mine, but he used his utmost endeavours to get my work changed to the place he occupied and his placed where mine hung, as they were exactly the same size. (Jones, *Turner*, pp. 5–6)

On another occasion the competition took a different form:

> 'The View of Venice with Canaletti painting' hung at the Royal Academy 237 [in 1833] next to a picture of mine which had a very blue sky. He joked with me about it and threatened that if I did not alter it he would put down my bright color, which he was soon able to do by his magical contrasts in his own picture, and laughed at his exploit, and then went to work at some other picture. I enjoyed the joke and resolved to imitate it, and introduced a great deal more white into my sky, which made his look much too blue. The ensuing day, he saw what I had done, laughed heartily, slapped my back and said I might enjoy the victory. (Ibid., p. 5)

Jones, whose recollections of Turner were entirely affectionate, could cite examples of Turner's generous treatment of other men's works at the Academy, as when 'He, when arranger, took down one of his own pictures to give a better place to a picture by the late Mr Bird, before that artist was a member of the Academy' (ibid.).

Since his profession was the central focus of his life, and the Academy in many ways a home for him more truly than any of the houses in which he so perfunctorily dwelt, it is not surprising that he regarded the varnishing days as family gatherings, times for the free and convivial exchange of ideas, and for the expression of affection, in the form of humorous competition, towards friends and colleagues. Leslie understood this:

> Turner was very amusing on the varnishing, or rather the painting days, at the Academy. Singular as were his habits, for nobody knew where or how he lived, his nature was social, and at our lunch on those anniversaries, he was the life of the table. . . . I believe, had the varnishing days been abolished while Turner lived [the rules were changed in November 1851, a few weeks before his death], it would have almost broken his heart. – When such a measure was hinted to him, he said, 'Then you will do away with the only social meetings we have, the only occasions on which we all come

together in an easy unrestrained manner. When we have no varnishing days we shall not know one another.' (C. R. Leslie 1860, 1, pp. 201–2)

But the most memorable of the events of the varnishing days were those apparently spontaneous creations of new works of art from almost bare canvases on which, from about the time of his Roman exhibition in 1828 onwards, Turner seems to have increasingly relied for the completion of his annual entry at the Academy. He nearly always sent in three or four, if not more, canvases, some of which were mere 'lay-ins' of pale colour.

Turner went about from one to another of them on the varnishing days piling on, mostly with the knife, all the brightest pigments he could lay his hands on, chromes, emerald green, vermilion, etc., until they literally blazed with light and colour. They looked more like some of the transformation scenes at the pantomime than anything else. Artists used to dread having their pictures hung next to them, saying that it was as bad as being hung beside an open window. They caught the eye the instant you entered the room. . . . Turner used to send these pictures into the Academy with only a delicate effect, almost in monochrome, laid on the canvas, and very beautiful they looked, often like milky ghosts. They had probably been painted for a time, as they were quite dry and hard; all the bright colour was loaded on afterwards, the pictures gradually growing stronger in effect and colour during the three varnishing days.

I believe that Turner had for a long time been in the habit of preparing works for future exhibition, laying in, with simple colours, the effect and composition, painting them solidly and very quickly with considerable *impasto*, and allowing the whole to dry and harden together. He would use no fugitive pigments in these preparations, contenting himself with the ochres, siennas, and earth browns, with real ultramarine, black, and a very liberal allowance of white. He must, I think, have had many works thus commenced laid by in his studio, from which he would take one, from time to time, to send to the Academy exhibition. (G. D. Leslie, pp. 146–7)

A famous instance of a lay-in being transformed into a masterpiece before the eyes of his colleagues is that of *The Burning of the House of Lords and Commons, 16th of October, 1834* submitted to the British Institution in 1835. He was to show another view of the fire at the Academy later in the spring. The two pictures form a striking testimony to the excitement that this huge conflagration generated. Turner's response was undoubtedly dominated by the pictorial possibilities suggested by the visual drama of the fire; but the fact that he painted it twice suggests that the occasion was one of extra significance for him. The Reform Bill had been passed two years earlier, in March 1832, and he cannot but have recognized in it the fulfilment of his friend Walter Fawkes's lifelong aspiration to re-establish a 'Parliament full, free and frequent' in England. It is hard to resist the thought that he saw in the burning of the old Parliamentary buildings, as many others did, a symbol of the passing of the old, corrupt order and painted his incandescent visions of it partly to celebrate the new dispensation and partly as tributes to the memory of Fawkes.

The version shown at the British Institution is the closer view of the fire. The blaze occupies half the canvas, and is seen from the opposite bank of the Thames. Its light is reflected on the flank of Westminster Bridge to the right, swarming with onlookers and receding in steep perspective into the picture space – a characteristic and powerfully literal device of Turner's for creating three-dimensional space in his compositions. According to a witness, he arrived early in the morning on varnishing day:

235

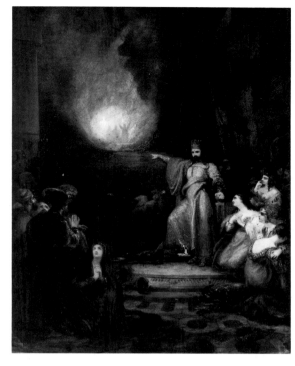

251 George Jones: *The Burning Fiery Furnace*, 1832.

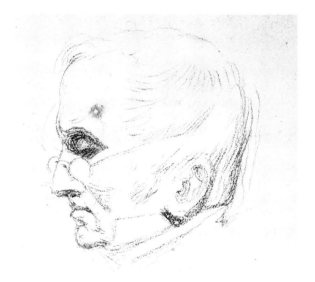

252 George Jones in old age, drawn by C. H. Lear in 1865.

Indeed it was quite necessary to make the best use of his time, as the picture when sent in was a mere dab of several colours, and 'without form and void', like chaos before the creation. The managers knew that a picture would be sent there, and would not have hesitated, knowing to whom it belonged, to have received and hung up a bare canvas, than which this was but little better. Such a magician, performing his incantations in public, was an object of interest and attraction. Etty was working at his side and every now and then a word and a quiet laugh emanated and passed between the two great painters. Little Etty stepped back every now and then to look at the effect of his picture, lolling his head on one side and half closing his eyes, and sometimes speaking to some one near him, after the approved manner of painters: but not so Turner; for the three hours I was there — and I understood it had been the same since he began in the morning — he never ceased to work, or even once looked or turned from the wall on which his picture hung. All lookers-on were amused by the figure Turner exhibited in himself, and the process he was pursuing with his picture. A small box of colours, a very few small brushes, and a vial or two, were at his feet, very inconveniently placed; but his short figure, stooping, enabled him to reach what he wanted very readily. Leaning forward and sideways over to the right, the left hand metal button of his blue coat rose six inches higher than the right, and his head buried in his shoulders and held down, presented an aspect curious to all beholders, who whispered their remarks to each other, and quietly laughed to themselves. In one part of the mysterious proceedings Turner, who worked almost entirely with his palette knife, was observed to be rolling and spreading a lump of half-transparent stuff over his picture, the size of a finger in thickness. As Callcott was looking on I ventured to say to him, 'What is it that he is plastering his picture with?' to which inquiry it was replied, 'I should be sorry to be the man to ask him.' . . . Presently the work was finished: Turner gathered his tools together, put them into and shut up the box, and then, with his face still turned to the wall, and at the same distance from it, went sidelong off, without speaking a word to anybody, and when he came to the staircase, in the centre of the room, hurried down as fast as he could. All looked with a half-wondering smile, and Maclise, who stood near, remarked, 'There, that's masterly, he does not stop to look at his work; he *knows* it is done, and he is off.' (*Art Journal*, 1860, p. 100)

A similar story is told of another canvas which, however, was not painted from scratch on the varnishing day. *Regulus* had been executed in Rome, and was 236 shown there in 1828. But when Turner submitted it to the British Institution in 1837 it underwent a comprehensive revision, as John Gilbert, who was twenty at the time, later recorded:

He had been there all morning, and seemed likely, judging by the state of the picture, to remain for the rest of the day. He was absorbed in his work, did not look about him, but kept on scumbling a lot of white into his picture — nearly all over it. The subject was a Claude-like composition — a bay or harbour — classic buildings on the banks on either side and in the centre the sun. The picture was a mass of red and yellow in all varieties. Every object was in this fiery state. He had a large palette, nothing on it but a huge lump of flake-white: he had two or three biggish hog tools to work with, and with these he was driving the white into all the hollows, and every part of the surface. This was the only work he did, and it was the finishing stroke. The sun, as I have said, was in the centre; from it were drawn — ruled — lines to

253 *Keelmen heaving in coals by night*, oil, 1835.

mark the rays; these lines were rather strongly marked, I suppose to guide his eye. The picture gradually became wonderfully effective, just the effect of brilliant sunshine absorbing everything, and throwing a misty haze over every object. Standing sideway of the canvas, I saw that the sun was a lump of white, standing out like the boss of a shield. (Quoted by L. Cust in *Magazine of Art*, 1895, pp. 249–50)

The shimmering envelope of light that he created in *Regulus* was an unusually powerful example of the golden atmosphere in which he bathed a long sequence of his exhibited paintings during this decade. He produced a series of Italian subjects that mark the epitome of his classical manner, notably *Childe Harold's pilgrimage – Italy* in 1832, *The golden bough* in 1834, and *Ancient Italy – Ovid banished from Rome* in 1838. Even *Mercury and Argus*, of 1836, which is reported to have been based on a landscape drawn while Turner was staying with Munro of Novar in Ross and Cromarty, is steeped in the hot glow of a mythological south. The almost physical heat radiated by such pictures was the subject of a characteristic joke of his friend Chantrey's.

254 *An open-air theatre*, one of a group of studies showing theatrical performances, on dark brown paper which Turner used for some of his views in Venice. They share the fascination with Rembrandtian lighting effects that appears so frequently in Turner's work of the early 1830s, and may have been done on the tour of 1833.

These warm effects which Turner produced by a wholesale application of orange chrome were well illustrated by Chantrey on a varnishing day at the Academy when the weather for the time of year was unusually raw and cold. Stopping before a picture by Turner, he seized the artist's arm – placed his hands before a blaze of yellow in an attitude of obtaining warmth – and said, with a look of delight, 'Turner, this is the only comfortable place in the room. Is it true, as I have heard, that you have a commission to paint a picture for the Sun Fire Office?' (Cunningham, Obituary)

As we have already seen in the case of the *Helvoetsluys*, Turner employed a very different palette in his marines based on Dutch history. They imitate the Dutch painters with a fidelity and reverence that is astonishing in an artist so mature and independent: Van Goyen and Ruysdael are actually referred to in some of the titles. One of his most magnificent tributes to Claude, on the other hand, is an entirely original and wholly Turnerian seaport subject, the *Keelmen* 253 *heaving in coals by night* of 1835, at once a modern industrial scene and a nocturne prophetic of Whistler, shot through with the silver and gold of moon and firelight. But it is not only the northern subjects that are accorded cool palettes. He painted Venice at night-time, throbbing in the warm moonlit air with 231 masqueraders and rockets, and Juliet on her balcony pondering the destiny that is waiting for her, disguised, in the festive crowd.

The superimposition of the Shakespearean subject onto a Venetian view has baffled critics since the time it was painted; yet it seems that Turner was irresistibly reminded of the theatre when he was in Venice. He visited the city for a second time in 1833, and it is just possible that he saw a performance of *Romeo and Juliet* while he was there. He made a number of free studies in bodycolour, very probably during that stay, which appear to record theatrical 254 performances (one seems to show the last act of *Othello*); and another painting, *Scene – a street in Venice*, was exhibited in 1837 with a subtitle taken from *The Merchant of Venice*, a play to which he had already alluded with an invented quotation for his portrait of *Jessica* of 1830. He was a keen theatre-goer – 'very distinctly voluble on Shakespeare, and Macready's scenic effects' (T., II, p.

265); and, as his paintings repeatedly proclaim, used his experience of theatrical effects in the creation of works of art. It is the language of the drama, sometimes of lyric comedy, sometimes of violent tragedy, that his pictures speak: all are, to a greater or lesser degree, properly described as theatrical. His fascination with stage effects was, in a sense, truly professional. Eastlake drew attention to it:

> Turner, knowing the difficulty, as every painter must, of clearly expressing an idea distinct from any other, was always ready to appreciate examples of success in this particular, whether in old or modern works of Art. He was even an observer of contrivances for the same end on the stage. He had long maintained that it was impossible to express, on the stage, the bottom of the sea. On hearing that a new attempt of the kind had been made in some pantomime, he inquired particularly what were the means resorted to. Various incidents were enumerated, at which he shook his head. At last he was told that an anchor was lowered from above, by its cable, till it rested on the stage. He reflected for a few moments, and then said, 'That's conclusive.' (Eastlake 1870, p. 342)

Juliet and her nurse was shown at the Academy in 1836 with two other canvases, *Mercury and Argus* and *Rome from Mount Aventine*. All three were the object of an attack which was to have immeasurably significant repercussions for Turner. That autumn, *Blackwood's Magazine* published a virulent criticism of modern 255 British art, and of Turner in particular. It was penned by the Rev. John Eagles, an enthusiastic amateur artist and friend of Francis Danby at Bristol. Of *Juliet and her nurse* Eagles wrote:

> This is indeed a strange jumble – 'confusion worse confounded'. It is neither sunlight, moonlight, nor starlight, nor firelight, though there is an attempt at a display of fireworks in one corner . . . Amidst so many absurdities, we scarcely stop to ask why Juliet and her nurse should be at Venice. For the scene is a composition as from models of different parts of Venice, thrown higgledy-piggledy together, streaked blue and pink, and thrown into a flour tub. Poor Juliet has been steeped in treacle to make her look sweet, and we feel apprehensive lest the mealy architecture should stick to her petticoat and flour it. (*Blackwood's Magazine*, 1836, xl, pp. 550–51)

The burden of Eagles's complaint was that Turner was so eager to 'outstrip all others' that he would 'fly off into mere eccentricities': a suspicion, commonly levelled against him at the time, that his bravura was a result of affectation rather than of feeling. This remains, indeed, the nub of much criticism of Turner: his emancipated virtuosity in combination with the sheer grandeur of his vision seem mannered and self-indulgent to a superficial inspection.

It was the glib superficiality of Eagles's responses, and, no doubt, the fact 293 that they were broadly representative of public opinion, that fired John Ruskin, the seventeen-year-old son of a prosperous wine importer, to compose a rebuttal. He had been converted to Turner by the engraved vignettes in 228 Rogers's *Italy* of 1830, and had been increasingly roused by the failure of the critics each year to give Turner his due. Now he was resolved to vindicate him. In doing so he created prose descriptions of Turner's canvases which are in themselves justifications for the paintings, without further argument: precocious *tours de force* that brilliantly meet and parallel Turner's own.

In his righteous wrath, Ruskin was eager to publish what he had written; but his father, a circumspect Scot, insisted that Turner should be sent a copy first, for his approval. This was done, though only Ruskin's initials were supplied. The reply, sent to 'J.R. Esq^re', care of the publishers Smith, Elder and Co., was sympathetic but sobering:

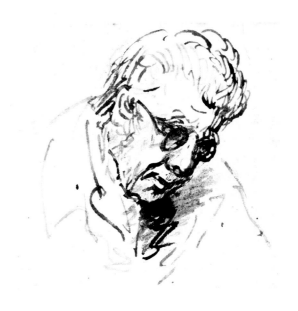

255 Rev. John Eagles: *Self-portrait.*

My Dear Sir
 I beg to thank you for your zeal, kindness, and the trouble you have taken in my behalf in regard of the criticism of Blackwoods Mag for Oc respecting my works, but I never move in these matters. They are of no import save mischief and the meal tub which Maga fears for by my having invaded the flour tub.

 [signature cut away]

P.S. If you wish to have the Mans [i.e. manuscript] back have the goodness to let me know. If not with your sanctions I will send it to the Possessor of the Picture of Juliet. (G. 202)

The 'Possessor' was Munro of Novar, who by this date had established himself as a principal patron of Turner, acquiring both watercolours and paintings (of which he eventually owned about fifteen) with an enthusiasm that matched Fawkes's own. They had been friendly since at least 1826, but Munro's first recorded purchase of an oil painting is the *Venus and Adonis* which he 73 acquired in 1830 for 85 guineas at the sale of its previous owner, John Green of Blackheath. He was one of several new patrons who had begun to form collections featuring Turner's work; others were Henry McConnell, a Manchester industrialist, and Elhanan Bicknell, the proprietor of a whaling fleet, who first took an interest in Turner in about 1835, but does not seem to have begun buying until the early 1840s.

Perhaps the most dedicated of these later patrons was B. G. Windus, a coachmaker who lived in what was then the small village of Tottenham, just north of London. Windus appears to have been one of those inspired by Fawkes's exhibitions at Grosvenor Place: during the 1820s and 30s he built up a large collection of contemporary watercolours which included drawings by Turner for the *Southern Coast* and *England and Wales*. He eventually owned 'upwards of two hundred' by him, and later acquired paintings as well.

> The cottage, though not large, contains several well-proportioned apartments fitted up in an extraordinary style of neatness and with much taste. The library and drawing rooms are hung with the choicest of *Turner's* 256 drawings, framed and glazed, to the number of seventy; the remainder of the collection are preserved in portfolios. (Robinson)

The house was to become a place of pilgrimage for artists and connoisseurs, whom Windus was happy to receive.

In view of Turner's unpredictable responses to the overtures of prospective buyers, it is perhaps surprising that he had not long ago availed himself of the services of an intermediary. But he liked to keep his own hand firmly on the rudder of his business affairs, and in the end did not much trust other people to act on his behalf. Nevertheless, by the 1830s he had acquired a stockbroker, Charles Stokes, himself a keen collector of Turner's drawings and prints; and many of the artist's dealings with his new patrons were now conducted through an agent, Thomas Griffith. Griffith resided at a villa in Norwood, outside London in the hills of north Surrey. Later, in 1845, he opened a gallery in Pall Mall; but he was perhaps too gentlemanly to be described strictly as a dealer. He was at any rate much respected by the many distinguished artists who benefited from his services. He bought a large group of the *England and Wales* watercolours from Charles Heath, after their exhibition at the Egyptian Hall in 225 1829. The publication of *England and Wales* was now in the hands of Messrs Moon, Boys & Graves who, in June 1833, held an exhibition of drawings to boost the enterprise at their gallery in Pall Mall. Most of the exhibited watercolours were by Turner, and Griffith lent a substantial number. The

publishers held a reception or 'conversazione' on 3 July; it was attended, according to *The Times*, by 'two hundred artists and literati'. The occasion was later remembered by a visitor as an

> exhibition of a very numerous and beautiful collection of Turner's drawings. Turner himself was there, his coarse, stout person, heavy look and homely manners contrasting strangely with the marvellous beauty and grace of the surrounding creations of his pencil. Stothard . . . appeared to be absorbed in the contemplation of the works around him, and scarcely exchanged a word with anyone. Etty was there; also Stanfield, Brockedon and other distinguished painters. (*The University Magazine*, 1878, I, iv, p. 301)

The general critical excitement was justified, and was centred largely on the drawings for the *England and Wales* series, on which Turner was still engaged, and which was still appearing in occasional parts, despite financial problems. It was an irony that the public could not be persuaded to buy the prints: they are for the most part masterly transcriptions of designs which rank among the most complex and beautiful of all his watercolours, thematically rich and varied, offering an unparalleled survey of the national life. They comprehend every type of landscape and seascape: panoramas of towns and cities, insights into the labour and leisure of all classes of people. Urban, rustic, sporting, mercantile, industrial and maritime life is presented in countless manifestations, in settings observed and invented with supreme subtlety and wisdom, and executed with a combined freedom and precision never equalled in the medium.

184,
257–62,
275

Turner finished about a hundred of these superb drawings, and by the end of the decade ninety-six had been engraved. But the project met with repeated misfortune; Heath was virtually ruined, and a succession of publishers, Moon, Boys & Graves and the later permutations and combinations of their company, failed to attract the public. It was Longman who were finally left holding the stock of copperplates and unsold prints, and in 1839, having failed to sell it for a lump sum of £3,000 to the print dealer H. G. Bohn,

256 *The Library of Benjamin Godfrey Windus at Tottenham*, by John Scarlett Davis, 1835. 'Mr Turner had many patrons, – and his pictures have found their way into many of our best private collections . . . but it is at Mr Windus's on Tottenham Green that Turner is on his throne. – There, he may be studied, understood, and admired – not in half-a-dozen or twenty instances, but in scores upon scores of choice examples' (*The Athenæum*, 1851). Subjects from the *Southern Coast* and *Rhine* series are on the left-hand wall, with *Alnwick, Trematon, Kilgarren, Pembroke* and other *England and Wales* watercolours on the right.

Picturesque Views in England and Wales

The full range of Turner's topographical knowledge and pictorial imagination is displayed in this magisterial work, which occupied him for a decade from 1825 and, though unfinished, comprised 96 published subjects. William Miller's print of *Carew Castle, Pembroke* (257), of 1832, is shown here in an incomplete state. Robert Wallis's engraving of *Stone Henge, Wiltshire* (258) appeared in 1829; the original

watercolour was acquired by Samuel Rogers. The scene at Northampton (259) during the triumphant return of Lord Althorp in 1830 to serve in the Reformist government of Lord Grey once again illustrates Turner's interest in Parliamentary reform: a banner prominent in the centre foreground reads: 'The Purity of Elections is the Triumph of LAW'. This subject was never engraved.

Turner's concern for the life of the ordinary human beings who people the landscape is nowhere better seen than in the *England and Wales* series. He shows them taking their ease, both politely (see ill. 184) and more uninhibitedly, on *Plymouth Hoe* (260); or alarmed by the dangers that nature can offer, as when the incoming tide threatens to overtake a party crossing *Lancaster Sands* (261).

261

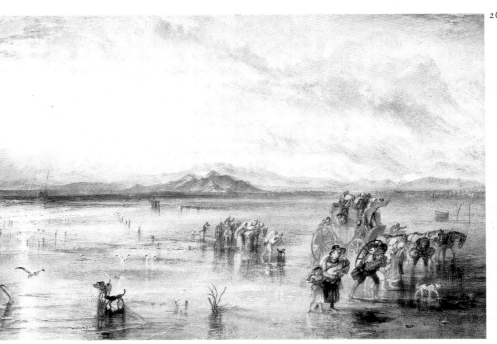

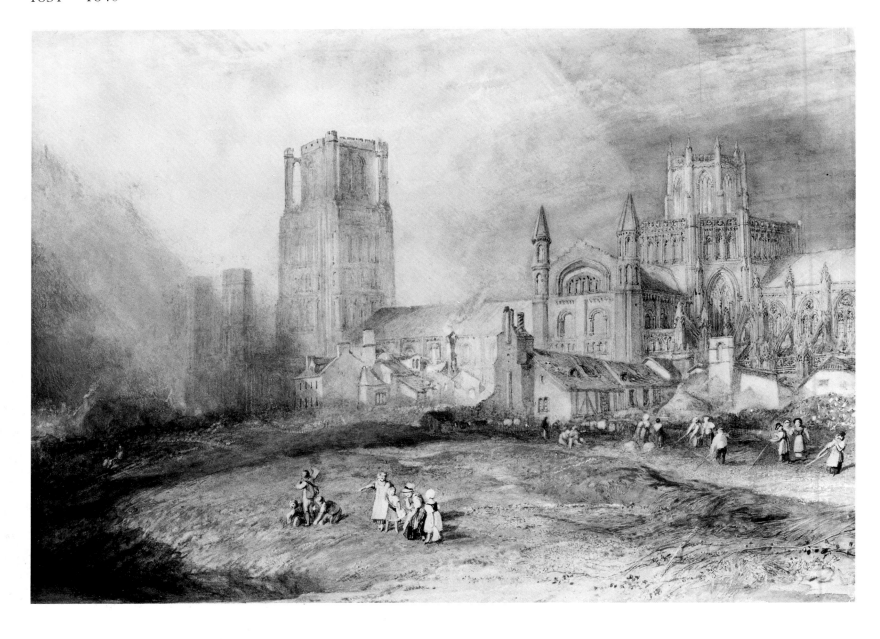

262 *Ely Cathedral*, watercolour, *c.*1831. One of the *England and Wales* subjects that Turner developed from drawings made in his youth. He had sketched the view as early as 1794, and made a watercolour from it shortly afterwards. Now he reconstitutes it to conform to the visionary topography of his maturity. This drawing was one of those acquired by Thomas Griffith, his agent in the 1830s and 40s.

it was placed in the hands of Messrs Southgate and Co. for sale by auction. After extensive advertising, the day and hour of sale had arrived, when just at the moment the auctioneer was about to mount his rostrum, Mr Turner stepped in, and bought it privately, at the reserved price of three thousand pounds, much to the vexation of many who had come prepared to buy portions of it. Immediately after the purchase, Mr Turner walked up to Mr Bohn, with whom he was very well acquainted, and said to him: 'So, Sir, you were going to buy my England and Wales, to sell cheap I suppose, – make umbrella prints of them, eh? – but I have taken care of that. No more of my plates shall be worn to shadows.' Upon Mr Bohn's replying, that his object was the printed stock (which was very large) rather than the copper-plates, he said, 'O! Very well, I don't want the stock, I only want to keep coppers out of your clutches. So if you like to buy the stock come and breakfast with me to-morrow, and we will see if we can deal.' At nine the next morning Mr Bohn presented himself, according to appointment, and after a few minutes Mr Turner made his appearance, and forgetting all about the breakfast, said, 'Well, Sir, what have you to say?' 'I come to treat with you for the stock of

your England and Wales,' was the reply. 'Well! what will you give?' Mr Bohn told him, 'that in the course of the negociation, the coppers and copyright had been estimated by the proprietors at £500, and therefore he would deduct that sum, and the balance, £2500, should be handed to him immediately. 'Pooh? I must have £3000, and keep my coppers; − else good morning to you.' As this was not very likely after having refused both stock and coppers at £3000, 'Good morning' was the reply, and so they parted. (Watts, pp. xxi−xxii, n.)

At Moon, Boys & Graves's show in 1833 there were also a few of the illustrations to Scott's *Poetical Works*, lent by Robert Cadell, the Edinburgh publisher for whom they were undertaken. The *Poetical Works* were part of a comprehensive scheme to publish all Scott's writings, in prose and verse; 263–9 Turner had been to Scotland in 1831 to collect material for it. He visited Scott at Abbotsford, and explored the Highlands and Islands travelling as far afield as Staffa and Inverness, both of which duly appeared as the subjects of vignettes in the *Poetical* or *Prose Works*, which were published between 1834 and 1836. He had already met Scott on his tour of 1818 to the Border country, in connection with the *Provincial Antiquities of Scotland*, and the two men had not hit it off. They had been in touch again when Turner visited Scotland in 1822, though they may not have met. By now, Scott was ailing, and had only one more year to live; but he invited Turner to say at Abbotsford, and this time things went more smoothly. On 20 April 1831 Turner replied to his summons in a letter that seems more than usually tongue-tied and uncharacteristically anxious for advice. It smacks, perhaps, of obsequiousness. Turner was rarely insincere, but he was apparently not a little in awe of this literary colossus − no doubt specially conscious in his presence of his own literary ambitions and shortcomings:

263 Sir Walter Scott at Abbotsford in 1832; detail of a portrait by Sir William Allen.

Dear Sir Walter

It is no small compliment to me your invitation to Abbotsford in manner or purpose and therefore do allow me to offer you my thanks and be pleased to include in that word whatever feeling may be pleasing most to yourself for compliments to you can be of no value.

Mr Cadell has said that he would most cheerfully pay the expenses if a Journey should prove necessary and my having 15 of the subjects induced a thought that he might without he particularly wished me so to do be managed by another means. By your letter I read it is desired and in my furtherance of your wish I will try what can be done (Oh for a feather out of Times wing) I have a trip to make across the Channel if circumstances permit and the days of last July [*sic*] do not make the next too hot and impracticable. Therefore do pray say how long do you think it will take me to collect the material in your neighbourhood. Many are near but my bad horsemanship puts your kind offer of Poney I fear out of the account of shortening the time and when I get as far as Loch Kathrine shall not like to turn back without Staffa Mull and all. A steam boat is now established to the Western Isles so I have heard lately and therefore much of the difficulty becomes removed but being wholly unacquainted with distances &c will thank you to say what time will be absolutely wanting. Mr Cadell has most probably another list or I would inclose the one he sent me. Skiddaw from Penrith round is the most southern subject and could be taken in my way homewards or out or whatever way you think best or most convenient.

I am most respectfully
Yours most truly
J. M. W. Turner (G. 169)

Scotland and Sir Walter Scott

264

Scott's publisher Robert Cadell recorded in his Diaries many incidents from Turner's stay in Scotland in 1831, and the artist showed Scott, Cadell and himself picnicking in his view of *Melrose* (detail, 265). Another watercolour executed as one of the frontispieces to Cadell's edition of Scott's *Poetical Works* is the view of *Berwick on Tweed* (266). Although they measure only some 90 × 150 mm (3½ × 6 in.), these subjects have all the atmospheric range and breathtaking scale of his larger watercolours – a token of the flexibility of his technique by this date. For the titlepages themselves Turner designed vignettes framed in lively cartouches with an air of impromptu invention (264).

On his visit to Staffa Turner made rapid outline sketches inside Fingal's Cave (268), from which the title vignette for *The Lord of the Isles* was evolved (269). That stormy trip also resulted in the great oil painting of *Staffa, Fingal's Cave* (267), exhibited in 1832 with a quotation from the same poem.

265

266

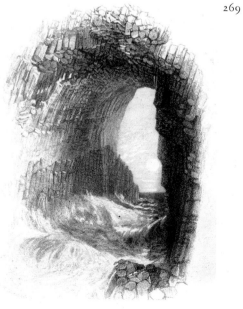

270 C. R. Leslie: *Sancho Panza in the Apartment of the Duchess*, 1824.

271 C. R. Leslie: *Self-portrait*.

He was away from late July until mid-September, when a friend noted that 'Mr Turner is returned from Scotland, where the weather has been very boisterous, and his health not improved by the excursion' (T., II, p. 96). Apart from the quantity of watercolours that resulted from the tour, there was one important painting, *Staffa, Fingal's Cave*, which he showed at the Academy in 1832. When the picture was eventually sold to James Lenox, of New York, in 1845, he gave its new owner a description of the steamer-trip that it records – another of his traveller's tales: 267

> We left the Sound of Mull, in the Maid of Morven, to visit Staffa, and reach Iona in due time; but a strong wind and head sea prevented us making Staffa until too late to go on to Iona. After scrambling over the rocks on the lee side of the island, some got into Fingal's Cave, others would not. It is not very pleasant or safe when the wave rolls right in. One hour was given to meet on the rock we landed on. When on board, the Captain declared it doubtful about Iona. Such a rainy and bad-looking night coming on, a vote was proposed to the passengers: 'Iona at all hazards, or back to Tobermoray'. Majority against proceeding. To allay the displeased, the Captain promised to steam thrice round the island in the last trip. The sun getting towards the horizon, burst through the rain-cloud, angry, and for wind; and so it proved, for we were driven for shelter into Loch Ulver, and did not get back to Tober Moray before midnight. (G. 288) 268

Lenox had bought *Staffa* through C. R. Leslie, who selected it himself from a number that Turner indicated were for sale at the price Lenox offered – £500. Inevitably perhaps, the work thus purchased by mail order did not satisfy the customer. Lenox wrote to Leslie, 271

> after a first hasty glance, to express his great disappointment. He said he could almost fancy the picture had sustained some damage on the voyage, it appeared to him so indistinct throughout. Still he did not doubt its being very fine, but hoped to see its merits on farther acquaintance; but for the present he could not write to Mr Turner, as he could only state his present impression. (C. R. Leslie 1860, I, p. 206)

'Unfortunately,' Leslie continued, 'I met Turner, at the Academy, a night or two after I received this letter . . .' Some explanations were necessary. Leslie replied to Lenox with an account of what happened:

> I saw Turner last evening; and upon his asking me if I had heard from you I was obliged to tell him I had, & that the picture appeared indistinct to you. As it was varnished with mastic varnish the day before it was packed, it is possible the varnish may have chilled, and I asked him what he would recommend in that case. – He suggested the usual practice, namely rubbing the surface of the picture gently with an old and very soft silk handkerchief wherever the bluish chill appeared. – If this does not remove it he recommends a fresh coat of mastic varnish over the whole picture. – Turner said, 'You should tell Mr Lenox that indistinctness is my fault;' – and indeed it is a fault he is often accused of with justice. (Holcomb, p. 557)

But in due course, and with the help of Leslie's explanations, Lenox was converted and came to admire the work, as he said, 'greatly', though he felt 'it will never be a favourite with the multitude'. That reflection no doubt gave him some satisfaction.

Leslie won Lenox's approval with the most emphatic praise of Turner. Turner, he claimed, was 'a man who, whatever may be the defects of his style,

and I admit he has defects enough to ruin a dozen inferior artists, is the greatest living genius, not only in England, but in the world, and whose genius is such that it may not be equalled in a century' (Holcomb, pp. 557–8). Leslie was nine years Turner's junior, and his admiration was as sincere as it was unrestrained.
270 He was a painter of small-scale historical genre scenes, and, different as his rather tight, unimaginative art was from Turner's, it nevertheless probably exerted a certain influence on him. Turner was always susceptible to the ideas of his colleagues, and it is difficult to explain the series of small historical interiors that he painted in the early 1830s except as exercises in Leslie's vein. In
272 particular, his little panel of 1831, *Watteau study by Fresnoy's rules*, which celebrates simultaneously Watteau the painter and white the colour (it embodies some of the results of his experiments with pure black and white in the late 1820s), is a genre scene in the manner of Leslie. And a similar small panel shown
273 in the same year, *Lucy, Countess of Carlisle and Dorothy Percy's visit to their father, Lord Percy, when under attainder upon the supposition of his being concerned in the gunpowder plot*, which makes use of figures from Van Dyck portraits at Petworth, actually anticipates a subject begun by Leslie a few years later for Lord Egremont. Its very title is an imitation of the elaborate descriptions with which sentimental-historical painters such as Leslie liked to label their works.

Leslie and Turner saw each other frequently at Lord Egremont's. They were both regular guests at Petworth now, and Turner seems to have spent several Christmases there in the 1830s. One of Leslie's sons, Robert, provided Ruskin with a reminiscence of one such visit.

My father was staying at Lord Egremont's; it was in September, I believe, of 1832 [Robert later decided it must have been 1834, when he was eight years old]. The sun had set beyond the trees at the end of the little lake in Petworth Park; at the other end of this lake was a solitary man, pacing to and fro, watching five or six lines or trimmers, that floated outside the water lilies near the bank. 'There,' said my father, 'is Mr Turner, the great sea painter.' He was smoking a cigar, and on the grass, near him, lay a fine pike. As we came up, another fish had just taken one of the baits, but, by some mischance, this line got foul of a stump or tree root in the water, and Turner was excited and very fussy in his efforts to clear it, knotting together bits of twine, with a large stone at the end, which he threw over the line several times with no effect. 'He did not care,' he said, 'so much about losing the fish as his tackle.' My father hacked off a long slender branch of a tree and tried to poke the line clear. This also failed, and Turner told him that nothing but a boat would enable him to get his line. Now it chanced that, the very day before, Chantrey, the sculptor, had been trolling for jack, rowed about by a

272 *Watteau study by Fresnoy's rules*, oil, 1831. Du Fresnoy's *Art of Painting* was one of the principal sources of academic instruction in Turner's lifetime. This picture was shown at the Academy with a couplet from William Mason's translation:

White, when it shines with unstained lustre clear,
May bear an object back or bring it near.

The passage as a whole, which also discusses the use of black, sums up many of the issues that had preoccupied Turner in his experiments with mezzotint in the 1820s. The picture is painted on a cupboard door which, it is thought, may have come from Petworth.

273 *Lucy, Countess of Carlisle and Dorothy Percy's visit to their father, Lord Percy, when under attainder upon the supposition of his being concerned in the gunpowder plot*, oil (also painted on a cupboard door), 1831. The Percy family had owned Petworth for over five hundred years before the arrival of the Wyndhams in the late seventeenth century. Among other quotations from Petworth Van Dycks in the picture, the figure of Lord Percy is based on a posthumous portrait of the 'Wizard Earl' of Northumberland, held for sixteen years in the Tower.

man in a boat nearly all day; and my father, thinking it hard that Turner should lose his fish and a valuable line, started across the park to the keeper's cottage, where the key of the boathouse was kept. When we returned, and while waiting for the boat, Turner became quite chatty, rigging me a little ship, cut out of a chip, sticking masts into it, and making her sails from a leaf or two torn from a small sketch-book, in which I recollect seeing a memorandum in colour that he had made of the sky and sunset. The ship was hardly ready for sea before the man and boat came lumbering up to the bank, and Turner was busy directing and helping him to recover the line, and, if possible, the fish. This, however, escaped in the confusion. When the line was got in, my father gave the man a couple of shillings for bringing the boat; while Turner, remarking that it was no use fishing any more after the water had been so much disturbed, reeled up his other lines, and, slipping a finger through the pike's gills, walked off with us towards Petworth House. Walking behind, admiring the great fish, I noticed as Turner carried it how the tail dragged on the grass, while his own coat-tails were but little further from the ground; also that a roll of sketches, which I picked up, fell from a pocket in one of these coat-tails, and Turner, after letting my father have a peep at them, tied the bundle up tightly with a bit of the sacred line. I think he had taken some twine off this bundle of sketches when he was making his stone rocket apparatus, and that this led to the roll working out of his pocket. My father . . . asked Turner, as a matter of curiosity, what the line he had nearly lost was worth. Turner answered that it was an expensive one, worth quite half a crown.

Turner's fish was served for dinner that evening; and, though I was not there to hear it, my father told me how old Lord Egremont joked Chantrey much about his having trolled the whole of the day without even a single run, while Turner had only come down by coach that afternoon, gone out for an hour, and brought in this big fish. . . . I have often thought that Turner went out to catch that pike because he knew that Chantrey had been unsuccessful the day before. (R., xxxv, pp. 571–2, 574)

The roll of sketches that young Robert Leslie glimpsed may have been some of the small coloured studies that Turner made on sheets of blue paper during one of his visits to Petworth. They record – for the most part very rapidly and broadly – impressions of the park and house, and of the activities of Egremont's notoriously large and unorthodox family and his multifarious guests. Egremont managed to combine aristocratic aloofness with geniality and an obsessive desire for companionship: Turner found the conditions ideal. He was free to amuse himself as he liked in a beautiful setting, to talk with his host or with the many colleagues from the Academy who were fellow-guests, to paint or draw either in the Old Library where he had a studio, or anywhere in the house and park: several of the colour studies show bedrooms, while many record evening gatherings, conversations, discussions between artists about paintings in progress, recitals, mealtimes, or services in the parish church. They are executed in colours of great brilliance and intensity, comparable to those he used when drawing the south coast of France in 1828, or making his designs for the 'Rivers of Europe' project.

He evidently felt at ease in Egremont's house, and the best of his nature was revealed there. George Jones, ever ready to put his friend in a good light, remembered:

Turner's tenderness towards his friends was almost womanly; to be ill was to secure constant attention and solicitude from him towards the sufferer.

When on a visit to Petworth with Turner, I hurt my leg, his anxiety to procure for me every attendance and convenience was like the attention of a parent to a child; his application to the house-keeper, butler, and gardener for my comfort and gratification was unremitted. (Jones, *Turner*, p. 2)

The desire to show affection is touching; Turner had little opportunity to do so in a world where nearly all his close friends were men, and where men were not in the habit of betraying their inner feelings. On another occasion at Petworth,

Lord Egremont said to him, 'I have written to Jones to join us but he won't come.' Turner felt this remark as important to me and wrote instantly to tell me of the generous Earl's observation. Of course I did not hesitate, but went. Fortunately I did so, for in three weeks the kind and hospitable nobleman ceased to be. (Ibid., p. 3)

When Egremont died on 11 November 1837, Turner was deeply affected and travelled down to Sussex for the funeral, walking in the procession at the head of a group of artists in front of the hearse. Knowing that he would be feeling the loss, a friend, the industrialist and amateur watercolourist John Hornby Maw, invited him to stay over Christmas. Turner replied on 7 December, making reference to another book that had just been published with illustrations after his designs, the *Poetical Works* of Thomas Campbell:

274 *Petworth: The Old Library, with two men discussing a picture*, bodycolour, *c.*1830. Several of the Petworth studies show artists talking about pictures; it has been suggested that in this one the standing figure may be Lord Egremont himself. *Jacob's Dream* by the American painter Washington Allston is identifiable over the fireplace. Turner experimented with the same subject on a large canvas in the 1830s.

Many thanks for your kindness in thinking of my loss at Petworth and offer to fill up in part, by a few days at Guildford [?] towards the Xmas [holiday]. I must confess I do feel disposed but fear much it would be to you and Mrs Maw a great trouble, for I am now more than an invalid and Sufferer either from having taken cold at the Funeral of Lord Egremont or at the Life Academy, but I hope the *worst is now past*, but Sir Anthony Carlisle, who I consult in misfortune says I must not stir out of door until it is dry weather (frost) I hope he includes, or I may become a prisoner all the Winter. . . . Glad you like the *Campbell illustrations*. (G. 214)

One of Egremont's ambitions had been to get Turner and Constable together at Petworth, but it never quite happened. Now Constable too was dead – since 31 March; and the previous November William Frederick Wells, whom Turner had known since his boyhood, had died. Wells's daughter Clara, now Mrs Wheeler, like George Jones could supply insights into Turner's tender-heartedness, and remembered his reaction to the news of her father's death:

He came immediately to my house in an agony of grief. Sobbing like a child, he said, 'Oh, Clara, Clara! these are iron tears. I have lost the best friend I ever had in my life.'

Clara added some reflections on Turner's good nature and the reasons for its concealment:

Oh! what a different man Turner would have been if all the good and kindly feelings of his great mind had been called into action; but they lay dormant, and were known to so very few. He was by nature suspicious, and no tender hand had wiped away early prejudices, the inevitable consequence of a defective education. (T., II, p. 56)

Shortly after Wells's death, and just before Constable's, in January 1837 another old friend died. Sir John Soane had reached the age of eighty-four, and left his house in Lincoln's Inn Fields with its collections to the public as a museum. Turner's *Forum Romanum* had been painted for it in 1826, and his rebuilt gallery in Queen Anne Street was probably influenced by it. We know that Sandycombe Lodge was heavily indebted to Soane for some of its detail. The full impact of Soane's ideas on Turner had indeed already been revealed in the terms of Turner's will, which underwent modification twice in the course of the 1830s. Both men had for long been active in the administration of the Artists' General Benevolent Fund, and both wished to make charitable provision in their wills for the welfare of artists. Turner had signed a new will on 10 June 1831, revising and clarifying the legalities of his provision for an institution

for the Maintenance and Support of Poor and Decayed Male Artists being born in England and of English parents only and lawful issue . . . which Institution I desire shall be called 'Turner's Gift' and shall at all times decidedly be an English Institution and the persons receiving the benefits thereof shall be English born subjects only and of no other Nation or Country whatsoever.

He also substituted the *Sun rising through vapour* for the *Decline of Carthage* as the second of the two pictures to be bequeathed to the National Gallery. This change of mind suggests that the common interpretation of the two Carthage subjects as a pair, with the inference that they must be read jointly as conveying the inevitability of glory leading to ruin, may not be as intrinsic to their significance as has been supposed.

His plans were considerably expanded in the following year when, on 20 August, he appended a codicil, which however was not attested and never proved, in which a new idea was put forward. Referring to the new will of 1831 he directed

> that . . . as regards a certain Charitable Institution therein named and called Turner's Gift which I mean to be carried into effect by giving my whatever sum or sums of money may be standing in my name in the three per cent. Consols Bank of England for the erection of the Gallery to hold my Pictures and places houses or apartments for one two three or more persons according to circumstances or means which my Executors may find expedient keeping in view the first objects I direct namely is to keep my Pictures together so that they may be seen known or found at the direction as to the mode how they may be viewed gratuitously I leave to my Executors and that the building may for their reception be respectable and worthy of the object which is to keep and preserve my Pictures as a collection of my works.

Further on in the codicil he directed his Executors, in the event that his bequest was not implemented within five years, 'to keep all the Pictures and property in Queen Ann St West N⁰ 47 held under lease of the Duke of Portland', and appointed Hannah Danby as

> Custodian and Keeper of the Pictures Houses and Premises 47 Queen Ann Street and One hundred a year for her service therein during her natural life and fifty pounds for her assistance service which may be required to keep the said Gallery in a viewable state at all times concurring with the object of keeping my works together and to be seen under certain restrictions which may be most reputable and advisable.

This codicil was, it is said, drawn up by Turner's solicitor, George Cobb of Clement's Inn; yet the prose, for all its convolutions, is surely not that of a lawyer. It reads suspiciously like one of Turner's own compositions, and there may have been excellent legal reasons why it was never attested. Cobb may have been called in; but Turner, with his instinct for literary pastiche, was surely trying his own hand at lawyer's English. He was also experimenting with an idea borrowed from Soane: that of leaving not just two paintings but his complete output to the nation in the form of an entire museum. In due time this at first hazy notion was resolved into the provisions for 'Turner's Gallery' that were stipulated in a codicil of 1848.

By the time he came to alter his will again another figure had become prominent enough in Turner's private life to earn a significant place in his dispositions. This was a certain Sophia Caroline Booth, whom he had met in Margate in the early 1830s, or perhaps in the late 1820s. She had been living in Deal, married to a man named Henry Pound, by whom she had a son, Daniel John, but on becoming a widow had married again. Her second husband's name was John Booth; he was an older man with some property. In 1827 they moved from Deal to Margate where she ran a boarding house on the sea front at Cold Harbour. It was here that Turner came as a lodger. He had never abjured his long-standing connection with Margate, having painted many views of it both in oil and watercolour, and frequently visited it, slipping down the Thames, by one of the regular steam packets which plied between London Bridge and the Kent resorts:

> Mr Turner was very fond of Margate, and in the summer often went there on Saturday morning by the Magnet or King William steamer. Most of the

time he hung over the stern, watching the effects of the sun and the boiling of the foam. About two o'clock he would open his wallet of cold meat in the cabin, and, nearing himself to one with whom he was in the habit of chatting, would beg a clean plate and a hot potato, and did not refuse one glass of wine, but would never accept two. It need hardly be added that he was no favorite with the waiters. (Watts, p. xxxii)

These short holidays were always combined with the constant business of sketching and observing the shipping, the sea and the sky. 'He knew the colours of the clouds over the sea, from the Bay of Naples to the Hebrides,' wrote Ruskin, 'and being once asked where, in Europe, were to be seen the loveliest skies, answered instantly, "in the Isle of Thanet"' (R., XXVII, p. 164).

John Booth died in 1833, and left his wife reasonably well provided for. She was not a woman to require much in the way of comforts – a simple, uncomplicated soul it seems, who was described after Turner's death as 'exactly like a fat cook and not a well educated woman' (Charles Turner, Diary, 6 September 1852). She and Turner evidently found each other perfectly congenial, and in due course a close, if not necessarily a sentimental, relationship sprang up between them. She was still only in her thirties at this date, and there is no reason to doubt that she provided Turner with more comforts than those supplied by a mere landlady. She was never introduced into the London house, but kept typically apart, a being from a different and quite separate world. Eventually, in the 1840s, he moved her from Margate to Chelsea, and established her in a small house overlooking the river there where 288 he could gratify his desire to be completely incognito. He even borrowed her name, allowing himself to be known among the locals as Mr Booth, even on occasion Admiral Booth. It was an escape from that other, all too real identity that he found so much of a burden and so much of a responsibility.

The new arrangement was a relief from the loneliness that was closing round him; he had a nurse and companion for his old age. But Mrs Booth's relative youth must have increased his consciousness of advancing years. Whether or not such a personal interpretation should be placed on the work, his picture of *The Fighting 'Téméraire' tugged to her last berth to be broken up, 1838* can 240 easily be seen as a wry comment on his own stage of life. It was on his way back from one of his visits to Margate that he saw the hulk of the old warship *Téméraire* being towed to the breaker's yard, and was moved to record the scene. As it happened, he was noticed by William Frederick Woodington, a sculptor who later retailed the anecdote to a colleague, Thomas Woolner:

One day in 1838, Woodington, the sculptor of the reliefs on the base of the Nelson column, was on a steam boat returning from a trip to Margate; and in the midst of a great blazing sunset he saw the old *Temeraire* drawn along by a steam tug. The sight was so magnificent that it struck him as being an unusually fine subject for a picture, and he noted all the points he thought would constitute its glory if presented on canvas. But he was not the only person on board who took professional notice of the splendid sight, for he saw Turner himself there, also noticing and busy making little sketches on cards. He pointed him out to his companion as Turner the great landscape painter . . . On the year following, going to the R.A: Ex: what was his amazement on beholding the veritable scene that had so delighted him again blazing before him in all its glory! (Woolner, pp. 260–61)

The subject was presented to Turner ready, as it were, for the easel: a historical fact in an observed natural setting. Yet its layers of significance were at once apparent to the Academy audience, and the critics acclaimed it. The *Morning*

275 *Margate, Kent*: Turner's view of the town for the *Picturesque Views in England and Wales*, engraved by Robert Wallis, 1832.

Chronicle wrote on 7 May 1839: 'There is something in the contemplation of such a scene which affects us almost as deeply as the decay of a noble human being.' Turner's point was indeed taken. But an even more interested observer was at the exhibition, witnessing the setting of the sun with feelings of awe and admiration: John Ruskin. He met Turner for the first time at a dinner-party of Griffith's at Norwood on 22 June 1840. His identity as the author of the counter-attack on *Blackwood's Magazine* was still unknown to Turner, so Ruskin was able to form an impression of his hero at first hand from the privileged position of one who is quite unrecognized. That evening he wrote up the occasion in his Diary. His comments on the man are as penetrating as those on his pictures:

> Introduced to-day to the man who beyond doubt is the greatest of the age; greatest in every faculty of the imagination, in every branch of scenic knowledge; at once *the* painter and poet of the day, J. M. W. Turner. Everybody had described him to me as coarse, boorish, unintellectual, vulgar. This I knew to be impossible. I found in him a somewhat eccentric, keen-mannered, matter-of-fact, English-minded gentleman: good-natured evidently, bad-tempered evidently, hating humbug of all sorts, shrewd, perhaps a little selfish, highly intellectual, the powers of his mind not brought out with any delight in their manifestation, or intention of display, but flashing out occasionally in a word or a look. (R., xxxv, p. 305)

293

Chronology 1831–1840

1831

Turner was in poor health throughout this year.

February: Robert Cadell, Scott's publisher, invited Turner to illustrate a new edition of Scott's *Poetical Works*. He agreed to do so, at a fee of 25 guineas for each of 24 designs. He was already engaged on drawings for a further edition of Byron's *Works*, to be published by Murray in 1832. In April he accepted Scott's invitation to Abbotsford.

Royal Academy exhibition: 7 oil paintings shown, *Lifeboat and Manby apparatus going off to a stranded vessel making signal (blue lights) of distress* (73; B&J 336), acquired by John Nash and later by John Sheepshanks; *Caligula's palace and bridge* (162; B&J 337); *Vision of Medea* (178; B&J 293); *Lucy, Countess of Carlisle and Dorothy Percy's visit to their father, Lord Percy, when under attainder upon the supposition of his being concerned in the gunpowder plot* (263; B&J 338); *Admiral Van Tromp's barge at the entrance of the Texel, 1645* (288; B&J 339); *Watteau study by Fresnoy's rules* (298; B&J 340); and *Fort Vimieux*, titled in the catalogue with an account of the action taken from 'Naval Anecdotes' (406; B&J 341).

10 June: Turner's second will signed. He wished a fund to be set up from which his various legacies and charities were to be financed; and *The Decline of Carthage* was to be replaced by *Sun rising through vapour* in the gift to the National Gallery. Otherwise its terms were similar to those of the will of 1829.

11 June: Cadell visited Turner in London and found him 'a little dissenting clergyman like person [with] no more appearances of art about him than a ganger'.

July–August: to Scotland. He left London c. 20 July and travelled via Penrith and Langholm to Abbotsford, where he arrived on 4 August. Cadell, John Gibson Lockhart (Scott's biographer) and the Rev. James Skene, an amateur artist, accompanied him on some of his excursions. He then visited Berwick, Edinburgh, Stirling, Loch Katrine, Loch Lomond and Glasgow, and made his first trip to the west coast and north of Scotland: Oban, Skye, Staffa, Tobermory, Fort William, Inverness and Elgin. He probably visited Munro of Novar near Evanton in Ross and Cromarty. He left for London by boat probably on 18 August. Sketchbooks used on the tour are *Berwick* (TB CCLXV), *Minstrelsy of the Scottish Border* (TB CCLXVI), *Abbotsford* (TB CCLXVII), *Edinburgh* (TB CCLXVIII), *Stirling and Edinburgh* (TB CCLXIX), *Stirling and the West* (TB CCLXX), *Loch Long* (TB CCLXXI), *Loch Ard* (TB CCLXXII), *Staffa* (TB CCLXXIII), *Sound of Mull No. 1* (TB CCLXXIV), *Sound of Mull No. 2* (TB CCLXXV), *Fort Augustus* (TB CCLXXVI) and *Inverness* (TB CCLXXVII).

Christmas: perhaps at Petworth. By the end of the year he had probably accepted Cadell's invitation to illustrate a further volume of Rogers's *Poems* (published in 1834).

1832

14 March: 12 of the Scott illustrations exhibited at the gallery of Moon, Boys & Graves in Pall Mall.

Royal Academy exhibition, from 7 May: 6 oil paintings shown, *Childe Harold's pilgrimage – Italy* (70; B&J 342); *The Prince of Orange, William III, embarked from Holland, landed at Torbay, November 4th 1688, after a stormy passage* (153; B&J 343); *Van Tromp's shallop, at the entrance of the Scheldt* (206; B&J 344); *Helvoetsluys; – the City of Utrecht, 64, going to sea* (284; B&J 345); *Shadrach, Meshach, and Abednego in the burning fiery furnace* (355; B&J 346), titled with a quotation from Daniel, and painted in friendly competition with George Jones, who also painted the subject for this year's exhibition; and *Staffa, Fingal's Cave* (453; B&J 347).

20 June: Turner appointed to a committee to discuss a new building for the National Gallery and Royal Academy. The National Gallery, consisting of the collections of Angerstein and Beaumont, was currently housed in Angerstein's London home, 100 Pall Mall.

20 August: the first codicil added to Turner's will, but not attested. It stipulated that if the charitable institution that he proposed could not be set up within five years of his death, the funds were to be used for the upkeep of his Queen Anne Street house as a public gallery of his works, with a salaried curator. (He was probably influenced in the plan by the arrangements being made by Soane to turn his house in Lincoln's Inn Fields into a public museum.) The codicil also referred again to the establishment of a Professorship of Landscape Painting at the Academy.

21 September: death of Sir Walter Scott.

By this date Turner was in Paris on a tour collecting material for the *French Rivers* volumes of the 'Rivers of Europe' and for his illustrations to Scott's *Life of Napoleon*, for Cadell's edition of the *Prose Works*. Possibly during this visit he met Delacroix, who later recollected Turner visiting him at the Quai Voltaire (where he lived from 1829 and 1835). Sketchbooks used on the trip are *Seine and Paris* (TB CCLIV), *Paris and Environs* (TB CCLVII), and probably *Tancarville and Lillebonne* (TB CCLIII).

Two sketchbooks apparently used this year, TB CCLXXVIII and CCLXXIX, contain studies along the lower reaches of the Thames and the north coast of Kent from Purfleet to Margate.

By now Turner was a regular visitor in Margate at Mrs Booth's lodging house.

This year F. G. Moon published 60 plates of the *England and Wales* series in book form, with text by Hannibal Evans Lloyd.

22 December: at an Academy Council meeting Turner was again elected as one of the three Auditors for the ensuing year.

Christmas: at Petworth.

1833

Royal Academy exhibition: 6 oil paintings shown, *Rotterdam ferry-boat* (8; B&J 348), bought by Munro of Novar; *Bridge of Sighs, Ducal Palace and Custom-house, Venice: Canaletti painting* (109; B&J 349), bought by Robert Vernon for 200 guineas; *Van Goyen, looking out for a subject* (125; B&J 350), subsequently bought by Elhanan Bicknell in 1844; *Van Tromp returning after the battle off the Dogger Bank* (146; B&J 351); and *Ducal Palace, Venice* (169; B&J 352), bought by B. G. Windus. The Venetian subjects were the first oil paintings of Venice by Turner to appear. The pictures were generally smaller than those of previous years, though more expensive. Turner told Jones: 'If they will have such scraps instead of important pictures they must pay for them.'

1 June: the first of the three volumes of the 'Rivers of France' appeared: *Turner's Annual Tour – Wanderings by the Loire*. It included 21 plates after Turner (w.930–950; R.432–452) with a text by Leitch Ritchie.

8 June–6 July: Moon, Boys & Graves held their second display of Turner's watercolours in Pall Mall. The printed catalogue of this 'Private Exhibition' (Courtauld Institute Library, London) lists the titles of 66 designs for *England and Wales* and 12 for Scott's *Poetical Works*; another 13 *England and Wales* and 3 Scott illustrations made a total of 94 exhibits; 27 of the *England and Wales* drawings were lent by Thomas Griffith, who became Turner's regular agent about this time.

Early July: Christie's sold the collection of Dr Thomas Monro. The sale catalogue listed nearly 400 early works by Turner (most of them in fact produced in collaboration with Girtin); 13 lots were bought back by Turner, together with 2 drawings ascribed to Rembrandt, some studies by Hoppner and work by De Loutherbourg and Dayes.

August: *Arnold's Magazine of the Fine Arts* published a lively appreciation of Turner's more recent work – perhaps, as Finberg suggests, influential on the young John Ruskin (aged fourteen) whose arguments it anticipates.

Autumn: almost certainly this year, Turner made a long tour through Europe, perhaps partly motivated by a desire to look at the buildings and collections of the most important Continental art galleries, notably those of Germany and Austria, with London's new National Gallery in mind. (Wilkins's building for it in Trafalgar Square was begun this year.) He probably travelled by sea to Copenhagen, then south to Berlin – where it has been suggested he may have met Gustav Waagen, Director of the Berlin Museum – and on to Dresden; thence to Prague and Vienna and east along the Danube to Salzburg and Innsbruck. He then crossed the Brenner Pass into Italy, visiting Verona and Venice. The return journey seems to have been back to Salzburg, thence through Munich, Augsburg, Ulm and Stuttgart to Heidelberg and so down the Neckar to the Rhine which he followed northwards. Sketchbooks used on the tour are probably *Berlin and*

Dresden (TB CCCVII), *Dresden* (TB CCCI), *Dresden and River Elbe* (TB CCCVI), *Linz, Salzburg, Innsbruck, Verona and Venice* (TB CCCXI), *Salzburg and Danube* (TB CCC), *Danube and Graz* (TB CCXCIX), *Venice* (TB CCCXIV), *Dover, Rhine and Innsbruck* (TB CCCIX) and possibly *Heidelberg up to Salzburg* (TB CCXCVIII), *Coburg, Bamberg and Venice* (TB CCCX) and *Rhine, Frankfurt, Nuremberg and Prague* (TB CCCIV). A large number of small sheets of loose grey paper were also used (TB CCCXLI). He was back in London in late October.

October: the Society of British Artists held the second of a series of winter exhibitions. Turner was represented by one painting, and two watercolours lent by Sir Watkyn Williams Wynn.

Elected a Visitor to the Life Academy (a new post), with Eastlake, A. E. Chalon and Abraham Cooper. He was also once again Auditor.

John Booth, husband of Turner's Margate landlady, died this year.

1834

At the beginning of the year Rogers's *Poems* were published; the book was illustrated with 33 vignettes by Turner (w.1177–1209; R.373–405).

Turner's drawings for the *Annual Tour* of the River Seine were exhibited at Moon, Boys & Graves's gallery, and Colnaghi's showed those for Murray's *Works of Lord Byron*. Murray and Tilt were in the process of issuing three volumes of *Finden's Landscape and Portrait Illustrations to the Life and Works of Lord Byron*, including the 26 that Turner designed (w.1210–1235; R.406–431).

March: *Finden's Landscape Illustrations of the Bible* began to appear in monthly parts. Turner made 25 designs, and an unpublished one (w.1236–1263; R.572–597).

April: the final volume of Cadell's twelve-volume edition of Scott's *Poetical Works* appeared, completing the series published this year. Turner had made 24 illustrations for it (w.1070–1093; R.493–516), each volume having a title-page vignette and frontispiece. Many of the original designs in watercolour were bought by Munro of Novar.

May: The first of 22 monthly issues of Scott's *Prose Works* published by Cadell, with, in all, 40 illustrations by Turner (w.1094–1133; R.517–556). Turner had arranged with Cadell to receive 50 proofs of each subject.

May–June: Parts XVII and XVIII of the *England and Wales* series published.

Royal Academy exhibition: 5 oil paintings shown, *The fountain of Indolence* (52; B&J 354); *The golden bough* (75; B&J 355), bought by Vernon; *Venice* (175; B&J 356), a view of S. Giorgio and the Dogana from the steps of the Grand Hotel; *Wreckers – coast of Northumberland, with a steam-boat assisting a ship off shore* (199; B&J 357); and *St Michael's Mount, Cornwall* (317; B&J 358), acquired by Sheepshanks.

July: probably visited Oxford. At the end of the month he travelled to Brussels and Liège, and repeated his tour of 1826, following the Meuse and Moselle via Namur, Metz and Coblenz, and returning along the

Rhine. The tour was no doubt prompted by a need for more 'Rivers of Europe' material, but nothing further came of the project. Sketchbooks which may have been used are *Oxford and Bruges* (TB CCLXXXVI), *Spa, Dinant and Namur* (TB CCLXXXVII; possibly used in 1839), *Givet, Mézières, Verdun, Metz, Luxembourg and Trèves* (TB CCLXXXVIII), *Moselle and Oxford* (TB CCLXXXIX), *Trèves to Cochem and Coblenz to Mayence* (TB CCXC), *Rhine (between Cologne and Mayence), also Moselle and Aix-la-Chapelle* (TB CCXCIA) and *Cochem to Coblenz – Home* (TB CCXCI).

On his return he visited Petworth; Egremont had tried to invite Turner and Constable there together, but the latter had just left, though Leslie and Chantrey were both among the guests.

16 October: the Houses of Parliament destroyed by fire. Turner was a witness, spending some time in a boat on the river with Clarkson Stanfield. A book of colour sketches in the Turner Bequest (TB CCLXXXIII) is usually considered to record the event, and a watercolour (TB CCLXIV-373; W.522) shows Old Palace Yard during the conflagration. Two oil paintings of the subject were to appear the following year.

The second of the *Annual Tours* appeared this month, containing 20 plates of views on the Seine (w.951–970; R.453–472).

December: the third winter exhibition of the Society of British Artists contained 4 early paintings of Turner, including Lord Egremont's *Cockermouth Castle* of 1810 and *Windsor Castle* of 1812. He was also represented in exhibitions at Birmingham and Manchester.

10 December: elected a Visitor in the School of Painting at the Royal Academy.

1835

The third and final volume of the *Annual Tours* of French rivers published, containing a second set of views of the Seine (w.971–990; R.473–492).

16 January: Elhanan Bicknell saw Turner drawings at W. B. Cooke's. He was to become a patron in the 1840s.

British Institution exhibition, February: Turner had not contributed since 1817. He now showed the first of 2 oil paintings of the *The Burning of the House of Lords and Commons, 16th of October, 1834* (58; B&J 359), working on the canvas largely after it had been hung. The *Spectator* for 14 February considered that 'Turner's picture transcends its neighbours as the sun eclipses the moon and the stars'.

March: Rogers's *Poetical Works* with Turner's vignettes began to appear in monthly parts, as did *Finden's Landscape Illustrations of the Bible*, including in all 25 plates after Turner (w. 1236–1261; R.572–597).

Turner's Gallery, from April: only early works appear to have been shown, one of the most recent being *The Bay of Baiae* (R.A. 1823).

Royal Academy exhibition: 5 oil paintings shown, a second view of *The burning of the Houses of Lords and Commons, October 16, 1834* (294; B&J 364); *Keelmen heaving in coals by night* (24; B&J 360); *The bright stone of honour (Ehrenbrietstein) and the tomb of Marceau, from Byron's Childe Harold* (74; B&J 361); *Venice, from the*

porch of *Madonna della Salute* (155; B&J 362); and *Line-fishing off Hastings* (234; B&J 363), bought by Sheepshanks.

June: the engravings for Turner's three *Annual Tours* began to be reissued in parts. Part XIX of *England and Wales* was issued this year, and Macrone's edition of Milton's *Poetical Works* appeared with 7 vignettes after Turner (w.1264–1270; R.598–604).

Summer: Turner possibly travelled on the Continent, though most of the sketchbooks relating to a mid-European tour about this time have been assigned to 1833. Finberg (*Life*, p. 357) associates a visit to northern Germany and Austria with a commission from Moxon to illustrate a collected edition of Thomas Campbell's poems.

Christmas: probably at Petworth, though there is no specific evidence for a visit.

Chantrey knighted this year.

1836

British Institution exhibition, February: 2 oil paintings shown, *Wreckers on the North Shore* (53), which had been shown under a slightly different title at the Academy in 1834; and *Fire of the House of Lords* (69), similarly shown at the Academy in 1835.

Royal Academy exhibition: held for the last time at Somerset House; Turner showed 3 oil paintings, *Juliet and her nurse* (73; B&J 365); *Rome from Mount Aventine* (144; B&J 366); and *Mercury and Argus* (182; B&J 367). The first two were bought by Munro of Novar, who would have acquired the third but that he was 'ashamed of taking so large a haul'. The landscape of *Mercury and Argus* was apparently inspired by the scenery of Munro's native Ross and Cromarty, which Turner had visited in 1831. In a long article on modern British painting in *Blackwood's Magazine* for October the Rev. John Eagles ridiculed *Juliet and her nurse*; but the *Spectator* felt that 'Turner's dreams are finer than the waking thoughts of many, for, in spite of his exaggerations, he cannot forget nature'.

June: Wilkie knighted.

July-September: sketching tour with Munro of Novar through France to Switzerland. Their route took them from Calais to St Omer, Arras, Rheims, Dijon, Geneva, Lausanne, Vevey, Bonneville, Cluse, Chamonix, through the Col du Bonhomme and Col de la Seigne to Courmayeur, Aosta and Turin. Munro then left him and Turner proceeded via the Mont Cenis pass to Chambéry. According to Munro, he returned along the Rhine. Sketchbooks used on the journey are *Val d'Aosta* (TB CCXCIII), *Fort Bard* (TB CCXCIV) and at least two 'roll' sketchbooks, now disbound and numbered as leaves from TB CCLXIII, CCCXLIV and CCCLXIV. Other sheets are dispersed (see w.1430–1456). This year he gave Munro a sketchbook used on his last visit to Farnley in 1824.

Summer: a Government inquiry was instituted into the proceedings of the Academy, prompted by the attacks of Haydon. One criticism was that Turner's Perspective lectures had not been given for many years. In his reply Shee, the President, referred to 'the

respect they [the Academicians] feel for one of the greatest artists of the age in which we live'.

George White's *Views in India*, for which Turner made 7 designs (W.1291–1297; R.606–612) appeared this year and in 1837.

October: Ruskin, aged seventeen, drafted an angry reply to Eagles's attack on Turner in *Blackwood's Magazine* and sent it to the artist, who however discouraged him from publishing.

10 November: death of Wells.

Elected to the Academy Council, and appointed Visitor to the Life Academy.

This winter he was again in poor health.

1837

20 January: death of Soane.

British Institution winter exhibition: Turner showed *Regulus* (120), painted in Rome in 1828 but extensively reworked, largely on the varnishing days.

16 February: he presented to the Academy a group portrait by J. F. Rigaud of Bartolozzi, Cipriani and Carlini.

31 March: death of Constable.

Royal Academy exhibition: Turner was a member of the Exhibition Committee this year, hanging the first show to be held at the new Trafalgar Square premises which the Academy shared with the National Gallery. The exhibition was opened on 28 April by William IV. Turner showed 4 oil paintings, *Scene – a street in Venice* (31; B&J 368), catalogued with a two-line caption from *The Merchant of Venice*; *Apollo and Daphne* (130; B&J 369); *The parting of Hero and Leander – from the Greek of Musæus* (274; B&J 370); and *Snowstorm, avalanche, and inundation – a scene in the upper part of the Val d'Aout, Piedmont* (480; B&J 371). These subjects demonstrate a return to the 'poetical' and imaginative subject-matter that Turner had largely avoided in recent years.

29 May: the British Institution's summer exhibition of old masters opened. It included Turner's *Dutch boats in a gale* (the 'Bridgewater Sea-piece') of 1801, lent by Lord Francis Egerton, hanging with the Van de Velde for which it was a pendant.

Moxon published Campbell's *Poetical Works* with 20 vignettes designed by Turner (W.1271–1290; R.613–632).

20 June: death of William IV. Among the honours distributed by the new monarch, Victoria, were knighthoods for Callcott and Westmacott.

July/August: to Paris, visiting Versailles, among other places.

October: at Petworth.

11 November: death of Lord Egremont; Turner travelled down for the funeral on the 21st.

Early December: illness prevented him from accepting an invitation to stay at Guildford with J. H. Maw, a collector of his work.

28 December: resigned his Professorship of Perspective. He was not replaced until 1839, when John Prescott Knight was appointed.

1838

British Institution winter exhibition: this included Turner's *Fishing boats, with Hucksters bargaining for fish* (134; B&J 372), perhaps conceived as a 'sequel' to the *Dutch boats in a gale* of 1801, shown at the Institution the previous summer.

Royal Academy exhibition, from 7 May: 3 oil paintings shown, *Phryne going to the public bath as Venus – Demosthenes taunted by Æschines* (31; B&J 373); and *Modern Italy – the Pifferari* (57; B&J 374) and *Ancient Italy – Ovid banished from Rome* (192; B&J 375), a pair, acquired by Munro of Novar.

August–September: visited Margate.

6 September: the *Téméraire*, a warship of Nelson's fleet at Trafalgar, towed up the Thames to be broken up. Turner saw it on his way back from Margate 'in a great blazing sunset'.

The *Picturesque Views in England and Wales* came to a premature end this year, having failed commercially because of competition from publications using the more economical steel plates. The 96 finished engravings were issued in two volumes with text by Hannibal Evans Lloyd. The plates and prints were sold in the following year.

1839

British Institution winter exhibition: Turner showed *The Fountain of Fallacy* (58; B&J 376). Finberg considered this a different work from *The Fountain of Indolence* of 1834, but Joll argues that it is probably the same canvas, partly repainted, the reference to Thomson replaced by one to Turner.

Royal Academy exhibition: 5 oil paintings shown, *The Fighting 'Téméraire' tugged to her last berth to be broken up, 1838* (43; B&J 377); *Ancient Rome; Agrippina landing with the ashes of Germanicus. The triumphal Bridge and Palace of the Cæsars restored* (66; B&J 378); *Modern Rome – Campo Vaccino* (70; B&J 379); *Pluto carrying off Proserpine – Ovid's Metam.* (360; B&J 380); and *Cicero at his villa* (463; B&J 381). The *Téméraire* excited general admiration; it was ecstatically described in an article by Thackeray in *Fraser's Magazine*: 'when the art of translating colours into music or poetry shall be discovered, [it] will be found to be a magnificent national ode or piece of music'.

At the sale of the plates and prints of *Picturesque Views of England and Wales* by Southgate and Co. Turner bought the stock for £3,000.

2 August: left London on a tour of Belgium, the Meuse and the Rhine. He probably went via Ostend, Bruges and Brussels, up the Meuse to Coblenz and along the Rhine to Mannheim and Würzburg. Sketchbooks possibly in use on the tour are *Brussels up to Mannheim* (TB CCXCVI) and *Ostend, Rhine and Wurzburg* (TB CCCIII). He may also have used the *Spa, Dinant and Namur* book (see 1834).

An exhibition in the Music Hall, Leeds, showed over 40 watercolours by Turner from the Fawkes collection at Farnley.

Thomas Moore's *Epicurean*, with 4 vignettes engraved

after designs by Turner (w.1298–1301; R.634–637) published by Macrone.

Turner subscribed to Fields's *Outlines of Analogical Philosophy*, published in two volumes.

A codicil to his will revoked several legacies, including annuities to Sarah Danby and his two daughters. Hannah Danby was constituted sole custodian of his paintings.

1840

British Institution winter exhibition: Turner showed *Mercury and Argus* (59; R.A. 1836). Moon published an engraving of the subject by Willmore (R.650) in November 1841.

Royal Academy exhibition: 7 oil paintings shown, *Bacchus and Ariadne* (27; B&J 382), the first of the circular or square compositions of the 1840s, with figures derived from those in Titian's *Bacchus and Ariadne* in the National Gallery; *Venice, the Bridge of Sighs* (55; B&J 383); *Venice, from the Canale della Giudecca, chiesa di S. Maria della Salute, &c.* (71; B&J 384), acquired by Sheepshanks; *Slavers throwing overboard the dead and dying – Typhon coming on* (203; B&J 385); *The new moon; or 'I've lost my boat, you shan't have your hoop'* (243; B&J 386); *Rockets and blue lights (close at hand) to warn steam-boats of shoal water* (419; B&J 387); and *Neapolitan fisher-girls surprised bathing by moonlight* (461; B&J 388 or 389), bought by Vernon. *Slavers* attracted much critical derision, but Ruskin later described it as 'the noblest sea that Turner ever painted'.

22 June: Ruskin met Turner for the first time at the house of Thomas Griffith in Norwood.

August–October: travelled to Rotterdam and up the Rhine as far as Bregenz in company with a friend, E. H., whose identity is not further known. He went on to Venice where he spent about three weeks, and returned via Innsbruck, Munich, Ratisbon (Regensburg), where he saw the newly-built Walhalla, Nuremburg and Coburg. Sketchbooks probably used are *Rotterdam* (TB CCCXXI), *Rotterdam and Rhine* (TB CCCXXII), *Rotterdam to Venice* (TB CCCXX), *Venice and Botzen* (TB CCCXIII), *Venice up to Trient* (TB CCCXII), *Coburg, Bamberg and Venice* (TB CCCX), and various 'roll' sketchbooks which may have been used at Venice or afterwards for recording impressions or recollections in watercolour; the only one of these to remain intact is TB CCCXV, watermarked 1834. Loose sheets are TB CCCXVI, CCCXVII, CCCXVIII, CCCXIX.

Early November: Turner was one of a number of artists who presented 'a superb piece of plate' to Thomas Griffith in recognition of his agency in selling their work.

Eastlake's translation of Goethe's *Farbenlehre* published this year as *Theory of Colours*. Turner must already have known of Goethe's ideas through Eastlake, but he owned the translation, and alluded to 'Goethe's Theory' in the title of a picture exhibited in 1843.

1841–1851

276 *Peace – burial at sea*. This, one of the most strikingly original of Turner's late 'square' compositions, is the companion to his picture of Napoleon on St Helena, *War. The exile and the rock limpet*; both were shown at the Academy in 1842 with lines from the *Fallacies of Hope*. As a contrast to *War*, a meditation on the rewards of overweening political ambition, *Peace* pays tribute, as Turner was so fond of doing, to a fellow-artist; in this case Sir David Wilkie, who had died at sea and was buried off Gibraltar. It is thus a kind of sequel to the more informal study of Lawrence's funeral that he showed in 1830 (189). The lines of verse that Turner composed for it are:

The midnight torch gleamed o'er the steamer's side,
And Merit's corse was yielded to the tide.

277 *Shade and darkness – the evening of the Deluge* was exhibited at the Academy in 1843 with these lines from the *Fallacies of Hope*:

The moon put forth her sign of woe unheeded;
But disobedience slept; the dark'ning Deluge closed around,
And the last token came: the giant framework floated,
The roused birds forsook their nightly shelters screaming,
And the beasts waded to the ark.

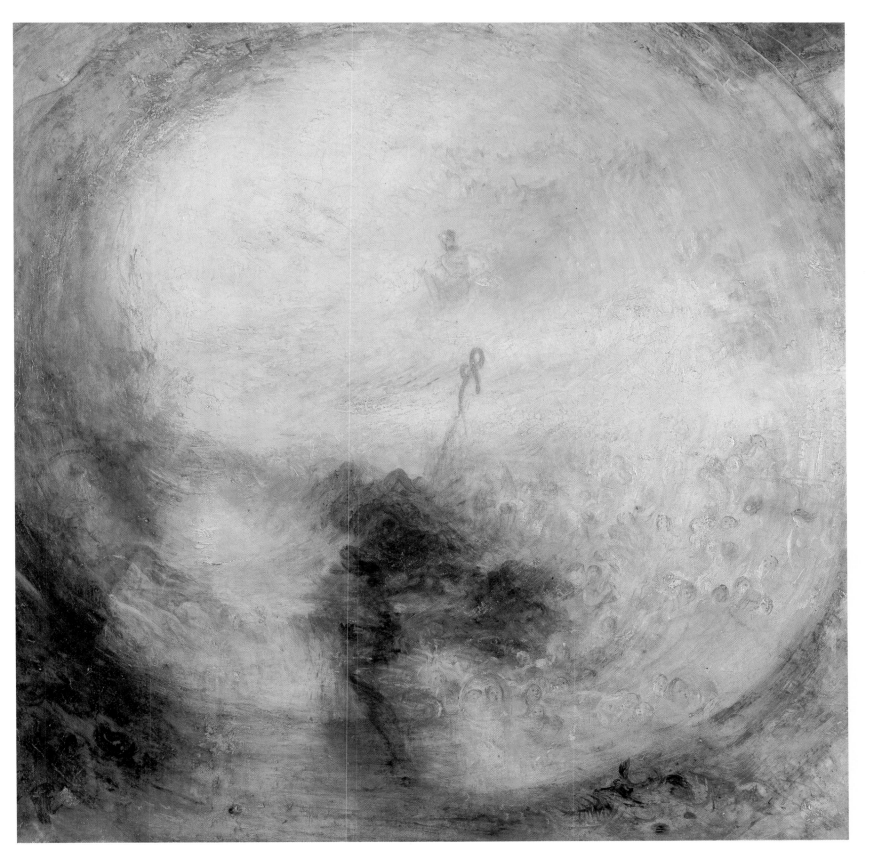

278 *Light and colour (Goethe's Theory) – the morning after the Deluge – Moses writing the book of Genesis* formed the pair, strongly contrasted in mood and palette, to *Shade and Darkness*. It too was accompanied by a quotation from the *Fallacies of Hope*. Here Turner not only pays tribute to a modern theory of colour – Goethe's, according to which certain colours, chiefly red and yellow, evoke positive, happy feelings, while others, notably blue and purple, suggest the reverse; he also returns to the Deluge story as a vehicle for his intuition of the primeval forces of earth, air and water as they are recreated by the originating power of light.

CCCLXIV — 281

The late Swiss watercolours

Turner's fascination with the landscape of Switzerland in the last decade of his career manifested itself almost exclusively in watercolours: studies briefly noted on the spot and worked up in colour afterwards were transformed, under the stimulus of consciously sought commissions, into a sequence of transcendental visions of mountains and lakes defined by the sweeping, swirling spaces between them. They uncover the ultimate significance of the revolution in watercolour painting that John Robert Cozens had initiated seventy years before, in the decade of Turner's birth.

The set of ten Swiss views that he completed in 1842 included several panoramas of Lake Lucerne, suffused with an ineffable serenity like this one of *The Bay of Uri from Brunnen* (279; and see p. 224); while the bird's-eye view of *Zurich* (280) from the same series presents Turner's abiding love of bustling townscapes and passionate identification with human life. One of the 'sample studies' that he made for a later set is the view of *Fluelen from the Lake* (281), of which a finished watercolour was executed for Munro of Novar in 1845.

Sketchbooks of the 1840s

The studies that Turner made on his journeys in Switzerland in the 1840s were made in soft-covered 'roll' sketchbooks, mostly now disbound. The impressively vertiginous view of the ruins of Hohenrätien above the entrance to the Via Mala (282) is one such sheet, and probably belongs to the tour of 1843. Another book, the *Lucerne* sketchbook of 1844, is still intact; it contains this broad and expressionistic note of the Rigi at sunset (283), seen from Turner's favourite hotel, Le Cygne.

An even rarer item is the recently rediscovered *Channel* sketchbook (284), which Turner used on his trip to Boulogne in the spring of 1845, his last visit to the Continent. It contains pencil sketches of the progress of a sunset, and, beginning at the other end as Turner often did, richly coloured studies of sea and sky, testifying to his indefatigable involvement with nature and with the technical materials of his art.

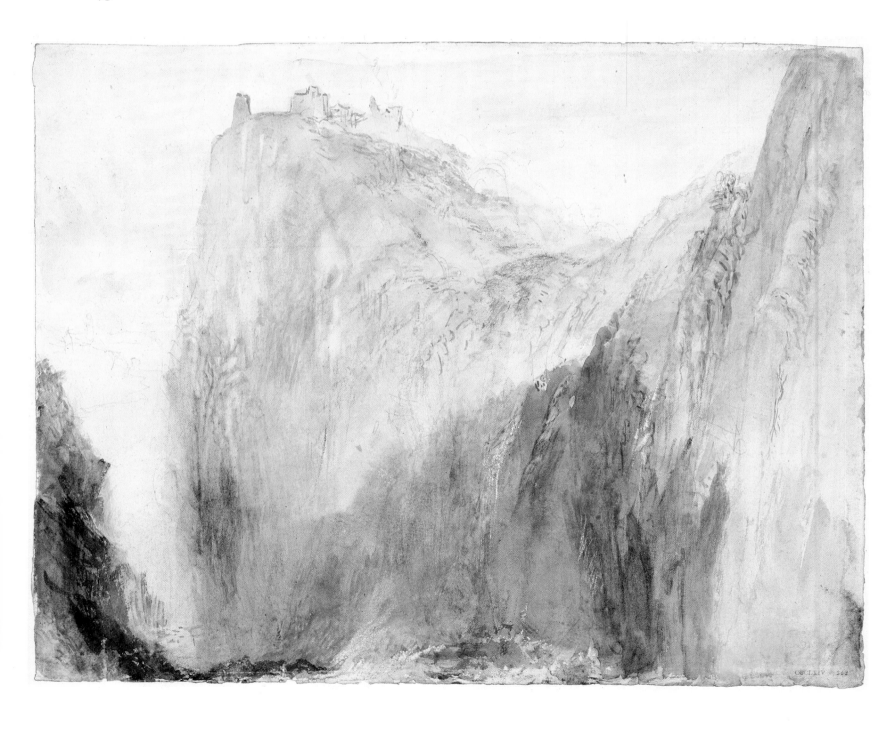

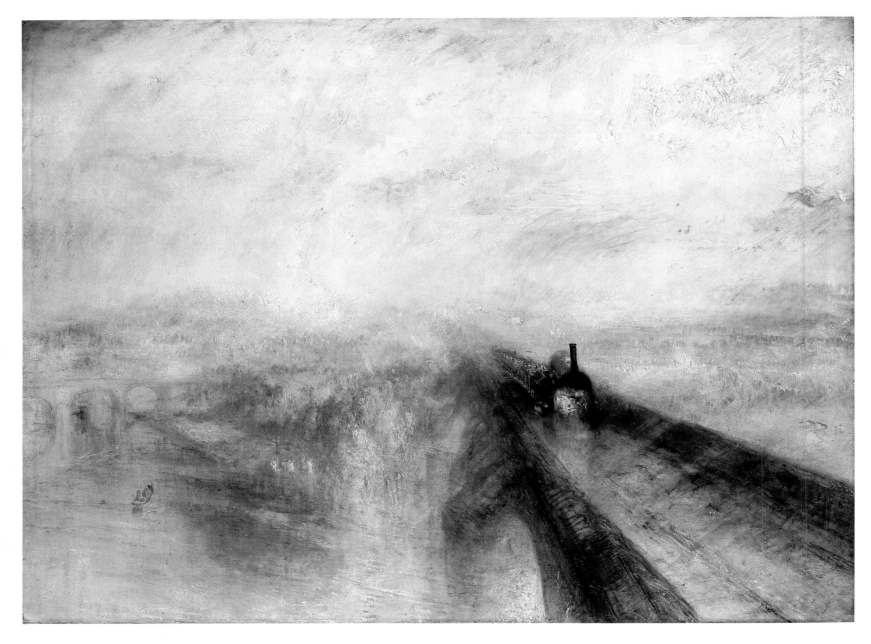

285 *Rain, Steam, and Speed – The Great Western Railway*. This celebrated picture, shown at the Academy in 1844, is an astonishing synthesis of Turner's passion for experiment and his love of the old masters, his commitment to classical landscape and his vivid response to the modern world. Structurally, the picture is Poussinesque, with its firm geometrical elements, while in its creamy impasto it seems to emulate Rembrandt even while anticipating the impressionism of a later generation. The dancing maidens on the bank of the Thames and the plough in a distant field bespeak a society that is fading before the impact of the scientific revolution. A hare racing before the fiery dragon of the train opposes natural to mad-made velocity. The omnivorous richness of Turner's mind, and his ultimate acceptance of both man and nature is an endlessly changing world, are nowhere better illustrated.

1841~1851

ON 9 DECEMBER 1841 Turner added to a note declining an invitation from Mrs Carrick Moore this postscript: 'very low indeed for our loss in *Dear* Chantrey' (G. 248). The sculptor had died suddenly on 25 November; and Turner was already grieving for another Academician friend, David Wilkie: his death, equally unexpected, had occurred at sea, off Gibraltar during his return from a tour to the Middle East, on 1 June. When Turner came to commemorate
276 Wilkie's maritime funeral in a picture of 1842, he painted the sails of the ship black, which Stanfield criticized as unlifelike. Turner's reply was: 'I only wish I had any colour to make them blacker' (T., II, p. 183) These bereavements, personal and professional at once, struck deep into him, and drove him still further towards isolation.

The last years of his life were played out against two characteristic backgrounds: one, the familiar house in Queen Anne Street which, by this time, reflected the venerable age and reclusive habits of its occupant in being dingy
287–8 and unkempt; the other a small artisan's house looking out over the Thames at Chelsea: 6 Davis Place, Cremorne New Road (now the western end of Cheyne Walk), where, more than he had ever done at Hammersmith, Isleworth or Twickenham, he retreated into a world apart from his professional life, resisting the efforts of his colleagues to discover his whereabouts. He may have acquired the house as early as 1839, but was certainly settled in, with Mrs Booth and her son Daniel John, by the autumn of 1846. He took an avuncular interest in the boy, who was training to be an engraver. He probably derived a certain satisfaction from the implication (if only to himself) of a confirmed family unit. The paternity of Daniel John was, of course, attributed to him by gossip. Presumably such conjectures did not worry him unduly; he was much more anxious to preserve his anonymity in Chelsea, and to protect his home there from the intrusions of colleagues. Private and professional life must be kept rigidly apart. His determined ruses to maintain the distinction were often related:

> Now and then, as an after dinner freak, men who were intimate with Turner, as intimate, indeed, as any men could well be with one of his close and eccentric habits, endeavoured to discover his new abode by many odd devices . . . But he was not to be trapped. Offers were made to walk home with him from the Athenæum – for a little chat about Academy matters, such as the new Associate and the election of a President. No; he had got an engagement, and must keep it. Some of the younger sort attempted to follow him, but he managed either to get away from them or to weary them with the distance and his dartings into cheap omnibuses or round dark corners. If he thought he was followed he would make off for a favourite Tavern where he could sit unknown, and which, as soon as he was known or seen there by one whom he knew, he was sure to depart . . . He had been dining at Greenwich, had partaken freely of various wines at table, and, on reaching town, was a little off balance – unable, it was thought, to call a cab. The party, as planned, dropt all of them away, save one, without saying good night to Turner, and that one walked along with the great painter,

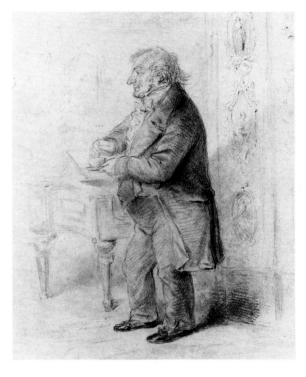

286 *Turner at a Conversazione of Elhanan Bicknell in Herne Hill*, by Count d'Orsay, 1850. 'Turner was a short stout man, somewhat sailor-like with a great deal of colour in his face. He was cheerful and sociable, enjoyed a joke, and was fond of dining out. He gave, however, no dinners himself' (Lovell Reeve). 'He was not ill-formed, but he had an awkward shuffling way of moving along. He had a fine head . . . of a sort of Italian Jewish form. His eye was keen, his nose inclined to a hook, and his mouth was good in shape, but there was a cynical expression about it that I thought repelling. He was a great artist, but personally there was nothing pleasant or amiable about him' (*Leitch*, pp. 78–9). This chalk drawing was published as a lithograph on 1 January 1851 with the title 'The Fallacy of Hope'.

placed him in a cab with a sober driver and a steady horse; and shutting the door, said, 'Where shall he drive to?' He was not, however, to be caught. 'Along Piccadilly,' was the reply, 'and I will then tell him where.' (Burnet, pp. 34–5)

But it was not only his fellow-artists who were thus kept at arm's length. All his acquaintance, almost without exception, were excluded from this private region of his life:

While living at Chelsea, a gentleman who knew him well, chanced to be out on business in the neighbourhood early; and found Turner in the same steam-boat with himself, going towards the City. Seeing Turner clean-shaved, and his shoes blacked, and looking as if he had just left home, he made some remark about his living in the neighbourhood, wondering to see him there so early. 'Is that your boy?' said Turner, pointing to the gentleman's son, and evading all questions as to his own 'whereabout'. (Miller, p. 40)

The abrupt yet not untactful parrying gambit, and the fatherly interest in the boy, seem entirely in keeping with what we know of Turner; the anecdote, with all its absurdity, rings true, and documents amusingly his almost obsessive desire for privacy – a privacy which cannot, like his general solitariness, have been sought for the purpose of creating time to work: he had worked all his life in the house in London which everyone knew. Yet there seem to have been moments of relaxation from this rigid secrecy. John Martin, the successful painter of visionary subjects which, albeit crude, take their derivation from Turner, was once led with his son Leopold on a walk from Queen Anne Street to Cremorne Gardens which the boy remembered in old age:

Mr Turner intimated that, on my father's arrival [in Queen Anne Street], he was on the point of walking over to his small place at Chelsea. If inclined for a walk, would he accompany him? This my father willingly agreed to do.

287 The Thames at Chelsea as it was in Turner's time. The trees in the distance are those of Cremorne Gardens; Davis Place faced the river in the curve on the right.

Crossing Hyde Park, Brompton, and so on by the footpaths through market gardens to Chelsea – a very pleasant ramble – Mr Turner introduced us to a small six-roomed house on the banks of the Thames, a squalid place past Lindsay Row, near Cremorne House. The house had but three windows in front, but possessed a magnificent prospect both up and down the river. With this exception, the abode was miserable in every respect. The only attendant seemed to be an old woman, who got us some porter as an accompaniment to some bread and cheese. The rooms were very poorly furnished, all and everything looking as though it was the abode of a very poor man. Mr Turner pointed out, with seeming pride, to the splendid view from his single window, saying, 'Here you see my study – sky and water. Are they not glorious? Here I have my lessons night and day!' The view was certainly very beautiful, but hardly of that description one would have expected the great Turner to glory in. Effect was all he required. (Martin, chap. 11)

At the Queen Anne Street House, on the other hand, there were numerous visitors: artists and engravers, of course; collectors, statesmen, ladies and gentlemen, all who could obtain admittance would try to glimpse the closely guarded secrets of Turner's studio. For though the public were admitted by appointment, they were often confronted by considerable obstacles and sometimes made to feel decidedly unwelcome. Even an old friend such as F. E. Trimmer could only gain access to the whole house after its owner was dead:

First, the entrance hall. Here were several casts, from the antique, of Centaurs in conflict with the Lapithæ, and a picture of Sir Joshua, all very trite and depressing. Turning to the right was the dining-room, over the fire-place a small model of a female figure, and a small Wilson obscured by smoke, quite in keeping with the sombre walls. . . . there was also a picture of Tassi, Claude's master. Backwards stretched a large unfurnished room filled with unfinished pictures; then a larger and drearier room yet; lastly, a back room, against the walls of which stood his unfinished productions, full-length canvasses placed carelessly against the wall, the damp of which had taken off the colours altogether, or had damaged them. . . . Then we went into Turner's sleeping apartment; it is surprising how a person of his means could have lived in such a room; certainly he prized modern luxuries at a very modest rate. . . . I reserved the studio as the finale. . . . That august retreat was now thrown open; . . . his painting-room, which had no skylight. It had been originally the drawing-room, and had a good north light, with two windows. (T., II, pp. 279–80, 283)

A much more complete picture of the Queen Anne Street house is provided by the inventory of its contents drawn up after Turner's death (p. 248).

194 The exterior, of course, was open to the inspection of all, but no less provocative of speculation. George Jones noted that 'the area and door-step were clean although the windows were neglected and the outside had long been guiltless of paint' (Jones, *Turner*, p. 6). A less partisan observer, Peter Cunningham, provides a more imaginative description:

The house is on the south side of the street, and at the time of his death – indeed for years before – presented the appearance of a place in which some great crime has been committed – where the tax-gatherer had long ceased to call, which no one would inhabit, and about which the landlord himself had abandoned all hope. The street-door had not been painted for at least twenty years, and the windows were grimed with successive coats of dust and rain.

288 No. 6 Davis Place, Cremorne New Road, Chelsea. A photograph showing the terrace on the roof that Turner built to serve as a viewing platform from which he could observe the changing light on the Thames.

It was always a wonder to me that the windows were unbroken. . . .
Passengers have been known to point to Turner's house, as one the street
door of which had not been seen opened for years; 'but yet it is believed
somebody lives there – at least the policeman says so.' The truth is, he was
seldom at home; and his house was in charge of an old woman who had lived
with his father, and had caught and copied the close economy of both
establishments. Her wants were few; and yet there was some sense of
neatness about her. When a known person knocked at the door, and that
person was a gentleman or a lady, she would keep them waiting till she could
cover her dirty gown by a huge apron, which she kept for the purpose on a
nail behind the street door. (Cunningham, pp. 28–9)

This was Hannah Danby. F. E. Trimmer remembered her in her later years, and
helps to explain her own reclusive habits: 'Mrs. Danby was his housekeeper,
and had lived with him for many years. She had some fearful cancerous malady
which obliged her to conceal her face, which did not add to the charms of the
domicile' (T., II, p. 178). When one of the most ardent enthusiasts for Turner's
works, Elizabeth Rigby (soon to become Lady Eastlake), visited the house with 289
Munro of Novar on 20 May 1846 they were greeted by a 'hag of a woman, for
whom one hardly knew what to feel most, terror or pity':

She showed us into a dining-room, which had penury and meanness written
on every wall and article of furniture. Then up into the gallery; a fine room – 291,
indeed, one of the best in London, but in a dilapidated state; his pictures the 307
same. The great *Rise of Carthage* all mildewed and flaking off; another with
all the elements in an uproar, of which I incautiously said: 'The End of the
World, Mr Turner?' 'No, ma'am; *Hannibal crossing the Alps*'. His *Battle of* 147
Trafalgar excellent, the disposition of the figures unstudied apparently.
Then he uncovered a few matchless creatures, fresh and dewy, like pearls
just set – the mere colours grateful to the eye without reference to the
subjects. The *Temeraire* a grand sunset effect. The old gentleman was great 240
fun: his splendid picture of *Walhalla* had been sent to Munich, there 290
ridiculed as might be expected, and returned to him with £7 to pay, and
sundry spots on it: on these Turner laid his odd misshapen thumb in a
pathetic way. Mr Munro suggested they would rub out, and I offered my
cambric handkerchief; but the old man edged us away, and stood before his
picture like a hen in a fury. (Lady Eastlake 1895, I, pp. 188–9)

289 Elizabeth Rigby, later Lady
Eastlake, photographed by her friends
Hill and Adamson about 1845.

290 *The opening of the Wallhalla, 1842*, oil.
A celebration of the achievements of
Ludwig I of Bavaria, whose Walhalla, a
German Pantheon built above the
Danube, Turner had visited in 1840
during its construction. It was shown at
the Academy in 1843 with suitable lines
from the *Fallacies of Hope*: they referred
to the defeat of Napoleon and the dawn
of a new age of prosperity for Europe,
and concluded:

But peace returns – the morning ray
Beams on the Wallhalla, reared to science
 and the arts,
For men renowned, of German fatherland.

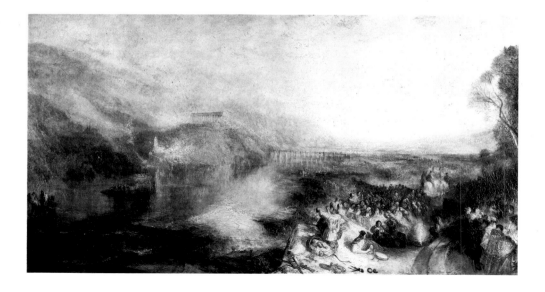

Elizabeth Rigby's spontaneous interpretation of the *Hannibal* is interesting. It reflects the type of subject-matter that John Martin had made popular in the 1820s: sensationally apocalyptic rather than strictly Biblical. She was too young to remember the picture when it was exhibited in 1812.

Another young enthusiast who had never seen *Hannibal* before, the Scots painter William Leighton Leitch, sought admission to the house in 1842, through the intermediary offices of one of Walter Fawkes's daughters, who

asked if I had seen Mr Turner's gallery. I said I had not, and that I had heard that Mr Turner had an objection to artists seeing his pictures. She said that that was because he had once caught an artist rubbing or scraping out one of the pictures in the gallery, but that he would know who I was, and that there would be no difficulty. She said she would write to him that afternoon, and let me know his answer. On this I said I would like to have the answer to keep as an autograph; but she said there was little chance of my getting that, as Mr Turner was a very singular person, and very chary of writing now. It appears, she said, that he once heard of an autograph of his having been sold for fifteen pence, and she was quite sure that rather than let me have such a chance he would come down all the way from Queen Anne Street and leave his answer verbally at the door. And it turned out just as Miss Fawkes had predicted. Turner himself came to Wilton Place, and left word that he was going out of town, but that his housekeeper would let me see the pictures. Miss Fawkes told me that I was highly favoured, as Turner hardly ever allowed visitors to see his gallery when he was not on the spot himself. She told me he had a 'peep-hole' from his painting-room to the gallery, so as to be able to see what people were doing, and hear what they were saying.

So I went. I had heard of dirty rooms and of the mysterious

292 Paw marks of one of Hannah Danby's cats, tracked in grey watercolour on the back of an illustration for a Perspective lecture.

OPPOSITE

293 John Ruskin, after a watercolour portrait by George Richmond, 1843.

In Part V of *Modern Painters* Ruskin analysed 'Turnerian Topography' by means of a close examination of the 1843 watercolour of *The Pass of Faido* (294) which he contrasted with his own etching (295) of the valley as it appears in the cold fact of 'Simple Topography': 'There is nothing in this scene, taken by itself, particularly interesting or impressive. The mountains are not elevated, nor particularly fine in form . . . But, in reality, the place is approached through one of the narrowest and most sublime ravines in the Alps, and after the traveller . . . has been familiarized with the aspect of the highest peaks of the Mont St. Gothard. Hence it speaks quite another language to him from that in which it would address itself to an unprepared spectator . . . the aim of the great inventive landscape painter must be to give the far higher and deeper truth of mental vision, rather than that of the physical facts . . .' (R., VI, p. 35).

housekeeper, and my curiosity was excited. The house had a desolate look. The door was shabby, and nearly destitute of paint, and the windows were obscured by dirt. When I rang the bell the door was opened a very little bit, and a very singular figure appeared behind it. It was a woman covered from head to foot with dingy whitish flannel, her face being nearly hidden. She did not speak, so I told her my name, and that Mr Turner had given me permission to see the pictures. I gave her my card and a piece of silver with it, on which she pointed to the stair and to a door at the head of it, but she never spoke a word, and shutting the door she disappeared.

I felt a strange lonely feeling come over me as I looked about before going into the gallery. The hall was not like that of an ordinary London house. It had a square empty appearance; no furniture in it, a dingy brown colour on the walls, and some casts from the Elgin marbles inserted in the upper part. Everything was covered with dust, and had a neglected look. When I entered the gallery and looked at the pictures I was astonished, and the state in which they were shocked me. The sky-lights on the roof were extremely dirty, many of the panes of glass were broken, and some were awanting altogether. It was a cold wet day in autumn, and the rain was coming in through the broken glass, on to the middle of the floor; and all the time I was there – fully an hour – I had to keep my umbrella open over my head. The whole place looked wretched.

I need not describe the pictures, as most people have now seen them, or may see them, in the national collection; but on this occasion two of the finest of them, 'The Rise of Carthage,' and 'Crossing the Brook,' were in 122, anything but good condition. The sky of the first was in a very 126 unsatisfactory state. It was cracking – not in the ordinary way, but in long lines, like ice when it begins to break up. Other parts of the picture were peeling off – one piece, I recollect, just like a stiff ribbon turning over. . . .

I walked backwards and forwards in the gallery . . . feeling cold and uncomfortable – no sound to be heard but the rain splashing through the broken windows upon the floor, where it must have been dripping for three hours. I at last found a common, and very dirty chair, and sat down in the middle of the room, with my umbrella over my head, and I became abstracted in contemplating the finest of the pictures. From this state I was brought back to myself by feeling something warm and soft moving across the back of my neck; then it came on my shoulder, and on turning my head I was startled to find myself confronted by a most peculiarly ugly broad-faced cat of a dirty whitish colour, with the fur sticking out unlike that of any other cat. The eyes were of a pinky hue, and they glared and glimmered at me in a most unearthly manner, and then the brute moved across my chest, rubbing its head and shoulders against my chair. I put up my hand to shove the creature away, and in doing so let my umbrella fall, and this startled four or five more cats of the same kind, which I observed moving about my legs in a most alarming way. I did not like the thing at all, and to tell the truth I was frightened. So I picked up my umbrella and made for the door, and got to the foot of the stair as fast as I could. On looking back I saw the cats at the top glaring at me, and I noticed that every one of them was without a tail. As I could see nothing of the housekeeper, I opened the door for myself, and shut it after me with a bang, so that she might hear I had gone. (*Leitch*, pp. 81–6)

One of the few who would have felt nothing of Leitch's sensations of loneliness and fear in the Queen Anne Street house was young John Ruskin. His 293 original defence of Turner against the criticisms of *Blackwood's* had by 1841

assumed the proportions of a massive enterprise, which was preoccupying him mentally and physically. The two men continued to meet at Griffith's, and Ruskin grasped every opportunity to study his subject at close quarters, recording their meetings in his Diary. By the end of 1841 he was able to visit the gallery, and sometimes take friends. On 20 November he took the painter Joseph Severn and his wife 'to Turner's. Severn comparing Turner to the old Italian School, for his luminous handling, as opposed to Rembrandt. . . . Turner out . . .'

By 1843, friendly intercourse was well established; Turner relished the attentions of so intelligent and admiring a youth, while Ruskin for his part was determined in his ardour to bring Turner into his family circle. On 27 January he 'called on Turner; found him in, and in excellent humour, and will come to me on my birthday'. The birthday dinner was a great success; 'the happiest birthday evening (save one) I ever spent in my life. Turner happy and kind'. On 24 February he 'Called at Turner's; found him panting with exertion heaving the plates into his cupboard with Griffiths [sic]. Insisted on my taking a glass of wine, but I wouldn't. Excessively good-natured today – Heaven grant he may not be mortally offended with the work!'

By 15 May 'the work', *Modern Painters*, was out, and he could expect that his next visit would put his suspense to rest. But Turner, like Ruskin himself, was inescapably an Englishman, and nothing explicit was said on this momentous subject: 'Called on Turner today, who was particularly gracious. I think he must have read my book, and been pleased with it, by his tone.' It was not until 20 October 1844 that he was able to record 'Turner's thanking me for my book for the first time', at a quiet dinner with Griffith and Windus on the 17th.

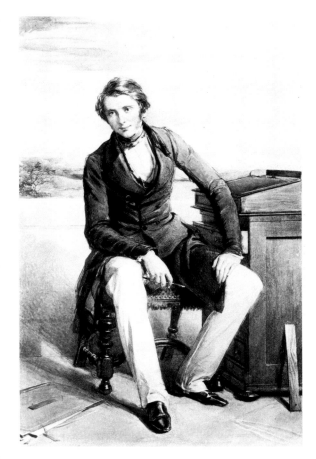

The young man's regard for Turner was much more than the dog-like devotion that emerges from the Diary. Apart from *Modern Painters*, which could hardly have been more eloquent testimony to the highest admiration, he was able to offer the very practical homage of direct patronage. He had already, through the generosity and indulgence of his father, become the owner of
184 several of Turner's watercolours; each acquisition taking on the aspect of a luminous new dimension to his perception of the world. Like so many of Turner's patrons in the past, he found acquiring anything from him a sometimes puzzling business. In 1841, the artist, having been on a revelatory tour of Switzerland that summer, was inspired by what he had seen there to add a new complication to the buying process, as Ruskin recounted much later, in *Praeterita*: 'In the early Spring [of 1842], a change came over Turner's mind. He wanted to make some drawings to please himself; but also to be paid for making them' (R., xxxv, p. 309). The full story is given in the Epilogue to his catalogue of the Turners in his own collection shown at the Fine Art Society in 1878. A study of Dazio Grande,

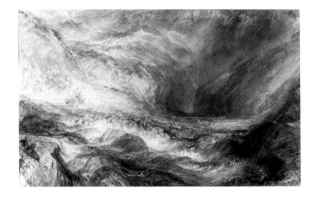

with fourteen others, was placed by Turner in the hands of Mr Griffith of Norwood, in the winter of 1841–2, as giving some clue to, or idea of, drawings which he proposed to make from them, if any buyers of such productions could by Mr Griffith's zeal be found.

There were, therefore, in all, fifteen sketches, of which Turner offered the choice to his public; but he proposed to make only *ten* drawings. And of these ten, he made anticipatorily four, to manifest what their quality would be, and honestly 'show his hand' (as Raphael to Dürer) at his sixty-five years of age, – whether it shook or not, or had otherwise lost its cunning.

Four thus exemplary drawings I say he made for specimens, or *signs*, as it were, for his re-opened shop, namely:

1 The Pass of Splügen.

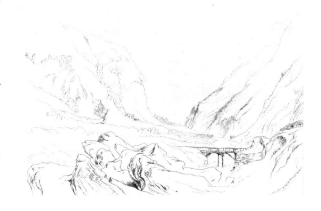

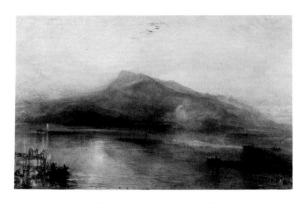

296 *The dark Rigi*, 1842. The finished watercolour acquired by Munro of Novar.

2 Mont Righi, seen from Lucerne, in the morning, dark against the dawn.

3 Mont Righi, seen from Lucerne, at evening, red with the last rays of sunset.

4 Lake Lucerne (the Bay of Uri) from above Brunnen, with exquisite 279 blue and rose mists and 'mackerel' sky on the right.

And why should he not have made all the ten, to his own mind, at once, who shall say? . . . why . . . of these direct impressions from the nature which he had so long loved, should he have asked anybody to choose which he should realize? So it was, however; partly, it seems, in uncertainty whether anybody would care to have them at all . . . (R., XIII, pp. 477–8).

Ruskin, with his perception of Turner as the great Romantic artist, the hero-figure to whom all ways were open, all means of communication legitimate, perhaps gave too little thought to the sheer professionalism that was so crucial a driving force in Turner's career. Having spent so much of his life working on commission for engravers and publishers in the production of long series of views *en suite*, he was impelled almost by force of habit to create the conditions in which he could continue working like that, even when, in his old age, such commissions were no longer forthcoming and, as Ruskin lamented, his drawings were appreciated by only a very few people:

One day, then, early in 1842, Turner brought the four drawings above-named, and the fifteen sketches in a roll in his pocket, to Mr Griffith (in Waterloo Place, where the sale-room was).

I have no reason to doubt the substantial accuracy of Mr Griffith's report of the first conversation. Says Mr Turner to Mr Griffith, 'What do you think you can get for such things as these?'

Says Mr Griffith to Mr Turner: 'Well, perhaps, commission included, eighty guineas each.'

Says Mr Turner to Mr Griffith: 'Ain't they worth more?'

Says Mr Griffith to Mr Turner: (after looking curiously into the execution which, you will please note, is what some people might call hazy) 'They're a little different from your usual style' – (Turner silent, Griffith does not push the point) – 'but – but – yes, they are *worth* more, but I could not *get* more.' . . .

So the bargain was made that if Mr Griffith could sell ten drawings – the four signs, to wit, and six others – for eighty guineas each, Turner would make six others from such of the fifteen sketches as the purchasers chose, and Griffith should have ten per cent, *out* of the eight hundred total (Turner had expected a thousand, I believe).

So then Mr Griffith thinks over the likely persons to get commissions from, out of all England for ten drawings by Turner! and these not quite in his usual style, too, and he sixty-five years old . . .

He sent to Mr Munro of Novar, Turner's old companion in travel; he sent to Mr Windus of Tottenham; he sent to Mr Bicknell of Herne Hill; he sent to my father and me.

Mr Windus of Tottenham came first, and at once said 'the style was changed, he did not quite like it . . . He would not have any of these drawings.' I, as Fors would have it, came next . . . The Splügen Pass I saw in an instant to be the noblest Alpine drawing Turner had ever till then made; and the red Righi, such a piece of colour as had never come *my* way before. I wrote to my father, saying I would fain have that Splügen Pass, if he were home in time to see it, and gave me leave . . .

Mr Bicknell of Herne Hill bought the Blue Righi, No.2 . . .

Then Mr Munro of Novar, and bought the Lucerne Lake, No.4 (and the red Righi?) and both Mr Munro and Mr Bicknell chose a sketch to be 'realized' – Mr Bicknell, another Lucerne Lake; and Mr Munro, a Zürich, with white sunshine in distance.

So . . . three out of the four pattern drawings he had shown were really bought – 'And not *that*' said Turner, shaking his fist at the Pass of Splügen; but said no more!

Munro of Novar came again . . . and made up his mind, and bought the Pass of Splügen. . . .

. . . only nine drawings could be got orders for, and there poor Mr Griffith was. Turner growled; but said at last he would do the nine, i.e. the five more to be realized.

He set to work in the spring of 1842; after three or four weeks, he came to Mr Griffith, and said, in growls, at intervals, 'The drawings were well forward, and he had after all put the tenth in hand, out of those no one would have; he thought it would turn out as well as any of them; if Griffith liked to have it for his commission he might.' Griffith agreed, and Turner went home content, and finished the ten drawings for seven hundred and twenty guineas, cash clear. (Ibid., pp. 478–80)

Turner was possibly impelled to this curious system of doing business by the need to raise cash for an enterprise he had very much at heart early in 1842: the publication of five large-plate engravings after some of his most important oil paintings, including *Mercury and Hersé* of 1811, *Dido and Æneas* of 1814 and *Crossing the brook* of 1815. The other two subjects were from more recent pictures: *Caligula's Palace and Bridge* of 1831, and *Juliet and her Nurse* of 1836. The project may have been some kind of revival of the scheme for four separate plates that he had proposed to J. O. Robinson in 1822. One of the new subjects, 297 *Caligula's Palace*, was executed by Edward Goodall, whose son later remembered something of the transaction:

I saw him constantly at our house when I was very young, from the time my father began the large plate of 'The Palace of Caligula.' After a few days he called and asked for a piece of whiting, and hastily sketched on the picture with a piece of chalk.

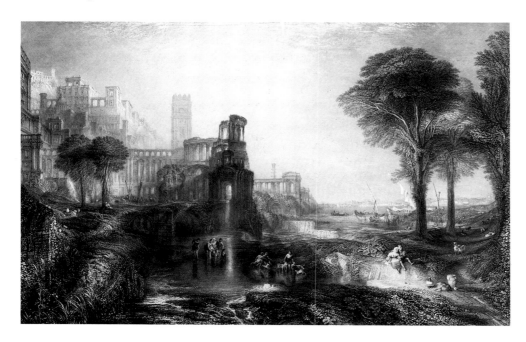

297 *Caligula's Palace and Bridge*, engraved by Edward Goodall after Turner, 1842.

'Mr Goodall,' he said, 'I must have two more boys in here, and some goats. You can put these in for me.'

'I have taken many liberties in putting in figures in other men's works,' my father replied, 'but in this case I must decline. You only can paint them in.'

'You'll do it well enough,' Turner retorted.

But my father made him promise to come and paint in the figures. The palette was set for him ready on the promised day. He took two whole days to paint these figures in the picture, but they were very beautifully done.

The commission was for 700 guineas, which shows, I am proud to say, the appreciation he had of my father's work. (Goodall, p. 50)

A considerable outlay, therefore, was involved in the production of the set of plates, which were advertised in the *Art-Union* in March 1842. They seem to have represented for Turner the pinnacle of his achievement in the field of reproductive engraving. Although he attached great importance to printmaking as a channel for the dissemination of his work and had devoted much time to the supervision of engravings and mezzotints after his watercolour designs, very few such prints had ever been made after his paintings. This set of carefully chosen subjects – they are all calculated to underline his status as a painter in the classic tradition of European landscape – were intended to be worthy successors to the great prints that William Woollett and the eighteenth-century masters had made after subjects by Wilson and Claude. It is an irony that today they are regarded as mere reproductions and accorded only scant attention.

Turner himself probably felt that the large payments he was obliged to make to his engravers severely mitigated the value of the scheme. It was, after all, more expeditious for him to execute his own watercolours, working on commission through Griffith. Despite the evident shortage of buyers for his 1842 Swiss subjects he adopted the same procedure with further sets in the next few years. He was now obsessed with the landscape of Switzerland, and returned to it in the summers of 1842, 1843 and 1844; he would surely have gone there again in 1845 if his health had not broken down. He may also have been put off by the disturbed state of the country as he had found it the previous year. Both factors are mentioned in a letter he wrote to Hawksworth Fawkes on 28 December 1844, thanking him for a customary present of 'Yorkshire Pie equal good to the olden time of Hannah's culinary exploits':

Now for myself, the rigours of winter begin to tell upon me, rough and cold and more acted upon by changes of weather than when we used to trot about at Farnley, but it must be borne with all the thanks due for such a lengthened period.

I went however to Lucerne and Switzerland, little thinking or supposing such a cauldron of squabbling, political or religious, I was walking over. The rains came on early so I could not cross the Alps, twice I tried, was set back with a wet jacket and worn-out boots and after getting them heel-tapped I marched up some of the small valleys of the Rhine and found them more interesting than I expected . . . (G. 275)

We have a vivid record of him on one of these last tours (probably that of 1843) in the recollection of the topographical watercolourist and pioneer photographer William Lake Price, who told the readers of one of his didactic articles that

Some years since, on the Lake of Como, he happened to be on the same

298 *Heidelberg Castle from the Neckar*, from the *Heidelberg* sketchbook, 1844.

steamer with the great poet of the pencil, TURNER, and thus had an opportunity, of which very few can boast, of seeing him sketching or painting. Turner held in his hand a tiny book, some two or three inches square, in which he continuously and rapidly noted down one after another of the *changing* combinations of mountain, water, trees, &c., which appeared on the passage, until some *twenty* or more had been stored away in an hour-and-a-half's passage. This example of so consummate an artist shows the engrossing love of the pursuit, with which excellence in it must always be accompanied. (*Photographic News* 1860, p. 407)

Another glimpse of Turner's practice comes from Ruskin:

Turner used to walk about a town with a roll of thin paper in his pocket, and make a few scratches upon a sheet or two of it, which were so much shorthand indication of all he wished to remember. When he got to his inn in the evening, he completed the pencilling rapidly, and added as much colour as was needed to record his plan of the picture. (R., XIII, p. 190)

281–3 He produced hundreds of colour studies on these Swiss journeys, and was bursting with new responses to the lakes and mountains which needed to find expression in the 'changed' and 'hazy' manner he had newly evolved. But it was hardly in his nature to make finished watercolours without a clear economic purpose like engraving or sale to a collector. An oil painting was different: it could be hung at the Academy, and that was justification enough for its existence. He knew that the Academy was no place for the shimmering subtleties of these works. He was no doubt conscious that they represented, hazy or not, the culmination of his achievement in the medium: underlying the whole of the dialogue with Griffith reported by Ruskin is the ironic certainty that Turner knew these drawings to be his masterpieces. Young John Ruskin saw it too, and the artist must have been duly grateful. For the six Swiss watercolours that Turner made in 1843, there were only two purchasers: Ruskin and Munro of Novar. Perhaps this discouraged him from a similar venture in 1844; though that year he was contemplating an ambitious panorama of the view from the top of the Rigi for one of the new patrons he had found for his

later work: Francis McCracken, a Belfast-based ship-owner who also dealt in pictures and handled the packing of works of art for the Royal Academy. This panorama is mentioned in a letter from Turner to McCracken of 29 November 1844:

> My Dear Sir,
> Many thanks to you for your kind accordance with my notions of Copy right &c &c. but I must request your conclusion respecting the subjects to be painted, for the more I read your words 'I will wait readily another year' which implies the top of the said *Riggi* only – if therefore it is to be done this season I think I can do it by the means of the Swiss Panoramic Prints and knowing tolerably well the geography all round the neighbourhood.
> If it is to be left for the next season summer trip to Switzerland I must request you give up the Venice commission – but pray bear in mind I do not wish to drag you into two commissions – altho I have commenced one of Venice and one of the lake of Lucerne sun-rise – but as I wish to meet your wishes soley pray tell me conclusively how I am to direct my steps towards it this year.
>
> Yours most truly
> J. M. W. Turner (G. 273)

Once again, the note of disciplined professionalism is dominant: Turner's tone is amenable and obliging like that of the most respectful tradesman. In the company of those whose admiration he knew to be sincere he could afford to be humble. He relished, throve on, the decorous relationship between artist and patron; it had been a staple of his way of life since he was a boy, and no doubt played a considerable part in fulfilling his requirements of life. It was essentially different from the brisker, sharper contact he had with his engravers. He had no pressing need to sell; only a need to be treated professionally by those who took his work seriously. In a letter to Dawson Turner of Norwich, written on 16 May 1845, he gave expression to his intense feeling for the works of art he had created. Dawson Turner had enquired into the possibility of purchasing *Crossing the brook* (which he had first thought of buying in 1817): 126

> My Dear Sir
> I have great pleasure in acknowledging your kind note – indeed from a friend and name the same and to thank you respecting the Crossing the Brook picture (Thank Heaven which in its kindness has enabled me to wade through the Brook) – it I hope may continue to be mine – it is one of my children –
>
> Many thanks for your regard and
> Believe me truly
> J. M. W. Turner (G. 283)

The most famous avowal of this kind is that which occurs in a draft letter of a year or two later, alluding to the *Téméraire*: 'no considerations of money or 240 favour can induce me to lend my Darling again' (G. 291). And a letter to Griffith of 1 February 1844 gives a more detailed picture of his feelings about the works which lay untended in the Queen Anne Street house:

> The large Pictures I am rather fond of tho it is a pity they are subject to neglect and Dirt – the Palestrina [R.A.1830] I shall open my mouth widely ere I part with it. The Pas de Calais ['*Now for the painter*', R.A.1827] is now in the gallery (suffering). The Orange Merchant [R.A.1819] I could not get at – if I could find a young man acquainted with Picture cleaning and would help *me* to clean accidental stains away, would be a happiness to drag them

299 *View of Eu, with the Cathedral and Château of Louis Philippe*, watercolour, 1845.

300 The gold snuff-box presented to Turner by Louis Philippe in 1838.

from their dark abode. – to get any lined is made almost an obligation confer'd – and subject to all remarks. (G. 264)

In 1848 he did manage to find an assistant, Francis Sherrell, a young artist who was introduced to Turner by his brother, the painter's barber. Sherrell long afterwards recalled seeing Turner mixing his chrome yellows in a bucket with his hands, which he also used to apply the pigment to the canvas. In exchange for lessons – probably consisting mainly of observing Turner at work – he acted as studio factotum, stretching canvases as old William had done, and perhaps starting the massive job of repairing and retouching the damaged canvases; though little of substance seems to have been achieved in this respect.

The 'next season summer trip to Switzerland' planned for 1845 did not take 284 place; instead Turner paid two brief and leisurely visits to the north French coast, first to Picardy and the neighbourhood of Boulogne and later to Dieppe, Tréport and Eu, where he seems to have visited an old acquaintance – Louis Philippe. He had met the French King in 1815, during his exile, while he was living at Orleans House close to Sandycombe Lodge; in 1838, Louis Philippe 300 had presented him with a large and ornate snuff-box decorated with the royal cipher in Brazilian diamonds. He took lodgings at Eu in a fisherman's house, we are told; and

299 He had not been long there before an officer of the court inquired for him, and told him that Louis Philippe, the King of the French, who was then staying at the Château, hearing that Mr Turner was in the town, had sent to desire his company to dinner. . . . Turner strove to apologize – pleaded his want of dress – but this was overruled; his usual costume was the dress-coat of the period, and he was assured that he only required a white neck-cloth, and that the King must not be denied. The fisherman's wife easily provided a white neck-cloth, by cutting up some of her linen, and Turner declared that he spent one of the pleasantest of evenings in chat with his old Twickenham acquaintance. (R. and S. Redgrave, II, p. 86)

These were his last ventures on to the Continent. But he did not cease to make watercolours of the Swiss scenery that had impressed itself on his

imagination as the embodiment of his ultimate perception of nature. His panorama of the view from the Rigi did not materialize, as far as we know; though in 1845 he produced another ten watercolours, pursuing the theme of the organic wholeness of the world – men and mountains, lakes, air, light and space bound up in one immensely grand expression of life: a resolution of the tensions and stresses of nature with which so much of his art had characteristically been concerned. He seems to have been planning yet further series of these Swiss subjects, and Ruskin acquired two more in 1848; but although the flood of creativity could not be staunched, from now on his health undoubtedly prevented him from doing much that he would have wished.

Ill-health interfered with his official duties, yet in 1845 he acted as *locum tenens* for the President when Sir Martin Archer Shee became too old and ill to continue actively in that office. This he regarded, he told Ruskin (G. 301), as an 'unpleasant duty'; and when he acknowledged Hawksworth Fawkes's annual Christmas pie on 26 December 1846 he unbosomed still more freely on the subject.

> in regard to my health sorry to say the tiresome and unpleasant duties of [presiding] during the continued illness of our President for two years – viz my rotation of Council – and being senior of the lot made me Pro Pre – it distroyd my happiness and appetite [so] that what with the business and weak[ness] I was oblidged to give [up] my Summer's usual trip abroad – but thank Heaven I shall be out of office on Thursday the 31 of this month. (G. 302)

He would, no doubt, have been happy to wear the Presidential mantle with more legitimate authority, earlier in his career; but much as he was respected as the doyen of the Academy his eccentricity and somewhat rough exterior had been a permanent barrier to the achievement of that ambition. Now it was too late. There was no honour in the discharging of such official chores, which he did for the sake of the Academy alone; he was ill, and glad to be free of the responsibility.

One of his more pleasant responsibilities, he felt, was to continue sending in works to the annual exhibitions as long as he could manage to do so. The torrent of Swiss studies and finished watercolours in the first half of the decade had been matched by an equally astonishing outpouring of canvases, all executed in a style as original for their medium as the watercolours were in theirs. The most striking innovation was perhaps a preference for square, round or octagonal frames which gave a strong emphasis to the vortical dynamism of many of the late subjects. The new type was announced at the 1840 Academy exhibition by a strange circular reinterpretation in highly charged Turnerian terms of Titian's *Bacchus and Ariadne*. In 1841 he showed *Dawn of Christianity* and *Glaucus and Scylla*, which are painted in contrasting cool and warm colours respectively and invite interpretation as a pair, though their connection as subjects is hard to determine. The next year *Peace – burial at sea* and *War. The exile and the rock limpet*, 276 similarly contrasted, can more readily be seen as linked comments on the peaceful trade of artist, as represented by Turner's long-standing colleague and rival Wilkie, and the warlike one of soldier and tyrant as exemplified in the career of Napoleon: the 'exile's' solitary end on St Helena is depicted as far from peaceful, nagged by loneliness and futility. The purpose of such pairings became more apparent in 1843, when *Shade and darkness – the evening of the Deluge* 277 was explicitly coupled with *Light and colour (Goethe's Theory) – the morning after* 278 *the Deluge – Moses writing the book of Genesis*. The allusion was to Goethe's *Farbenlehre* (1810) which had been published in English, as *Theory of Colours*, in a translation by Eastlake, in 1840. Turner owned, read and annotated a copy of

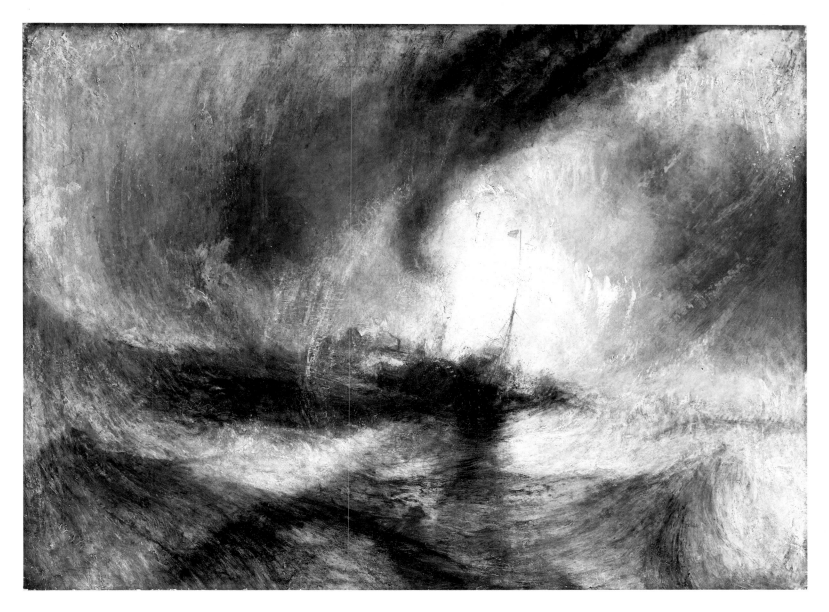

this translation. His remarks make it clear that he did not always agree with Goethe's ideas; indeed, there is no reason to interpret the 1843 paintings as an 'advertisement' for Goethe: Turner wished rather to draw attention to his own well-established use of contrasting colour schemes for emotional purposes, for which he thought he had found authority in Goethe, and which he identified in one of his annotations to the *Theory of Colours* as 'The ancient simbolical notion of colour to designate Qualities of things'.

The historical or mythological subject-matter of these works, with its associations of pure theory, is complemented by another sequence of pictures painted in the same years. Their subjects are taken from contemporary life, and are chosen to give fullest rein to the artist's capacity to render atmosphere in all its subtlety: *Snow storm – steam-boat off a harbour's mouth making signals in shallow water, and going by the lead* was intended to be a precise record of particular circumstances, as its very exact title tells us; Turner even added the further information that 'the author was in this storm on the night the Ariel left Harwich' to leave us in no doubt that it is no fantasy but the plain unvarnished truth of nature that he offers us. He perhaps anticipated the public reaction, but was nonetheless distressed by the derision with which the picture was greeted when it appeared at the Academy in 1842: the *Athenæum* for 14 May, for instance, protested that

302 Richard ('Dicky') Doyle: *Turner painting one of his pictures*, 1846. A famous caricature from *The Almanack of the Month* which makes the point that Turner's love of chrome yellow, which he had been using since the 1820s, continued to shock and amuse the public until the end of his career.

This gentleman has, on former occasions, chosen to paint with cream, or chocolate, yolk of egg, or currant jelly, – here he uses his whole array of kitchen stuff. Where the steam-boat is – where the harbour begins, or where it ends – which are the signals, and which the author in the *Ariel* . . . are matters past our finding out.

This was the kind of criticism that could sometimes prompt him to turn a joke against himself, as in an incident recounted by William Powell Frith:

Strange as it may sound, it is absolutely true that I have heard Turner ridicule some of his own later works quite as skilfully as the newspapers did. For example, at a dinner when I was present, a salad was offered to Turner, who called the attention of his neighbour at the table (James Lloyd, afterwards Lord Overstone) to it in the following words: 'Nice cool green that lettuce, isn't it? and the beetroot pretty red – not quite strong enough; and the mixture, delicate tint of yellow that. Add some mustard, and then you have one of my pictures.' (Frith, I, pp. 130–31)

But now another critic accused him of painting the *Snow storm* with 'soapsuds and whitewash', the jibe seems particularly to have upset him. Ruskin had an opportunity to see how much he was riled by it:

Turner was passing the evening at my father's house on the day this criticism came out: and after dinner, sitting in his arm-chair by the fire, I heard him muttering to himself at intervals, 'soapsuds and whitewash! I wonder what they think the sea's like? I wish they'd been in it.' (R., XIII, p. 161)

It is revealing that after so long and successful a career, in which he had received more than his share of hostile reviews, he could still be wounded by the clumsily hurled darts of the press. But there was something more deeply rooted than mere dislike of criticism; perhaps his possessive, even protective attitude to his 'children' rendered him more than normally sensitive to any response the outside world might bring to them. This would explain his often-noted reluctance to discuss them candidly and straightforwardly, and even his occasional rudeness to those who might genuinely admire and understand, at a certain level. The 1842 *Snow storm* was the subject of a striking instance of this, as the Rev. William Kingsley told Ruskin:

I had taken my mother and a cousin to see Turner's pictures, and, as my mother knows nothing about art, I was taking her down the gallery to look at the large 'Richmond Park', but as we were passing the 'Snowstorm' she stopped before it, and I could hardly get her to look at any other picture; she told me a great deal more about it than I had any notion of, though I have seen many sea storms. She had been in such a scene on the coast of Holland during the war. When, some time afterwards, I thanked Turner for his permission for her to see his pictures, I told him that he would not guess what had caught my mother's fancy, and then named the picture; and he then said, 'I did not paint it to be understood, but I wished to show what such a scene was like; I got the sailors to lash me to the mast to observe it; I was lashed for four hours, and I did not expect to escape, but I felt bound to record it if I did. But no one had any business to like the picture.' 'But,' said I, 'my mother once went through just a scene, and it brought it all back to her.' 'Is your mother a painter?' 'No.' 'Then she ought to have been thinking of something else.' (R., VII, p. 445, n.)

There are occasions when it seems that the pressures of genius become almost

intolerable; the gulf that separates the inspired from the commonplace, the professional from the amateur, seems unbridgeable, the best-intentioned compliments gauche and false.

303 The other outstanding 'modern' subjects of the 1840s are the whaling scenes of 1845 and 1846, painted with Elhanan Bicknell, the whaling entrepreneur, in mind, and exhibited with references in the catalogues to Thomas Beale's *The Natural History of the Sperm Whale* (1839), and hence intended without doubt to be representations of real life, authentic enough to satisfy those in a position to know. A more easily verifiable experience for most visitors to the Academy was that of travelling in a railway train, and Turner painted that, too, for the
285 exhibition of 1844. *Rain, Steam, and Speed – The Great Western Railway* surely challenged the viewer to compare his own experience with the painted canvas more explicitly and provocatively than any previous subject; if so, it succeeded remarkably well, for most reviewers were compelled to admire it, even if they were bound to express their reactions in the language of shock and incomprehension. In the opinion of *Fraser's Magazine* for June 1844, Turner

303 *Whalers – Vide Beale's Voyage, p. 175* (known as 'The Whale Ship'), 1845. This picture seems to derive much of its detail from a work in the collection of Elhanan Bicknell, *A Whaler in the South Sea Fishery* by the marine painter William Huggins, who died the year Turner's canvas was exhibited. Despite his interest in whale fishing Bicknell bought, or at any rate retained, none of Turner's whaling subjects.

> has out-prodiged almost all former prodigies. He has made a picture with real rain, behind which is real sunshine, and you expect a rainbow every minute. Meanwhile, there comes a train down upon you, really moving at the rate of fifty miles an hour, and which the reader had best make haste to see, lest it should dash out of the picture. . . . All these wonders are performed with means not less wonderful than the effects are. The rain . . . is composed of dabs of dirty putty *slapped* on to the canvass with a trowel; the sunshine scintillates out of very thick, smeary lumps of chrome yellow. The shadows are produced by cool tones of crimson lake, and quiet glazings of vermillion[;] although the fire in the steam-engine looks as if it were red I am not prepared to say that it is not painted with cobalt and pea-green. And as for the manner in which the '*Speed*' is done, of that the less said the better, – only it is a positive fact that there is a steamcoach going fifty miles an hour. The world has never seen anything like this picture.

Turner's extraordinary claim to 'realism' in his late pictures seems vindicated in this reaction. It is significant, and deeply ironic, that of all his greatest works *Rain, Steam, and Speed* was scarcely discussed by Ruskin, who mentioned it only when asked what his opinion was, and then said merely that it was painted 'to show what he could do even with an ugly subject' (R., xxxv, p. 601, n. 1).

The young George Dunlop Leslie recalled seeing Turner touching *Rain, Steam, and Speed* on a varnishing day:

> He used rather short brushes, a very messy palette, and, standing very close up to the canvas, appeared to paint with his eyes and nose as well as his hand. Of course he repeatedly walked back to study the effect. Turner must, I think, have been fond of boys, for he did not seem to mind my looking on at him; on the contrary, he talked to me every now and then, and pointed out the little hare running for its life in front of the locomotive on the viaduct. (G. D. Leslie, p. 144)

Until 1847 Turner's contributions to the Academy exhibitions were as liberal as ever: he generally showed about six new pictures, and in 1846 these included the last of the paired works: *Undine giving the ring to Masaniello, fisherman*
304 *of Naples* and *The Angel standing in the sun* – a coupling the reverse of perspicuous which still gives rise to ingenious explanations, but which, with its accompanying citations from the Book of Revelation and from the *Poems* of Samuel

304 *The Angel standing in the sun*, oil, 1846.

Rogers, is evidently an important statement from the hand of a venerable master. If the allusion to Undine and Masaniello is a mixture of references to recent offerings on the London stage, the Angel of Revelation cannot be so lightly explained, but has been taken as an acknowledgment of Ruskin's support: he had called Turner 'the great angel of the Apocalypse' in *Modern Painters*. If that is the point, the picture is at once a highly personal and characteristically jocular dialogue with a friend, and a sweeping claim on the part of the artist to the most serious of critical attention. The lines from Rogers's *Voyage of Columbus* which appeared in the catalogue might well refer to the labours of the artist and the response of his critics: 304

> The morning march that flashes to the sun
> The feast of vultures when the day is done.

The vignettes that surround the central figure depict Biblical incidents of violent death and despair, half glimpsed through the radiance of the avenging angel. At all events, the picture seems to turn on some meaning of a private nature, to provide a misty and brooding, if gloriously transfigured, insight into Turner's mind.

He was now turned seventy, and the frailty of old age was beginning to overtake him. If he could still work in watercolour with some degree of success, painting in oil was evidently a considerable strain. This did not prevent him contributing to the exhibitions; but there was a markedly makeshift quality to his offerings. The three works that he sent in 1847 and 1849 were all canvases that had been in his studio since the early years of the century. Two were largely repainted; one, *Venus and Adonis*, he submitted as it was. It was his most explicit 73 tribute to the art of Titian which he had admired at the Louvre in 1802, and as such provides an interesting commentary on the *Bacchus and Ariadne* shown in 1840, which in its very different way is also a direct reference to Titian, borrowing its figures from the great painting which had been acquired for the National Gallery in 1826.

This harking back to the themes of his early career lay behind several works of the time. He executed a series of contemplative oil studies based on subjects taken from plates in the *Liber Studiorum*. He did not intend these to be exhibited, it seems. They reinterpret in the transcendental light of his latest art some of the leading ideas of his landscape repertoire. Perhaps the most moving of them is the iridescent *Norham Castle, sunrise*, the culmination of a long sequence of views of the ruin extending as far back as 1797. Further echoes of the past appeared in his exhibited pictures. *Fishing boats bringing a disabled ship into Port Ruysdael*, of 1844, recalled both in its large size and in its general composition the 'Bridgewater Sea-piece' of 1801 – surely a deliberately nostalgic reference, just as was the 'Port Ruysdael' of the title, which Turner had originally invented to celebrate a great Dutch painter in a small marine of 1827. In rather the same spirit *The hero of a hundred fights*, his sole contribution in 1847, which records the casting of an equestrian statue of the Duke of Wellington, was a partly repainted canvas of about 1798. It was hung next to a large painting by Daniel Maclise, *The Sacrifice of Noah after the Deluge*. George Jones reported a dialogue between the 305 two men as they were touching their pictures on one of the varnishing days:

> Turner, always a friend to talent, suggested to Maclise an alteration in his picture with the following colloquy:
> Turner: 'I wish Maclise that you would alter that lamb in the foreground, but you won't.'
> Maclise: 'Well, what shall I do?'

Turner: 'Make it darker behind to bring the lamb out, but you won't.'

Maclise: 'Yes I will.'

Turner: 'No you won't.'

Maclise: 'But I will.'

Turner: 'No you won't.'

Maclise did as Turner proposed and asked his neighbour if that would do.

Turner (stepping back to look at it): 'It is better, but not right.'

He then went up the picture, took Maclise's brush, accomplished his wish and improved the effect. He also introduced a portion of a rainbow, or reflected rainbow, much to the satisfaction of Maclise, and his work remains untouched.

Jones continues:

On the same occasion, one of the members came to Turner, and said, 'Why, Turner, you have but one picture here this year.' Turner replied, 'Yes, you will have less next year,' doubtless alluding to his declining health. (Jones, *Turner*, p. 8)

305 Daniel Maclise: *Noah's Sacrifice*, 1847.

And indeed he sent nothing in 1848. He must have felt it an admission of weakness: only four times in his whole career had he been altogether absent from the Academy's walls, and now it could only be for lack of the necessary energy to work. He seems to have been preoccupied with his approaching end this year, for he added an important new codicil to his will, directing that all his finished pictures should become the property of the National Gallery, and be housed in specially built rooms to be known as 'Turner's Gallery', or, failing this, that they should remain in his own house, to be seen by the public 'gratuitously' in displays to be changed 'every one or two years as my said Trustees shall think right'. He made a second codicil stipulating that the National Gallery's claim to the pictures should become void if the terms of the bequest were not carried out 'within the term of Five years on or before the expiration of the lease of my present Gallery'.

These plans were evidently precipitated by Robert Vernon's gift of his important collection of modern British pictures to the National Gallery in 1847, just as Turner's first will had been inspired by the provisions of Soane for leaving his house to the public as a museum. There was no room, however, to display the 160 works selected to form Vernon's gift, and only one, Turner's *The Dogano, San Giorgio, Citella, from the steps of the Europa*, bought from the 1842 Academy exhibition, was actually on show. Turner must have been anxious to ensure that a similar fate did not overtake his own bequest. Such concern for his 'children' seems ironic in view of the appalling neglect into which he had allowed the Queen Anne Street house to fall; and although there can surely be no doubt that he was perfectly convinced of the importance of his own achievement, it is hard not to suspect that there was an element of sheer fantasy in his vision of a complete studio becoming the property of the nation. The terms of his will and codicils make it clear that he had not, in fact, thought the problem through; for no explicit provision is made for the sketchbooks and loose studies in which his studio abounded. Even as late as 1848 he made provision for the finished oil paintings only; though Finberg records a memorandum which came into the hands of Turner's executors, stipulating 'that four different selections of his finished pictures might be exhibited annually, that a selection of his unfinished canvases might be shown in every fifth year, and a selection of his "unfinished drawings and sketches" every sixth year' (Finberg, *Life*, p. 444, n. 1). However, there can have been little chance

that more than a tiny fraction of the studies in either oil or watercolour, let alone the sketchbooks, would have been considered suitable for public display at the time, or, alternatively, acceptable on the open market. Turner cannot have envisaged his sketchbooks being sold; if he imagined that they would be exhibited alongside his paintings in the national 'Turner's Gallery', he made no attempt to clarify this point in his will.

According to Ruskin, Turner's 'Actually Last Sketchbook', as he described one in his own possession (R., XIII, p. 474), can be dated to about 1847; but it contains few drawings, and there are no other books which can be dated so late. It testifies to a very considerable decline in Turner's output of sketches, though we can tentatively ascribe a fair number of watercolour studies, even some finished works in that medium, to the last few years of his life. The accounts of him sitting on the foreshore at Margate, or on the viewing platform which he had had specially constructed on the roof of the Chelsea house, staring at the water of the Channel or the Thames and contemplating effects of sky and clouds, seem to summarize fairly accurately his later activities as an observer of nature. He did not need to make notes; William Leighton Leitch 'used to give an account of meeting him somewhere near London when Leitch was sketching a winter sunset. After putting down a few hasty washes Leitch gave up the effort and asked Turner how he would have proceeded. 'I would have gone home to bed,' Turner replied, 'and as soon as I was awake got up and put down my impression' (*Leitch*, p. 110). But when he was able to do so he rarely missed the chance to use his pencil. The watercolour studies fit more readily into the pattern of his late paintings. It is clear that until almost the end he continued to paint in both oil and watercolour: the four scenes from the *Æneid* that he showed at the Academy in 1850 were a conscious and quite determined proclamation of 'business as usual', wrung from him, no doubt, by a sharpened sense of urgency as his life drew to its close.

He was not by any means extinguished in these last years. He could still respond to the stimulus of congenial society. The American photographer J. J. E. Mayall has left an account of Turner frequently visiting his London studio to discuss the new science. Mayall did not at first know who he was, but 'was much impressed with his inquisitive disposition' and

> carefully explained to him all I then knew of the operation of light on iodized silver plates. He came again and again, always with some new notion about light. He wished me to copy my views of Niagara – then a novelty in London – and inquired of me about the effect of a rainbow spanning the great falls . . . He told me he should like to see Niagara, as it was the greatest wonder in nature; he was never tired of my descriptions of it. (T., II, p. 260)

In 1849 Mayall eventually discovered his identity; Turner never came again.

F. T. Palgrave observed him at a party in the summer, he says, of 1851 though it seems more likely from his description of Turner that the event took place a year, if not two years, earlier. The artist was engaged in a discussion about incunabula:

> What he said on this and on politics, to which the talk soon turned . . . impressed me with its eminent sense and shrewdness. Like other men of genius I have known, the mode of its manifestation . . . was a clear practical view of the subject in hand; an evidence of general mental lucidity. So Turner talked of the mysteries of bibliography and the tangle of politics neither wittily, nor picturesquely, nor technically; but as a man of sense before all things . . . He appeared as secure in health, as firm in tone of mind, as keen in interest, as when I had seen him years before; as ready in his dry

288

short laugh, as shrewd in retort, as unsoftened in that straightforward bearing which seems to make drawing-room walls start and frightens diners-out from their propriety. (Finberg, *Life*, p. 434)

Certainly, in the early autumn of 1850 he was not only in lively form, but a participant in Academy affairs, newly agitated by the death of the President, Shee, as recalled by George Dunlop Leslie:

The only occasion I remember of Turner's visiting at my father's house was in 1850, the year before he died. My father took a great deal of interest in the election of Sir Charles Eastlake to the Presidency, and he invited several members to his house, in order to discuss the subject, among others, I remember, the two Chalons, Mr [Philip] Hardwick, the Treasurer, and Turner; the latter was full of spirits on the evening, and apparently in his usual good health. He quite won the hearts of my two sisters, pretty girls of twenty-two and twenty at the time, flirting with them in his queer way, and drinking with great enjoyment the glass of hot grog which one of them had mixed for him. He always had the indescribable charm of the sailor both in appearance and manners; his large grey eyes were those of a man long accustomed to looking straight at the face of nature through fair and foul weather alike. (G.D.Leslie, pp. 143–4)

Turner was conscious of his sailor-like appearance; as we have seen, he was fond of calling himself 'Admiral Booth' among his acquaintance along the Chelsea reach. It was a piece of camouflage very much in keeping with his claims to be from Devon, or Kent, or to have been born in the same year as the Duke of Wellington. Even his doctor, a Mr W. Bartlett, who supplied him with a set of false teeth and attended him during his final illness, was not allowed to know his true identity:

he never told me his real name; he went by the name of 'Booth'. There was nothing about the house at all to indicate the abode of an artist. The Art Journal and Illustrated London News were always on the table. He was very fond of smoking and yet had a great objection to any one knowing it. His diet was principally at that time rum and milk. He would take some times two quarts of milk per day and rum in proportion, very frequently to excess . . . (Letter to Ruskin, 7 August 1857; see Finberg, *Life*, p. 437)

The false teeth were not a success; he had become, as he told the Rev. William Kingsley, 'so nasty in his eating, the only way he could live being by sucking meat' (see Finberg, *Life*, p. 438). His inveterate physical self-consciousness was intensified by the infirmities of old age, and so tended to cut him off even more than they would in any case have done from friends and society. But he was still interested in the world, and especially in the places and works of art that he had seen on his travels. Bartlett mentioned that 'he offered should he recover to take me on the continent and shew me all the places he had visited.' And a letter to Hawksworth Fawkes written on 24 December 1849 contains news from Europe:

Ruskin has been in Switzerland with his whife this summer, and now is said to be in Venice. Since the revolution shows not any damage to the works of high Art it contains, in Rome not so much as might have been expected. Had the 'Transfiguration' occupied its old situation, the St. Pietro Montoreo, it most possibly must have suffered, for the church is completely riddled with shot and balls. The convent on Mount Aventine much battered with cannon balls, and Casino Magdalene, near the Porto Angelino, nearly destroyed; occurred by taking and storming the Bastion No. 8.

This is from an eye-witness who has returned to London since the siege by Gen. Oudinot.

I am sorry to say my health is much on the wain. I cannot bear the same fatigue, or have the same bearing against it I formerly had – but time and tide stop not – but I must stop writing for to-day . . . (G. 315)

And the following Christmas his letter (of 27 December) still reflects a determined energy, if also the somewhat forced jollity of those for whom life has become a daily effort:

Old Time has made sad work with me since I saw you in Town.

I always dreaded it with horror now I feel it acutely now whatever – Gout or nervousness – it having fallen into my Pedestals – and bid adieu to the Marrow bone stage. . . .

Mr Vernons collection which he gave to the National Gallery are now moved to Marlborough-House and the English Masters likewise.

The Crystal Palace is proceeding slowly I think considering the time, but suppose the Glass work is partially in store, for the vast Conservatory all looks confusion worse confounded. (G. 318)

There was a further bulletin on the Crystal Palace in his letter to Fawkes of 31 January 1851, the last he wrote to Farnley:

The Crystal Palace has assumed its wonted shape and size. It is situated close to the Barracks at Knights Bridge, between the two roads at Kensington and not far from the Serpentine: it looks very well in front because the transept takes a centre like a dome, but sideways ribs of Glass frame work only Towering over the Galleries like a Giant. (G. 323)

One detects a note of gratification at being able thus to report on the latest matter of national interest to someone in the distant provinces, unable to be *au courant*. His last surviving letters are short notes to Thomas Griffith written in May, and one to Charles Stokes dated 1 August 1851:

Dear Stokes

I am and have been so bad and fear the worst my limbs are so weak

May I ask you to call and Hannah to take what may be wanted of the Exchequer Bill

J. M. W. Turner (G. 327)

At the Academy exhibition this year he showed nothing, but, as Peter Cunningham records, attended the Private View: 'it seemed to me, and to others to whom I observed the circumstance, that he was breaking up fast – in short, that he would hardly live the year out' (Cunningham, p. 30). That summer his absences from Academy meetings alarmed his colleagues, and, as Thornbury says,

one of them (Mr. David Roberts) wrote to Queen Anne-street, stating how all his brethren regretted his absence from their meetings, and to beg him, if he was ill and could not attend, to let him know, that he might come and see him, reposing the most perfect confidence in him, should it be his wish that the place of his residence should remain private.

Turner did not reply; but some two weeks after he appeared at Mr. Roberts' studio in Fitzroy-square, sadly broken and ailing. He was evidently deeply moved by the letter his friend had written, for he said –

'You must not ask me; but whenever I come to town I will always come to see you.'

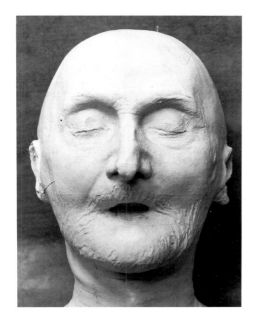

'I tried to cheer him up, but he laid his hand upon his heart and replied, "No, no; there is something here which is all wrong." As he stood by the table in my painting-room, I could not help looking attentively at him, peering in his face, for the small eye was as brilliant as that of a child, and unlike the glazed and "lack-lustre eye" of age. This was my last look.' (T., II, pp. 272–3)

As he declined Mrs Booth tended him at the Chelsea house, making sure that he had paper and pencils by him if he wished to draw. He had taught her to arrange his palette and brushes, and she encouraged him to continue working as long as he could, knowing that that alone could distract him from his forebodings. Thornbury tells us that Turner,

> feeling dangerously ill, had sent for a well-known doctor from Margate, whom he had before employed, and in whom he had confidence. The sick man, who had once said that he would give all his money if he could but be twenty once again, watched the doctor's face with eager anxiety. He was told that death was near. 'Go downstairs,' he said to the doctor; 'take a glass of sherry, and then look at me again.' The doctor did so, but the reply was the same. (T., II, pp. 274–5)

Mr Bartlett was in attendance on the day Turner died, 19 December 1851. He later told Ruskin: 'On the morning of his decease it was very dull and gloomy, but just before 9 a.m. the sun burst forth and shone directly on him with that brilliancy which he loved to gaze on and transfer the likeness to his paintings. He died without a groan' (see Finberg, *Life*, p. 438).

Bartlett gave the cause of death as 'natural decay'. Turner's body was placed in a coffin and taken to his gallery in Queen Anne Street, where it lay, and where many friends came to pay their last respects, until the day of the funeral, 30 December. At Turner's own request he was buried in the crypt of St Paul's Cathedral, near the tomb of his admired Sir Joshua Reynolds and in the company of the greatest of the nation's heroes. Hannah Danby saw him to the grave:

> By the way, they say that the poor creature who was so long the porteress of these faded halls, was helped into one of the coaches by the undertaker, followed in her master's train, and was supported into the mighty edifice, sobbing and weeping – perhaps the only true mourner in that long procession. (R. and S. Redgrave, p. 84)

306 Turner's death mask.

307 George Jones: *Turner's coffin in his gallery at Queen Anne Street*, c.1852. Jones's second recollection of the gallery (see ill. 291), looking the opposite way towards *Richmond Hill* of 1819, with a group of mourners round the coffin as it stood in the room for about ten days in December 1851.

Lady Eastlake summed up Turner's life and personality, and the consequent eccentricities of his will, in her Journal for 2 January 1852:

> Turner's funeral on Tuesday was a very grand one, and, at the Academy dinner last night, the will was freely talked of. It is a very stupid will – that of a man who lived out of the world of sense and public opinion. The bulk of the property goes to build almshouses for decayed oil-painters – a class who, if good for anything, can never want almshouses. His finished pictures are left to the National Gallery, if a room is built for them. To his own only daughter he has not left a penny, though his housekeeper gets 150 l. a year. He has left a professorship of 60 l. a year (if the fund be sufficient) for landscape-painting to the Royal Academy; and to his eight executors 20 l. each (they having immense trouble), or rather 19 l. 19 s. to save the legacy duty. His life is proved to have been sordid in the extreme, and far from respectable. It is odd that, two days before he died, he suddenly looked steadily and said he saw 'Lady Eastlake.' This the woman who lived with him, and whose name he passed under in a quarter where nobody knew him, told his executors. They consist of Hardwick, Charles Turner (no relation), Ruskin, Munro, Stokes, Mr Rogers, and a Mr Harper [i.e. Harpur], a relative. A sum of 1000 l. is to be spent on his monument, and not far short of that must have been spent on his funeral. (Lady Eastlake 1895, I, pp. 272–4) 308

It would constitute the crowning irony of Turner's life of parsimony and frugality if the executors whom he had appointed from among his oldest and closest friends to ensure the implementation of his will were discouraged from doing so by the exiguous recompense he had provided for them, carefully calculated as it was to evade the duty payable on all bequests of £20 or over. For whatever reasons, they were evidently reluctant to exert themselves in his cause when battle was joined with the Turner relations. Most of them were elderly; the youngest and most energetic of them, Ruskin, stood down, unwilling to take on the responsibility and still, perhaps, smarting from a quarrel the two men had had some years before. In his Diary for 30 January 1854 he noted: 'I hear that poor Turner brought my last letter, closing our intercourse, to Griffiths [sic], and was very sorry about it, but could not make up his mind about answering or putting the thing to rights.' Nevertheless Ruskin was deeply affected when his father wrote to him in Venice with the news of Turner's death. He received a further bulletin in February 1852:

> I have just been through Turner's house with Griffith. His labour is more astonishing than his genius. There are £80,000 of oil pictures, done and undone. Boxes, half as big as your study table, filled with drawings and sketches. There are copies of Liber Studiorum to fill all your drawers and more, and house walls of proof plates in reams – they may go at 1s. each . . .
>
> Nothing since Pompeii so impressed me as the interior of Turner's house; the accumulation of forty years partially cleaned off: daylight for the first time admitted by opening a window on the finest productions of art buried for forty years. The drawing-room has, it is reckoned, £25,000 worth of proofs, and sketches, and drawings, and prints. . . .
>
> The house must be as dry as a bone – the parcels were apparently quite uninjured. The very large pictures were spotted, but not much. They stood leaning, one against another, in the large low room. . . . The top of his gallery is one ruin of glass and patches of paper, now only just made weather-proof . . . (Collingwood, p. 174)

Ruskin made amends for his estrangement from the man by dedicating

himself to the artist once the dispute over the will was settled. A Decree of the Court of Chancery in 1856 confirmed a compromise settlement between the litigants by which Turner's estate was divided among the family, while the contents of the studio became the property of the nation. A preliminary selection of the paintings was hung in Marlborough House, and Ruskin set to work to render the drawings available for exhibition and study:

> In seven tin boxes, in the lower rooms of the National Gallery, I found upwards of nineteen thousand pieces of paper drawn upon by Turner in one way or another, many on both sides; some with four, five, or six subjects on each side, the pencil point digging spiritedly through from the foregrounds of the front into the tender pieces of sky in the back; some in chalk, which the touch of the finger would sweep away; others in ink, others – some splendid coloured drawings amongst them – long eaten away by damp and mildew, and falling into dust at the edges, in capes and bays of fragile decay; others worm-eaten, some mouse-eaten, many torn half way through; numbers doubled – quadrupled, I should say – into four, being Turner's favourite mode of packing for travelling; nearly all rudely flattened out from the bundles in which Turner had rolled them up and squeezed them into his drawers in Queen Anne Street. Dust of thirty years' accumulation – black, dense, and sooty – lay in the rents of the crushed and crumpled edges of these flattened bundles, looking like a jagged black frame, and producing altogether unexpected effects in brilliant portions of skies where an accidental or experimental finger-mark of the first bundle unfolder had swept it away. About half, or rather more, of the entire number consisted of pencil sketches in flat, oblong pocket-books, dropping to pieces at the back, tearing laterally whenever opened, and every drawing rubbing itself into the one opposite. These first I paged with my own hand; – then unbound, and laid every leaf separately in a clean sheet of perfectly smooth writing paper, so that it might receive no further injury; then enclosing the contents and boards of each book . . . in a separate sealed packet, I returned it to the tin box. The loose sketches needed more trouble. The dust had first to be got off them, from the chalk ones it could only be blown off; then they had to be variously flattened, the torn ones to be laid down, the loveliest guarded so as to prevent all future friction, and four hundred of the most characteristic framed and glazed, and cabinets constructed for them which would admit of their free use by the public. With two assistants I was at work all the autumn and winter of 1857, every day, all day long, and often far into the night. (R., VII, pp. 4–5)

It was an act of art-historical dedication quite in keeping with the spirit of his published work on Turner, yet a remarkable feat of detailed appreciation for its time, and one which has been more criticized for its shortcomings than recognized as the revolution in museum philosophy and practice which it actually represents. Its origins in Turner's own conception of a one-man museum, derived from Soane's idea (which, however, was far from being devoted to a single artist) and, no doubt, with the Casa Buonarotti of Michelangelo in mind, are likewise worthy of consideration as an innovatory and quintessentially romantic statement of the role and significance of the artist. This sprang entirely from Turner himself, as an expression of his own perception of his genius: a gesture more easily associated with the Nietzschean romanticism of the late nineteenth century – with Wagner and G. F. Watts, say – than with the stern and realistic professional that he was. In this Turner did truly anticipate later developments in art. It seems, retrospectively, to explain and justify much of the enigma of his extraordinary life.

308 The statue of Turner in St Paul's Cathedral, by Patrick MacDowell, 1852.

Chronology 1841–1857

1841

British Institution exhibition: Turner showed 2 pictures recently seen at the Academy – *Snow Storm, Avelanche and Inundation in the Alps* (104; R.A.1837), and *Blue Lights (close at hand) to warn Steamboats of shoal water* (112; R.A.1840).

Royal Academy exhibition: 6 oil paintings shown, *Ducal Palace, Dogano, with part of San Georgio, Venice* (53; B&J 390), bought on varnishing day by Chantrey; *Giudecca, la Donna della Salute and San Georgio* (66; B&J 391), bought by Bicknell; *Schloss Rosenau, seat of H.R.H. Prince Albert of Coburg, near Coburg, Germany* (176, B&J 392); *Depositing of John Bellini's three pictures in la Chiesa Redentore, Venice* (277; B&J 393); and *Dawn of Christianity (Flight into Egypt)* (532; B&J 394) and *Glaucus and Scylla* (542; B&J 395), both circular in format, which were bought by Windus.

1 June: death at sea of David Wilkie, on his return from the Middle East. He was buried off Gibraltar.

Late July–Autumn: tour of Switzerland. His route was from Harwich to Rotterdam and up the Rhine as far as Basle, then via Schaffhausen, Constance and Zürich along the Splügen road to Maienfeld or possibly Andeer; from Zürich to Lucerne, where he spent much time; then to Sarnen, Brünig, Brienz and Thun, returning via Lausanne, Geneva, Berne and Basle. Sketchbooks probably used on this tour are *Rhine and Switzerland* (TB CCCXXV), *Lucerne and Berne* (TB CCCCXXVIII), *Between Lucerne and Thun* (TB CCCXXIX) and *Rhine, Flushing and Lausanne* (TB CCCXXX). Others, now disbound, are *Fribourg, Lausanne and Geneva* (TB CCCXXXII), *Fluelen, Berne and Fribourg* (TB CCCXXXIII), *Lausanne* (TB CCCXXXIV) and *Fribourg* (TB CCCXXXV).

22 October: the first of several letters from Turner to William Miller concerning Miller's engraving of a large plate of *Modern Italy*, 1838 (R.658).

November: engraving of *Mercury and Argus*, 1840, by Willmore published by Moon (R.650).

25 November: death of Chantrey, which had a profound effect on Turner.

This year Ruskin began to visit Turner's gallery in Queen Anne Street.

1842

Turner's health was again bad this winter.

Winter–spring: he asked Griffith to find commissions for 10 finished watercolours, the subjects to be chosen from a series of 15 'samples' taken from the roll sketchbooks used on the Swiss tour of the previous summer. He made 4 finished specimens and settled that Griffith should ask 80 guineas each for the drawings. Griffith obtained only 9 orders; Turner gave him the tenth drawing as commission. The buyers were Munro of Novar, who took 5, Ruskin and Bicknell, who took 2 each. These drawings (W.1523–1527, 1529–1533) were considered by Ruskin to be the climax of Turner's achievement as a watercolourist.

March: Turner advertised in the *Art-Union* the publication by subscription of a series of 5 large plates after his work: *Dido and Æneas* (1814) engraved by W. R. Smith (R.652), *Caligula's Palace and Bridge* (1831) engraved by E. Goodall (R.653), *St Mark's Place, Venice – Juliet and her Nurse* (1836) engraved by G. Hollis (R.654), *Mercury and Hersé* (1811) engraved by J. Cousen (R.655), and *Crossing the brook* (1815) engraved by R. Brandard (R.656). The engravers were paid large fees for their work: Goodall received 700 guineas; Finberg (*Life*, p. 389) conjectures that this outlay was the cause of Turner's anxiety to find purchasers for his Swiss watercolours. The prints were sold through the agency of Griffith, in a limited edition of 500 impressions, signed by the artist.

Royal Academy exhibition: 5 oil paintings shown, *The Dogano, San Giorgio, Citella, from the steps of the Europa* (52; B&J 396), bought by Vernon; *Campo Santo, Venice* (73; B&J 397), bought by Bicknell; *Snow storm – steamboat off a harbour's mouth making signals in shallow water, and going by the lead. The author was in this storm on the night the Ariel left Harwich* (182; B&J 398); and a pair of square canvases (shown in octagonal flats), *Peace – burial at sea*, commemorating the burial of Wilkie (338; B&J 399) and *War. The exile and the rock limpet* (353; B&J 400). *Peace* was conceived as a complement to a drawing of Wilkie's funeral by George Jones.

About this time Turner bought back from Thomas Campbell the set of 20 drawings he had made to illustrate Campbell's poems, Campbell having tried unsuccessfully to sell them.

25 May: the bankruptcy of William and Edward Francis Finden, engravers, announced. Two of Turner's watercolours, *Oberwesel* (W.1380) and *Lake Nemi* (W.1381) had recently been engraved as part of *Finden's Royal Gallery of British Art* (R.660, 659), but had not been published. Turner wrote to Clara Wells, now Mrs Wheeler: '*Woe is me* – one failure after another is quite enough to make one sick of the whole concern' (G.249)

August: set out for Switzerland, sailing from Dover to Ostend and reaching Liège by the beginning of the month. He again centred his tour on Lucerne, travelling there along the Rhine via Basle and Olten, and going on over the St Gotthard to Faido, Bellinzona, Locarno, Lugano, Menaggio, Como, Stelvio, Bolzano and Landeck; thence probably back to Constance and Basle. At least some of the way he seems to have travelled with companions. The roll sketchbooks used on this journey are disbound and confused; they included sheets now listed among TB CCCXLIV and CCCLXIV.

1843

1 January: Miller's plate of *Modern Italy* published.

This month Turner again proposed to make 10 watercolours of Swiss subjects on the same terms as in 1842. According to Ruskin, Griffith obtained only 5 commissions, but in fact 6 drawings were made and

sold: 4 to Munro of Novar and 2 to Ruskin.

Royal Academy exhibition: 6 oil paintings shown, *The opening of the Wallhalla, 1842* (14; B&J 401); *The Sun of Venice going to sea* (129; B&J 402); *Dogana, and Madonna della Salute, Venice* (144; B&J 403), bought by Edwin Bullock; *St Benedetto, looking towards Fusina* (554; B&J 406); and a pair of 'square' pictures, *Shade and darkness – the evening of the Deluge* (363; B&J 404) and *Light and colour (Goethe's Theory) – the morning after the Deluge – Moses writing the book of Genesis* (385; B&J 405).

May: Smith, Elder & Co. published the first volume of Ruskin's defence of Turner, *Modern Painters: their superiority in the art of landscape to all The Ancient Masters proved by examples of the True, the Beautiful, and the Intellectual, from the works of modern artists, especially from those of J. M. W. Turner, Esq., R.A.* by 'A Graduate of Oxford'. 'It was written', Ruskin told Samuel Prout, 'for the class of people who admire Maclise; . . . for the paid novices of the *Times* and of *Blackwood*' (R., XXXVIII, p. 336).

Summer: again to Switzerland, probably via Holland or Belgium up the Rhine to Basle, and on to Baden, Arth and Lucerne; then along the St Gotthard route via Fluelen to Bellinzona, Locarno, Pallanza, Como and Menaggio, returning north via Chiavenna and the Splügen through the Via Mala to Thusis, Maienfeld and Zürich. The itinerary seems to have been shortened on account of illness: Ruskin comments on the effects of this on some drawings made at Bellinzona this year. Sketchbooks used on the tour are probably *Lake of Zug and Goldau* (TB CCCXXXI), *Bellinzona* (TB CCCXXXVI), *Como and Splügen* (TB CCCXXXVIII) and *Mountain Fortress* (TB CCCXXXIX).

1844

By the end of 1843 *Modern Painters* was beginning to have a perceptible effect on the public, and potential buyers started to ask Griffith about work unsold in the studio. Among them was Joseph Gillott, the Birmingham steel-pen manufacturer, who probably this year bought 8 paintings for £4,000, among them the *Rosenau* (R.A. 1841); 6 of these he later resold.

27 March: Ruskin recorded in his diary that Elhanan Bicknell had just purchased *Palestrina* for 1,000 guineas, together with 5 other pictures, probably *Port Ruysdael* (R.A. 1827), *Helvoetsluys* (R.A. 1832), *Van Goyen, looking out for a subject* (R.A. 1833), *Wreckers* (R.A. 1834) and *Ehrenbreitstein* (R.A. 1835). Ruskin was 'quite beside myself with joy'.

30 March: the first volume of *Modern Painters* went into a second edition, with a new preface attacking Turner's critics.

28 April: Ruskin visited Turner, and complained that 'the worst of his pictures was one could never see enough of them'. 'That's part of their quality,' said Turner.

Royal Academy exhibition: 7 oil paintings shown, *Ostend* (11; B&J 407); *Fishing boats bringing a disabled ship into Port Ruysdael* (21; B&J 408); *Rain, Steam, and Speed – The Great Western Railway* (62; B&J 409); *Van Tromp, going about to please his masters, ships a sea, getting a good wetting* (253; B&J 410); *Venice – Maria della Salute* (345; B&J 411); *Approach to Venice* (356, B&J 412); and *Venice Quay, Ducal Palace* (430; B&J 413).

24 July: Turner signed an 'Indenture of Bargain and Sale' giving the unused land (76 perches) that he had bought at Twickenham in 1818 to a group of Trustees, Samuel Rogers, Munro of Novar, Charles Turner and Sir Martin Archer Shee, for the establishment of almshouses there, to be called 'Joseph Mallord William Turner's Charity for the Relief of Decayed and Indigent Artists'. The document was not implemented, and as a consequence Turner's careful provisions for the Charity were found after his death to be unrealizable.

Summer: final tour of Switzerland, visiting Basle, Berne, Thun, Interlaken, Lauterbrunnen, Grindelwald, Neiringen, Brünig, Lucerne, Brunnen, Goldau, Zürich and Schaffhausen, and returning down the Rhine to Rheinfelden and Heidelberg. The itinerary was curtailed by bad weather. He was accompanied at one point by 'W. B.', who is not identified. Sketchbooks used on the tour are probably *Berne, Heidelberg and Rhine* (TB CCCXXVI), *Ostend, Rhine and Berne* (TB CCCXXVII), *Lucerne* (TB CCCXLV), *Thun, Interlaken, Lauterbrunnen and Grindelwald* (TB CCCXLVI), *Meiringen and Grindelwald* (TB CCCXLVII), *Grindelwald* (TB CCCXLVIII), *Between Olten and Basle* (TB CCCL), *Heidelberg* (TB CCCLII), *Rheinfelden* (TB CCCXLIX) and *Rhine and Rhine Castles* (TB CCCLI). By the end of the year he had begun work on a further set of 10 Swiss watercolours.

8 October: saw Louis Philippe land at Portsmouth.

17 October: met Ruskin at dinner with Griffith and Windus and thanked him 'for the first time' for his book.

25 November: death of Callcott, an event which deeply distressed Turner.

1845

Turner's health broke down this year.

February: 2 pictures shown at the Royal Scottish Academy in Edinburgh, *Palestrina* (R.A. 1830) and *Neapolitan Fisher-girls bathing by Moonlight* (R.A. 1840).

8 February: dined with the Ruskin family at Denmark Hill on the occasion of Ruskin's birthday.

April: Ruskin made his first journey abroad, visiting many of the locations of Turner's paintings and drawings.

During the illness of Shee, Turner took the President's chair at Academy Council meetings.

Royal Academy exhibition: Turner was a member of the hanging committee. He showed 6 oil paintings himself, 2 called *Whalers*, both with the gloss '*Vide Beale's Voyage*' (50, 77; B&J 414, 415); and 4 Venetian scenes, *Venice, evening, going to the ball* (117; B&J 416), *Morning, returning from the ball, St Martino* (162; B&J 417), *Venice – noon* (396; B&J 418) and *Venice – sunset, a fisher* (422; B&J 419). These works were not much admired, though the Venetian subjects found some favour; the *Noon* 'beheld from one particular point, is a beautiful dream, full of Italy, and poetry, and summer' (*Athenæum*, 17 May). Finberg (*Life*, p. 408) notes 'a marked falling off in the exhibits of this year.

. . The attenuation of form and content in his work had nearly reached its limit.'

After the exhibition Turner went to Margate, and later crossed the Channel to Boulogne. At least two roll sketchbooks were used on this trip: *Ambleteuse and Wimereux* (TB CCCLXVII) and *Boulogne* (TB CCCLVIII); and the newly rediscovered *Channel* sketchbook of sunset studies and seascapes. The studies of whales in the *Whalers* sketchbook (TB CCCLIII) may relate to the Channel crossing.

14 July: appointed Deputy President of the Academy after the resignation of Shee in June. George Jones subsequently became acting President.

August: James Lenox of New York paid £500 for *Staffa* (R.A. 1832), in a transaction effected by C. R. Leslie. This was the first of Turner's paintings to go to America.

In a letter to Mrs Carrick Moore probably written this summer Turner, pursuing a joke in which she had called him 'Mr Jenkins', referred to himself as 'Mr Avalanche Jenkinson' (G. 269).

September–October: a short tour to Dieppe and the coast of Picardy. The following sketchbooks were used: *Eu and Treport* (TB CCCLIX), *Dieppe* (TB CCCLX) and *Dieppe and Kent* (TB CCCLXI). While at Eu he was invited to dine with Louis Philippe. This was his last journey abroad.

Turner, with other distinguished European artists, was invited to contribute a picture to the Congress of European Art, celebrating the opening of the Temple of Art and Industry in Munich. He sent the *Wallhalla* of 1843, but it was 'laughed at by every beholder' because of 'the want of exactness of portraiture in the place represented'. The picture was returned, somewhat damaged, to Turner, who had £7 to pay for its transport.

An exhibition at the Royal Manchester Institution included 2 Turners lent by Gillott: *The Temple of Jupiter Panhellerius – Island of Ægina* (228; R.A. 1816) and *Palace of Prince Albert of Cobourg, Nr. Cobourg, Germany* (285; R.A. 1841).

This year Turner executed 10 further watercolours of Swiss views, possibly on the same terms as those of 1842 and 1843. They were purchased by Ruskin, Munro of Novar, Windus and perhaps another patron. Also this year, Griffith opened a gallery in Pall Mall.

About this year Charles Meigh, of Shelton, Staffordshire, bought *Fort Vimieux* (R.A. 1831) for about £500.

1846

New Year: visited the Ruskin family.

February: attended John Ruskin's birthday.

An exhibition at the Royal Scottish Academy included 2 works by Turner lent by their owners: *Ivy Bridge, Devon* (158; T.G. 1812) and *Mercury and Argus* (231; R.A. 1840).

British Institution winter exhibition: Turner showed *Queen Mab's Cave* (57; B&J 420). This appears to be an 'imitation' of the work of Francis Danby.

Royal Academy exhibition: 6 oil paintings shown. There were 2 Venetian subjects, *Returning from the ball (St Martha)* (59; B&J 422) and *Going to the ball (San Martino)* (74; B&J 421); 2 whaling subjects, '*Hurrah! for the whaler Erebus! another fish!*' (237; B&J 423) and *Whalers (boiling blubber) entangled in flaw ice, endeavouring to extricate themselves* (494; B&J 426); and a pair of 'square' pictures, *Undine giving the ring to Masaniello, fisherman of Naples* (384; B&J 424) and *The Angel standing in the sun* (411; B&J 425). Elizabeth Rigby said of these works: 'Turner living by the grace of Art. Turner proves how vulgar we are.'

29 August: signed a further codicil to his will, by which Sophia Caroline Booth joined Hannah Danby as custodian of his pictures. They were each to receive an annual sum of £150. This codicil was later revoked.

This autumn, if not earlier, Turner moved with Mrs Booth and her son into 6 Davis Place, Cremorne New Road, Chelsea.

The Royal Hibernian Academy exhibition in Dublin included *Saltash, Devon* (106; T.G. 1812), lent by its owner, James Miller. Miller was to lend it again, to the Royal Scottish Academy, Edinburgh, in 1853 (72).

10 December: at the general meeting of the Academy, Turner declined re-election as Auditor, a post he had held since 1824.

30 December: presided over the last Council meeting of his term of office as Deputy President. He was glad to be rid of the responsibility of the position, as his health was now very bad.

1847

Royal Academy exhibition: only one work shown, *The hero of a hundred fights* (180; B&J 427), a largely repainted canvas of about 1798.

Summer: probably spent mostly at Margate; sketchbooks used this year may include *Hythe and Walmer* (TB CCCLV) and *Folkestone?* (TB CCCLXII). The small memorandum book now in the British Museum (1981–12–12–1) was thought by Finberg to belong to this time; it contains a draft letter which may relate to a proposal by an engraver for a new plate of the *Téméraire* (one had already been made by Willmore for *Finden's Royal Gallery of British Art*, and published this year): Turner refused.

An exhibition at the Royal Scottish Academy included *Hurley House on the Thames* (158; B&J 197) and *The Temple of Jupiter at Athens* (175; probably *The Temple of Jupiter Panhellenius restored*, R.A. 1816).

This year the American photographer J. J. E. Mayall set up a studio in London; Turner was a frequent visitor until 1849.

22 December: Robert Vernon signed a deed giving part of his collection of British art to the nation. There being no space for all the pictures at the National Gallery, one was chosen to hang 'in the name of the whole': Turner's *Dogano, San Giorgio, Citella, from the steps of the Europa* (R.A. 1842).

At the end of the year he was working on at least 2 further Swiss watercolours, the *Brunig Pass* and *Descent of the St Gothard* (w.1550, 1552), delivered to Ruskin early in 1848.

1848

This year Turner hired a studio assistant, the young artist Francis Sherrell.

Royal Academy exhibition: no works shown, for the first time since 1824.

An exhibition at the Royal Scottish Academy included *Cicero's Villa* (144; R.A. 1839), lent by James Miller.

25 July: attended a general meeting of the Academy to investigate a charge against R. R. Reinagle, who was found to have exhibited and sold as his own work a picture by another artist, and in September was asked to resign.

2 August: two further codicils added to Turner's will. The first stipulated that a new gallery, to be called 'Turner's Gallery', should be added to the National Gallery; until it was built his finished paintings 'shall remain entire' at Queen Anne Street, where the lease was to be regularly renewed 'that such pictures may always remain and be one entire Gallery'. Thomas Griffith and John Ruskin were added to the list of Executors and Trustees, who were to ensure that 'so many of the Pictures as may be necessary shall be seen by the public gratuitously so that from the numbers of them there may be a change of Pictures either every one or two years'. The second codicil declared the bequest to the National Gallery void if the terms of the first were not carried out within 'Five years on or before the expiration of the lease of my present Gallery' – i.e. April 1882.

1849

1 February: a final codicil added to Turner's will: it revoked the codicil of 29 August 1846, and limited the time for compliance with the terms of his bequest to the National Gallery to a period of ten years after his death. If these terms were not met, his Trustees were to exhibit his work free at the Queen Anne Street Gallery until two years prior to the expiry of the lease, when the pictures were to be sold and the proceeds donated to specified charities, including the Pension Fund of the Royal Academy and the Artists' General Benevolent Fund. Clara Wheeler and her two sisters were to receive legacies, Hannah Danby and Mrs Booth small annuities.

Royal Academy exhibition: 2 oil paintings shown, *The Wreck Buoy* (81; B&J 428) and *Venus and Adonis* of c.1804 (206; B&J 150). Both already belonged to Munro of Novar, who had acquired the latter in 1830; he may have purchased *The Wreck Buoy* earlier; it probably dates from about 1807, but was extensively repainted for this exhibition.

An exhibition at the Royal Scottish Academy included *The Wreckers* (339; R.A. 1834), lent by Bicknell.

June: the British Institution's exhibition of old masters opened, including 2 early works by Turner lent by the Earl of Yarborough: *The Wreck of a Transport Ship: painted for the Father of the Earl of Yarborough* of c.1810 (38; B&J 210), and *The Opening of the Vintage of Mâcon: painted in 1803 and purchased by the Grandfather of the Earl of Yarborough* (43; R.A. 1803). Both were unanimously praised.

24 December: Turner in a letter to Hawksworth Fawkes, thanking him for his customary gift of Christmas fare, admits that his 'health is much on the wain' (G. 315).

1850

Royal Academy exhibition: 4 pictures painted at Chelsea shown, which formed a suite of subjects from the *Æneid* and concluded the series of meditations on the story of Carthage that had fascinated him for so long: *Mercury sent to admonish Æneas* (174; B&J 429), *Æneas relating his story to Dido* (192; B&J 430), *The visit to the tomb* (373; B&J 431) and *The departure of the fleet* (482; B&J 432). All had lines from the *Fallacies of Hope* appended to their titles in the catalogue. They were the last pictures submitted to an Academy exhibition by Turner. Critics were favourable – Finberg says 'compassionate'.

The Society of Painters in Water-Colours showed 3 of Turner's drawings, lent by John Dillon, a prominent collector of his work: 2 views of *Vesuvius* (284, 299; w.698, 699) and *Junction of Tees and Greta* (291; w.566).

An exhibition at the Liverpool Academy included *Van Tromp, going about, etc.* (37; R.A. 1844), lent by James Miller. He was to lend it to the Royal Scottish Academy in 1852 (21).

19 August: death of Shee, the last of the Academicians of 1802, when Turner had been elected to their ranks. Eastlake succeeded him, prompting the resignation of George Jones, who had been acting President since 1845.

Hawkesworth Fawkes compiled a catalogue of the drawings (some 200) made by Turner for his father, and sent the artist a copy, acknowledged in Turner's Christmas letter of 27 December (G. 318).

1851

Turner's health prevented him from taking part in social events, such as Ruskin's birthday dinner in February (G. 322).

Royal Academy exhibition: he sent no work, but attended the varnishing days, taking great interest in Maclise's picture of *Caxton's Printing-Office*.

7 May: taken by S. A. Hart to a dinner of the Royal Academy Club, his last attendance at such a function.

An exhibition at the Royal Scottish Academy included 2 pictures lent by the Earl of Yarborough: *Opening of the Vintage of Mâcon* (158; R.A. 1803) and *The Wreck of the Minotaur, Seventy-four, on the Haack Sands, 22nd December 1810* (306), a new title for *The Wreck of a Transport Ship* of c.1810.

Turner negotiated with Griffith the sale of his series of views on the Loire for the first *Annual Tour* of 1833. They were eventually acquired by Ruskin, who gave them to the University of Oxford. Griffith was apparently also anxious to acquire the 'sample' studies for the Swiss watercolours of 1842 (G. 325), but Turner would not part with them.

He was probably engaged on a new series of Continental subjects in watercolours, including Swiss scenes, though he seems to have concealed this activity from

Ruskin and others who might have been interested, probably because he was aware that his work no longer displayed the consummate power of his earlier watercolours.

1 May: the Great Exhibition opened in Hyde Park. Turner gave Hannah Danby 'strict orders to admit no one' at Queen Anne Street, evidently anticipating a show of interest from tourists and sightseers.

28 May: Charles Turner saw Turner for the last time.

August: publication of Ruskin's pamphlet *Pre-Raphaelitism*, containing a long discussion of Turner's work, especially the watercolours at Farnley which Ruskin had been studying in the spring.

Too ill to leave the Chelsea house, he was attended by Mrs Booth, and by a surgeon, Mr Bartlett; also by Dr Price of Margate.

19 December: Turner died at 10 a.m. His body, in its coffin, was taken to Queen Anne Street and placed in the centre of the gallery.

30 December: he was buried in the crypt of St Paul's Cathedral, according to his own wish. Numerous people had applied to the executors to accompany them to the service, but there was not room. As Griffith reported, 'we filled eleven coaches, and there were besides, eight private carriages.' Immediately afterwards, at Queen Anne Street, his will was read to his executors: Henry Harpur (his cousin and solicitor), Philip Hardwick, George Jones, Munro of Novar and Thomas Griffith. Other executors, not present, were Charles Turner, Henry Scott Trimmer and Samuel Rogers. Ruskin had also been named, but he declined the responsibility.

1852–1857

Early in 1852 Turner's next-of-kin disputed probate of the will, claiming that the testator was of unsound mind, and a long-drawn-out Chancery suit followed. The provisions of the will were vulnerable only in regard to the Indenture of Bargain and Sale of 24 July 1844, making over to the executors the freehold land at Twickenham on which Turner proposed to build his Almshouses. Since the land was not put into their possession within a year of Turner's death it could not be used for the charitable purpose stipulated. The dispute was resolved by a compromise agreement between the executors and the relatives embodied in a Decree of Vice-Chancellor Kindersley, 9 March 1856. By its terms Turner's money (almost £140,000) and property was divided among the family, while the contents of his studio, which had been transferred from Queen Anne Street to the National Gallery by his executors in 1854, became the responsibility of the Trustees of the National Gallery. *Dido building Carthage* and *Sun rising through vapour* had been hung beside the Claudes, according to Turner's wishes, in December 1852. A preliminary catalogue drawn up by the assessors (Eastlake and John Prescott Knight, the President and Secretary of the Royal Academy) in September 1856 gave the total numbers of items in the 'Turner Bequest' as:

Finished Pictures	100
Unfinished pictures, including mere beginnings	182
Drawings and sketches in colour and in pencil, including about three hundred coloured drawings	19,049
	19,331

In February 1857, 34 oil paintings and 102 watercolours, selected by Ruskin, were displayed at Marlborough House.

TURNER'S LIBRARY

The collection of Turner's books remaining in the possession of his family was listed by C. M. W. Turner and first published by Falk in 1938. What follows is an attempt to clarify, correct, and expand that list, in consultation with the family. Several volumes have been lost; they are marked '(M)'. Any information leading to their recovery will be gratefully received. Works annotated by Turner or containing his sketches are marked with an asterisk (*). See also the lists of books included in the Inventory, p.248.

Aglionby, William, *Painting Illustrated in Three Dialogues; containing some choice observations upon the art; together with the Lives of the most Eminent Painters from Cimabue to the time of Raphael and Michael Angelo*, 1685

*Ahn, Franz, *Handbuch der Englischen Umgangsprache*, 1834

[annotated]
Anderson, Robert, *The Works of the British Poets with Prefaces Biographical and Critical*, 13 v., 1795

Androuet du Cerceau, Jacques, *Leçons de Perspective Positive*, 1576

Angus, William, *Principal Seats of the Nobility and Gentry, in Great Britain and Wales, in a Collection of Select Views*, no. XIII, 1800

Ariosto, Ludovico, *Orlando Furioso*, Venice 1565

Artist's Assistant in the Study and Practice of Mechanical Sciences, n.d. [annotated]

Artists' General Benevolent Institution, *An Account of the General Benevolent Institution for the Relief of decayed Artists of the United Kingdom whose works have been known and esteemed by the public*, 1816

*Artists' Joint Stock Fund, Regulations Established 22nd

March 1810 [interleaved, with notes] (M)

Athenæum Club, *Rules and Regulations, Lists of Members*, 3 v., 1833, 1842, 1847 (M)

Batty, Robert, *Hanoverian and Saxon Scenery, from drawings by Lieut.¹ Colonel Batty*, III (proof and etchings), 1827

Blair, William, *Anthropology: or, the Natural History of Man*, 1803 [presentation copy from the author]

Blessington, Marguerite Gardiner, Countess of, ed., *Heath's Book of Beauty*, 1840 (M)

*Blunt, Rev. John James, *Vestiges of Ancient Manners and Customs, discoverable in modern Italy and Sicily*, 1823 [notes]

Bulwer-Lytton, Edward, *King Arthur, etc.*, 2nd ed., 1849 [presentation copy from the author]

Bunyan, John, *The Pilgrim's Progress*, 1834 (M)

Burns, Robert, *The Works of Robert Burns with an account of his life*, 3rd ed., 4 v., 1802

Bury, Lady Charlotte, *The Three Great Sanctuaries of Tuscany, Valombrosa, Camaldoli, Laverna* (with ills. after Edward Bury), 1833 (M)

Byron, Lord, *The Works of Lord Byron; with his letters and journals, and his life by Thomas Moore*, 17 v., 1832–3

Campbell, Thomas, *The Poetical Works of Thomas Campbell* (with ills. after Turner), proof copy, 1837

Carey, William, *A Descriptive Catalogue of a Collection of Paintings by British Artists, in the Possession of Sir John Fleming Leicester, Bart. . . . with occasional Remarks, &c. by Sir Richard Colt Hoare, Bart.*, 1819

A Collection of Water Colour Drawings in the Possession of Walter Fawkes, Esq., 1819

Cooke, William Bernard and George, *Views on the Thames*, 1822 [with a letter from W. B. Cooke to Turner]

— *Descriptions of the Views on the Thames*, 1822

— *W. B. Cooke's List of the New Prints, and Engraved Works . . .*, 1824

Cooper, Edward Joshua, *Views in Egypt and Nubia executed in lithography by Harding and Westall from a collection of drawings taken on the banks of the Nile by S. Borse*, Pts 1, 2, 3, 5, 6, 1824 (M)

The Copper-Plate Magazine; or, A Monthly Treasure for the Admirers of the Imaginative Arts, no. 7

Crabbe, George, *The Poetical Works of the Rev. George Crabbe: with his letters and journals, and his life, by his son*, I, 1834 [with a note to Turner from the publisher, John Murray]

Dayes, Edward, *The Works of the Late Edward Dayes*, 1805

Du Fresnoy, Charles Alphonse, *The Art of Painting, . . . translated into English verse by W. Mason . . . with annotations by Sir Joshua Reynolds*, 1783 (M)

Euclid, *Euclid's Elements of*

Geometry. The whole revised . . . by S. Cunn . . . Carefully revised and corrected by John Ham, 8th ed., 1759

Fawkes, Walter, The Chronology of the History of Modern Europe, from the extinction of the Western Empire, A.D. 475, to the death of Louis the Sixteenth, King of France, A.D. 1793, In ten Epochs, York, 1810 [presentation copy from the author]

Field, George, Chromatography; or, a treatise on colours and pigments, and of their powers in painting, 1835 (M)

Gallery of Modern British Artists consisting of a series of Engravings from Works of the most eminent Artists of the day, I, 1835

*Genlis, Madame Brulart de, Manuel du Voyageur, or, the Traveller's Pocket Companion in English and German, new ed., 1829 [annotated]

Geological Society, Transactions, 2 v., 1811 (M)

*Goethe, Johann Wolfgang von, Theory of Colours. Translated from the German with notes by C. L. Eastlake, 1840 [annotated]

*Goldsmith, Oliver, The Roman History, from the foundation of the City of Rome, to the destruction of the Western Empire, 1786 [notes and sketches]

Hakewill, James, A Picturesque Tour of Italy from drawings made in 1816–17, No. 2, 1818
— A Picturesque Tour in the Island of Jamaica from drawings made in the years 1820 and 1821, 1825

Halfpenny, Joseph, Gothic Ornaments in the Cathedral Church of York, 1795 (M)

Hall, Chambers, The Picture, a nosegay for amateurs, painters, picture-dealers, picture-cleaners . . . and all the craft. Being the autobiography of a Holy Family, by Raphael, faithfully written by actual dictation of the picture itself, 1837 [presentation copy from the author]

Hall, Samuel Carter, ed., The Book of Gems. The Poets and Artists of Great Britain, 1836–8 (M)

*Hansard, Thomas Carson, and others, Report . . . on the Mode of Preventing the forgery of Bank Notes, 1819 [notes]

Hayter, Charles, An Introduction to Perspective Drawing and Painting, 2nd ed., 1815 (M)

Henley, John, The Antiquities of Italy, 2nd ed., 1725

Highmore, Joseph, The Practice of Perspective on the Principles of Dr Brook Taylor, 1763 (M)

Hoare, Sir Richard Colt, Hints to Travellers in Italy [by H. R. C.], 1815

Hope, Thomas, Costume of the Ancients, 1809

Howlett, Bartholomew, A Selection of Views in the County of Lincoln, 1797 (M)

Hughes, Rev. Thomas Smart, Travels in Sicily, Greece and Albania, 2 v., 1820

Hunt, Thomas Frederick, Designs for Parsonage Houses, Alms Houses, etc. with examples of gables, and other curious remains of old English Architecture, 1827 (M)

Jombert, Charles Antoine, Méthode pour Apprendre le Dessein, 1755

Junius, Franciscus (François Du Jon), The Painting of the Ancients in three bookes: declaring by historicall observations and examples the beginning, progresse, and consummation of that . . . art, 1638 [Turner's signature in pencil on flyleaf]

Keepsake: 48 Engravings. Rare Proofs, pub. Charles Tilt

Kirby, Joshua, Dr Brook Taylor's Method of Perspective made easy both in theory and practice, 3rd ed., 2 v., 1765 [ex libris H. S. Trimmer] (M)

Lamy, Bernard, Perspective made easie; or, the art of representing all manner of objects as they appear to the eye in all scituations . . . (trans. A. Forbes), 1710

Landseer, John, Lectures on the Art of Engraving, delivered at the Royal Institution of Great Britain, 1807 [presentation copy from the author]

Livy, The Roman History written in Latine by Titus Livius . . . faithfully done into English [by E. Bohun], 1686

Lloyd, Hannibal Evans, Picturesque Views in England and Wales from drawings by J. M. W. Turner, R.A., 1832

Lockhart, John Gibson, Life of Sir Walter Scott, Bart, 2nd ed., 10 v., 1839 (M)

Lowry, —, A New Treatise on Perspective, 1810 (M)

Macquer, Pierre Joseph, Elements of the Theory and Practice of Chemistry (trans. A. Reid), 2nd ed., 2 v., 1764

Mawman, Joseph, An Excursion to the Highlands of Scotland and the English Lakes, 1805 [presentation copy from the author]
— A Picturesque Tour through France, Switzerland, on the banks of the Rhine and through part of the Netherlands during 1816, 1817

Milton, John, The Poetical Works of John Milton with imaginative illustrations by Turner, and a Life of Milton by Sir Samuel Egerton Brydges, 6 v., 1835
— Paradise Regained, and other poems, 1713 (M)

Moore, Thomas, The Epicurean. A Tale with vignette illustrations by J. M. W. Turner, R.A., and Alciphron A Poem, 1839

[Morgan, John Minter], The Revolt of the Bees, 1826 [presentation copy from the author] (M)

*Morlent, M. J., Voyage Historique et Pittoresque sur la Seine en Bateau à Vapeur, 3rd ed., Rouen 1829 [marginal sketches]

Moxon, Joseph, Practical Perspective, or perspective made easy, n.d. (1670?)

O'Brien, Charles, The British Manufacturer's Companion and Callico Printer's Assistant. Being a treatise on callico printing, 1795

*Opie, John, Lectures on Painting delivered at the Royal Academy of Arts. With a letter on the proposal for a public memorial of the naval glory of Great Britain. To which are prefixed a memoir by Mrs Opie, and other accounts of Mr Opie's talent and character, 1809 [annotated]

Ossian, The Poems of Ossian (trans. James Macpherson), 1797 (M)

Pickett, William Vose, New System of Architecture, founded on the forms of nature, and developing the properties of metals, 1845 [presentation copy from the author]

Plutarch, The Lives of the Noble Grecians and Romans compared together (trans. T. North), 1657 (M)

The Pocket Magazine; or, Elegant Repository of Useful and Polite Literature, 1795

Pope, Alexander, The Iliad of Homer, Edinburgh 1773

*Priestley, Joseph, A Familiar Introduction to the Theory and Practice of Perspective, 1770 [annotated]

The Review of Publications of Art, 1 June 1808

Reynolds, Sir Joshua, The Works of Sir Joshua Reynolds, ed. Edmond Malone, 4th ed., 3 v., 1809

Rhodes, Ebenezer, Peak Scenery, or Excursions in Derbyshire with Engravings by . . . W. B. and G. Cooke from Drawings by F. L. Chantrey, 1818–22

Richardson, Sir John, The Zoology of the Voyage of H.M.S. Erebus and Terror, pt v, Fishes, 1845 (M)

*Richardson, Jonathan, The Works of Jonathan Richardson. All corrected and prepared for the press by his son . . . J. Richardson. With portraits of painters, 1792 [annotated]

Ritchie, Leitch, Travelling Sketches in the North of Italy, the Tyrol, and on the Rhine, in Belgium and on the Sea Coasts of France. With engravings from drawings by Clarkson Stanfield (Heath's Picturesque Annuals), 4 v., 1832, 1834, 1840, 1841 (M)
— Heath's Picturesque Annual of Ireland, 1838
— Heath's Picturesque Annual of Versailles, 1839
— Wanderings by the Loire and Wanderings by the Seine. Turner's Annual Tour, 3 v., 1833, 1834, 1835

Rogers, Samuel, Italy, a Poem, 2 v., 1824
— Italy, 1830
— Poems, 1834
— Poems, 1839 [presentation copy from the author]

Roscoe, Thomas, The Tourist in Switzerland and Italy. Illustrated from drawings by S. Prout (The Landscape Annual), 1830 (M)

Royal Academy of Arts, Abstract of the Instrument of Institution and Laws of the Royal Academy, 4 v., (2 M), 1797–1815
— Catalogues of exhibitions (M)

Ruskin, John, The Stones of Venice, I, The Foundations, 1851 [presentation copy from the author]

Salmon, William, Polygraphice; or the art of drawing, engraving, . . . varnishing, . . . and dying, &c., 3rd ed., 1675

Sass, Henry, A Journey to Rome and Naples . . . in 1817 giving an account of the present state of society in Italy; and containing observations on the fine arts, 1818

Schreiber, Aloys Wilhelm, The Traveller's Guide down the Rhine, 1818

Scott, Sir Walter, The Poetical Works of Sir Walter Scott, 11 v., 1830 (M)
— Waverley Novels, 31 v., 1836–8

Senefelder, Alois, A Complete Course in Lithography, accompanied by specimens of drawings. To which is prefaced a History of Lithography . . ., 1819

*Shee, Martin Archer, Elements of Art, a poem; in six cantos; with notes and a preface; including strictures on the state of the arts, criticism, patronage, and public taste, 1809 [interleaved, with notes]

Soane, Sir John, Sketches in Architecture; containing Plans and Elevations of Cottages, Villas, and other . . . Buildings, 1793 (M)
— Designs for Public Improvements in London and Westminster, 1828 [presentation copy from the author]
— Description of the House and Museum on the north side of Lincoln's Inn Fields, the residence of Sir John Soane, 1830 and 1835 (1835 M) [presentation copies from the author]

Somerville, Mrs Mary, Mechanism of the Heavens, 1831 (M)

Starke, Mariana, Information and directions for travellers on the Continent, 7th ed., 1829 (M)

Taylor, Brook, Linear Perspective; or, a new method of representing justly all manner of objects as they appear to the eye in all situations, 1715

Tickell, Thomas, The Poetical Works of Thomas Tickell, with the Life of the Author, 1796 (M)

Tinney, John, A Compendious Treatise of designing, painting, and sculpture, On 8 Copper plates, 1772 (M)

Turner, Dawson and Mrs Mary, Outlines in Lithography, from a small collection of pictures, 1840 (M)

Turner, Mrs Dawson, One Hundred Etchings by Mrs Dawson Turner, 1837 [presentation copy from the artist with letter to J. M. W. Turner]

*Vatican, Musée Vatican, Galerie des Tapisseries au Vatican, 1842; and Galeries des Tableaux au Vatican, 1845 (M) [interleaved, with notes and drawings by Turner (?); however, these two titles are scored through in C. M. W. Turner's inventory and may not have belonged to this collection]

Webb, Daniel, An Enquiry into the Beauties of Painting, and into the merits of the most celebrated Painters ancient and modern, 2 v., 2nd ed., 1761, 4th ed., 1777 (1777 M)

Westall, William, Views of the Caves near Ingleton, Gordale Scar, and Malham Cove, in Yorkshire, 1818 [presentation copy from the author]

Williams, Hugh William, Select Views in Greece with Classical Illustrations, 1829 (M)

Wolffius, Jeremias, Views on the Danube, 1822 (M)

Wright, Rev. George Newenham, Landscape-Historical Illustrations of Scotland and the Waverley Novels: from drawings by J. M. W. Turner, Professor, R.A., I, 1836

INVENTORY
of 47 or 46a Queen Anne Street
The Late Residence of J. M. W. Turner

Date November 1854

2nd Floor
East Room
Pantheon Stove and Fender
Brussels Carpet
Mahogany Pillar 4 post
 bedstead and furniture
 Hair Mattress and bed
 Feather bed bolster &
 pillow
 2 Blankets &
 counterpanes
Mahogany night Table
3 and 2 elbow Black Chairs
Mahogany corner basin
 stand
Mahogany shut up dressing
 table
Satin Wood Cabinet
2 Glazed cases with models
 of ships
4 Mahogany hand pallattes
Japaned box with papers of
 colors
An old writing Case
6 Mill Boards
2 Sketching books
Sundry pamphlets
3 small Telescopes
12 large folio and other
 books for sketches
Sundry drawing boards etc.

West Room
Pantheon Stove
5ft 6in 4 post bedstead
 incomplete
A square carpet
Mahogany Night Table
Mahogany corner basin
 stand
4 Chairs and 2 elbow ditto
6 Chair Cushions & morine
 cases
Large bolster
A large Sea Chest
2 Red Morine Window
 Cushions
4 Silk Ditto lined with
 lamony
Quantity of worsted Rope
Quantity of Old Chintz and
 Dimity Furniture
Satin table Cover
6 pairs of Trousers
2 Waistcoats
3 Shirts Cravat
½ dozen D'Oyleys

First Floor
Front Room [studio]
Register Stove, Steel Fenders
 & set of Fire Irons
Square Axminster Carpet.
 Persian Rug
3 Mahogany hair seat chairs,
 5 ebonized chairs
2 Mahogany elbow chairs
3 Caned Window settees
Large Mahogany Oval Table
 on pillar and Claw
2 semi circular tables

Mahogany Oval table with
 trays and centre
Mahogany desk on stand
Mahogany table with sliding
 Top
2 small mahogany pembroke
 Tables with drawers
Mahogany shut up Ink stand
 glasses & drawers
Gun by Jns Manton, case
 and fittings
Deal Cupboard with quantity
 of drawing paper
Wainscot Cupboard and
 quantity of colors
2 Light Lamps
Mahogany box & quantity
 of Colors
36 Portfolios
Japanned box with sundry
 paper
Ditto with colors
Set of 3 Mantel Vases
2 Plaster Models
A ditto. A Church
 monument
Small Magnifying Glass

Picture Gallery
Register Stove & bow
 fender
Drugget on Floor
Sofa with two bolsters in
 morine
3 Old Chairs
2 Cloth Curtains to folding
 doors
2 Ditto for end of Room
A Japanned box
Mahogany Cabinet with 16
 Glass jars of Colors
Mahogany easel

Ground Floor
Parlour
Register Stove, Steel Fender
 and fire irons
Turkey Carpet and Persian
 Rug
Pair of morine Window
 Curtains brass rods &
 rings
Mahogany Pedestal
 sideboard
4ft Oak Loo Table
6 mahogany chairs with
 leather seats
A mahogany dumb Waiter
Mahogany Cheffonier with
 Drawer
Inlaid rosewood ditto with
 scagliola top
Pair of large Sienna scagliola
 marble pedestals
Scagliola plinth
Pair of deal portfolio Cases
 with shelves
Pair of sideboard Lamps
 with bronze figures
Pair of Mantel Candlesticks
 with glass pedestals

Small marble pedestal for
 figure
Compo cast of Apollo
4 Ditto Groups
Pair of small Alabaster cups
Pair of China Vases with
 pierced covers
3 shelves
3 Ormolu mounted cups of
 five pieces of china
Plaster female figure glass
 shade and stand
Double barrelled pistol
Cast of a Scull
Plaster Cast in a gilt frame
Small carved Oak panel
A bronze ditto
China figure, Water Carrier
Decanter and 5 Wine Glasses
Stand & Tray

Dining Room
Register Stove Brass Fender
 & fire irons
Chimney Glass 30 × 20
Pair of Mahogany Pedestals
 with Vases
Mahogany frame table with
 marble top 4ft × 2ft
Pair of Table Globes
Small Bookcase with glazed
 door
2 light Candle shades
Large feather dusting brush
Mahogany Chest of 3
 Drawers
2 Large mahogany 2 flap
 tables
Mahogany Pembroke table
Small mahogany 2 flap table
4 mahogany Hall Chairs 3
 old chairs
Gilt Window Cornice
8 Day clock in upright Case
 (case only)

Books Vols

	Vols
Scott's Prose Works	28
„ Poetical Ditto	12
„ Waverley Novels Vol 32 deficient	48
„ ditto incomplete	41
Lockhart's life of Scott	10
Byron's life & works incomplete	15
Milton's Works	6
Turner's Annual tour	27
„ Keepsake	4
Book of Gems	2
Heath's Annuals	7
James Naval History	5
Ruskin's Stones of Venice	1
Campbell's Works	2
Bulwer's King Arthur	
Hope's Costumes	
Various	About 70
Sundry pamphlets etc	
6 Books of Music and sundry ditto	
British Poets	13
Scott's Poetical Works in boards	10
Various	40

Set of Maps (Scotland)
 in case
Gothic Ornaments York
 Cathedral
Illustrations of the Waverley
 Novels
Mrs Dawson Turner's Etchings

Antiquities of Italy	
Virgilii opera folio	
Scotch Airs	
Lincoln illustrated	
Peak Scenery	3

Soan's sketches on
 Architecture
 „ House & Museum
 „ designs for
 improvements
Field's Chromatography
Gallery of Modern British
 Artists
The 3 great sanctuaries
 by Lady C. Bury
Drawing from Pictures
 (D. Turner)
Sundry pamphlets etc
Antiquities of Cornwall
Livy's Roman History
Opie on Painting
About 36 vols various

Further Rooms
Stove & fender, Kneehole
 Chest of Drawers, piece of
 Oil cloth, Large deal
 Easel, 2 Canvassed frames,
 4 loose panelled boards
Stuffed Bird, Compo bust
Small mahogany table with
 drawers and various
 contents for painting,
 Loose stove, Sundry Mill
 Boards
2 Pedestal Blocks of Wood,
 Sundry Rolls of paper
High folding steps, 2 deal
 panel boards
Sundry broken Casts, 3 tin
 boxes

Entrance Hall & Staircase
The Oil Cloth planned.
 Door Mat
5 Mahogany Hall Chairs
2 Lightlamps, Stair carpet &
 rods
8 Day Clock in Mahogany
 Case
Pair of painted pedestals
 with marble tops &
 plaster Bust on one
4 large Compo groups on
 walls
China jar and stand
2 India Jars (broken)
Compo figure on staircase
Chest of 3 drawers with
 paper
A colored print

Building in Yard
Stove, 2 fenders
High folding steps
Walnut Cabinet with
 Drawers under
Large quantity of Lumber

Rooms Over
Stove
Sundry old gilt cornices
Old Chest of drawers with
 old Newspapers etc
Wainscot cupboard
Sundry Lumber

Sundry Lumber in Yard

Basement
Kitchen
The range with oven etc
Fender and Fire Irons
2 Brass Candlesticks
Snuffers and Tray
2 hot water plates
Mahogany Butler's tray
Wainscot Bureau with
 Drawers
Sugar Nippers
Japanned Coffee Pot
Large Mahogany 2 flap table
Knife box & 6 Knives &
 forks
Japanned Tea Chest
Willow pattern Dinner Ware
 40 pieces
Carpet & Rug
Copper Coal Scuttle
Brass Footman
Stew Dish & Cover

Washhouse
Copper as set
Cupboard with shelves &
 cupboard under
Nest of shelves and hinged
 board
Plate Rack
Knife Board
Iron french Bedstead
6 India China plates
14 Cups & 6 saucers
2 Bowls 2 matching pots
Round dish
Large Napkin Bowl
Jug 14 Finger Glasses and
 Wine Coolers
2 Decanters & Jug

Back Kitchen
Old Stove
Large table
6 Beer Barrels
Sundry Lumber

Plate
A Tea pot Cream jug &
 Sugar Basin
Pint tankard
Pepper Castor & pair of salts
Pair of table spoons
6 tea spoons & 2 salt spoon
 – two forks
Sauce ladle Punch ditto and
 Butter knife
Wine Strainer
Pair of Sugar Tongs
 (broken)

2 French Watches
2 Medals in Cases
1 Prize Palette ditto

The articles herein
mentioned are valued for
payment of Duty at the sum
of one hundred and two
pounds.

 March 1857
 J. G. Elgood
Appraiser & Auctioneer
98 Wimpole Street

BIBLIOGRAPHY

This select list is limited to the documents cited in this book and to biographical and other writings that directly augment the material presented here. For fuller general bibliographies see B&J or W.

Abbreviations used below are BMag. (*Burlington Magazine*) and TS (*Turner Studies*).

General abbreviations:

B&J Martin Butlin and Evelyn Joll, *The Paintings of J. M. W. Turner*, 2 v., 1977, rev. ed. 1984

G. John Gage, *Collected Correspondence of J. M. W. Turner*, 1980 [a supplement is in *TS*, 6, 1, 1986, pp. 2–9]

R. W. G. Rawlinson, *The Engraved Work of J. M. W. Turner*, 2 v., 1908, 1913

R. Ruskin: Sir E. T. Cook and A. Wedderburn, eds., *The Works of John Ruskin* (Library Edition), 39 v., 1903–12: vols. VI and VII (*Modern Painters*), XII (*Lectures*), XIII (*Catalogues*), XXVII and XXVIII (*Fors Clavigera*), XXXV (*Praeterita* and *Dilecta*), XXXVIII (*Bibliography and Catalogue of Drawings*) — *Diaries*, ed. Joan Evans and John Howard Whitehouse, 3 v., 1956

T. Walter Thornbury, *The Life of J. M. W. Turner, R.A.*, 2 v., 1862, rev. ed. 1876

TB A. J. Finberg, *A Complete Inventory of the Drawings of the Turner Bequest*, 2 v., 1909

W. Andrew Wilton, *The Life and Work of J. M. W. Turner*, 1979 (cat. of watercolours)

Anon., Obituary of Turner in *The Times*, 23 Dec. 1851
Armstrong, Sir Walter, *Turner*, 1902
Athenæum: see M. H.
Bayes, Walter, *Turner, A Speculative Portrait*, 1931
Bell, C. F., 'Turner and his Engravings', in *The Genius of Turner*, ed. C. Holmes, 1903
Burnet, John, *Turner and his Works: illustrated with Examples from his Pictures and critical remarks on his principles of painting. The Memoir by Peter Cunningham, F.S.A.*, 1852
Carey, William, *Some Memoirs of the Patronage and Progress of the Fine Arts*, 1819

Chantrey: George Jones, *Sir Francis Chantrey, R.A. Recollections of his Life, Practice, and Opinions*, 1849
Collingwood, William Gershom, *The Life and Work of John Ruskin*, 1900
Constable: C. R. Leslie, *Memoirs of the Life of John Constable*, 1843; ed. Jonathan Mayne, 1951
Cunningham, Peter, Obituary of Turner in the *Athenæum*, 27 Dec. 1851
— 1852: see Burnet
Eastlake, Charles Lock, *Contributions to the Literature of the Fine Arts*, 2nd ser., 1870
Eastlake, Lady: Charles Eastlake Smith, ed., *Journals and Correspondence of Lady Eastlake*, 1895
Falk, Bernard, *Turner the Painter: His Hidden Life*, 1938
Farington: Kenneth Garlick and Angus Mackintyre, and Kathryn Cave, eds., *The Diary of Joseph Farington*, 16 v., 1978–84
Fawkes, Edith Mary, *Turner at Farnley*, typescript in the National Gallery, London
Finberg, A. J., *The History of Turner's Liber Studiorum*, 1924
— *In Venice with Turner*, 1930
— *The Life of J. M. W. Turner, R.A.*, 1939; 2nd ed., 1961
Finberg, Hilda F., 'Turner's Gallery in 1810', *BMag.*, XCV, 1953, pp. 98–9
Finley, Gerald, 'J. M. W. Turner's Proposal for a "Royal Progress"', *BMag.*, CXVII, 1975, pp. 27–35
— *Landscapes of Memory: Turner as Illustrator to Scott*, 1980
— *Turner and George IV at Edinburgh*, 1981
Frith, William Powell, *My Autobiography and Reminiscences*, 3 v., 1887
Gage, John, 'Turner's Academic Friendships: C. L. Eastlake', *BMag.*, CX, 1968, pp. 677–85
— *Colour in Turner: Poetry and Truth*, 1969
— 'The Distinctness of Turner', *J. Royal Soc. of Arts*, CXXIII, 1975, pp. 448–58
— 'Turner's Annotated Books: "Goethe's Theory of Colours"', *TS*, 4, 2, 1984, pp. 34–52
— 'Turner in Venice', *Art Bulletin*, LIII, 1971, pp. 84–7
— 'Turner in Europe in 1833', *TS*, 4, 1, 1984, pp. 2–21
Goodall: *The Reminiscences of Frederick Goodall, R.A.*, 1902
Hamerton, Philip Gilbert,

The Life of J. M. W. Turner, R.A., 1879, new ed., 1895
Haydon: Willard Bissell Pope, ed., *The Diary of Benjamin Robert Haydon*, 5 v., 1960
Hill, David, *Turner in Yorkshire*, exhib. cat., York City Art Gallery, 1980
— '"A Taste for the Arts": Turner and the Patronage of Edward Lascelles of Harewood House', *TS*, 4, 2, 1984, pp. 24–33, and 5, 1, 1985, pp. 30–46
Holcomb, Adele, '"Indistinctness is my Fault". A letter about J. M. W. Turner from C. R. Leslie to James Lenox', *BMag.*, CXIV, 1972, pp. 557–8
Horsley, John Callcott: Mrs Edmund Helps, ed., *Recollections of a Royal Academician*, 1903
Hutchison, Sidney C., *The History of the Royal Academy, 1768–1968*, 1968
Jones, George, *Recollections of J. M. W. Turner*, MS in Ashmolean Museum, Oxford; pub. in G.
Lawrence: D. E. Williams, *The Life and Correspondence of Sir Thomas Lawrence, Kt.*, 2 v., 1831
Leitch: A. MacGeorge, *William Leighton Leitch, Landscape Painter. A Memoir*, 1884
Leslie, Charles Robert, *Autobiographical Recollections*, ed. Tom Taylor, 2 v., 1860
Leslie, George Dunlop, *The Inner Life of the Royal Academy*, 1914
Lindsay, Jack, *J. M. W. Turner. His Life and Work. A Critical Biography*, 1966
— *The Sunset Ship; The Poems of J. M. W. Turner*, 1966
— *Turner, the Man and his Art*, 1985
Livermore, Ann Lapraik, 'Sandycombe Lodge', *Country Life*, 6 July 1951, pp. 40–42
— 'Turner and Music', *TS*, 3, 1, 1983, pp. 45–8
Lloyd, Mary, 'A Memoir of J. M. W. Turner, R.A.', *Sunny Memories*, 1880, pp. 31–8 (repr. *TS*, 4, 1, 1984, p. 22)
M. H. [Marcus Huish?], 'The Early History of Turner's Yorkshire Drawings', *Athenæum*, 1894, pp. 326–7 (repr. *TS*, 5, 2, 1985, pp. 24–7)
Martin, Leopold, 'Reminiscences of John Martin, K.L.', *Newcastle Weekly Chronicle*, March 1889
Miller, Thomas, ed., *Turner and Girtin's Picturesque Views, Sixty Years Since . . . with Thirty Engravings*

of the Olden Time, 1854
Monkhouse, W. Cosmo: *Turner*, 1879
— Entry on Turner in the *Dictionary of National Biography*
Pye: J. L. Roget, ed., *Notes and Memoranda respecting the Liber Studiorum of J. M. W. Turner, R.A. written and collected by the late John Pye, Landscape Engraver*, 1879
Rawlinson, W. G., *Turner's Liber Studiorum, a Description and a Catalogue*, 1878, 2nd ed., 1906
Redding, Cyrus, 'The Late J. M. W. Turner', *Fraser's Magazine for Town and Country*, XLV, Feb. 1852
— *Fifty Years' Recollections, Literary and Personal*, 2 v., 1858
— *Past Celebrities Whom I Have Known*, 1866
Redgrave, F. M., *Richard Redgrave, C.B., R.A., A Memoir*, 1891
Redgrave, Richard and Samuel, *A Century of Painters of the English School*, 2 v., 1866, esp. II, pp. 80–135
Reeve, Lovell, Obituary Memoir of Turner in *Literary Gazette*, 27 Dec. 1851 and 3 Jan. 1852
Reynolds, Graham, *Turner*, 1969
Rigaud: William L. Pressly, ed., 'Facts and Recollections of the XVIIIth Century in a Memoir of John Francis Rigaud Esq., R.A. by Stephen Francis Dutilh Rigaud', *Walpole Soc.*, L, 1984, pp. 1–164
Robinson, W., *The History and Antiquities of Tottenham*, 1840, I
Roget, John Lewis, *A History of the 'Old Water-Colour' Society*, 2 v., 1891
Shanes, Eric, *Turner's Picturesque Views in England and Wales, 1825–1838*, 1979
— *Turner's Rivers, Harbours and Coasts*, 1981
Soane: Arthur T. Bolton, ed., *The Portrait of Sir John Soane, R.A.*, 1927
Swinburne, C. A., *Life and Works of J. M. W. Turner, R.A.*, 1902
Thornbury, Walter, *The Life of J. M. W. Turner, R.A.*, 2 v., 1862, 2nd ed., 1877
Turner, Charles, Diary; MS in the Beinecke Library, Yale University, New Haven
Turner, J. M. W., Perspective lectures; MSS quoted are the drafts in British Library, Dept of Manuscripts, Add. MS 46151. Other drafts are in a private collection. Transcripts by Maurice

Davies are to be published by the Walpole Soc.
— Verse Book; MS in a private collection: see J. Lindsay, *The Sunset Ship*, 1966
Uwins: Sarah Uwins, *A Memoir of Thomas Uwins, R.A.*, 1858
Venning, Barry, 'Turner's Annotated Books: Opie's "Lectures on Painting" and Shee's "Elements of Art"', *TS*, 2, 1, 1982, pp. 36–46; 2, 2, 1982, pp. 40–49; and 3, 1, 1983, pp. 33–44
Walker, R. J. B., 'The Portraits of J. M. W. Turner: A Check-List', *TS*, 3, 1, 1983, pp. 21–32
Warburton, Stanley, *Turner and Dr Whitaker*, exhib. cat., Towneley Hall Art Gallery, Burnley, 1982
Watts, Alaric, 'Biographical Sketch of J. M. W. Turner, Esq., R.A.' in *Liber Fluviorum* (a reprint by H. G. Bohn of *Wanderings by the Seine* and *Loire*, 1833–5), 1853
Webber, Byron, *James Orrock, R.I.*, 2 v., 1903
Whitley, William T., *Artists and their Friends in England, 1700–1799*, 2 v., 1928
— *Art in England, 1800–1820*, 1928
— *Art in England, 1821–1837*, 1930
Wilkie: D. Laing, *Etchings by Sir David Wilkie . . .*, 1875
Wilkinson, Gerald, *Turner's Early Sketchbooks, Drawings in England, Wales and Scotland, 1789–1802*, 1972
— *The Sketches of Turner, R.A.*, 1974
— *Turner's Colour Sketches, 1820–1834*, 1975
Wilton, Andrew, *Turner in Wales*, exhib. cat., Mostyn Art Gallery, Llandudno, 1984
Woolner: Amy Woolner, *Thomas Woolner, R.A., Sculptor and Poet. His Life in Letters*, 1917
Youngblood, Patrick, 'The Painter as Architect: Turner and Sandycombe Lodge', *TS*, 2, 1, 1982, pp. 20–35
— '"That House of Art": Turner at Petworth', *TS*, 2, 2, 1983, pp. 16–33
Ziff, Jerrold, '"Backgrounds: Introduction of Architecture and Landscape": A Lecture by J. M. W. Turner', *J. Warburg and Courtauld Inst.*, XXVI, 1963, pp. 124–47
— 'Turner on Poetry and Painting', *Studies in Romanticism*, III, 1964, pp. 193–215

LIST OF ILLUSTRATIONS

Unless otherwise stated, works are by Turner. Titles of his paintings are occasionally given in abbreviated form; the full title will be found in the caption. Dates given for his paintings are generally those of their first exhibition. The support for watercolour is paper, and for oil canvas unless otherwise stated. Measurements (given only for works by or after Turner; for prints, the plate size) are in centimetres, followed by inches, height before width; in the case of details, the overall size is given. *Photo credits are in italic.*

Abbreviations

bc bodycolour (gouache)
wc watercolour
B & J, R., see the Bibliography, p. 249
TB:
BL by courtesy of the British Library Board, London
BM by courtesy of the Trustees of the British Museum, London
CI Courtauld Institute of Art, University of London
NG by courtesy of the Trustees of the National Gallery, London
NPG by courtesy of the Trustees of the National Portrait Gallery, London
NT The National Trust
PMC Paul Mellon Centre for Studies in British Art, London
RA Royal Academy of Arts
Tate The Tate Gallery, London
TC Turner Collection, The Tate Gallery, London
Yale BAC Yale Center for British Art, Paul Mellon Collection, New Haven

109 Design for *Lake of Thun, Swiss* in the *Liber Studiorum* (pub. 1808); pen and brown wash, 18.3 × 26.4 (7$\frac{3}{16}$ × 10$\frac{3}{8}$). TB CXVI–R. TC

110 After Turner: *London from Greenwich* from the *Liber Studiorum*, pub. 1811; etched by J.M.W. Turner and mezzotinted by C. Turner, 20.8 × 29.1 (8$\frac{3}{16}$ × 11$\frac{7}{16}$); R.32. R.76. BM

111 Etched outline for *Young Anglers* from the *Liber Studiorum* (pub. 1811); 20.8 × 29.1 (8$\frac{3}{16}$ × 11$\frac{7}{16}$); R.32. The Fine Arts Museums of San Francisco. California State Library, long loan

112 *The Garreteer's petition*, 1809; oil on panel, 53 × 78 (20$\frac{7}{8}$ × 30$\frac{3}{4}$). TC

113 *The Amateur Artist*, c.1809; pencil, pen and wash, 18.5 × 30.2 (7$\frac{1}{4}$ × 11$\frac{7}{8}$). TB CXXI–B. TC

114 P. J. de Loutherbourg: *Storm and Avalanche near the Scheideck*, 1804; oil. NT, Petworth

115 *The fall of an Avalanche in the Grisons*, 1810; oil, 90 × 120 (35$\frac{1}{2}$ × 47$\frac{1}{4}$). TC

116 Detail from the catalogue of the exhibition at Turner's Gallery, 1810; 13.3 × 8.9 (5$\frac{1}{4}$ × 3$\frac{1}{2}$). Private Coll.

117 *Thomson's Aeolian Harp* (detail), 1809; oil, 167.6 × 302 (66 × 118$\frac{7}{8}$). City Art Gallery, Manchester

118 *Tabley, Cheshire . . . Calm Morning*, 1809; oil, 91.5 × 117 (36 × 46). Tate (Petworth Coll.)

119 J. Varley: *Walter Fawkes*, c. 1812; pencil. V&A

120 *Shooting-party on the Moors, 12th August*, c.1815; wc with scratching-out, 28 × 39.7 (11 × 15$\frac{5}{8}$). Private Coll.

121 *Farnley Hall seen across Wharfedale from the West Chevin*, c.1817; wc, 28 × 39.8 (11 × 15$\frac{5}{8}$). Private Coll.

122 *Dido building Carthage* (detail), 1815; oil, 155.6 × 231.8 (61$\frac{1}{4}$ × 91$\frac{1}{4}$). NG

123 *Interior of a Prison*, c.1810; wc, 48.6 × 68.6 (19$\frac{1}{8}$ × 27). TB CXCV–120. TC

124 *The Interior of the Brocklesby Mausoleum*, ?1818; wc, 63.5 × 48.2 (25 × 19). TB CXCV–130. TC

125 *Distant View of Plymouth*, 1813; oil on prepared paper, 15 × 23.4 (6 × 9$\frac{1}{4}$). B&J 225a. Private Coll.

126 *Crossing the brook*, 1815; oil, 193 × 165.1 (76 × 65). TC

127 *Venice: Looking east from the Giudecca, sunrise*, 1819; wc, 22.2 × 28.7 (8$\frac{3}{4}$ × 11$\frac{5}{16}$). TB CLXXXI–5. TC

128 *Naples from Capodimonte*, 1819; wc, 40.7 × 25.5 (16 × 10). TB CLXXXVII–13. TC

129 *Rome from the Vatican* (detail), 1820; oil, 177 × 335 (69$\frac{3}{4}$ × 132). TC

130 *Leeds*, 1816; wc, 29 × 42.5 (11$\frac{3}{8}$ × 16$\frac{3}{4}$). Yale BAC

131 *Gibside*, 1817; wc, 27.5 × 45 (10$\frac{3}{4}$ × 17$\frac{3}{4}$). Bowes Museum, Barnard Castle

132 C. R. Leslie: sketch of Turner lecturing at the R.A., 1816; pencil. NPG

133 T. Cooley: sketch of Turner lecturing at the R.A., c.1812; pencil. NPG

134 Analysis of Raphael's

Transfiguration, c.1817; brush and black and red colour, 74.9 × 54.6 (29$\frac{1}{2}$ × 21$\frac{1}{2}$). TB CXCV–163. TC

135 *St George's, Bloomsbury*, c.1810; wc and bc, 74.3 × 46.4 (29$\frac{1}{4}$ × 18$\frac{1}{4}$). TB CXCV–145. TC

136 *Ceiling of the Great Room, Somerset House*, c.1810; wc and bc, 66.7 × 99 (26$\frac{1}{4}$ × 39). TB CXCV–70. TC

137 *Doric frieze and cornice with perspective projection*, c.1810; pencil and wc, 66.7 × 100.3 (26$\frac{1}{4}$ × 39$\frac{1}{2}$). TC

138 *Glass spheres filled with water*, c.1810; wc, 44.5 × 67.3 (17$\frac{1}{2}$ × 26$\frac{1}{2}$). TB CXCV–177. TC

139 J. Green: *Thomas Stothard*, 1830; oil. NPG

140 J. Linnell: studies made during Turner's lecture on Perspective, 27 Jan. 1812; pencil. Tate

141 Sketch of Watchet, in *The British Itinerary or Travellers Pocket Companion (Devonshire Coast No. 1* sketchbook), 1811; pencil, 11.6 × 7.5 (4$\frac{9}{16}$ × 2$\frac{15}{16}$). TB CXXIII–f.170v. TC

142 G. Cooke after Turner: *Watchet, Somersetshire* from the *Southern Coast*, pub. 1820; engraving, 23.8 × 15.6 (9$\frac{3}{8}$ × 6$\frac{1}{8}$). R.107. V&A

143 *The Tamar valley from Tavistock*, from the *Plymouth, Hamoaze* sketchbook, 1813; pencil, 15.7 × 9.5 (6$\frac{3}{16}$ × 3$\frac{3}{4}$). TB CXXXI–f.118. TC

144 J. Pye after Turner: *Pope's Villa*, pub. 1811; engraving, 17.5 × 22.9 (6$\frac{7}{8}$ × 9). R.76. BM

145 W. B. Cooke after Turner: *Lyme Regis, Dorsetshire*, proof D of the engraving for the *Southern Coast*, pub. 1814; 22.2 × 14.6 (8$\frac{3}{4}$ × 5$\frac{3}{4}$). R.94. BM

146 F. Chantrey: *Augustus Wall Callcott*, c.1830; pencil. NPG

147 *Snow storm: Hannibal and his army crossing the Alps*, 1812; oil, 145 × 237.5 (57 × 93). TC

148 T. Rowlandson and A. C. Pugin: *Private view at the Summer Exhibition*, 1807; etching and aquatint. RA

149 *Frosty Morning*, 1813; oil, 113.7 × 174.6 (44$\frac{3}{4}$ × 68$\frac{3}{4}$). TC

150 *The East Gate at Farnley*, c.1818; bc on grey paper, 29.7 × 41.1 (11$\frac{3}{4}$ × 16$\frac{1}{4}$). Private Coll. CI

151 *The Wharfe, from Farnley Hall*, c.1815; bc on grey paper, 29.6 × 41.3 (11$\frac{5}{8}$ × 16$\frac{1}{4}$). Private Coll. CI

152 *Farnley Hall from the east*, c.1815; bc and black chalk on grey paper, 31.1 × 39.4 (12$\frac{1}{4}$ × 15$\frac{1}{2}$). Private Coll. CI

153 *The Drawing-room, Farnley Hall*, 1818; bc on grey paper, 31.5 × 41.2 (12$\frac{3}{8}$ × 16$\frac{1}{4}$). Private Coll. CI

154 *The Oak Panelled Room, Farnley Hall*, c.1818; bc on grey paper, 31 × 40.5 (12$\frac{3}{16}$ × 15$\frac{15}{16}$). Private Coll. CI

155 '*Revolution 1688*' from the 'Historical Vignettes', 1815; pencil and wc, 21 × 15.6 (8$\frac{1}{4}$ × 6$\frac{1}{8}$). Private Coll. Jerry Hardman-Jones

156 *A heron*, from the 'Book of Ornithology', c.1815; wc over pencil, 22.5 × 28 (8$\frac{7}{8}$ × 11). Private Coll.

157 *Dort*, 1818; oil, 157.5 × 233 (62 × 91$\frac{3}{4}$). Yale BAC

158 *A First-Rate taking in Stores*,

1818; pencil and wc, 28.6 × 39.7 (11$\frac{1}{4}$ × 15$\frac{5}{8}$). Cecil Higgins Art Gallery, Bedford

159 Letter from Turner to Callcott, probably c.1820. Add. MS 50118, f.59. BL

160 *The Field of Waterloo*, 1818; oil, 147 × 239 (57$\frac{7}{8}$ × 94$\frac{1}{8}$). TC

161 *Raby Castle*, 1818; oil, 119 × 180.6 (46$\frac{7}{8}$ × 71$\frac{1}{8}$). Walters Art Gallery, Baltimore

162 Cover of the catalogue of Walter Fawkes's exhibition at Grosvenor Place, 1819; pen and ink and wc, 16.5 × 12 (6$\frac{1}{2}$ × 4$\frac{3}{4}$). Private Coll. CI

163 J. C. Buckler: *The Large Drawing-room at 45 Grosvenor Place*, 1819; wc. Private Coll. Jerry Hardman-Jones

164 Sketch plan of Turner's land at Twickenham (detail), from the *Sandycombe and Yorkshire* sketchbook, c.1812; pen and ink, 12.5 × 20 (4$\frac{15}{16}$ × 7$\frac{7}{8}$). TB CXXVII–f.21v. TC

165 Early designs for Sandycombe Lodge, from the *Windmill and Lock* sketchbook, c.1812; pen and ink, 8.6 × 11 (3$\frac{3}{8}$ × 4$\frac{5}{16}$). TC. CI

166 W. B. Cooke after W. Havell: *Sandycombe Lodge, Twickenham*, 1814; engraving. Coll. Bamber and Christina Gascoigne

167 The hall of Sandycombe Lodge. Copyright Country Life

168 Model ship in a glass case with background painted by Turner. TC

169 T. Phillips: *Francis Chantrey* (detail), c.1817; oil. NPG

170 *Wycliffe, near Rokeby*, c.1819, for Whitaker's *Richmondshire*; wc and bc, 29.2 × 43 (11$\frac{1}{2}$ × 16$\frac{7}{8}$). Walker Art Gallery, Liverpool

171 *England: Richmond Hill, on the Prince Regent's Birthday*, 1819; oil, 180 × 335 (70$\frac{7}{8}$ × 131$\frac{3}{4}$). TC

172 Sketches after plates in *Select Views in Italy* (pub. J. Smith, W. Byrne and J. Emes, 1792–6), from the *Italian Guide Book* sketchbook, 1819; pen and ink, 15.5 × 10.2 (6$\frac{1}{8}$ × 4). TB CLXXII–f.19v. TC

173 *Turin Cathedral*, from the *Turin, Como, Lugarno, Maggiore* sketchbook, 1819; pencil, 11.2 × 18.4 (4$\frac{1}{2}$ × 7$\frac{1}{4}$). TB CLXXIV–f.28. TC

174 *Rome: the Portico of St Peter's and the Via della Sagrestia*, from the *Rome: C. Studies* sketchbook, 1819; wc and bc, 36.9 × 23.2 (14$\frac{1}{2}$ × 9$\frac{1}{8}$). TB CLXXXIX–6. TC

175 *The Colosseum and the Arch of Constantine from the Via di San Gregorio*, from the *Small Roman C. Studies* sketchbook, 13.2 × 25.5 (5$\frac{1}{4}$ × 10$\frac{1}{8}$). TB CXC–f.4. TC

176 *Passage of Mt Cenis*, 1820; wc, 29.2 × 40 (11$\frac{1}{2}$ × 15$\frac{3}{4}$). City Museums and Art Gallery, Birmingham

177 *Ulysses deriding Polyphemus* (detail), 1829; oil, 132.7 × 203.2 (52$\frac{1}{4}$ × 80). NG

178 *The Bay of Baiae*, 1823; oil, 145.4 × 237.5 (57$\frac{1}{4}$ × 93$\frac{1}{2}$). TC

179 *Forum Romanum*, 1826; oil, 145.7 × 236.2 (57$\frac{3}{8}$ × 93). TC

180 *Cologne*, 1826; oil, 168.6 × 224 (66$\frac{3}{8}$ × 88$\frac{1}{4}$). The Frick Collection, New York

181 *Margate. Sunrise*, 1822; wc and bc, 43 × 64.6 (16$\frac{15}{16}$ × 25$\frac{7}{16}$).

Yale BAC

182 *Shields on the River Tyne*, 1823; wc, 15.4 × 21.6 (6$\frac{1}{16}$ × 8$\frac{1}{2}$). TB CCVIII–V. TC

183 *Cockermouth Castle*, c.1830; wc and chalk, 34.4 × 48.4 (13$\frac{1}{2}$ × 19). TB CCLXII–192. TC

184 *Richmond Hill and Bridge*, c.1831; wc with bc, 29.1 × 43.5 (11$\frac{1}{2}$ × 17$\frac{1}{8}$). BM

185 *Rouen: the west front of the cathedral*, c.1832, for *Wanderings by the Seine*; bc on blue paper, 14 × 19.4 (5$\frac{1}{2}$ × 7$\frac{5}{8}$). TB CCLIX–109. TC

186 *A castle on a river*, c.1826–34; bc on grey paper. approx. 14 × 19 (5$\frac{1}{2}$ × 7$\frac{1}{2}$). TB CCXCII–67. TC

187 *Saumur*, c.1830; wc, 28.3 × 42.3 (11$\frac{1}{8}$ × 16$\frac{5}{8}$). BM

188 *Datur Hora Quieti*, c.1832; wc, approx. 9.6 × 13 (3$\frac{3}{4}$ × 5$\frac{1}{8}$). TB CCLXXX–199. TC

189 *Funeral of Sir Thomas Lawrence, a sketch from memory*, 1830; wc and bc, 61.6 × 82.5 (24$\frac{1}{4}$ × 32$\frac{1}{2}$). TB CCLXXIII–344. TC

190 J. T. Smith: *Turner in the Print Room of the British Museum*, late 1820s; wc. BM

191 Plans of nos. 7–10 New Gravel Lane, from the Indenture of Partition, 1821. Private Coll.

192 Opening from the *Colour Studies No. 1* sketchbook, c.1830; grey brown wash, each page 7.7 × 10.2 (3 × 4). TB CCXCI(b)–ff.29v–30. TC

193 C. Turner (?): *William Turner Senior*, c. 1820; chalk. Private Coll.

194 No. 47 Queen Anne Street West, photographed in the late 19th C. (demolished). Private Coll.

195 Chinese porcelain figurine formerly at Queen Anne Street. Hastings Museum and Art Gallery

196 Two wine coolers and two hall chairs formerly at Queen Anne Street. Hastings Borough Council

197 *Shields Lighthouse*, from the 'Little Liber', c.1826; mezzotint, 15.1 × 21.2 (5$\frac{15}{16}$ × 8$\frac{3}{8}$). R.801. Yale BAC

198 F. Danby: *Sunset at Sea after a Storm*, 1824; oil. Bristol Museum and Art Gallery

199 *George IV at St Giles's, Edinburgh*, c.1822; oil on panel, 76 × 91.5 (29$\frac{7}{8}$ × 36). TC

200 *The Battle of Trafalgar*, 1824; oil, 259 × 365.8 (102 × 144). National Maritime Museum, Greenwich

201 A. W. Callcott: *Dutch Fishing-boats running foul, in the endeavour to board, and missing the painter-rope*, 1826; oil. Untraced

202 '*Now for the painter*' (*rope*). *Passengers going on board*, 1827; oil, 170.2 × 223.5 (67 × 88). City Art Gallery, Manchester

203 J. M. Gandy: *The Crypt of Sir John Soane's house in Lincoln's Inn Fields*, 1813; wc. By courtesy of the Trustees of Sir John Soane's Museum

204 T. Cooley: sketch of John Soane lecturing at the R.A., c.1812; pencil. NPG

205 *View from the terrace of a villa at Niton, Isle of Wight*, 1826; oil, 45.5 × 61 (18 × 24). Private Coll.

206 *The seat of William Moffatt, Esq., at Mortlake, Early*

(*Summer's*) *Morning*, 1826; oil, 93 × 123.2 (36$\frac{5}{8}$ × 48$\frac{1}{2}$). The Frick Collection, New York

207 East Cowes Castle, from a photograph taken before its demolition in 1950

208 *Boccaccio relating the tale of the birdcage*, 1828; oil, 122 × 91.5 (48 × 36). TC

209 Drawing made at East Cowes, 1827; pen and ink with white bc on blue paper, 19 × 14 (7$\frac{1}{2}$ × 5$\frac{1}{2}$). TB CCXXVII(a)–41. TC

210 *East Cowes Castle, the seat of J. Nash, Esq.; the Regatta starting for their moorings*, 1828; oil, 91.5 × 123.2 (36 × 48$\frac{1}{2}$). V&A

211 *Between Decks*, 1827; oil, 31 × 48 (12$\frac{1}{4}$ × 19). TC

212 *A Music Party*, c.1830; oil, 122 × 90 (48 × 35$\frac{1}{2}$). TC

213 *Petworth Park: Tillington Church in the Distance*, c.1828; oil, 64.5 × 145.5 (25$\frac{3}{8}$ × 57$\frac{3}{8}$). TC

214 T. Phillips: *George O'Brien Wyndham, Third Earl of Egremont*; oil. NT, Petworth

215 J. Partridge: *Charles Lock Eastlake*, 1825; pencil. NPG

216 J. Gibson: *Hylas and the Nymphs*, 1826–8; marble. Tate

217 L. Signorelli: *The Damned*, fresco in Orvieto Cathedral, c.1500–1504. Alinari

218 Michelangelo: *The Last Judgment*, fresco in the Sistine Chapel, Rome, 1536–41. Anderson

219 *Vision of Medea*, 1828; oil, 173.7 × 248.9 (68$\frac{3}{8}$ × 98). TC

220 Italian cartoon attacking Turner, 1828. From E. Fuchs, *Geschichte der erotischen Kunst*, 1912

221 *Messieurs les voyageurs*, 1829; wc and bc with scraping-out, 54.5 × 74.7 (21$\frac{1}{2}$ × 29$\frac{3}{8}$). BM

222 Detail of *Carte Itinéraire de la Bretagne* (1799–1800) with pencil sketches by Turner, probably 1829. TB CCCXLIV–426. TC

223 *La Chaise de Gargantua, near Duclair*, c.1830–32, for *Wanderings by the Seine*; bc on blue paper, 13.7 × 18.8 (5$\frac{3}{8}$ × 7$\frac{3}{8}$). TB CCLIX–106. TC

224 *Soldiers in the upper room of a café*, c.1830; wc and bc with pen on blue paper, 14 × 19 (5$\frac{1}{2}$ × 7$\frac{1}{2}$). TB CCLIX–263(b). TC

225 H. Corbould after Mrs Dawson Turner: *Charles Heath*, 1822; engraving. BM

226 Opening from the *Rivers Meuse and Moselle* sketchbook, 1826; pencil, each page 11.7 × 7.7 (4$\frac{1}{2}$ × 3). TB CCXVI–ff.57v–58. TC

227 Monument to Turner's parents in St Paul's Church, Covent Garden, 1832. Emily Lane

228 E. Goodall after Turner: *Lake of Como*, from Rogers's *Italy*, 1830; engraving, approx. 6.4 × 8.2 (2$\frac{1}{2}$ × 3$\frac{1}{4}$). R.357. BL

229 Vignette for 'Written in Westminster Abbey' in Rogers's *Poems*, c.1832; wc and pencil, 15 × 16.5 (5$\frac{7}{8}$ × 6$\frac{1}{2}$). TB CCLXXX–171. TC

230 Sir T. Lawrence: *Self-portrait* (detail), c.1825; oil. RA

231 *Juliet and her nurse* (detail), 1836; oil, 92 × 123 (36$\frac{1}{4}$ × 48$\frac{1}{4}$). Private Coll. *Sotheby Parke Bernet Inc.*

232 *Petworth: a recital in the White Library*, c.1828–32; bc on

INDEX

Numbers in *italic* type refer to illustrations and their captions.

253

255

256